WHO INVENTED OSCAR WILDE?

WHO INVENTED OSCAR WILDE?

The Photograph at the Center of Modern American Copyright

David Newhoff

Potomac Books
An imprint of the University of Nebraska Press

Library of Congress Cataloging-in-Publication Data
Names: Newhoff, David, author.
Title: Who invented Oscar Wilde?: the photograph at the
center of modern American copyright / David Newhoff.
Description: Lincoln: Potomac Books, University
of Nebraska Press, 2020. | Includes bibliographical
references and index.
Identifiers: LCCN 2020007565
ISBN 9781640121584 (hardback)
ISBN 9781640123861 (epub)
ISBN 9781640123878 (mobi)
ISBN 9781640123885 (pdf)
Subjects: LCSH: Copyright—United States—Philosophy. |
Copyright—Photographs—United States. | Copyright—
Motion pictures—United States.
Classification: LCC KF2994 . N49 2020 |
DDC 346.7304/82—dc23
LC record available at https://lccn.loc.gov/2020007565

Set in Whitman by Laura Buis.

For Jake, Sasha, and Julien

It is well worth one's while to go to a country which can teach us the beauty of the word FREEDOM and the value of the thing LIBERTY.

—Oscar Wilde, *Impressions of America* (1883)

CONTENTS

ILLUSTRATIONS

ACKNOWLEDGMENTS

Several years ago, I did not know the difference between an author and an "author," between criticizing a work for being derivative and the right to prepare a "derivative work." It was solely thanks to many discussions with, and the encouragement of, my dear friend and fellow Bard College alum, Sandra Aistars—now a law professor at George Mason University—that I stumbled into the arena of copyright policy and advocacy of creators' rights in late 2011. Subsequently, writing *The Illusion of More* blog provided an introduction to some wonderfully thoughtful readers, including several brilliant and dedicated legal minds, who welcomed me into the conversation and were beyond generous with their time, expertise, and support for a guy without a law degree insinuating himself into their company.

Specifically, Terry Hart has patiently (dare I say, at times eagerly) fielded my most arcane, hobbledehoy, and impractical questions and ideas; but in that same spirit, debts of gratitude are owed to Keith Kupferschmid, Steven Tepp, and Neil Turkewitz for their gentle and lighthearted guidance during my legal wanderings. More broadly, I am grateful for the enlightening law and policy discussions I have had with Allan Adler, Jonathan Bailey, Matthew Barblan, Bruce Boyden, Alicia Calzada, Stephen Carlisle, Terrica Carrington, Christian Castle, Joseph Fishman, Hugh Hansen, Devlin Hartline, Sarah Howes, Robert Levine, Kevin Madigan, Adam Mossoff, Lateef Mtima, Chris Newman, Sean O'Connor, Maria Pallante, Eric Priest, Mary Rasenberger, Michael Remington, Zvi Rosen, Bill Rosenblatt, Mark Schultz, and Thomas Sydnor.

In the wider community of friends and colleagues whose efforts on behalf of creators' rights have been inspirational, supportive, and informative, I must include Rick Allen, Richard Bennett, Linda Bloss-Baum, Eileen Bramlet, T Bone Burnett, Leslie Burns, Rick Carnes, Christopher Carroll, Kat Caverly, Rebecca Cusey, John Degen, Lori Flekser, Howard Gantman, Tom Giovanetti, Andrew Grimm, Marla Grossman, Don Groves, Graham Henderson, Crispin Hunt, Chris Israel, Rebecca Jones, Dean Kay, Tom Kennedy, Rick Lane, Adam Leipzig, Tessa Lena, Claudia Lima, Helienne Lindvall, Lauren Lossa, David Lowery, Brian McNelis, Doug Menuez, Blake Morgan, Miranda Mulholland, Andrew Orlowski, Chris Ortman, Mickey Osterreicher, Janice Pilch, David Poe, Cecile Remington-Deutsch, Amanda Reynolds, Marc Ribot, Chris Ruen, Maria Schneider, Ben Sheffner, Michelle Shocked, Barry B. Sookman, Per Strömbäck, Jonathan Taplin, Paul Williams, Krzysztof Wiszniewski, and Nancy Wolff. More broadly, as an advocate and a fan, I am always grateful to the countless artists and creators who stand up for their rights, as well as the many organizations that support and defend their work.

For sharing their time, insight, and stories at various stages in my research, I want to thank Andrew Duhey, Christian Fleury, Robert and Dee Gibson, David Golumbia, Eric Hart, John Kitsch, Chad Kleitsch, Craig Oleszewski, Anton Orlov, Erin Pauwels, Ross Shain, and David Slater. I also want to acknowledge the assistance of Berni Metcalfe at the National Library of Ireland, Ryan Brubacher and Rosemary Hanes at the Library of Congress, Leonard deGraaf at Thomas Edison National Historic Park, Ruth Frendo at the Stationers' Company, and Lauren Lean at the George Eastman House.

I am of course grateful to my agent Jonathan Lyons at Curtis Brown Ltd. for his sage counsel through several proposals and phases of this project; and I want to thank the wonderful folks at University of Nebraska Press—Thomas F. Swanson for believing in and shepherding the project, as well as Jackson Adams, Ann Baker, Laura Buis, Tish Fobben, Andrea Shahan, Abigail Stryker, Anna Weir, and Emily Wendell for their assistance with the many production and marketing details. I cannot overstate how pleased I was to receive such insightful and deft

copy edits from Amy Pattullo, who truly made this a better book. And in that spirit, my longtime friend, and one of my favorite writers, Jeff Turrentine, was generous enough to provide exactly the notes I needed on the first draft manuscript.

It is no exaggeration to say that without the encouragement and support of my dear friend and fellow rights advocate Ruth Vitale, this book very probably would not have been written; and I am similarly indebted to Walter Zalenski, whose early enthusiasm from the perspective of a photo history expert, fine art collector, and polymath meant more than I can adequately express. Finally, my wife, Scarlett, and children, Jake, Sasha, and Julien, are owed my enduring gratitude for hanging in there while I bang on the keys, yell at inanimate objects, and frighten the cats, all while muttering about arcane flotsam out of the nineteenth century.

WHO INVENTED OSCAR WILDE?

Prologue

Eidolons

In 1825 an English physician named John Ayrton Paris invented a toy he called a thaumatrope. From the Greek *thauma*, meaning "miracle," this simple device, which one will find depicted in any history of cinema book, was made with a small cardboard disk suspended by two strings at opposite ends of its median. Each side of the disk had a printed image—classically a bird on one side and an empty birdcage on the other—and when the disk was spun quickly enough between the winding tension of the strings, the viewer would perceive the two images composited, thus the bird appearing inside the cage. This third image is perceived because the human retina holds the last picture seen for a fraction longer than it actually appears in front of the eye; and this interval, known as the *persistence of vision*, is the physiological trait that makes motion in cinema appear seamless. Hence, the visual medium we tend to think of as the most "realistic" is also the one that relies most on an illusion.

That composite image created by the spinning disk—the one that is both there and not there at the same time, made of equal parts science and magic—is a figment the ancient Greek philosopher Democritus would have called an *eidolon*. The contemporary definition is 1) a specter; phantom; or 2) an idealized figure;[1] but Democritus tried to explain our visual perception of the ever-changing world by theorizing that films of atoms he called *eidola* were constantly sloughed off by animate and inanimate objects, and that these films floated through the

air, some of them shrinking small enough to enter the eye. Although far from an accurate conception of light, Democritus was on the right track, contemplating a world composed of indivisible particles. And he left behind a lyrical way to express the intersection between the tangible and the ephemeral—as when Walt Whitman wrote in the 1881 edition of *Leaves of Grass*,

> The present now and here,
> America's busy, teeming, intricate whirl,
> Of aggregate and segregate for only
> thence releasing
> To-day's eidólons.[2]

I do like a good paradox. So let me admit at the outset that it is probably this quixotic aspect of my curiosity about various matters that inspires me to explore the subject at hand. Tell a friend you're writing a book about copyright, and the answer will be a head nod with a response like, "Cool." What this actually means is, "Good for you. I support you and truly wish you the best of luck." Or some variation on that theme. But the one thing this response does not mean is that they think the idea is in fact *cool*. Copyright? Why would anyone other than a legal scholar ensconced in some office behind an ivy-covered wall write a book about copyright? But bear with me. Because even if it's a tough sell to assert that copyright itself is cool, I would like to propose that copyright is cool-adjacent because it happens to be the legal framework that grapples with the meaning and purpose of human creativity. And human creativity is more than just cool, it is essential to democratic societies—perhaps American democracy most of all.

This is why on a chilly, drizzle-gray morning in late March 2017, I started this journey with a road trip from the Hudson Valley to the Winterthur Museum in Delaware to attend a two-day conference on the subject of nineteenth-century image-making and copyright law.[3] On the way down, I took a detour to Edison National Park in West Orange, New Jersey, to poke around the labs with Craig Oleszewski, my best friend

since college, now a conservator with the National Parks Service who happened to be doing restoration work on Edison's house at the time. Pulling into the small lot across from the entrance to wait for him, I was eager to finally get a chance to see the replica of the "Black Maria," America's first movie studio—its plaque says "world's first"—situated in the front of the factory grounds right along Main Street (fig. 1).

A familiar icon, usually found on a page following the one with the thaumatrope in the film history book, this oblong shed of a building is entirely sheathed in black tar paper tacked onto the wooden frame with square-head nails that add a Frankenstein neck-zipper quality to the general homeliness of the structure. The largest section of the roof is pitched at a steep angle and hinged at the bottom so that it could be opened to the daylight—the only light source strong enough to expose early motion-picture film—and the entire structure rests on a center spindle with each end supported by large casters that roll on a circular track, thus enabling the Black Maria to be rotated by a couple of men pushing it to follow the sun's progress like a giant, ungainly clock. Hastily assembled in the winter of 1892–93 at the direction of Edison's lead motion picture inventor William Kennedy-Laurie Dickson,[4] it was inside this improvised studio that several of the earliest American motion pictures were made, including the oldest ever registered for copyright, generally referred to as "The Sneeze."

Edison had been promising to introduce moving pictures for about a decade before the hectic winter of 1894, by which time his Kinetoscope team was behind on several phases of the project, including shooting the scenes that were needed to play inside the peep-show boxes for a nickel a view. Amid all this hubbub, a journalist named Barnet Phillips was developing a story about the Kinetoscope for *Harper's Weekly*, and subsequent to his tour of the labs, wrote a letter to Edison in October of 1893, requesting, "Might I then ask if you would not kindly have some nice-looking young person perform a sneeze for the Kinetograph?"[5] This entreaty was either ignored, forgotten, or postponed, as it arrived in a time when Edison and Dickson were possibly too consumed by other matters to deal with PR projects; but they did respond rather quickly

to a second letter, dated January 2, 1894, in which Phillips added that a young woman would be an ideal subject to have sneeze for the camera. This specification may have been mildly risqué, according to Aaron Schuster, whose brief history of famous cinematic sneezes—from droll Stan Laurel to alluring Edie Sedgwick—notes that the article Phillips eventually wrote, analyzing ten stages of the two-second sneeze, is "practically indistinguishable from a description of religious or sexual ecstasy."[6]

If Phillips did hope that Dickson's camera might capture some eidolon of the erotic in the paroxysm of a sneeze, then a richly mustachioed inventor named Fred Ott would have to do; and this was probably fortunate for whichever woman might otherwise have volunteered because it turned out that inducing a sneeze for the camera was quite an ordeal. Already bitter cold inside the unheated, uninsulated Black Maria, even before the roof was opened to the January air, it is a wonder they didn't all sneeze quite naturally. But in fact it took several olfactory assaults with snuff, ground tobacco, and black pepper, while cameraman William Heise rolled film through the Kinetograph waiting to capture Ott's historic sternutation. "In vain, the wretched youth coughed, choked, sniffed, finally dissolving into tears, and amid shouts of laughter the attempt was abandoned, only to be renewed a few days later when the results were secured. Science hath her martyrs as well as religion," wrote Dickson in his account of turning Ott into America's first movie star.[7]

Two sets of contact photographs were printed from the strip of film—one depicting eighty-one frames arranged in a nine-by-nine grid and sent to Phillips to accompany his article, and another pair of prints each comprising the salient forty-five frames in a five-by-nine grid, to be sent to the Library of Congress for copyright registration (fig. 2). On January 7, Dickson hand wrote a short, casual note on stationery "from the Laboratory of Thomas A. Edison" to the Librarian of Congress requesting registration under the title "Edison Kinetoscopic Record of a Sneeze," and mentioned the enclosed fifty-cent fee. Although Dickson had previously registered motion picture scenes generically named "Edison Kinetoscopic Records" in August of 1893, those deposit copies have never been found, which makes the contact photograph of "The

Sneeze" the oldest surviving specimen of a *motion picture* registered for an American copyright; and this practice of registering early films as *photographs* was a workaround—one that may have been Dickson's idea—to the obstacle that motion pictures were not yet a protected category of works by statute and would not be until 1912.

Dickson might have been aware that a similar prefatory solution to registration had also been used by early photographers, who registered their images as *prints*—a category that covered works like etchings, engravings, and lithographs—in the years before *photographic works* was added to the statute in 1865. But "the law did not decree the permissible dimensions of a photograph. There was apparently no legal reason why it might not be 35mm wide and a hundred yards long," writes motion picture historian Erik Barnouw, referring to the nearly thirty thousand film titles deposited with the Library of Congress between the 1890s and 1912 as very long rolls of photographic paper.[8]

This copyright solution was unintentionally good fortune for preservationists and film historians because the nitrate-based celluloid used at the time was so volatile that, if it did not simply catch fire or explode, it disintegrated to dust or gelatinous blobs within just a few years or less, depending on storage conditions. When these paper rolls were discovered in the archives in the 1930s, they were largely still intact; and beginning in the 1950s, the Academy of Motion Picture Arts and Sciences (AMPAS), with the aid of an appropriation by Congress, financed the Paper Prints Program to painstakingly rephotograph approximately two million feet of these prints, frame-by-frame, onto new celluloid. This project is the reason every film student in the world can watch Fred Ott sneeze in motion or is able to view the rest of the catalog from this period. In fact, the motion picture record before 1912 is more complete than the years immediately following because nitrate film was still in use while being phased out for acetate-based "Safety Film" stocks. And although the library accepted celluloid motion picture reels for copyright deposits beginning in 1912, the facility itself refused to keep the first several years' worth of materials on the premises because it was too dangerous to store. At the same time, because

there was no longer a registration reason to make paper prints after 1912, many of the films produced during the transitional period were lost to deterioration many decades ago.

Although every historic account that I have read says "The Sneeze" was *mailed* to the Library of Congress on January 7 and received a registration stamp on the ninth, this seems highly unlikely. Even if the post office could conceivably have been so quick in 1894, it is certain that the Librarian of Congress, Ainsworth Rand Spofford, was not. A January 1893 item in the *New York Times* reported, "Applications for copyright must wait eight weeks before they can be taken up, and literary men and publishers are in a state of great unrest, which they contribute [sic] to Mr. Spofford."[9] As Dickson was adamant about asserting both credit and copyright for his photographs and motion pictures (even while in Edison's employ), he would not have been satisfied to wait two months or more, with Phillips's article soon to be published (March 24) and the first Kinetoscope parlor about to open in New York (April 14). So, it seems far more probable that some envoy of the Edison Labs was dispatched to Washington DC with the sole purpose of expediting registration for "The Sneeze"; and assuming this is what happened, the emissary from West Orange would have seen exactly why his task was so urgent—namely that the library was in an impressive state of disorder.

Arriving in the oblong, skylighted atrium in the west front of the Capitol, the "Sneeze" courier might have believed that the elegant, neoclassical library had been converted into a war bunker fortified by creative works in lieu of sandbags. Piles of wayward books, manuscripts, sheet music, maps, photographs, and prints lined the perimeters of every floor. Unopened mail sacks leaned like exhausted soldiers against some of the teetering paper columns held in place by giant folios that were repurposed into paperweights. At the end of the chamber, the courier would likely find the white-haired Spofford standing at the large Queen Anne desk, which was turned parallel to the room and set off to one side—no longer presiding authoritatively over the library, as it once did, but rather timidly holding its own against the encroaching jumble. At Spofford's feet were some three hundred books stacked

precariously beneath the pavilion of the desk, just barely contained within the perimeter of its eight legs (fig. 3).

What had once been the serene and august legislative library when Spofford first became its custodian looked more like America's junk drawer by the 1890s—a condition that Spofford himself had warned Congress would be "the greatest chaos in America."[10] This may have been too sensational a description coming from a man who was appointed the sixth librarian during the waning days of the Civil War, but if the library was not the greatest American chaos, it was certainly a great American mess. Twice in history the facility and its collection had been destroyed by fire—first by British soldiers in 1814 and then by accident in 1851— and it is easy to wonder whether Spofford did not occasionally wish for a third conflagration. On the contrary, Spofford's "chaos" was a necessary, if unintended, step in fulfilling his ambition to transform the Library of Congress into a public institution and a monument to America's capacity for creative, cultural, and intellectual achievement. All he had to do was to gather the works of the nation's creators in one place; and by getting what he asked for, he very quickly acquired more than he could handle.

Following models adopted by the French and English, Spofford lobbied Congress, beginning in the 1860s, to place the task of copyright registration under the auspices of the library for the purpose of growing the collection through the receipt of mandatory deposit copies. Registration was initially a function of district courts in each state, and for a brief period, records were maintained by the U.S. Patent Office, until the Copyright Act of 1870 officially centralized all copyright registration at the library, requiring two deposit copies of each work, which could even be sent postage-free if properly identified. By 1874, Spofford and his staff, for the first time, received more materials through copyright registration than by the precedent convention of purchasing existing collections.[11] Already overwhelmed with more than seventy thousand books, "piled on the floor in all directions," Spofford redoubled his entreaties to Congress, which he had begun in 1871, to build a new facility to house the collection. An appropriation bill for the new library passed in 1886, and a site was chosen just east of the Capitol.

By the mid-1890s, at about the same time that Dickson and Edison's motion pictures were flickering to life, the magnificent Beaux Arts palace, with its mythological sculptures and friezes, and copper dome topped by the flame of knowledge, was nearing completion. It must have been a source of both pride and anxiety for Spofford as the unsorted piles—the genius of a would-be-great nation—were transported from the floors of the Capitol library to the floors of the new facility. Still unsorted.

To say that copyright registration at this time exceeded the capacity of Spofford's forty-two-person staff would be generous. In fact, the operation was so disordered that in 1895, the Treasury Department investigated Spofford over the matter of some missing deposit fees that were eventually found among the haystacks of works—literally tucked between the pages of manuscripts—that had been moved over to the new building.[12] Spofford was no embezzler, but neither was he ideally suited to the broader management of copyright, which is one reason why in 1897, concurrent with the grand opening of what is today the Thomas Jefferson Building, Spofford stepped down, and the U.S. Copyright Office was established within the library along with the position of Register of Copyrights.

If we mark the birth of the United States at the ratification of the Constitution in 1788–89, then "work in earnest" on the new library was a true milestone of the American centennial, and Ainsworth Spofford, surrounded by all those disheveled mountains of American creativity, makes a pretty good symbol for the improvisational spirit of the young nation at the approximate midpoint in its history.[13] There must have been moments when Spofford could no more have believed that his efforts would become the world's largest library than that the Framers would have expected America to one day be the world's largest producer of professional creative works.

Immediately following passage of the 1870 Copyright Act, the library received just over 5,700 deposits, or roughly one work for every 6,600 citizens; by the peak year (for the century) of 1893, the library received just over 48,000 deposits, or roughly one work for every 1,360 cit-

izens. So, while the population nearly doubled in this same period (from about 38 million to about 75 million), creative output increased roughly fivefold.[14]

Yes, in its most prosaic application, copyright is the statutory instrument by which authors and creators assert the right to exploit the use of their works, mainly for the purpose of getting paid. But, as writer Elizabeth Wurtzel puts it, "at the time of the Constitutional Convention, in 1787, with nine out of ten Americans milking cows or literally reaping what they sowed, it was a supreme leap of faith to believe that there would ever be culture in this country, anything like literature and art, science and invention, anything that would demand and command copyright and patent."[15]

Article 1, section 8, clause 8 of the Constitution states that Congress shall have the power "to promote the progress of science and useful arts, by securing for limited times to authors and inventors the exclusive right to their respective writings and discoveries." Referred to as the Progress Clause or the Intellectual Property (IP) Clause, this foundation for patent and copyright law is in fact the first mention of any rights expressly protected for individual citizens of the new nation, predating the Bill of Rights by nearly four years. Although nobody can deny that the early United States was broadly racist, sexist, and classist by any contemporary measure, the constitutional Framers, even with their explicit rejection of nobility in article 1 section 9, could hardly have imagined that the establishment of copyright in particular was one of the most instantly and thoroughly democratic statements they had made.[16]

Without necessarily meaning to do so, the Framers anticipated both the commercial value and the political power of creative expression that was latent among the entire population, including those who were officially disenfranchised from the opportunities and liberties articulated by the great experiment. Madison and his contemporaries could not have imagined, for instance, that in 1845, a man who had been born into slavery would—while still a fugitive—register as *his* property a literary work entitled *Narrative of the Life of Frederick Dou-*

glass, an American Slave in a Massachusetts District Court.[17] That this book is itself a story of deliverance and empowerment through literary achievement epitomizes the latent power of the constitutional foundation of copyright.

Wurtzel is right, of course, that most Americans at the threshold of independence were semiliterate farmers, but encoding intellectual property into the general legislature was perhaps more a hop of faith than a whole leap given the literary nature of the Revolution itself. Not only did the cause of independence, and eventual union, spill more ink than blood (at least metaphorically), but creative expression through song, poetry, drama, and visual works played a substantial role in propagandizing and defining the character of the fledgling republic.[18] The nation's first woman playwright, Mercy Otis Warren, was as sharp with her satirical pen as any of the early statesmen were eloquent with their disputations, and she even engaged in hand-to-hand literary combat with British general (and dramatist) John Burgoyne after the American victory at the Siege of Boston.[19] Likewise, the suffragette movement and advocates of women's rights in general relied substantially on their literary talents and publishing to advance their cause. "Nothing in the United States struck me more than the fact that the remarkable intellectual progress of that country is very largely due to the efforts of American women, who edit many of the most powerful magazines and newspapers," Oscar Wilde observed in 1887.[20] Susan B. Anthony signed a letter written by novelist Margaret Lee to Congress in 1899 advocating a perpetual copyright in the United States; and, although the letter uses masculine pronouns throughout, it was no trifling matter that copyrights were a form of property accessible to women, in contrast to land, stocks, and other business enterprises.[21]

Intellectual property has long been intertwined with other notions of justice and fairness, but as a matter of legal theory, it cannot be denied that the underlying foundation of copyright is indeed paradoxical, which is why I think so many of its contemporary critics, in one way or another, seek to minimize the concept as a "requisite fiction" that

we choose to believe about the metaphysical relationship between the author and the work she produces. Fundamental to this skepticism is the view that a central argument for copyright's existence is tautological—that it protects "original works" made by "authors" *because* "authors" are people who make "original works." Scholar Jane M. Gaines, in her 1991 book *Contested Culture*, notes that very tautology after she describes the lawsuit at the center of this story thus: "In *Burrow-Giles*, . . . the author's right obscures the contradictory evidence offered by the technology itself, the evidence that photography *is* mechanical. Authorship in the photograph is a requisite fiction. But then so is authorship in the literary work."[22]

Gaines is not wrong. Copyright *is* a requisite fiction built on circular reasoning. But my main quarrel with this as a rationale for either weakening or abolishing such constructs is the fact that whole civilizations—indeed all liberal democracies—are built upon requisite fictions and circular reasoning. Doesn't the rationale for American independence begin with an impetuous, unprovable assertion that says, "We hold these truths to be self-evident"? And this despite the fact that the truths Jefferson was about to enumerate hardly applied in practice to many inhabitants of the newly independent states—least of all those in bondage to Jefferson and his peers.

Still, if we generally agree that our founding principles are aspirational, that it is the job of every subsequent generation to rewrite what conservative columnist George Will calls the "American catechism" in the attempt to live up to those lofty ideals, I remain wary of academic conclusions that would abandon a worthy principle just because it happens to be a convenient fiction.[23] A republic like the turbulent and motley United States is itself a paradox whose continued existence depends upon balancing competing principles (e.g., republicanism versus direct democracy), like the two sides of a thaumatrope, in order for that ephemeral, composite image to remain visible. "The law is whatever is successfully argued and plausibly maintained," Aaron Burr proposed rather cynically, and perhaps even correctly, as we are recently forced to consider just how fragile the rule of law can be.[24] But on the

other side of that spinning disk is Burr's rival, Alexander Hamilton, who demonstrated with astounding prolixity and energy that a whole nation can be invented out of "successful argument."

Although the origins of this book are grounded in the past several years I have spent as a copyright advocate—primarily through my blog *The Illusion of More*—it is not my primary aim here to chronicle, or indeed litigate, the so-called copyright war that was sparked by the catalyst of the publicly available internet in the mid-late 1990s. Nevertheless, it is clear that tensions over the purpose and application of copyright law only seeped into public consciousness because of that war. For the first 209 years of America's existence, copyright was a subject that rarely escaped committee hearings on Capitol Hill. There was a brief moment of public attention in 1984, drawn by controversy over the VCR (a.k.a. the Betamax Case). But the real existential kerfuffle began when the file-sharing service Napster, in 1999, introduced the idea of free music to a generation of college students and teenagers.

Suddenly, copyright was controversial—a generational clash to which all manner of other topics attached barnacle-like to the hull of the copyright debate. It was no surprise, for instance, that when Peter Sunde, Swedish cofounder of the website The Pirate Bay,[25] wrote his 2015 lament for the lost idealism of the internet, that he described his ambition as synonymous with reinvigorating communist utopianism.[26] Make of that what you will, but the rights of an individual author to exploit her work as she sees fit would be meaningless in a truly communist society; or to reverse that, stripping the rights of individual authors (i.e., silencing artists) has always been a necessary ingredient in collectivist-authoritarian regimes. So, yes, I think copyright is about more than just copyright.

In this regard, if one spends a little time reading the internet-industry inspired (if not funded) academic papers criticizing copyright today, it becomes clear that many of the presumptive leaders on the subject do not merely doubt the value of individual expression but of individuality itself. For instance, Christopher Sprigman of NYU and Kal Raustiala of UCLA, while promoting the use of Big Data to inform the creative

process, advocate a collectivist—what they call a Panoptian—theory about the production of creative works.[27] In what reads to me like over-selling the questionable process of making art based on market research, this "new thinking" about the role of creators implies a future in which artists no longer surprise us with anything unexpected, but merely create what they think we think we want. More than dull, this implicit feedback loop sounds downright dystopian—a world in which the term "hive mind" is no longer just a joke we make on social media.

Quite often, opinions about copyright may be subsumed by the conflicted relationship society has with artists themselves. Viewed through more conservative eyes, the artist is often considered a slacker, unwilling to get a "real job," and this view might persist right up to the moment he makes a living, at which point, he will be taken more seriously. Then if the artist makes serious money, he may even be envied for obtaining wealth for what looks to the outsider like child's play. At the other extreme, the more liberal view, which often scorns commercial enterprise and likes to imagine the creative impulse as "pure," is more apt to accuse the artist of "selling out" if he crosses some imaginary line between sustenance and greed. These often contradictory sentiments run through the historic and contemporary debate about copyright, so that it not uncommonly serves as a proxy fight for broader social, political, aesthetic, and economic opinions. Many of the same Americans who in 2016 praised Neil Young for wanting to prevent candidate Donald Trump from using the song "Rockin' in the Free World" at campaign rallies would, in a different context, criticize Young if he asserted his copyrights by, say, removing unlicensed versions of the same song from YouTube.[28] So, a lot of responses to copyright have very little to do with copyright.

Now that I've gone there, it has to be acknowledged that the America I knew, perhaps even took for granted, when I first proposed to write this book is not the America in which I have been writing this book. And because it is not possible to explore, let alone endorse, the positive aspects of American copyright without at least a dash of exceptionalism, it is admittedly a matter of no small conflict to present this

narrative in a time when the national character has become so profoundly unexceptional—a theme manifest on Inauguration Day 2016, when, for the first time in living memory, a newly elected president was snubbed by the overwhelming majority of the creative community, who declined to help celebrate the peaceful transition of power. Watching the tepid performances that evening, my first thought was that this is what a country without the twin forces of free speech and copyright law would produce as "great" work—dusting off Toby Keith's chicken-hawk anthem "Courtesy of the Red, White and Blue," whose insipid bravado had long since been anachronized by the sober realities of the Iraq War. Even the Trumps didn't look like they were having a very good time—as though they knew there was a much cooler party happening in America to which they were not invited. And there was. Because creative expression continues to represent who we mean to be, if not quite who we manage to be.

When photographer Harry Benson traveled in 1988 to Hanoi in the company of a wheelchair-bound war veteran named Bill Fero, he captured a poignant image of Fero shaking hands with a former enemy—a veteran of the Vietcong, also confined to a wheelchair.[29] "Two broken men," Benson says about the photograph in the 2016 documentary film about his career.[30] He then tells us that the Vietnamese man confessed to Fero, "We used to sneak up on your positions at night, not to kill you, but to listen to your music." If this mental image—of enemy soldiers, especially in that war, foregoing a surprise attack because they preferred to hold still and listen to Credence or Hendrix or Janis Joplin playing over the GIs' radios—does not say something about America's better angels, it is hard to imagine what would. And if that story is affecting, then welcome to my quixotic journey to understand the nature and purpose of American copyright.

With this book, I hope to offer at least some framework for the many bits of legalistic flotsam that meander downstream, from the aeries of academia to the shorthand debates on Twitter—much of it scattering a lot of noise and confusion. To that purpose, I think it is fair to say that each of the individual battles being fought in the "copyright war"—e.g.,

the scope of protection, duration of terms, exceptions to copyright, the meaning of *originality*—are subcategories of two divergent, overarching views about copyright's original purpose. One view is that copyright is purely a creature of statute, written exclusively to serve the utilitarian aim of incentivizing creators to produce and disseminate works of cultural value to society. The opposing view is that copyright protects a natural right, a self-evident principle of justice that the author's expressive or intellectual works are naturally her property—albeit an intangible form of property. This is copyright's underlying paradox. Because of course it is both a legal framework with a clear utility, and one with some very natural-rights-like qualities, not least of these being that creative expression is a form of free speech.

I have selected the landmark case involving Napoleon Sarony's 1882 photograph of Oscar Wilde (fig. 4) as a focal point for describing some of the major principles of copyright, from their premodern origins to their contemporary implications. Photographs were added to statutory protection of the copyright law in 1865, and nineteen years later, the defendant in *Sarony* argued that Congress had exceeded its constitutional authority to extend copyrights to humans operating cameras. Because *Sarony* occurred at the threshold of the twentieth century and the Supreme Court had to decide whether there is human authorship in a mechanically made image, this case serves as a bridge between classical and modern modes of expression, testing the elasticity of the Constitution to embrace a more democratic notion of creativity. Photography was "the technological development that posed the most serious challenge to copyright's theoretical structure in the nineteenth century," writes Professor Justin Hughes of Loyola Law School, "and it did this because it challenged our understanding of creativity."[31]

Burrow-Giles Lithographic Co. v. Sarony was an important case without being especially controversial. It would make a lousy courtroom drama, but the concepts and themes that coalesced in this case have become dramatically relevant in the digital age, as conflicts over monkeys taking photos, fine artists appropriating other people's Instagram images, the development of artificial intelligence, and "deepfakes" pres-

ent new challenges to our concepts of authorship, ownership, privacy, and commercial and criminal enterprise.

The process of image-making may be the oldest known form of human labor that served no practical purpose whatsoever. Although theories abound (as theories do), we do not really know why Paleolithic humans on all continents—and for whom basic survival must have demanded the labor and attention of an average day—took the time to make handprints on cave walls and later created remarkably accurate depictions of the fauna roaming about in their worlds. In fact, as recently as February 2018, a team of archeologists published findings indicating that many of these primitive works were made circa 64,000 BCE and are, therefore, not the work of Homo sapiens, but of Neanderthals.[32] This tells us not only that Neanderthals were more sophisticated than previously believed but that the creative impulse is officially older than the human species itself.

As for motive, it is entirely possible, in fact it seems most probable, that all this cave decor is the first known example of the principle we call *art for art's sake*—that there was no meaning or purpose other than to liven up those drab stone walls. And just as we cannot say for certain why even protohumans painted these images, we also cannot know whether any of the prehistoric artists felt a sense of personal ownership in their work—whether there is an innate concept of intellectual property. The closest observation we can make on this subject is that the instinct to treat creative work as a form of property is evident in very young children presenting their own primitive works to be displayed with pride on walls and refrigerators everywhere. And of course many of these first works happen to be handprints.[33]

The notion of *art for art's sake* was first espoused in modern Western culture about sixty-six thousand years after the Neanderthals by the English Aesthetic movement in art, of which Oscar Wilde was the most prominent ambassador. And this is exactly why he ended up in America in 1882 and inadvertently became a key figure in the anthology of American copyright law. The same constitutional challenge could have been made over any photograph of the period. A portrait of Lillie Lang-

try or Abraham Lincoln. A city street or Niagara Falls. The hopeless, grimy faces of child laborers or the defiant, self-emancipated stare of Frederick Douglass. The image that tested the foundation of copyright in photography could have been any among the tens of thousands produced in the United States after 1865; and judicial consideration might even have been affected by prejudices attached to some other image. Plenty of photographs were copied without license in the nineteenth century—as they are once again in a world connected through social media platforms—but the fact that the photo in this particular case happened to be a portrait of a man whose life and work was paradox itself is the coincidence that initially inspired the pages that follow.

1

Dangerous Paradoxes

HEROD: Nay, but I will look at thee no more. One
should not look at anything. Never at things, nor at
people should one look. Only in mirrors is it well to
look, for mirrors do but show us masks.

—Oscar Wilde, *Salomé*

Asked by a friend at Oxford about his religion, Wilde replied, "I don't
think I have any. I'm an Irish Protestant." The quip was more than affec-
tation, stated at a time when Wilde truly struggled with the prospect of
converting to Catholicism against the adamant wishes of his father.[1] In
biographer Richard Ellmann's account, Oscar Fingal O'Flahertie Wills
Wilde, born October 16, 1854, is presented almost immediately as a
young man gifted with genius but suspended by strings of competing
forces—spiritual, national, cultural, sexual—that manifest as the con-
tradictory quality that colored his life and his work. His mother, Jane
Wilde, was a passionate Irish republican and poet, who wrote under
the pseudonym Speranza and played a prominent role in the literary
nationalism that erupted concurrently and symptomatically in Young
Ireland, Young Italy, Young America, and elsewhere in the 1840s. But
as Ellman writes of Oscar, "He would be neither a Catholic nor a Free-
mason; aesthetic one moment, he would be anaesthetic the next. This
conclusion jibed with what was perhaps involuntary, his oscillation
between the love of women and of men. As a result, Wilde writes his
works out of a debate between doctrines rather than out of doctrine."[2]

The line in Wilde's 1891 play *Salomé* that "mirrors reflect masks" is one small example of the many epigrams—the "dangerous paradoxes"—that he cultivated like flowers in his literary garden, always ready with a provocative retort, but not always quite so spontaneously as it might seem to the recipient. Author Coulson Kerhanan, in his book *In Good Company*, written sixteen years after Wilde died in November of 1900, describes being the target of this typical barb: "You are so evidently, so unmistakably sincere and most of all so truthful, that I can't believe a single word you say." Kerhanan accuses Wilde of practicing the joke on him before attending a dinner party, where the "aphorism or fancy [will seem] to rise as naturally and spontaneously to the surface of the conversation as the bubbles rise to the surface of the glass of champagne at your side."[3] Claiming that this was one of the few moments he "succeeded in inducing Wilde to drop attitudinsing and to be his natural self," if Kerhanan did achieve this homeostasis, it must have been as fleeting as the half-life of some rare element on the periodic table.

In this same chapter, Kerhanan claims to possess what he considers the best (i.e., most honest) photograph of Wilde ever captured—an unpublished group shot taken at a social gathering, about which he writes, "The portrait of Wilde, if grave, is frank, untroubled, and attractive, for, when he chose to be serious, the large lines of his face and features sobered into a repose and into a massiveness which were not without dignity. Too often, however, Dignity suddenly let fall her cloak, and Vanity, naked and unashamed, was revealed in her place."[4] This virtue/vice duality, which Kerhanan strives to reconcile in his account of Wilde, epitomizes a Victorian demand for binary ethical clarity as well as the eugenic assumption that moral character can be read in the physiology of a human face. In this regard, Kerhanan is hardly alone in striving to see in Wilde what he wants to see. To say the very least, in the roughly 150 years since Wilde first attracted—in fact purposely cultivated—popular attention, his biography has accreted and sloughed off a considerable volume of commentary that often says more about the social, moral, or financial motives of the commenters than it does about Wilde.

Even Ellmann's excellent biography, deservedly considered one of the most complete and accurate narratives, contains a photograph erroneously captioned "Wilde in Costume as Salomé," in which the playwright is allegedly dressed in drag as his eponymous character and kneeling before the severed head of John the Baptist.[5] But it is frankly hard to imagine anyone associated with Ellmann's in-depth research, if they gave a moment's thought to Wilde's habits, the urgency of sublimating his sexuality, the timing and official rejection of *Salomé*, or the use of theatrical photographs in the period, actually believing that Wilde would ever have posed for such a portrait. His grandson Merlin Holland, a writer who has spent part of his career correcting the record where he can, tells us that although the photograph published in Ellmann's book "spawned all sorts of articles about Wilde as transvestite, as necrophiliac," in fact "it was a photograph of a Hungarian opera singer called Alice Guszalewicz, photographed in Cologne in 1906, six years after [Oscar's] death."[6]

Separating the real Oscar Wilde from the characters he invented for himself defies most attempts to succinctly describe him, not least because his lasting fame derives from that rich anthology of quotable witticisms that compose the many masks he wore and which, by their very nature, are half-true glimpses at best. I think of Wilde in this regard as a literary photographer, whose contrarian epigrams captured the world as he observed it in brief, enigmatic, verbal snapshots. And this legacy includes many oft-repeated *bons mots* attributed to him for which there is no evidence he ever said them, though he would not necessarily deny having said them if he were alive to be asked. Most famously, it is generally agreed to be a fragment of Wildean apocrypha that upon disembarking from the steamship *Arizona* in New York on January 3, 1882, the twenty-seven-year-old aspiring author told the customs official that he had nothing to declare "other than his genius." In fact, neither of the works he had among his belongings—his book of poems and his first play—would be those for which he would be best remembered. His genius was still a work in progress.

Within a few days of his arrival in New York, Wilde traveled by hansom cab about fifteen blocks south from the Grand Hotel at Thirty-first Street and Broadway to the five-story building at number 37 Union Square (fig. 5).[7] Doubtless, he wore the "befrogged and wonderfully befurred green overcoat"[8] that a London tailor (probably still unpaid) had constructed for him in preparation for the American winter. Under this weighty frock, Wilde most likely wore the velvet jacket, knickers, and high knee-socks outfit that had been chosen especially for the national lecture tour set to debut on the evening of the ninth at Chickering Hall.

The lecture itself, to be titled "The English Renaissance of Art," was still unfinished, partly due to Wilde's own apprehensions about the whole enterprise of lecturing, but also because, from the moment he arrived, he was thrust into a whirlwind—interviewed, feted, scrutinized, and scorned as the new year's first spectacle to pass through the immigration gates at Castle Garden into the exuberant, curious gaze of the Americans. Three months later, the next foreign sensation bound for New York will be the African pachyderm Jumbo, purchased by P. T. Barnum at a cost of £2,000 from London's Royal Zoological Society to add to his American circus.[9] But for the moment, the object of leering contemplation and general buzz was the unusual young poet with the long, wavy locks—masculine in stature, feminine in posture—who had been promoted by publicist Colonel F. W. Morse as a rising star of English literature, who had crossed the pond to teach the Americans something about art and the appreciation of beauty.

Already ridiculed and misquoted by several of the reporters who had swarmed to meet him aboard the *Arizona*, Wilde was acutely aware, perhaps painfully so, of the centaur's role in which he had allowed himself to be cast for this American adventure. Hired to portray a self-mocking caricature as a marketing gimmick for Gilbert & Sullivan, he urgently needed the money that would be his share of the proceeds from the lectures. And with Gilbert & Sullivan's producer-partner Richard D'Oyly Carte covering expenses, Wilde hoped to use the visit to advance the career of the real author within the cartoon he was about to put on display.

The production of his first play, *Vera*, which Ellmann calls a "wretched play" that was not below the standards of the time, had recently been canceled in London because its revolutionary, antiroyalist themes were suddenly an investment risk after the 1881 assassinations of Czar Alexander II and U.S. President James Garfield. Still, presidential assassinations notwithstanding, Wilde hoped that the Americans were not nearly so squeamish as the English about regicidal motifs, and he arrived, play in hand, with the intent to secure an American copyright for *Vera* and to find an American actress willing to play the lead.[10] Thus it was in this state of tentative professional optimism and existential bifurcation that Wilde climbed out of the cab at Union Square and almost certainly found his attention drawn upward to the ten-foot tall iron letters looping across the facade of the building's fourth floor—the outsize signature of the diminutive photographer waiting inside to meet him. It read *Sarony*.

Most likely greeted by a member of the staff, quite possibly Sarony's son Otto, Wilde would have been escorted into the main reception room, which has been described as "filled wall to wall and floor to ceiling with Russian sleighs, Egyptian mummies, Indian pottery, Japanese armor, medieval arms, and Eastern draperies" all collected by the famous photographer over many years, either as potential props or just because they appealed to him.[11] There was even a stuffed crocodile suspended by wires from the ceiling; and after taking a moment to peruse this hodgepodge, and perhaps acclimate to the aromas of photographic chemistry, Wilde stuffed his six-foot-four-inch frame (befurred coat and all) into the closet-sized, slow-moving elevator that lifted him to the top floor where the sunlit studio was located.

It is hard not to smile at the thought of Napoleon Sarony, who barely touched the bottom edge of five-foot-two—not including the Turkish fez he usually wore—first greeting the Irish giant, literally swathed in green fur. Notwithstanding the Mutt and Jeff tableau, however, this pair of artists actually had a great deal in common, including mutual acquaintances. But most demonstrably they both conceived rather flamboyant public personae for themselves, generally relying on sar-

torial extravagance, which may be understood as equal parts honest self-expression and contrived self-promotion (fig. 6). Moreover, Sarony was among the first to engage in portrait photography as a performance designed to elicit response—"a game between photographer and subject," as Quebecois photographer Christian Fleury describes it, paraphrasing his new documentary film, *Three Seasons of Sarony*.[12] In that light, Sarony's reputation as the preeminent photographer of stars of the English-speaking theater cannot be separated from his ebullient, costumed character: confident eccentricity often adds a flair of authority to technical skill. The following excerpt from *Photographic Times and American Photographer* (1891) is one of the few published descriptions of Sarony at work:

> Sarony was in a high photographic fever. The tassel on his little red fez bobbed wildly up and down, and he circulated around the group of players which he was taking in costume with electrical rapidity. The pictures were to be used for "window work," and the manager of the company wanted them to be particularly effective. But the company would not respond to the photographer's efforts. They dropped out of pose with distressing frequency and insisted upon putting their own ideas of the photographically picturesque into practice.
>
> Finally, after half an hour of rearrangement and expostulation, Sarony produced a satisfactory grouping, and aimed the camera. Then he paused. Something was wrong.
>
> The dress suit worn by the star draped in a manner that offended his artistic eye, and in a minute he was painting new curves and high lights upon it with a soft brush and powdered chalk. The star was turned and twisted about as if he were nothing more than a painter's mannikin. His clothes were probably ruined, but neither actor nor artist seemed to think it a matter of small consideration. A final dab of the chalk and Sarony stepped back to survey the general effect.
>
> The leading comedian's hair was too sparsely sprinkled in front, and the altitude of brow which resulted gave him a grave and

erudite aspect. Without a word Sarony stepped up to him and dusted over the obtrusive scalp with a brushful of sepia. It made the comedian look five years younger.

Back went Sarony to the camera, up rose his warning finger, snap! and the picture was taken.[13]

Sarony did not lack confidence in his innate and well-honed talent for composition, styling, and lighting, even if his public image—the costumes, the society of artist friends, the atelier-inspired studio, and the giant signature on the building imitating that of the famous French photographer Nadar might betray some hint that he was posing as the classically trained artist he sometimes regretted he did not become. "I think he adopted the form of the artist as a kind of compensation for not being what people thought of as an 'artist,'" says art history scholar Erin Pauwels, whom I was fortunate to meet at Winterthur, and who is working on a biography about Sarony that she hopes will accord him long-overdue credit for his contributions to photography as an art form.[14] In this regard, it just so happens that Wilde was playing a similar psychological game at that time, allowing himself to be dispatched to America billed and frilled as a very important literary figure, nearly a decade before he actually wrote any of the works that would earn him a place in literature. So the meeting of these two men—both posers, and both legitimate artists—has the flavor of kismet in light of the fact that together they accidentally produced the photograph which became the subject of a legal battle as to whether photography was an expressive medium or only a mechanical means of reproducing "reality."

When the New York Times published the headline "Did Sarony Invent Oscar Wilde?" on December 14, 1883, the day after opening arguments at the Supreme Court in Burrow-Giles Lithographic Co. v. Sarony, it was a more loaded question than the mildly sarcastic editor probably intended.[15] Not only did the rhetorical headline provoke a central question in copyright, but it unwittingly alluded to the fact that on the day the photograph was taken, the eidolon of the young man who'd come to America was, in every sense, engaged in the process of inventing himself. And

unfortunately we have no record to tell us what the other inventor in the room thought of his subject or vice versa.

Of the twenty-seven poses captured that day, about four or five of these are the photos of Wilde that nearly everyone sees on book jackets or accompanying articles, or that will appear in the top results of a Google search. Though Wilde surely did not know that his life was already more than half over, or that Sarony's photographs would be the eternal icons they are, it is an unfortunate irony that the writer who so assiduously worked to craft his image did not spare a syllable for the artist who fixed that image indelibly for all time. The only near mention of Sarony appears in Wilde's 1887 short story *The Canterville Ghost* in which the much-abused spirit takes some small comfort in mocking the "large Saroni photographs" of the American family that has moved into Canterville Chase and proceeded to make a farce of his attempted hauntings. Hence, the ghost scorns the people in the photographs but says nothing about the photographer. Sarony was, of course, a much bigger deal than Wilde in the 1880s—one of the few brand-name photographers in the world—and he may have considered the young poet just another passing sideshow that theater impresario D'Oyly Carte had imported to America as Barnum would import his elephant.

At the center of all this speculation about the Wilde-Sarony encounter (the elephant in the room, as it were) is photography itself and the underlying question as to whether either of these men believed that the portraits they were making were in fact art. "Every portrait that is painted with feeling is a portrait of the artist, not the sitter," Wilde would write in *The Picture of Dorian Gray* and publish eight years later. "The sitter is merely the accident, the occasion. It is not he who is revealed by the painter; it is rather the painter who, on the colored canvas, reveals himself."[16] Whether Wilde would invoke such metaphysics to describe the production of a photograph is questionable given his tastes and sensibilities. But the fact that, of all people, the writer of those words happened to be the subject of the image that would trigger the landmark case asking the same philosophical question (i.e., is the spirit of the artist in the work?) about the mechanical medium is—if nothing else—a provocative accident of history.

Wilde's claim about portraiture was separately applied to Sarony by his friend, the cartoonist Thomas Nast, in an interview with the *New York Tribune* after Sarony's passing in 1896. "There was one particular feature which made his work stand apart from that of anyone else," said Nast. "He made everyone he photographed look like Sarony. You know what I mean. The same feeling was in every picture. Partly from imitation and partly from following out his directions, all his sitters seemed to catch the Sarony tricks of expression and pose. If they did not, he would not take them at all."[17]

A modern viewer casually glancing at the photo titled "Oscar Wilde No. 18" will, of course, see Oscar Wilde—familiar and iconic, the dreamy young poet, who was perhaps interrupted mid-inspiration and, so, glances up at us with that look of superior ennui. (Was he in fact mulling the task ahead of explaining art to the Americans?) In reality, capturing a truly candid moment, standard in the vocabulary of most photography today, was difficult with the technology of 1882, and Sarony was a pioneer in creating the illusion of the "moment" with the comparatively primitive tools at his disposal. As the photograph at the center of this story, Sarony's portrait is as paradoxical an image as the copyright question it provoked. That "Oscar Wilde No. 18" is simultaneously a picture of the emerging author *and* a character invented by W. S. Gilbert—a parody of Wilde no less—makes the image a lot like one of Wilde's famous epigrams: something one can review endlessly without ever coming to a conclusion about which truth, if any, it actually tells.

In considering Sarony's photograph of Wilde, the Supreme Court of 1883/84 affirmed the copyrightability of the medium nearly twenty years after it was added to protection by statute. Its landmark status was due to the constitutional challenge made by the defendant, who simultaneously claimed that photography cannot possibly be an expressive medium and that the language of the Constitution could not reasonably be interpreted to embrace the notion of the photographer as an "author." *Sarony* ultimately asked whether the rationale for copyright at the founding of the nation could remain relevant in the modern age, with the many unseen technological changes to follow in the coming century, which provokes the much broader question, *What is copyright?*

2

Copyright in a Few Snapshots

Terms of Art

If the Constitution is the Quick Start Guide to operating the United States, *The Federalist*—the series of eighty-five articles written between October 1787 and March 1788 by Hamilton, Madison, and Jay—is more like the complete User's Manual. Published predominantly in New York newspapers with the intent to both explain the Constitution and champion its ratification, *The Federalist* remains a primary source to which all constitutional scholars, historians, and legal experts appeal for guidance. It contains one of the few direct comments regarding the Intellectual Property Clause (IP) in the beginning of No. 43. Written by Madison, it says: "The utility of this power will scarcely be questioned. The copyright of authors has been solemnly adjudged in Great Britain to be a right of common law. The right to useful inventions seems with equal reason to belong to the inventors. The public good fully coincides in both cases with the claims of individuals. The States cannot separately make effectual provision for either of the cases, and most of them have anticipated the decision of this point by the laws passed at the instance of Congress."[1]

While Madison's matter-of-fact affirmation carries considerable weight, it also contains a few of the more robust seeds of subsequent dispute over both the reason for and application of intellectual property law. That word *utility*, for example, has spawned a litany of academic and public disagreement over the theoretical question as to whether copyright is grounded in natural rights or is merely a pragmatic, Faustian bargain that must be tolerated in order to incentivize authors to create

28

and distribute their works. The latter view is supported by Madison's reference to the *public good* and by the qualifying clause in the Constitution, which states that the purpose of IP is *to promote the progress of science and the useful arts.* "Promote the progress" is reasonably interpreted as "for the good of society," but these words did yield a pedantic, chicken-and-egg argument in the blogosphere as to whether copyright first serves the public or the author, despite the immutable fact that society cannot have what the author does not first create.[2] Hence, my personal rule of thumb: Beware Framer pull-quotes.

Those fallible geniuses we call the Founding Fathers left behind such a rich anthology of opinions on so many subjects—many of them self-contradictory—and were in such a state of ideological, and petty *ad hominem*, conflict with one another before the first administration was over that their myriad views are conveniently inconsistent enough to allow modern scholars, pundits, politicians, and activists to invoke their names in support of or in opposition to nearly any cause. Still, I think of the law as a literary form playing with live ammo, so the meaning of words is what we are always debating, often with great consequence. And that brings me to the memory of an afternoon in Nashville when, as a guest among actual attorneys and scholars, I proved the axiom that a little knowledge can be truly dangerous.

At a round-table hosted by the Center for the Protection of Intellectual Property (CPIP) I stuck my foot well in it by expounding upon some notion that the word "useful" (as in "useful arts" from the constitutional clause) was instructive to the conversation. After a moment's polite silence from the group, it was in fact Professor Justin Hughes—whose article "The Photographer's Copyright" I cited earlier—who volunteered to remind me that, as a matter of textual doctrine, the term "useful arts" refers to patent law while the term "science" refers to copyright. "To promote the progress of *science* and the *useful arts*, by securing for limited times to *authors* and *inventors* the exclusive right to their respective *writings* and *discoveries*." Appropriately chagrined, I ducked into the imaginary penalty box and eagerly anticipated cocktail hour. But upon further review of a little history, I would have to say

now that one could make equally reasonable arguments for reading the American IP clause either way and eventually run into a logical dead end no matter which path is chosen.

Although it is now settled law to read parallel-construction in the IP clause—*science* maps to *authors* who make *writings*, while *useful arts* maps to *inventors* who make *discoveries*—this was not always entirely clear. Without going too far down this particular rabbit hole, the legislative and case law history in the U.S. reveals several instances in the nineteenth century—and *Burrow-Giles v. Sarony* is one of these—when the lines separating copyrights and patents were not so clearly drawn. The House and Senate committees overseeing copyrights, patents, and trademarks were both called the Committees on Patents; and in an 1890 report urging passage of an international copyright law, the House committee states, "The Constitution authorizes copyrights in order 'to promote the progress of science and the useful arts,' primarily within the United States."[3] This combining *science and the useful arts* as a unified and generalized goal of copyright is just a tiny peek into the linguistic labyrinth one could wander for quite some time in an attempt to fully square the application of intellectual property law with the semantic history and rationale for its existence.

Take the idiomatic bugaboo in the clause which says that "discoveries" are the product of "inventors" and, therefore, contradicts the lesson we were all taught in grade school that *discoveries* are the opposite of *inventions*. One can *invent* (and patent) a toaster but can only *discover* (and not patent) the laws of physics that make bread toasty. To further complicate matters—and Sarony's attorney bangs on about this for about two pages in his brief—it is not very common these days to talk about artists *inventing* their creative works; but the word *invent* was widely used in the creative and fine arts up to and beyond the late nineteenth century. Even more of a pain is the fact that an *inventor* in the printmaking business referred to the *illustrator* or *designer* of the image, which is why the 1802 amendment to U.S. copyright law extended copyright to a person, "who shall *invent* and design, engrave, etch or work . . . historical or other print or prints."[4] And finally, most of

us non-attorneys do not generally think of *science* as the field of musicians, visual artists, writers, or filmmakers, but we do think of *science* as a field for inventors.

Welcome to the glossary the legal professionals call "terms of art," words or phrases that have specific meanings in the law, but which are either more narrow or more broad than their uses in everyday conversation or writing. *Author* is the most obvious example in copyright, which of course derives from the fact that England's protocopyright mechanisms were exclusively concerned with book publishing; but today, *author* is the proper term of art to describe *any* creator of any kind of protectable work—even a choreographer.

But the reason I am focusing on the lingo here is twofold. First because the challenge to photography was semantic, the defense in *Sarony* relying on a specific interpretation of the IP clause. Second because a lot of modern copyright theory and criticism (especially the criticism that seeps into the public discussion) assumes a somewhat linear history for the various terms that define what copyright actually is—and of course history is anything but linear.

Even the word *copyright*, as a contraction of *copy* and *right*, is something of an archaism born of legal devices that had very little to do with modern copyright law. In fact, *copy* meant something quite different a few centuries ago, and the concept *right* hardly existed as we use the term today. So it is little surprise that the two words were not consistently merged in Anglo-American usage until the early nineteenth century. Moreover, had the legal doctrine itself originated in the twentieth century, rather than having roots reaching back to the sixteenth, we would probably name the whole concept something else entirely. Nevertheless, copyright's first principle is founded—as first principles tend to be—on a raw intuition of justice, as we see in the story that is often called "the first copyright case."

The Battle of the Book

"While Rome and its ancient empire faded from memory and a new, illiterate Europe rose on its ruins, a vibrant, literary culture was blooming in secret along its Celtic fringe,"[5] writes Thomas Cahill, describing the

Western world descending into what is typically called the "dark ages," when our European ancestors supposedly spent about three hundred years wallowing in their own filth and forgetting how to read, write, and think. Although that generalization has been refined somewhat by various historians, Cahill very reasonably maintains that if it were not for the singular nature of Ireland's path to Christianization—beginning with Patrick in the early fifth century—the Western canon of literature and philosophy written in Latin, Ancient Greek, and Hebrew would almost certainly have been lost to the rampant illiteracy that accompanied the disintegration of Rome.

The unique combination of Ireland's geographic remoteness from barbarian invasion with its indigenous love of language steeped in its fantastical pagan mythology yielded a profusion of monasteries whose primary industry was the production of beautifully rendered copies of the works of the ancient world. By the mid-sixth century, Ireland was dotted by enclaves of beehive-shaped dry-stone huts, each occupied by a solitary "bee" painstakingly scratching out the words of the Bible, Aristotle, Cicero, and others. Against the backdrop of all this monastic duplication, in about the year 540, an event that is at least casually referred to as the first copyright case occurred at the monastery at Moville on the Inishowen peninsula that juts into the North Atlantic. Because records are incomplete, and because this is Ireland, the story of Columcille (*colum-kill*) is of course part history and part legend.

Born a prince of Clan Conaill on the northern edge of the country, Columcille might have become high king but instead pursued the path of a monk, and thus the turning point in his career places him as a student of the monastery at Moville, where he is discreetly copying a beautifully rendered Psalter that belongs to his master Finian.[6] As the story goes, Columcille conducted this nightly labor without the aid of a candle but by the "light of his left hand," and the reason for his secrecy was that he intended to keep his copy of the Psalter for himself rather than leave it with the monastery. Upon discovery of Columcille's handiwork and consequent dispute with Finian over possession of the book, the regional King Diarmait settled the matter with the edict, "To

every cow her calf, to every book its copy."[7] Thus, with the king finding for the plaintiff, Columcille's lovingly crafted replica was deemed the property of the monastery. Though not for long.

Wounded by the decision, Columcille's still-fertile piety yielded to his high-born, pagan impulses and initiated what is arguably the first appeal in the first copyright case by finding a pretense go to war against Diarmait. The ensuing battle in what is now County Sligo is said to have cost the lives of three thousand of the king's men and just one from Clan Conaill, the result of course being that Columcille reclaimed his book as a spoil of victory. Housed today at the Royal Irish Academy in Dublin, Columcille's copy of the Psalter is referred to as the Cathach, or "Battler," in honor of its legendary role in the life of the man who, as penitence for his little war, went on to personally Christianize Scotland and other parts of Europe as St. Columba.

"Latin literature would almost surely have been lost without the Irish," writes Cahill, "and an illiterate Europe would hardly have developed its great national literatures without the example of Irish, the first vernacular literature to be written down. Beyond that, there would have perished in the west not only literacy but all the habits of mind that encourage thought."[8] The same passion that drove Columcille to first painstakingly copy, then want to possess, the Cathach was the bequest of legions of itinerant Irish monks, who physically preserved the foundations of Western philosophy and stored their manuscript copies in monasteries that became the cornerstones of many of Europe's great cities.

Of course, metaphorical license notwithstanding, *Columcille v. Moville* was not in any true sense a copyright case. Copyright vests certain exclusive rights in authors to protect their original expressions, and neither Finian nor Columcille could claim authorship of the Book of Psalms nor, indeed, of the deft craftsmanship that was specifically being copied. Still, the story retains the flavor of a "copyright case" largely because of Columcille's familiar, human instinct to think of the product of his labor as his property—that the physical article he had made (by the light of his left hand no less!) was naturally his to keep. This "labor theory" as an underpinning of intellectual property was still a

good twelve centuries to becoming explicit, when the English philosopher John Locke would publish his *Two Treatises of Government* in 1689—marking the end of a volatile 150 years of religious and political turmoil for England, which was of course set in motion by the mercurial self-interests of Henry VIII.

A Most Egregious Infringement

All that classical knowledge so devoutly preserved by all that Irish scribbling fell largely into the hands of the Roman Catholic Church, which wielded its knowledge of ancient tongues, especially Latin, like magic incantations used to dazzle and frighten the faithful. The barrier of literacy between the common man and Scripture, so essential to the Church maintaining its authority, reached a tipping point with the Protestant Reformation beginning in 1517. Consequently, translation of the Bible from Latin, Ancient Greek, and Hebrew into vernacular languages was probably the most important element in the world-altering revolt against the widespread and multifaceted corruptions of the Pope and his ministers. The calling that would "cause a boy that driveth the plough [to] know . . . Scripture"[9] was answered by the English scholar and priest William Tyndale, whose translation circa 1525 of half the Old Testament and most of the New Testament has had greater lasting influence on English phraseology than even Shakespeare, according to Tyndale biographer David Daniell.[10]

Anecdotally, it is sometimes noted by historians that among Henry VIII's many hypocrisies was that he had Tyndale executed in 1536 for the heretical crime of translating the Bible into English and then, in 1539, ordered the publication of the first official English Bible, which was, of course, based almost entirely on Tyndale's "heretical" translations.[11] If this were entirely accurate, Tyndale would arguably be the victim of the most egregious copyright infringement in English-speaking history because it is not your average infringer who publicly strangles the author to death and burns his corpse at the stake before stealing his work. But this isn't quite what happened. It was officially the Court at Brussels, under the Catholic Emperor Charles, who executed Tyndale

for heresy in October of 1539, whereas Henry's relationship with the great translator, whose writings had provided him with a rationale to sever England from Rome in 1534, was more than a little complicated.

We all know that Henry's proximate motive for changing the course of human history was not an ideological conversion to Protestantism but rather a desire to get busy making male babies with Anne Boleyn. The Protestant movement was simply a convenient narrative—one reportedly fed to him by Anne in the form of a treatise written by Tyndale—in which Henry found the rationale he needed to declare Pope Clement VII a fraud and, therefore, unqualified to enforce the "unlawful vow" the king convinced himself he had made to his wife Catherine of Aragon. From there, it was a short logical leap to the conclusion that of course he was the head of the Church of England, and the eventual publication of the Great Bible was a work of propaganda with a frontispiece printed from a woodcut by Hans Holbein that shows Henry reigning above his subjects and the clergy with his authority derived directly from God.

It is not possible to adequately summarize the breadth and complexity of palace intrigue, competing interests, or indeed the whole pastiche of Henry's madness; but as if to foreshadow just how complex a narrative we're talking about, picture Henry lying in his deathbed in 1547—the man who, for his own purposes, had severed England from the Catholic Church—supposedly clinging faithfully to his rosary beads. Whether true or not, this image of Henry as religious centaur correctly anticipates the turmoil he had unleashed upon the nation; and the first major reckoning was about to come in the form of his daughter, Mary. During the seven-year pissing match between Henry and Rome leading up to the fateful marriage to Anne, one angry little byproduct of all that unfolding drama was the only child of Henry and Catherine, who found herself steadily demoted from the king's "pearl" to the king's bastard.

By the time Mary Tudor rather unexpectedly became England's first queen in 1553, she had been outcast and delegitimized, had witnessed the international humiliation of her mother, had suffered physical abuse by order of Anne Boleyn, had been threatened with execution by her

father, and had been scorned for her Catholicism by her half-brother Edward VI—the boy king who succeeded Henry but died at the age of fifteen. So it is little wonder that Mary I's efforts to restore England to the good graces of Rome was a furious torrent unleashed upon the Protestants, three hundred of whom she burned at the stake for heresy, including the sixty-seven-year-old Thomas Cranmer, Archbishop of Canterbury, who had personally sanctified the marriage of Henry and Anne.[12] And it was during this short, five-year reign of ecclesiastical and pyromaniacal frenzy—specifically in May of 1557—that Mary granted her royal charter to the Worshipful Company of Stationers and Newspaper Makers affirming its monopoly on publishing throughout the realm.[13]

The "Stationers' Copyright"

Founded in 1403, the Stationers' Company is one of over a hundred trade guilds located within the incorporated City of London—organizations often referred to as livery companies because members of each guild could be identified by their distinctive wardrobes, or *livery*. Initially, the stationers were craftsmen skilled in the various arts associated with manuscript book production such as illumination or binding. Unlike most of the itinerant tradesman of the medieval world, these early book purveyors would set up "stations" in the vicinity of St. Paul's Cathedral to ply their trade, hence their name and our word for certain paper products—*stationery*. The Company naturally became masters of printing with broad adoption of the printing press by the late fifteenth century; and today, Stationers' Hall still stands in the shadow of St. Paul's with its current membership of professionals working in print and electronic communications, publishing, advertising, and journalism.

The charter granting trade protection to the Stationers was not unique. The Crown retained the prerogative to bestow or rescind such monopoly privileges, granting letters patent to the various trade guilds, and this power was intermittently used either for legitimate economic interests of the realm or the capricious and selfish interest of the monarchs

themselves. The reason the Stationers' Company charter gets a fair bit of ink in the copyright narrative is that it was clearly Mary's hope to use the Stationers as de facto censors at about the same time that the Company instituted an internal practice typically referred to as the "Stationers' copyright." Extrude that story through several centuries until we get to the internet, and it comes out as *Copyright was created for the purpose of censorship.* But this is what happens when one tries to fit extraordinarily complex history into a tweet.

The preamble to Mary I's charter stated very clearly that a rationale for empowering the Stationers' Company was to rid the nation of "seditious and heretical books rhymes and treatises [that] are daily published and printed by divers scandalous malicious schismatical and heretical persons."[14] In fact, despite the modest economic value of the Stationers relative to other great guilds of the city, this brotherhood of booksellers ultimately received more attention from the state and was granted more monopoly control (at various times) over their industry than any other livery company,[15] and these privileges were undoubtedly tethered to the belief that controlling the press was intrinsic to the consolidation of power.

How effectively the press was ever really controlled is another matter since banned published material, both foreign and domestic, was consistently routed throughout England by various means. Tyndale's Bibles were smuggled into England hidden in bales of cloth.[16] Benjamin Franklin describes his ancestors, during the reign of Mary I, keeping their copy of an English Bible hidden under a "joint stool" that his great-great grandfather would turn upside down on his knees to read aloud while one of the children stood at the window keeping an eye out for the royal authorities.[17]

At about the same time that Mary issued her charter, the Stationers' Company established its internal practice whereby an individual member would formally register his intent to print a particular work, and the other members were expected to honor his exclusive claim to its publication. This regime, now commonly referred to as the "stationers' copyright," is the source of blogs, social media comments, and even

academic papers alleging that copyright's purpose at its foundation was to be a device of corporate monopoly and state censorship. But this is a bit like saying the main purpose of *salary* is to amass a great army just because that word happens to derive from the payment of salt to Roman soldiers. Because even the Stationers did not conceive of this registration regime as anything like copyright as we know it today.

In fact, the term *stationers' copyright* itself appears to be a neologism used by scholars and historians to describe this early registration regime because there is no record in the Company that uses the term *copyright* until the early eighteenth century. And even then, not quite. On March 31, 1701, a publisher named Timothy Childe apportioned "one moiety of this book & copy right" to a Mr. Awnsham Churchill (fig. 7), but as we'll discuss in the next section, the word *copy* (or *copie*) had slightly different meanings at the time; and as for the registration practice itself, the Stationers appear to have been inconsistent about it. Only about fifty out of sixteen hundred books were actually entered into the Company registry during the years 1557 to 1571; and although the booksellers did, at various times in history, take advantage of state censorship laws to enforce their own monopoly control, they were not terribly efficient censors compared to the Crown itself, which had more effective means to silence offending tongues, such as cutting them out or impaling them with hot irons.[18]

More to the point, it seems only reasonable to conclude that for more than a century after Mary's charter, any effort on the part of a particular bookseller to remain on the "right side" of political and religious doctrine would have been a bewildering endeavor to say the least. Before the split with Rome, loyalty to the Crown was synonymous with loyalty to Catholic doctrine; but after Henry, the interplay between religion and fealty to the state became dizzyingly complicated, as words like *treason* and *heresy* vacillated between one orthodoxy or another. For instance, when Mary signed the Stationers' charter, she was already failing in both health and public support; but when her half-sister—Anne Boleyn's only child and a Protestant—was crowned Elizabeth I in 1559, the renewed charter did not amend the Marian

language affirming commitment to "sound catholic doctrine of Holy Mother Church."[19] This was of course the religious duality that prefigured the "new-church-same-as-the-old-church" complaint that eventually inspired the Puritans of the 1620s and 30s to "vomit their way across the sea,"[20] to build a new promised land in America; but it also suggests that the censorious aspect of the Stationers' Company charter could not be taken too literally.[21]

Between 1559 and 1688, England produced five monarchs, interrupted by a civil war that erupted in 1642 between the Parliamentarians and the Royalists; and when Parliament declared itself the supreme authority in 1643, they passed a Printing Act meant to end the "great late abuses and frequent disorders in printing many false, forged, scandalous, seditious, libelous, and unlicensed papers, pamphlets, and books to the great defamation of religion and government." Notice that this language bears a clear resemblance to the Marian and Elizabethan charters to the Stationers' Company except here the meaning of "defamation of religion and government" was any publication antithetical to Parliament's authority and the fun-hating Puritanism that was then being shaped by Oliver Cromwell.

In response to this Printing Act, John Milton, though dedicated to the Puritan and Parliamentary causes, wrote his treatise *Areopagitica* inveighing against censorship through licensing statutes as anathema to the antiroyalist revolution itself. Advocating a seventeenth-century version of the "free flow of information," Milton argued that virtue and wisdom would prevail—indeed could only prevail—by allowing heterodox books, pamphlets, and newspapers to at least be published, even if this meant prosecution after the fact. "Lords and Commons of England," he wrote, "consider what Nation it is whereof ye are, and whereof ye are the governors: a Nation not slow and dull, but of quick, ingenious and piercing spirit, acute to invent, suttle and sinewy to discours, not beneath the reach of any point the highest that human capacity can soar to."[22]

This expression of the rather modern idea that a nation's enterprise should aspire to, rather than shrink from, a diverse range of expression is one reason *Areopagitica* is often described as one of the great

paeans to freedom of speech; but as with the "Stationers' copyright," Milton must remain in the context of his time and place. Just as the victory of the Parliamentarians in the English Civil War represented a clumsy, temporary lurch toward republicanism, likewise the monopoly privileges granted to the Stationers' Company, the printing acts, and the various royal decrees pertaining to publishing are all products of this embryonic and very muddled history. Most importantly, all these events occurred well on the other side of a philosophical threshold: the rights of individuals were not yet grounded in religious liberty and free expression. Although they are unquestionably the crucible in which we find many of the raw ingredients of those civil liberties, as well as some of the raw ingredients of copyright, their relationship to the modern world is roughly that of elements in the early universe to the design of modern civilizations on Earth.

Copy and Right

Leave it to Henry VIII and his world-altering fervor to sire a male heir to instead produce the daughter who presided over England's transformation into a world power and nascent empire. The forty-five-year reign of Elizabeth I, while hardly free of domestic turmoil, was a comparatively stable "golden age" when England literally became more English. And no figure personifies that transition more than every copyright skeptic's favorite example of an author who "did not need copyright," William Shakespeare. His birth recorded in Latin and death recorded in English, Shakespeare's contribution to English, like that of William Tyndale, is omnipresent if not always recognized. Consequently, he is one of those figures who lives in general consciousness as an icon of literary genius regardless of any specific knowledge about his life and work.

This gist of the Bard, perhaps complicated by volumes of unsubstantiated theories and narratives about him, makes Shakespeare an easy reference for copyright critics who consistently repeat the theme that *creativity existed before copyright*—an axiom that is both true and irrelevant—thanks largely to the common understanding that he often borrowed, or just plain stole, a lot of material from other works. Although

the cliché that Shakespeare never invented a plot in his life is not true, he did appropriate voraciously; and so the copyright skeptic's logic seems to provoke the question, Why should mere mortal authors be expected to work within the boundaries imposed by copyright when Shakespeare himself produced such monumental works in a time when no such boundaries existed?

The most commonly cited example in this line of reasoning is *Romeo and Juliet*, which is based on the poem *The Tragicall History of Romeus and Juliet* by Arthur Brooke, which borrows from a story by Italian author Matteo Bandello, which arguably owes much to "Pyramus and Thisbe" from Ovid's *Metamorphoses*; and the whole line is of course recognized as the source of modern masterpieces like *West Side Story*. In fact, Shakespeare lifted considerably more than that, even going so far as to copy whole passages from other sources, almost verbatim, into some of his plays.

The reason why Shakespeare's plays comprise such a patchwork of original virtuosity and plagiarized carelessness, however, has far more to do with the business of producing theater in London four hundred years ago than with the author's *need* to borrow from precedent works. His career was not merely different from that of a modern—let alone American—playwright, his entire world was antithetical to the values that shape our understanding and expectations of artists today. If Tony Kushner lifted a whole uncredited monologue from some other play, he would be scorned for doing so regardless of any legal implications; and this is one small example of how the nature of copyright has very likely informed modern sensibilities about what it means to be "original" in creative expression. Also, it is worth noting that Shakespeare was only modestly prolific by both sixteenth-century and contemporary standards. Sam Shepard, Tennessee Williams, Neil Simon, Eugene O'Neill, and Arthur Miller, to name a few, all wrote more plays well within the boundaries of copyright.

Borrowing and outright copying was not only common for Shakespeare and his contemporaries in the production of dramatic works, it was a matter of raw survival. A theater company like Shakespeare's

Lord Chamberlain's Men had to attract about two thousand visitors a day, roughly two hundred days a year, maintaining an active repertoire of some thirty plays, with the ability to cycle through as many as five or six of these in a given week.[23] Plus, they had to give command performances by order of the monarch or some other noble patron, who could request a performance of *Cymbeline* like we use Video on Demand. And this was all in hectic, seething London where the exigencies of commerce and staying alive were an unrelenting gauntlet between outbreaks of plague and other deadly maladies and daily hazards resulting in an average life-expectancy of about thirty-five years.[24]

So as a practical matter, it is little surprise that Shakespeare often cut and pasted "borrowed" material in between his own mastery, or that nearly all of his plays reworked existing stories. But of course the reason Shakespeare endures has less to do with plots or raw story ideas and almost everything to do with the intangible "property" that modern copyright does protect—the thing that makes Shakespeare Shakespeare: his voice. And ironically enough, one word that would have been used during his lifetime to describe that voice is *copy*.

Through at least the late eighteenth century, *copy* conveyed two distinct, almost opposite, meanings.[25] Derived from the Old French *copie*, as either verb or noun, the term referred to "replication" like the work performed by Columcille and other scribes; but from the Latin *copia*, the word could be used strictly as a noun meaning *abundance* or *copiousness*, as when Shakespeare writes in *Comedy of Errors*, "It was the copy of our conference," meaning "It was all we talked about."

Clearly, these definitions are related because copying, in the sense of replication, does yield a kind of abundance; but the notion of *bounty* inherent to the Latin meaning has more to do with variety than duplication—particularly in forms of expression. For instance, David Daniell is confident that Tyndale must have been aware of, if not directly influenced by, a book commonly referred to as *De Copia*, first published by the humanist Desiderius Erasmus in 1512 as a textbook for students of rhetoric at Cambridge, advocating the effective use of variety in language. Something like a sixteenth-century version

of *The Elements of Style*, "The book's aim was to license and encourage not only the invention which aided coherence of argument, but copiousness, enlargement, amplitude of mind and phrase," writes Daniell.[26]

Although it is unlikely that Shakespeare studied Erasmus—his formal education ended before university—his craftsmanship as an author epitomizes the lessons in *De Copia*, achieving what Bill Bryson calls "a positive and palpable appreciation for the transfixing power of language."[27] So, it is ironic that, although modern legal critics love to invoke Shakespeare as an example of the futility of copyright because of his tendency to *copy* (Old French meaning), it was in fact Shakespeare's *copy* (Latin meaning) that made him the playwright whose works remain vital four centuries after his death. Moreover, it is *copy* in this latter sense (i.e., originality of expression) that modern copyright protects as distinct from a work's underlying ideas or themes, which remain the property of the commons.

I don't know exactly when *copy* shed its Latin connotation, but throughout the eighteenth century, both case law and legislative debate use the word *copy* in almost the same way we use the word *copyright* today. Booksellers, jurists, and legislators all refer to the sale, purchase, or transfer of *copy* as the intangible property that may be conveyed from one party to another; and it is hard not to believe that there was a semantic transition whereby *copy*, as a noun, embodied the unstated right to *copy* as a verb. The later addition of the word *right*, taking several decades to bond into a compound, probably has a lot to do with the fact that the exclusivity of copying was solely an intramural function of the Stationers' Company, while a right pertaining to works of expression was not a right in the modern sense so much as permission (or not) granted by the state to publish. So it seems highly relevant that, although the American Framers imported the mechanisms of English copyright law, the addition of our uniquely liberal speech right naturally changed the concept of the author's rights.

The "Fruits of Labor"

The general thesis that copyright began as a publisher's right and became an author's right is a misleading summary because, as mentioned, the

concept of a right, particularly with regard to expression, simply did not exist as we use the term today. It would be more accurate to say that some very old licensing regimes eventually morphed into the author's right, because there can be no foundation for modern authorial rights without first inverting the relationship that existed between the individual and the state. Until the Enlightenment thinkers flip that narrative and declare that the state's purpose is to protect sovereign individuals—rather than the individual's obligation to serve a sovereign—neither the speech nor the labor rights underpinning modern copyright can be said to exist. And the man most often credited with overturning that relationship, especially in the IP world, is John Locke.

Never truly a philosopher at Oxford, Locke was bored by the rote disputations he called "hogshearing" (i.e., the "trimming of small hairs from the skins of vociferating animals"); and as he was timid and reclusive by nature, the fact that he bore witness to the stormiest transitions in English history fostered his appreciation for authority and order—someone who would "go to great lengths to secure quiet," according to the scholar Peter Laslett.[28] In fact, Locke's pursuit of political theory was an unintended consequence of his having first chosen a career in medicine, which led to a fateful encounter in the year 1666, when he saved the life of one of the most prominent Whig (republican) politicians in the nation, Lord Ashley, the first earl of Shaftesbury, who became Locke's patron and political mentor.

By this period, despite the fact that only 5 percent of the English population was Catholic, anxiety about "popish intrigue" was quite palpable—a disquiet exacerbated by the fact that King Charles II was financially subsidized by the Catholic Louis XIV of France, and that the presumptive heir to the throne, Charles's brother James, was unabashedly faithful to Rome. Meanwhile, in a propagandist maneuver in the ongoing tug-of-war between the Crown and Parliament over who was really in charge, Tory (royalist) factions republished a book originally written in 1620 by Sir Robert Filmer called *Patriarcha*, which argued on scriptural grounds that some of God's servants were naturally meant to rule over others—i.e., espousing the *divine right of kings*.

It was initially in response to Filmer that Locke began writing the first part of his *Two Treatises of Government* while lodged at Shaftesbury's Exeter House. This highly original argument that all men are created equal articulated Locke's concept of the social compact: rather than individuals serving rulers, as, in Filmer's view, God ordains, the state exists by consent of individuals and serves to protect their God-given (or natural) rights, namely life, liberty, and property. Locke balances this proposition against absolute liberty (i.e., anarchy) by writing, "*the end of Law is not to abolish or restrain, but to preserve and enlarge Freedom*: For in all the states of created beings capable of Laws, *where there is no Law, there is no Freedom*."[29]

Constituent to this rationale for the purpose of government is the role of property, by which Locke meant not only land or physical goods, but also an individual's capacity for physical and mental labor and his exclusive right to enjoy the "fruits" of that labor. "Though the Earth and all inferior Creatures be common to all Men, yet every Man has a *Property* in his own *Person*," he writes in the *Second Treatise*. "This no Body has any Right to but himself. The *Labour* of his Body, and the *Work* of his Hands, we may say, are properly his."[30]

It is no coincidence that the ennobled individual steps into the foreground of social and political philosophy during a period of advancement for science. Although official and popular doctrine was still some distance from a truly secularized analysis of the natural world, the kind of mysticism required to sustain fealty to the "divine right" was being chipped away by men like Isaac Newton mathematically explaining the movements of the planets. And in an observation that prefigures exploration of the science of photography, technology writer Steven Johnson notes that the development of the glass mirror at that time transformed Europeans' sense of *self* coincident with changes in social and legal paradigms. "Social conventions as well as property rights and other legal customs began to revolve around the individual rather than the older, more collective units: the family, the tribe, the city, the kingdom. People began writing about their interior lives with far more scrutiny," Johnson writes.[31]

While Locke is usually credited for the labor theory behind intellectual property, historian Lyman Ray Patterson also notes that conveyances between authors and publishers, even before *Two Treatises* and the so-called first copyright law, reveal an understanding that authors were selling something other than a physical manuscript to the publisher. An author had neither the authority of the state to approve his own work for publication nor the status of a Stationer to enforce a "copyright" against other publishers; but the conveyances, and other records of the Company, reveal a clear understanding that publishers were certainly expected to pay authors for the exclusive privilege to print their works and that, for instance, authors retained the sole discretion to amend their manuscripts in order to produce new editions.[32] So a nascent concept of an expressive work as intangible property was extant, even while England's political climate yawed from one extreme to another with various factions attempting—and often failing—to control publication overall.

It was in the comparatively safe climate after the Stuart dynasty ended in a bloodless coup called the Glorious Revolution that Locke first published *Two Treatises* anonymously through Awnsham Churchill, the same publisher mentioned earlier in association with the first recorded use of the term "copy right." "Books seem to me to be pestilent things," Locke wrote, "and infect all that trade in them. . . . Printers, binders, sellers, and others that make a trade and gain out of them have universally so odd a turn and corruption of mind, that they have a way of dealing peculiar to themselves, and not conformed to the good of society, and that general fairness that cements mankind." Locke was hardly alone in his general disdain for the corruption and authority of the members of the Stationers' Company, and in 1694, the law that had sustained their monopoly on the book trade was about to be consigned to the history whence it came.

The Licensing Act, first passed in 1662, intermittently renewed over the decades, contained the key statutes providing the privileges of the press and served the Stationers as a foundation for their monopoly. But when the Licensing Act was proposed for renewal in 1694, Locke

wrote a statute-by-statue rebuttal, including the following response to clause 6, which banned importation of foreign-made books:

> By this clause, the Company of Stationers have a monopoly of all the classical authors; and scholars cannot, but at excessive rates, have the fair and correct edition of those books printed beyond seas. For the Company of Stationers have obtained from the Crown a patent to print all, or at least the greatest part, of the classic authors, upon pretence, as I hear, that they should be well and truly printed; whereas they are by them scandalously ill printed, both for letter, paper, and correctness, and scarce one tolerable edition is made by them of any one of them. Whenever any of these books of better editions are imported from beyond seas, the Company seizes them, and makes the importers pay 6s. 8d. for each book so imported, or else they confiscate them, unless they are so bountiful as to let the importer compound with them at a lower rate.[33]

Whether influenced or not by Locke's denunciation of the Licensing Act (or of the mendacity of the Stationers for that matter), Parliament came to a similar conclusion that the law, with its roots dating back to Henry VIII, achieved little in the way of addressing "treason" or "sedition" but did manage to give the Stationers' Company a monopoly to the detriment of the public's interest in obtaining some of the most valuable works in print. The political emphasis was shifting at this point to one of expanding the diffusion of knowledge, with many members of Parliament seeking new legislation designed to curtail the Stationers' Company monopoly. The booksellers themselves tried various tactics to maintain their control, with their last attempt in 1703 proposing a bill that would prohibit "Licentiousness of the Press." Six years later, on December 12, a new bill was read in the House of Commons called formally "An Act for the Encouragement of Learning, by vesting the Copies of printed Books in the Authors, or Publishers, of such Copies, during the Times therein mentioned."

The Statute of Anne

Often referred to as the first English copyright law, or the first author's copyright law, the Statute of Queen Anne, ratified in 1710, was not really either of these things; but it did foster a legal conundrum that eventually led to the codification of modern copyright, vesting rights in the authors of creative works. The central problem up to that time was that patents granted for the exclusive right to publish were, in fact, based on mostly futile attempts at state censorship, while "copyright," as an ad hoc practice, was purely a function of the Stationers' Company. So even though the preamble to the Statute of Anne identifies authors as the protected parties of interest, there was little in the way of legal precedent that actually addressed the rights of authors. It was this jurisprudential gray area that led to the "Battle of the Booksellers" in the latter half of the eighteenth century.

As described by the Poetry Foundation, James Thomson (1700–1748) was "a Scot who spent his adult life in England [and so] embodied in his work a comity between the two lands and traditions."[34] What a coincidence, then, that Thomson's most famous poem, "The Seasons" (1730), was the subject of the two landmark copyright cases that finally ended the "Battle of the Booksellers," which was, in part, a conflict between the English members of the Stationers' Company and the mostly Scottish interlopers into the London book trade. Because the Statute of Anne established a flat twenty-one-year term for "holders of stationers' copyrights in old works,"[35] the law ostensibly ended the Stationers' perpetual copyrights, which had been the foundation of their stranglehold on, for instance, the classics, as criticized by Locke. The result of this term limit was twofold. First, it meant that booksellers outside the Stationers' Company began to print and sell cheaper editions of books which had presumably fallen into the public domain as the twenty-one-year terms expired. Second, this increase in "foreign" trade rankled the English booksellers, who responded by advancing a new theory in the courts—the author's perpetual copyright.

The booksellers' argument was that authors had always enjoyed a perpetual right to control their writings under common law, and thus the sale of the author's "copy" (meaning "license" or "copyright") transferred this perpetual right to the purchasing bookseller. The counter argument was that there was no such thing as an author's rights until the Statute of Anne, which clearly defines the term limits of those rights. This is how the booksellers, with both sides pursuing their own business interests, caused the English court to transform copyright from a publisher's privilege into something very close to an author's right.

Now, when the cheerless empire of the sky
To Capricorn the Centaur-Archer yields,
And fierce Aquarius stains th' inverted year,
Hung o'er the farthest verge of heaven, the sun
Scarce spreads o'er ether the dejected day.

"Winter" was the first season Thomson poeticized circa 1725 in a blank verse that was novel for its time; and by 1730, he was both popular in London's literary circles and financially comfortable by means of writing alone. Inspired by both science and politics, Thomson's patriotic idealism, like Milton's, celebrated Britain's capacity for works of genius and beauty, as expressed in the final stanza of his most famous poem, "Rule Britannia":

The Muses, still with freedom found,
Shall to thy happy coast repair:
Blest isle! with matchless beauty crowned,
And manly hearts to guard the fair.
"Rule, Britannia, rule the waves;
Britons never will be slaves."

In 1729, Thomson entered into contract with bookseller Andrew Millar for the exclusive right to print "The Seasons," and under the terms of the Statute of Anne, that copyright should have expired by the time a

bookseller named Robert Taylor reprinted the poems in 1767. Thomson died in 1748, but under the theory that Millar had purchased the poet's common-law, perpetual rights, he sued Taylor in the Court of King's Bench for the unlicensed publication. This reasoning required that the four presiding justices had to answer the question as to the existence of a common-law copyright for authors in the first place and then determine, if that right did exist, whether it was extinguished by the Statute of Anne.

As to the first question, Justice Aston opined, "I do not know, nor can I comprehend any property more emphatically a man's own, nay, more incapable of being mistaken, than his literary works."[36] Further, the bench not only expounded upon the inherent justness of compensation due to the author, but also upon the author's right to protect his reputation against careless and inaccurate renderings of his work. (This notion of protecting the author's reputation would evolve into a modern concept within copyright called "moral rights.") To the second question, the court held that the Statute of Anne did not extinguish the common-law right of the author and found for Millar in a 3–1 vote with the dissenting Justice Yates asserting that no common-law author's right had ever existed. Nevertheless, the significance of *Millar v. Taylor* is that it was the first official interpretation in Anglo-American law of the concept of copyright as a legal doctrine that begins with the individual author.

Andrew Millar died before the trial concluded in 1769, and his "copies" were sold at auction in June of that year. Because passage of the Statute of Anne had opened up the book trade to anybody, it was common practice for Stationers' members to hold these auctions in secret, or otherwise devise to keep nonmembers from purchasing "copy" outside the fraternity of the Company. In particular, men like Alexander Donaldson, who had set up his "Scottish trade" in low-priced books in the heart of London, were exactly the kind of outsiders the Stationers prevented from participating in these transactions.[37]

"The Seasons" was purchased for £505 (about $81,000 today) by one Thomas Beckett and fourteen partners, and when Donaldson claimed a right to print the book on the grounds that it was in the public domain,

Beckett and his associates were granted a perpetual injunction based on the decision in *Millar v. Taylor*. Donaldson then appealed to the House of Lords and set the stage for the final skirmish in the "Battle of the Booksellers," which would affirm the existence of the author's right but also conclude that it was indeed extinguished by the Statute of Anne—thus leaving copyright in a perpetual state of paradox.

The majority opinion held that the author's rights were a matter of common law in perpetuity up to his right of first publication, but that once a work was published, it was subject to the terms of statute. Though it is risky to oversimplify this narrative, it seems fair to say that it is from the debate in *Donaldson v. Beckett* that we inherit much of copyright's ongoing tension as a legal framework—one which functions much like other laws governing the disposition of tangible property but at the same time protects an intangible right linked to the natural right of expression. Lord Camden, in his dissenting opinion in this case, said the following:

> The arguments attempted to be maintained on the side of the Respondents, were founded on patents, privileges, Star Chamber decrees, and the by laws of the Stationers' Company; all of them the effects of the grossest tyranny and usurpation; the very last places in which I should have dreamt of finding the least trace of the common law of this kingdom: and yet, by a variety of subtle reasoning and metaphysical refinements, have they endeavoured to squeeze out the spirit of the common law from premises, in which it could not possibly have existence.[38]

This is a very sober account of the often medieval instruments of English law that were never conceived as the building blocks of a right to protect the creative and intellectual expression of individual authors. Nevertheless, this fair summary of the legislative history of the "copy right" was countered by the majority's view that the author's rights remained a matter of first principles. So the presence of copyright at the founding of the United States, which was built on a nexus of first

principles, is no surprise at all. *Donaldson v. Beckett* concluded on February 22, 1774, which just happened to be about a month before the first of the Intolerable Acts lit the slow fuse of American independence.

Rock-and-Roll Puritans

> America has convinced the world of her importance in a political and military line by the wisdom energy and ardor for liberty which distinguish the present era. A literary reputation is necessary in order to complete her national character. And she ought to encourage that variety and independence of genius in which she is not excelled by any nation in Europe.
>
> —Joel Barlow, Letter to the delegates of the Confederate Congress, 1783

I think the "Star-Spangled Banner" became truly American the day Jimi Hendrix played his electric-guitar solo version at Woodstock in 1969. Simultaneously patriotic and rebellious, this tortured, note-bending virtuoso synthesized a tight-assed, aristocratic English melody called "Anacreon in Heaven" through the filters of racism and the self-betrayal of the Vietnam War into an instrumental rendition that expressed a deeper, more complex narrative in the American-born, slave-rooted language of rock-and-roll.[39] That capacity to express irreverence and loyalty at the same time—to both criticize and keep faith by extemporizing on a sacred and nationalized melody—is one of the most American things we do. We reinvent ourselves without destroying ourselves. Or at least that's the idea. And at the risk of breaking my own rule about assuming we can know, or should necessarily care, what the Framers would think of America today, I do like to imagine that even the bitter rivals Hamilton and Jefferson would have eagerly bobbed their ponytails to Hendrix's performance (and they would certainly both be into rolling around in the mud with naked women) because America, from the beginning, was a nation of rock-and-roll Puritans. It had to be. Oth-

erwise, the *let's-do-this* chutzpah of the Revolution, which historian Gordon S. Wood calls "the most wanton and unnatural rebellion that ever existed,"[40] can hardly be explained.

Never in the history of the world had any people started a revolution, let alone against such overwhelming odds, in response to so trifling a set of complaints. By any measure of individual liberty in the eighteenth century, the American colonists were about as well-off as anyone could conceive at the time. Inviting the charge of treason against one of the most powerful military forces on earth simply did not make sense. And the Revolution certainly should not have succeeded. So maybe there is a case to be made that the real underlying rationale for the rebellion was not the Intolerable Acts or the tea debacle or the rest of that litany of bureaucratic, mercantile grievances we are forced to memorize in grade school, but was instead the simple truth that the American colonists were just too different to remain English for much longer—already too rock-and-roll to remain a chapter in England's patrician and decorous history. After all, it was hardly imperative, nor even a universally popular idea at the time, to establish an entirely new form of central government after the Revolution. And it is significant that, in order to sell the Constitution to the people of the independent states, the Federalists had to affirm the novelty of the framework as one based on principles that were already alive in the citizenry, rather than any one cultural tradition or—eventually—any one class of citizen. Thus, "The origin of the American REPUBLIC is distinguished by peculiar circumstances. Other nations have been driven together by fear and necessity—the governments have generally been the result of a single man's observations; or the offspring of particular interests. In the formation of our constitution, the wisdom of all ages is collected—the legislators of antiquity are consulted—as well as the opinions and interests of the millions who are concerned. In short, it is an empire of reason."

Those words are not from *The Federalist* but from a pamphlet that historian Joshua Kendall asserts "may well have exerted even more influence, particularly outside New York State," in advocating the con-

stitutional cause. Entitled *An Examination into the Leading Principles of the New Federal Constitution Proposed by the Late Convention Held at Philadelphia*, the treatise was written in two days, and published just before the convention assembled on September 17, 1787, to read aloud the final draft of the Constitution. The author, who had sequestered himself in his room on the fifteenth to write this encomium to the cause of union, was the lexicographer Noah Webster, often referred to as the father of American copyright, but whom Kendell, in his 2010 biography, more expansively describes as the "forgotten Founding Father."[41] In this account, Webster is revealed as a *deus ex machina* of the founding period whose counsel and writings whisper with intermittent force into the hearts and minds of the leading players of the Federalist cause. At least as prolific as Hamilton in endeavoring to write the United States into being, Webster was a man burdened with significant character flaws that disqualified him from participating as a true statesman. More Puritan than rock-and-roll for sure, he was "not the stuff of American mythology,"[42] writes Joseph Ellis, while Bill Bryson observes, "He was by all accounts a severe, correct, humorless, religious, temperate man who was not easy to like, even by other severe, religious, temperate, humorless people."[43]

Generally known as that guy who wrote the Dictionary (although even that monumental work is often miscredited to his cousin, the politician Daniel Webster), Noah Webster was arrogant, disagreeable, hectoring, a shameless self-promoter, and often fickle in regard to his own theories about language. The fact that he inspires such a catalog of pejoratives, however, does suggest that his contributions must have been of considerable value in order for the less-forgotten Fathers to put up with him at all. Indeed his first major work, the little "blue-backed speller" which revised the standard grammar books of the colonial period and laid the foundations of what we now call American English, was arguably the nation's first *literary* declaration of independence and was certainly its first blockbuster—eventually selling one hundred million copies by the end of the nineteenth century.[44] Given its lasting formal title, *The American Spelling Book*, in the same year the Constitution was

completed, it was the work Webster personally sought to protect during the years he lobbied the individual state legislatures to pass their own copyright laws and the financial engine that allowed him to embark on the quixotic journey to write the Dictionary. That monumental work took just over three decades, at the end of which Webster wrote of the January day in 1825, "When I had come to the last word, I was seized with trembling which made it somewhat difficult to hold my pen steady for the writing."[45] Three years later the *American Dictionary of the English Language* was published by Connecticut printer Sherman Converse; and the sixty-six-year-old Webster, who had dined with Washington forty years prior and discussed the need for union among the states, had written himself into the esteem of the statesmen, literati, and jurists of the postrevolutionary era.

By this time, the *American Spelling Book* was already common to the early educations of nearly everyone, and though Webster's Dictionary did attract some critics, the compendium of over seventy-thousand words was widely, and rightly, considered a herculean achievement—not least because it had been accomplished by one man. "Webster transformed definitions from little more than lists of synonymous terms to tightly knit mini essays, which highlighted fine distinctions," writes Kendall, comparing him to Samuel Johnson.[46] Assuming this is well-deserved credit for adding a fresh layer of connotation—so essential to making meaning out of the largest vocabulary in human civilization—then Webster's exertions as both lexicographer and copyright advocate are remarkably well suited to the aforementioned proposition that law is a literary form. Anyone who has ever read a court opinion that begins with a "plain text reading" of a statute will immediately appreciate the importance of connotation, recognizing that the course of history may be changed by the interpretation of a single word.

If law really is a literary form, then the fact that copyright presumes to wrangle with the nature of expression makes the subject something of a word-geek's playground. And if one likes that sort of thing, it is hard not to appreciate the fact that the man credited as the dominant force behind American copyright also happened to be the nation's pre-

eminent word geek. After William Tyndale's zeal for religious reform gave English some of its indelible phrases, after Shakespeare's natural gift for sound multiplied the vocabulary, and after Samuel Johnson first sought to make order out of chaos with his *Dictionary of the English Language* (1755), it was Noah Webster's obsessive-compulsive personality disorder that drove him to write the lexicon of a new, American English. "The thirty-three year quest to complete the Dictionary was inextricably linked to the fight to maintain his own sanity," Kendall writes; and so, Webster's promotion of copyright must be understood in light of the fact that, different from the multienterprising Founders we usually celebrate, words were Webster's only means of subsistence and, quite often, his only friends.[47]

As is true of most authors, Webster's intellectual property agenda was both ideological and mercenary; he advocated protecting the rights of authors (and inventors) as a matter of national identity, sovereignty, and prosperity, but he also needed to make a living and support a rather large family. Although his plodding, and occasionally unreasonable, determination to standardize American English was a semivoluntary act of madness, it was also emblematic of a sensibility that was not his alone—a belief that American sovereignty required a domestic creative culture. "America must be as independent in literature as she is in politics—as famous for arts as for arms," he wrote in a letter to a member of the Connecticut State Legislature in advocacy of that state's adoption of a copyright law—the nation's first, ratified in 1783.[48]

Thanks largely, though not exclusively, to Webster's barnstorming the state legislatures for literary rights, eleven other states also passed copyright acts over the next three years. "I take the liberty to address you on the subject of Literary property & securing to authors the copyright of their productions in the State of Virginia," he wrote to James Madison on July 5, 1784. Although none of these state laws had much time to exert tangible effect before copyright became the subject of federal law in 1789–90, the preambles of many of these short-lived statutes do provide insight into the thinking of the period, espousing that rationale of protecting the *natural rights* of authors. For instance,

the Massachusetts Copyright Act (March 1783) proclaims, "the principal encouragement such persons can have to make great and beneficial exertions of this nature must exist in the legal security of the fruits of their study and industry to themselves and as such security is one of the natural rights of all men there being no property more peculiarly a man's own than that which is produced by the labor of his mind."[49]

More than half the states included similar appeals to natural rights as the foundation of intellectual property, and Webster's behind-the-scenes efforts in Philadelphia during the Constitutional Convention were at least partly responsible for the introduction on August 18 of the proposals that would eventually become article 1, section 8, clause 8. Madison, along with South Carolina delegate Charles Pinckney, proposed new congressional powers with the purpose of advancing literature and the diffusion of knowledge. Madison's list included, "To secure to literary authors their copyrights for a limited time. To establish a university. To encourage, by premiums and provisions, the advancement of useful knowledge and discoveries." Pinckney's list included, "To establish seminaries for the promotion of literature, and the arts and sciences. . . . To grant patents for useful inventions. To secure to authors exclusive rights for a limited time."[50] There is no record of any argument raised against empowering the new Congress to advance these goals, and on September 5, the Brearly Committee (a.k.a. the Committee of Leftovers or the "committee of eleven") introduced five additions to the enumerated powers of the legislature, the fifth of which stated, "To promote the progress of science and the useful arts, by securing for limited times, to authors and inventors, the exclusive right to their respective writings and discoveries."[51]

Five days later, the Committee of Style (the word-geek committee) was formed to discuss and revise the final language of the Constitution, and when they issued their September 14 report on article 1, no mention was made in regard to any deficiency in the language used in what we now call the IP clause.[52] On the one hand, the absence of any discussion on this subject indicates unanimity among the delegates that intellectual property was plainly valuable enough to include in

the general legislature; and Madison will explain in Federalist 43 that it would have been chaos to have different IP laws in each state rather than a uniform federal code. On the other hand, the silence of the Framers on the topic has since been filled by generations of scholars, attorneys, jurists, and pundits engaging in often-heated debate predicated on diametrically opposing interpretations of that little clause.

The Copyright Act of 1790, approved on May 31, granted authors of "any map, chart, book or books" printed in the United States, and by citizens of the United States, "the sole right and liberty of printing, reprinting, publishing and vending" these works. Borrowing many mechanisms from the Statute of Anne, the act provided for a term of fourteen years with an option to renew, by the living author, for another fourteen; it established remedies for infringement like fifty cents per copied sheet and an order to destroy infringing copies; it split the fines collected for infringement between the author and the government; it required registration in the district courts and mandated that deposit copies be delivered to the Secretary of State. Further, the act's title, echoing the language of the Statute of Anne, is An Act for the Encouragement of Learning, by Securing the Copies of Maps, Charts, and Books, to the Authors and Proprietors of Such Copies, during the Time Therein Mentioned. (Clearly, the Framers lacked the modern legislators' flair for acronyms because AELSCMCBAPSCDTTM doesn't flow at all and would make a lousy hashtag.)

Patterson contends that there are four rationales for American copyright, which are all identifiable in the state laws, the constitutional clause, and the federal act of 1790, and that these rationales are: to promote learning, to provide order in the book trade through government grant of protection, to protect the author's natural rights, and to prevent monopoly. Patterson further posits that each articulation of copyright asserts a different priority among these four rationales. For instance, the state laws prioritize the natural rights of authors, while the Act of 1790 prioritizes society's interest in providing order in the book trade through government grants.[53] Though it is certainly true that all of these rationales are evident and interrelated, it is also true

that one can only write (a statute or clause) in linear form and so any apparent priority of one rationale over another may be a consequence of style rather than substance. Regardless, the first copyright case to be decided by the Supreme Court would settle one doctrine for good. Well, mostly. In 1834, in the case *Wheaton v. Peters*, the Supreme Court affirmed that copyright is solely a creature of statute, meaning that Congress *grants* rights to authors—but this was not before Noah Webster embarked on his final, natural-rights-based, copyright campaign.

Not long after completing the first manuscript of the Dictionary, Webster traveled to England to secure a publishing deal—an unsuccessful journey, but one that might have made him more acutely aware that in 1814, the English had extended the term of copyright to twenty-eight years or life of the author, whichever was the longer. This awareness coincided with Webster's pressing concern that his own copyrights, especially in the Dictionary he had completed so late in life, should survive his passing to be of benefit to his widow and children. "Webster was troubled by the case of Timothy Dwight (1752–1817), the President of Yale who died during the first term of his copyright and left his family unable to enjoy the value of the renewed term," writes copyright scholar Oren Bracha. Upon his return to the United States in 1826, Webster wrote a letter to cousin Daniel, then Chairman of the House Judiciary Committee, in which he quarreled with the decision in *Donaldson v. Beckett* and its holding that statutory copyright did not protect a natural right of the author: "As I firmly believe this decision to be contrary to all our best established principles of right & property, & as I have reason to think such a decision would not now be sanctioned by the authorities of this country, I sincerely desire that while you are a member of the House of Representatives in Congress, your talents may be exerted in placing this species of property, on the same footing, as all other property, as to the exclusive right & permanence of possession."[54]

Webster was calling England's precedent decision both wrong-headed and un-American, despite the fact that England's most recent revision was at least one reason he had been inspired to propose amendment to

the American law. One way or another, all credit or blame (depending on one's point of view) may be accorded to Webster for the copyright revision of 1831, which extended the term of protection to twenty-eight years and allowed surviving widows and children to renew copyrights, if warranted, after the author's death. (Note: Consistent with the times, the statute actually says "widow" and not "spouse.") There were other general revisions like the inclusion of musical works (as printed sheet music) among the protected categories and a requirement that a notice of copyright be placed on physical copies.

Although securing his family's financial future was foremost in Webster's mind, the principles upon which he advocated broader protections for authors were grounded in the belief that copyright is fundamentally a matter of justice that, like other civil rights, exist with or without statutory provision. This remains the underlying, endlessly circular argument upon which all debate over any expansion of copyright is predicated: If copyright is a natural right, how can it be limited in duration and require the author to take certain actions, like registration, in order to avail himself of the right? Conversely, what can be "more peculiarly a man's own than that which is produced by the labor of his mind"?[55]

Daniel Webster would find himself straddling these two competing, intertwined principles, and in response to Noah's letter of 1826, he wrote, "property, in the social state, must be the creature of law; and it is a question of expediency, high and general, not particular expediency, how and how far the rights of authorship should be protected. I confess, frankly, that I see, or think I see, objections to make it perpetual." But the irony in this particular moment, as Bracha notes, is that, eight years later, in his capacity as an attorney, Daniel will represent Henry Wheaton in *Wheaton v. Peters* and find that his client's best (albeit losing) argument will be to assert a common-law foundation for perpetual copyright.

The year 1829 was the turning point for Webster's revision crusade. Daniel was, by then, a member of the Senate, and Noah's son-in-law William Ellsworth, husband of his eldest daughter Emily, was newly appointed to the House Judiciary Committee. It would not be unjust

to describe Webster's position at this time as uniquely influential in Washington, but this was as much a product of his well-earned literary bona fides as the direct relationships he enjoyed on Capitol Hill. Without Ellsworth, it is conceivable that a bill to revise the copyright act might not have made steady progress through the House, but Webster's notoriety is arguably the reason the bill so easily became law. As mentioned above, by the late 1820s, any number of political leaders had spent part of their early educations nose-down in *The American Spelling Book*, and then the Dictionary further advanced Webster's already solid reputation to one of eminence. So, when he traveled to Washington in late 1830 to lobby for the copyright bill, a mere three days separated his address to the House on January 3, 1831, and passage of the bill on the sixth.

Ellsworth's own pecuniary interest in his wife's inheritance does not seem to have been mentioned in any complaint against the bill; instead, objections were raised on the same principles that were already—and would continue to be—central to the copyright debate. Michael Hoffman of upstate New York opposed it on the grounds that the public had rights and that the author enters into a contract with society in exchange for the temporary exclusivity of copyright. Gulian Verplanck of New York City countered that the literary right "was a right of property existing before the law of copyrights had been made."

This latter argument prevailed, and the 1831 amendment was easily shepherded by Daniel through the Senate and signed into law in February by President Jackson, whom Webster, a devout Federalist, despised. The fact that his lifetime of strident devotion to American letters and copyright culminated with a dinner he would rather have missed with a Democrat like Jackson is about as fitting a tableau of American paradox as one might ask for.

Three years later, the Supreme Court would have the more lasting word on copyright doctrine, when a retired reporter of that court named Henry Wheaton asserted his copyrights in the publication of his reports. Wheaton was an attorney, jurist, and diplomat who served as the third Reporter of Decisions to the United States Supreme Court

from 1816 to 1827 and would later become the legal colleague of Daniel Webster in a landmark case that shaped the limits and powers between state and federal legislatures and courts.[56] When Wheaton's successor Richard Peters proposed in 1828 to publish summary volumes of Supreme Court decisions, including his predecessors' reports, Wheaton took issue and sued for copyright infringement; and although the particulars of the ensuing *Wheaton v. Peters* are profoundly undramatic, the conflict provoked considerable interpersonal drama for those involved. "The justices could not have looked to their task with much pleasure," writes Patterson, "for their relationships with the former court reporters must have been characterized by a degree of intimacy which made the dispute a personally distasteful one."[57] Indeed, not only was *Wheaton* a friendship-ending event, but on the subject of that longstanding theoretical question of copyright's reason for existing, the six-justice court revealed itself to be as bipolar then as the subject remains to this day.

The only question on which the court was unanimous and unequivocal was that the material in question—the decisions of the court—could not be protected by copyright. But it was Peters's challenge that Wheaton had not fully complied with the statutory requirements for protection that, once again, raised the question of the existence of copyright at common law, making the *Wheaton* case America's own version of *Donaldson v. Beckett*. The court held in a 4–2 decision that copyright *is* created by statute and, therefore, "granted" by Congress rather than an existing right "protected" by Congress. While this may seem trivial, it makes a considerable difference in how one approaches copyright policy and practice; and although *Wheaton* is settled doctrine, it is by no means a settled argument. Justice Joseph Story, whose close friendship with Henry Wheaton was ruined over this decision, wrote to New York chancellor James Kent, "I am sorry for the controversy between Mr. Wheaton and Peters, and did all I could to prevent a public discussion of the delicate subject of copyright. . . . I wish Congress would make some additional provision on the subject to protect authors, of whom I would think no one more meritorious than Mr. Wheaton. You as a

Judge, have frequently had occasion to know how many bitter cups we are not at liberty to pass by."[58]

Likewise, the majority opinion, written by Justice John McLean, acknowledges the inherent tension in this intractable question.

> Perhaps no topic in England has excited more discussion among literary and talented men than that of the literary property of authors. . . . the law appears to be well settled in England that since the statute of 8 Anne, the literary property of an author in his works can only be asserted under the statute. And that, notwithstanding the opinion of a majority of the judges in the great case of Millar v. Taylor was in favor of the common law right before the statute, it is still considered in England as a question by no means free from doubt.[59]

The constitutional matter in *Wheaton* turned substantially on the court's interpretation of the word *secure* from the Progress Clause, "securing . . . to authors," holding that it is a "word of origination." "Congress, then, by this act, instead of sanctioning an existing right, as contended for, created it," states McLean's opinion.[60] But there are two funny things about this decision, and the first leapt immediately to mind because, as a child of the 1970s, I faithfully watched cartoons on the ABC network every Saturday morning, and these were interspersed with animated shorts called *Schoolhouse Rock!* that taught three-minute, musical lessons about grammar, arithmetic, history, and civics. Because of this series, my entire generation knows the preamble to the Constitution (we have to sing it, but we know it), and that rather prominent and consequential paragraph uses the word *secure* in exactly the opposite way that the Supreme Court interpreted it in *Wheaton*. When the Framers chose the expression "secure the blessings of liberty," it is anathema to think that they believed the Constitution *created* said blessings, since the entire Revolution had been prosecuted on the assertion that it was *self-evident* that *all men* were naturally *endowed* with the *blessings of liberty.*

Not that we should expect *Wheaton* to be overturned anytime soon, but this is a pretty good example of the semantic maze through which this narrative travels. On that note, the other amusing aspect of this decision—perhaps the real irony in this particular matter—is that the Supreme Court of 1834 might have consulted the very work which Noah Webster had nearly killed himself writing for over three decades. The 1828 edition of the *American Dictionary of the English Language* contained seven entries for the word *secure* as a verb, all of which are consistent with notions of "protection" and not a single one suggesting the definition "to create."[61] So in this landmark case, the father of American English was of little use to the father of American copyright law, suggesting that perhaps there is something to be said for Aaron Burr's cynical conclusion that "the law is whatever is successfully argued and plausibly maintained."

Most likely, the simplest explanations for the Framers' lack of debate on the proposal to empower Congress to enact IP laws are that, first, they had no idea what to expect of Americans as a creative society and, second, they had more pressing issues to resolve just to get the union to exist at all. This pragmatist's interpolation of those sweaty days in Philadelphia might also account for the fact that the first Copyright Act of 1790 was, for most practical purposes, a variation of England's Statute of Anne, but this should also be seen in context of the Americans pulling themselves away from the mother country like chewing gum from a shoe stuck to a hot cobblestone. Although England's legal frameworks of copyright were unquestionably born in a cauldron of greed, religious censorship, and royal prerogatives, it makes all the difference in the world that they would be codified anew as subordinates to the constitutional protections of free speech, a free press, and freedom of religion, along with an explicit rejection of titles of nobility.

Nothing in England's copyright history owed allegiance to those principles or conceived of those values as part of its national character. So for all of America's clumsy progress and missteps toward making good on its own superior idealism, for all its many hypocrisies on that journey, the nation's real exceptionalism lives in a doctrine of potential,

renewal, and reinvention. "Because of intellectual property," Elizabeth Wurtzel contends, "we live in a democracy of ideas and not a plutocracy of provenance. Here, ingenuity is everything."[62]

This idea embraces both an ideological and pragmatic reality about the founding period: that if Americans were going to foster a creative class, it would neither be financed through public academies, which the young nation could not afford, nor though the patronage of a nobility, which the young nation did not want—at least on paper. Actual mitigation of classist traditions was another matter, of course, but it has certainly been the case that the success or failure of authors and artists in the United States is largely left to the judgment of the democratic market rather than the opinions of a few wealthy patrons or, most especially, the authority of the government. Even our own tussles with censorship tend to be citizen versus citizen disputes, in contrast to England's legacy of state authority to approve the publication or distribution of works. As English as our first copyright law might have been, it was also clearly adopted under a very different and unprecedented assumption of personal liberty. In fact, as if to emphasize the novelty of American legal territory, the registration requirement in the Copyright Act of 1790 actually called for a date pegged to American Independence Day rather than to the Christian calendar, although this *anno Americae* regime was changed in the revision of 1831, possibly in response to the inflexibly pious Webster calling the original an "atheistical date."[63]

The fact that English fundamentals were transposed into American law at the nation's founding is almost certainly a contributing factor to the ongoing frustration that there is no unifying theory of American copyright law. Case law has since provided significant doctrinal guidelines for the practice of copyright, but this does not resolve the ongoing debate about its true nature. In addition to its historic Englishness, and the relative absence of discussion on the topic during the founding period, there is also the challenge that language itself is often inadequate to describe abstract principles and, in this case, leaves copyright highly dependent upon semantic analogy to more concrete areas of law. As I say, copyright can be a logophile's workshop, so it is

more than a little ironic that although its original advocate happened to be America's foremost logophile, describing its true nature seems to remain elusively beyond the scope of English.

Meanwhile, at about the same time that *Wheaton* was wending its way up to the Supreme Court, a Quebecois family named Sarony emigrated to New York City, including a pair of brothers, age twelve and thirteen, who would both become pioneers in a visual medium that was just about to be invented. Because the case involving the photograph of Oscar Wilde posed a constitutional challenge, the decision, as in *Wheaton*, turned on the meaning of the Progress Clause, this time in regard to a technological medium of expression that no Framer would ever live to see, or could easily have imagined.

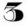

Stone Drawing

America is the noisiest country that ever existed.

—Oscar Wilde, *Impressions of America*

Above my desk is a lithograph registered for copyright in the Southern District Court of New York in 1854 by Nathaniel Currier. Its subject is the clipper ship *Nightingale* sailing northbound (I think) in New York harbor, about to pass Castle Garden in the background, which at that time was still an opera house before it was converted, the following year, into America's first immigration processing center. Whether intentional or not, this elegant example of marine art (a popular theme) is also a tribute to the Swedish opera singer Jenny Lind—another sensational import from P. T. Barnum—because the ship was named by its builders in Lind's honor and because her triumphant American debut began with performances at Castle Garden. In fact, Lind's visit was such a big deal that a reported twenty thousand people swarmed the docks to greet her arrival, and her opening night was so thoroughly sold out that eager fans who could not get tickets boarded skiffs and other light craft to bob in the waters near the opera house, hoping to hear the "nightingale" sing.[1]

Nineteenth-century Americans, and especially New Yorkers, enjoyed a good spectacle; and lithographs like the one on my wall were an affordable way for almost anyone to not only decorate a home with a handsome work of art, but to connect vicariously with current and historic events. Perhaps more significantly, this was the medium in

which the first mass-produced images of a common visual vocabulary were made. Today it is not remarkable that billions of us have seen many of the same images (e.g., Jeff Widener's "Tank Man" at Tiananmen Square, 1989), but lithography was the first printing method that offered both cost-effective reproduction and a minuteness of representational detail that would seem to convey the "truth" of the subject. This was not the case with all lithographs, of course, but images like that of the *Nightingale* on my wall are almost photorealistic, composed of such fine lines and subtle shades of grayscale that give it the quality of a twilight medium—a bridge between fine art and mechanical reproduction—a segue from the accepted fiction of illustration to the presumed nonfiction of photography.[2] In fact, lithography (*stone drawing*) has a lot in common with photography (*light drawing*) in the sense that the manual process of etching the image into the microscopic surface of the limestone is reminiscent of the chemical process by which light sculpts away the photosensitive particles on a photographic plate, celluloid negative, or paper.

Beginning in 1825, a little over a decade before practical photography became widely available, lithographic printmaking shops boomed during a significant twilight period for the United States—a time when the last witnesses to the Revolution were dying off and a new generation was poised to write the next chapters in both the history and mythology of the young nation. The "Nightingale" litho could be considered a tiny fragment in that history/myth dichotomy, with the clipper so majestically rendered that a viewer would never imagine her later service transporting sick, suffering, and dying African slaves.[3] In fact, the way we sometimes use the term *Currier-and-Ives* as a modern adjective to describe a too idealistic version of America harks back to this brief period when abundant lithographs were the primary illustrations of the national storybook. And it was in this medium that the twelve-year-old Napoleon Sarony began his career as a visual artist.

Born in Quebec in 1821, Gustave Adolphe Napoleon Sarony was among the youngest of eight or nine children belonging to Marie Lehoulier and Adolphus Sarony. The inclusion of Napoleon among his given

names was supposedly an homage to Bonaparte, who died that same year, and while this is certainly plausible with a mother who was French Canadian, it is a bit curious because his father was Prussian and about the right age to have fought—or have contemporaries who fought—at Waterloo against the army of his son's namesake. This apparent dichotomy typifies the available record on Sarony—only so much is known, and a fair amount is made up—but Erin Pauwels confirms that it was 1833 when he emigrated to New York City with his parents, along with his older brother Oliver, and three other siblings.[4] Exactly where the family lived or how they fared financially is not known, but it is certain that Marie passed away not long after arriving in America, that Adolphus became involved in city politics and Tammany Hall, and that Napoleon began his apprenticeship in the lithography firm of Risso and Browne, no doubt starting with the unglamorous job of cleaning and resurfacing the heavy stone slabs used in the printmaking process. It is possible that he left home at this time and lived under the same roof where he worked, but in the very scant interviews and commentary available, Sarony says almost nothing about these years other than cursory expressions of regret at never having had the opportunity to study fine art.[5]

By age fifteen, Napoleon was a skilled enough draftsman—drawing directly on stone with grease pencil and lithographic crayon—to work as a freelance illustrator, most often at first for the storefront shop at 52 Courtland (today Cortland) Street owned by Henry R. Robinson, a fervent Whig and caricaturist of Jacksonian Democrats and, as will later be discovered, one of the city's clandestine pornographers. Drawing political caricatures like the mutton-chopped head of Martin Van Buren on the body of a fox—not to mention whatever role Sarony might have played in the "fancy" trade in erotic material—casts the teenager as a participant at the center of a dramatic time and place. The fact that he would eventually become an archetype of the eccentric, bohemian artist and that his street education in visual works just happened to coincide with the period when the city first acquired its identity as a mecca for young artists makes his silence about these early years espe-

cially frustrating. Antebellum New York was an exciting, dangerous, enterprising, corrupt, and creative place, with all the action crammed into the roughly six square miles of lower Manhattan and much of it swirling in and out of Robinson's storefront.

The United States of the 1830s was young in every sense—not only a new nation, but home to seventeen million people with a median age just under eighteen years old and a majority of those well under thirty.[6] The New York of Sarony's adolescence had been jolted into place at the "center of the world"[7] by the completion of the Erie Canal in 1825, resulting in mass transportation of goods from the Midwest that made the city's ports the gateway to everywhere. This trade route was the catalyst to the fortune of America's first tycoon, John Jacob Astor, who shipped beaver pelts (nearly all the beaver pelts there were) to England for the production of a popular type of hat and thereby seeded a real-estate dynasty whose name is still carved into the face and sinew of the city.

Meanwhile, in contrast to the muscular ventures of the nation's vanguard aristocracy, waves of immigrants tromped down the gangplanks at the South Street Seaport to be gathered into the embrace of Tammany's political machine, promising jobs and a support network in exchange for loyalty at the ballot box. These polyglot new Americans were contemporaries of the first generation of citizens born in the republic, and so the proverbial "melting pot" of a million textbooks was set to simmer, though New York was not seldom a seething cauldron of incompatible ingredients that boiled over into protest, riot, and deadly conflict in the streets (see fig. 8). Exuberant scenes of violence—whether native against immigrant or immigrant against immigrant—only served to justify the politics of Whigs like Henry Robinson, who believed that President Jackson's largesse toward the common man would morally, fiscally, and ideologically corrupt the new republic before the paint was even dry. (Of course, as many of these European hopefuls would soon discover, the place wasn't painted at all and they were going to have to paint it.)[8]

A typical caricature, drawn by Sarony and published by Robinson in 1836, portrays a Democratic elector as an unwashed, besotted imbecile

trying to rise above his station (fig. 9).[9] Wooed by both the Tammany Committee and the Locofoco Committee (the latter being a more radical faction of Democrats), the voter declares, "As I'm a hindependent Helector, I means to give my Wote according to conscience and him as Tips most!" In all likelihood, Sarony would not only draw such an image according to Robinson's directions but would then do much, if not all, of the physical work of applying the various chemical coatings and rubbings used to etch the greasy image into the stone, which would then be used exactly like a typesetting form in a printing press to make multiple paper copies.

Periodically, work in the shop would be interrupted by a couple of news b'hoys[10]—foul-mouthed, ragtag, truculent, mostly Irish kids about the same age as Sarony, asking Robinson for more one-sheet cartoons to sell on the streets for a few pennies. This was antebellum America's version of "going viral," accomplished by a network of these untamed young denizens of the Bowery. Perhaps not aware that they earned their bread selling lampoons of themselves, they facilitated a paradox typical of the era. So, too, Robinson's caricature of the "hindependent Helector" was unkind, snotty, racist, and, in many ways, accurate. Tammany was indeed corrupt, and its most famous boss, William Marcy Tweed, would ultimately be brought down in 1876 by the cartoons of Thomas Nast.[11] But the new Democrats of the mid- to late 1830s were also the first Americans to take a baby step in that slow march toward a more inclusive form of republicanism. And in this regard, the most lasting influence of that spirit was a democratizing literary movement that began in 1837, the same year in which the first president born in the United States, Martin Van Buren, took office.

On August 31, Ralph Waldo Emerson delivered his address to Harvard's Phi Beta Kappa Society, proclaiming what might be considered the next literary declaration to follow in the spirit of Webster. "Our day of dependence, our long apprenticeship to the learning of other lands, draws to a close," he proclaimed. "The millions, that around us are rushing into life, cannot always be fed on the sere remains of foreign harvests. Events, actions arise, that must be sung, that will sing

themselves." Like Webster, Emerson challenged men of letters to mold American identity through domestic authorship, a spirit often referred to as *literary nationalism*, and for many of the writers who responded— Hawthorne, Whitman, Melville, Whittier, Thoreau—it was essential that a truly *American* voice break the bonds of patrician values embodied in the older generation of Whig politicians and intellectuals.

As historian Edward Widmer puts it, "To demand a new, more exciting, more inclusive culture was almost by definition a Democratic statement. . . . It was a protest against New England, and by extension, England, reenacting all the sweet memories of the Revolution. And to an extent, it was an ethnic protest, striving to replace New England's emphasis on Anglo-Saxon and Puritan traditions with a more universal belief in the openness and variety of the American experience."[12] Consequently, this literary-political movement that named itself Young America[13] prompted a geographical shift away from the Puritan cornerstones of Boston and Philadelphia to motley, rambunctious New York as the new epicenter of American culture. "New York is becoming more and more literary," wrote Henry Wadsworth Longfellow in 1839. "It will soon be the center of everything in this country;—the Great Metropolis. All young men of talent are looking that way; and new literary projects in the shape of Magazines and Weekly papers are constantly started, showing great activity, and zeal, and enterprise."[14]

It is no coincidence, then, that the work largely considered the apotheosis of all responses to Emerson's call was Walt Whitman's blank-verse love letter to the city, *Leaves of Grass*, initially self-published (and self-reviewed)[15] in 1855.

> I speak the password primeval . . . I give the sign of democracy;
> By God! I will accept nothing which all cannot have their
> counter-part of on the same terms.
>
> Through me many long dumb voices,
> Voices of the interminable generations of slaves;
> Voices of the prostitutes and of deformed persons;

Voices of the diseased and despairing, and of thieves and
 dwarfs,
Voices of cycles of preparation and accretion,
And of the threads that connect the stars—and of wombs, and
 of the fatherstuff,
And of the rights of them the others are down upon,
Of the trivial and flat and foolish and despised,
Of fog in the air and beetles rolling balls of dung.[16]

Neither this literary embrace of prostitutes and thieves, nor espe-
cially Whitman's fleshly verse, was quite what the priggish Webster
had in mind when he lobbied so earnestly for American copyright law.
But these new American authors of the 1830s and '40s also advocated
authorial rights, namely the urgency of respecting international copy-
rights; and it was fundamentally in service to the idea that "a creative
artist does not have to be educated or wealthy to be taken seriously as
an intellectual; that a raw teenager can say something as interesting
as an older person; and that a successful work ought to speak clearly
to the mass of American people, not just to intellectuals," as Widmer
writes to describe how these Young Americans viewed the role of cre-
ative expression in widening the embrace of democracy.[17]

To that end, the reason Whitman and his cohorts considered the
passage of an international copyright law necessary to the agenda of a
more inclusive democracy was a need to remedy an economic defect
that was plain enough to see in the marketplace. So long as Ameri-
can publishers were at liberty to print foreign (mostly English) books
without license, they had little incentive to risk investment in new
domestic authors. "The writers of America are more miserably paid
than their class are in any other part of the world," Whitman wrote
in the *Brooklyn Evening Star* in 1846. "And this will continue to be the
case so long as we have no international copyright. At this time there
is hardly any encouragement at all for the literary profession in the way
of book-writing. Most of our authors are frittering away their brains for
an occasional five dollar bill from the magazine publishers."[18]

In fact, American writers were at a double disadvantage: first, because pirated foreign books were cheap to reproduce and, second, because the foreign books most often printed were safe bets that had already proven popular among readers. This latter hurdle was further aggravated by a general prejudice among the purchasing class of Americans that although creative products of adequate utility might be made in America, "art" was only made by Europeans—a bias that was too often validated in the scrappy publishing market by an abundance of cheaply made, pirated English novels with flawed pages and weak bindings.[19]

But this same attitude also colored opinions of visual arts and other media, and it may be that America's reluctance to adopt an international copyright law during nearly sixty years of debate on the subject had something to do with the diffidence of a business-oriented society that did not want to think of itself as *artistic* like its European cousins—and that still grapples with the intersection between art and commerce. The brief filed in the Supreme Court on behalf of Burrow-Giles's use of "Oscar Wilde No. 18" will argue that the Framers, in adopting copyright, did not intend to protect art (in the sense of fine art) but only to advance the practical need for science and learning;[20] and indeed Wilde himself, when asked his opinion by a Sacramento reporter in 1882 about the still-lingering question of international copyright, replied that "a country gets small good from a literature it steals."[21] This quip perhaps summed up an earlier encounter he had had with "pirate America" aboard a westbound train:

> Perhaps the most beautiful part of America is the West, to reach which, however, involves a journey by rail of six days, racing along tied to an ugly tin-kettle of a steam engine. I found but poor consolation for this journey in the fact that the boys who infest the cars and sell everything that one can eat—or should not eat—were selling editions of my poems vilely printed on a kind of grey blotting paper, for the low price of ten cents. Calling these boys on one side I told them that though poets like to be popular they desire to be paid, and selling editions of my poems without giving me a

profit is dealing a blow at literature which must have a disastrous effect on poetical aspirants. The invariable reply that they made was that they themselves made a profit out of the transaction and that was all they cared about.[22]

Exactly forty years earlier, the gentry of New York hosted the "Boz ball" on February 15, 1842, to greet Charles Dickens (nicknamed "Boz") at the start of his American lecture tour, which was, in part, an inspiration for Wilde's tour.[23] "A curtain was raised in the intervals between the cotillions and waltzes to disclose a stage on which were exhibited a series of *tableaux vivants*, forming groups of the characters in the most striking incidents of 'Pickwick,' 'Nicholas Nickleby,' 'Oliver Twist,' 'The Old Curiosity Shop,' 'Barnaby Rudge,' etc.," wrote the diarist and one-time city mayor Philip Hone.[24] This theater of enthusiasm for Dickens's novels was not matched by a general receptiveness to his entreaties that America should recognize international copyright. "Mr. Dickens . . . has made an appeal to his hosts in behalf of a law to secure him a certain amount in *dollars and cents* for his writings," scoffed the *Morning Courier* and *New York Enquirer*. "We are . . . mortified and grieved that he should have been guilty of such great indelicacy and gross impropriety."[25] As remains the case today (especially with the ease of online piracy), these early American critics of copyright were never far from calling the author "greedy" for wanting to be paid for works the market was accustomed to acquiring for free, or almost free.

In another editorial that could almost be mistaken for one of today's anticopyright blogs, John O'Sullivan wrote in the *Democratic Review*, "He [Dickens] has certainly been richly enough paid at home, in pecuniary rewards as well as in public honor, for what he has done, to leave him but slender ground on which to ask a return of mere volunteer generosity on our part for the pleasure his admirable writings have afforded us. How is he injured if we do enjoy that pleasure, free as his home market is left from interference by our republications?"

O'Sullivan even paraphrases a line from a letter by Thomas Jefferson, writing, "May I not light my candle at my neighbor's lamp without

wrong to him or to my own conscience, if I can do so without intrusion upon him in the process, or inconvenience to him or his?"[26] In 1813, Jefferson's response to an inquiry by one Isaac McPherson of Alexandria included the beautiful sentiment, "He who receives an idea from me, receives instruction himself without lessening mine; as he who lights his taper at mine receives light without darkening me."[27] This quote is frequently cited by contemporary copyright critics, although usually without mentioning that Jefferson was referring to a tenuous *patent* claim to an ancient agricultural device, or acknowledging that Jefferson's libertarianism was so extreme that his zeal for the French Revolution never wavered, even as it devolved to wanton, head-lopping mayhem. Beware Framer pull-quotes.

The tricky thing about O'Sullivan's editorial is that he was one of the unifying literary forces of Young America, and the periodical he founded in 1837—its full title *The United States Magazine and Democratic Review*—published Whitman's first short stories along with contributions by Hawthorne and Melville in fraternal dedication to their common literary and political ideals. O'Sullivan, sincerely believing that passing an international copyright law would further delay investment in American authors, acknowledged that he was breaking ranks with his colleagues on the issue and fair-handedly published a rebuttal to his editorial, which reprises Locke's "fruits of labor" principle and forecasts Whitman's symbiotic egalitarianism in *Leaves of Grass*.

> The natural talents and qualifications of all men, whether of mind or body, are alike gifts from the Creator, and impose upon all a like responsibility for their use, abuse, or misapplication. The same duty attaches to each individual—to the laborer who, by his physical strength, earns his bread by the sweat of his brow—to the mechanic, who lives by the exercise of his manual skill—to the farmer, who cultivates the soil—and to the seaman, who navigates the ocean: all are alike responsible; and he to whom, "one talent" is granted is under the same obligation as he is to whom are entrusted "five talents."[28]

This parallel between the artist and the laborer as an argument for the raw justice of copyright is one that is still cited as a way to harmonize the traditionally conservative value of entrepreneurism with the traditionally liberal value of antielitism. The pragmatic industrial character of America that often clashes with the idea of *being* an artist is manifest in Sarony's young hands, employed to draw on stone in the bare-knuckle arena of antebellum politics—a bit-player shaping world events that seem to have had little effect in shaping him. It was customary for many illustrators to leave works unsigned, or to use pseudonyms, so it is difficult to know how many political cartoons Sarony drew during this period. But along with fellow New York printmaker E. W. Clay, his employer Henry Robinson was one of the most prolific satirists during Van Buren's one term up through the election of 1840.[29]

If Paul Revere's woodcut falsely depicting the "Boston Massacre" was the most important work of visual propaganda in American history, the cartoons produced during William Henry Harrison's campaign against incumbent Van Buren may be the next peak in the timeline of pictorial disinformation. Rumor, innuendo, and outright lies were nothing new in politics, but with the expansion of voting rights through the 1830s to nonlandowners, the urgency of appealing to the masses coincided with the expansion of the "penny papers" and one-sheet cartoons, which played a substantial role in what was arguably the first American election that was all style and no substance. The Whig strategy was to have Harrison say as little as possible as he was shaped into the Jackson-like war hero and man of the people—branded the Log Cabin & Hard Cider candidate, who had been victorious at Tippecanoe in 1811.[30] Meanwhile, Van Buren's image was morphed into an out-of-touch, effete aristocrat living in a gilded palace in the style of Queen Victoria. (I used to live in Kinderhook, New York, and have visited Van Buren's postpresidential estate "Lindenwald" many times. It's nice but hardly palatial and was never the least bit gilded. Moreover, Harrison was in fact wealthier and more aristocratic, if one may use the term, than Van Buren ever was.)

The only Robinson cartoon in the Library of Congress digital collection related to the 1840 election and signed by Sarony is called "The

Shipwreck" (fig. 10). It depicts the Van Buren administration tossed into the sea from the deck of a foundering sailboat with "Old Kinderhook" himself clinging to the mast on which the tattered mainsail is marked with the famous *O.K.*—the acronym that simultaneously referred to Van Buren's nickname and the sense of *okay* and, so, naturally inspired all manner of ridicule by political opponents. The fact that Sarony put his name on any of these images in simple block letters, *N. Sarony*, does provoke curiosity as to what he thought about these events or what relationship, if any, he maintained with his father. Adolphus was both an advocate for immigrants' rights and Tammany's President of the Third Ward, where Robinson's shop was located. And of course Napoleon himself was an immigrant who "ran with a francophile crowd" and whose incipient free spirit would seem to suggest kinship with the cultural revolutionaries of Young America more than with Whiggish curmudgeons like Robinson and Clay.[31] Then, as a practical matter, Robinson's preening righteousness was on a collision course with the inevitable exposure of his side trade in pornography—albeit a collision that occurred after Sarony had largely, or entirely, stopped working for Robinson.

"Such a scene was presented to the eyes of modest men as would cause a blush to gleam from the face of brass," wrote the *Herald* in its bloviating description of the police raiding the little shop at 52 Courtland Street in 1842. District Attorney James Whiting described Robinson as "a person of a wicked and depraved mind and disposition" when he charged him with violating the new federal law—the Tariff Act passed that same year—prohibiting the importation of "obscene" material, a law predicated on the assumption that smut (like art) generally came from Europe and was not yet produced in great quantity in Puritan America.[32]

In fact, much of the content sold by Robinson and others was piratically copied English or French material, making the porn business something of an underground manifestation of the international copyright issue. The Democrats naturally had a field day in their papers, mocking the staunchly outspoken representative of the party of "decency,"

although the apparently ad hoc enforcement of laws against obscenity suggests an equivalent hypocrisy. It is not even clear that Robinson was ever convicted; indeed, if he violated federal law, it is at least amusing to note that the same district court in which he was arraigned had, in 1836, filed his copyright for a wildly popular "licentious" print of the prostitute Hellen Jewett.

Misnamed "Ellen" on the image, Jewett is depicted half-naked, asleep, and feline amid her purple bedclothes, a postmortem homage of sorts, published on April 15, six days after she was stabbed to death—oddly enough by a different man named Robinson—and her body was found burned to a crisp along with her bed. If Robinson's lithograph, drawn by Alfred M. Hoffy, walked a blurry line between journalism and opportunism capitalizing on the prurient gawking that accompanied the Jewett murder, it was at least a more honest reflection of the era than the zeal of official moralizing embodied in the Tariff Act, which was enforced so absurdly that customs officials were confiscating lasciviously decorated snuff boxes at the city docks.[33]

In either case, whether judgment was passed on Robinson's politics or his pornographic trade, it seems that all such brushes only ever tarred the publishers of these works and not the artists who drew them. It was apparently understood that prints were the expression of whichever name appeared at the bottom of the image claiming copyright. Like other illustrators of the period, young Sarony earned his living as a grease-pencil for hire, and we do not know what he thought of his adolescent training in the world of stone and grease and sex and politics and savage b'hoys hawking his pictures in the streets. His subsequent biography and limited available commentary suggests that, like Wilde, he was an aesthete at heart, interested in beauty for its own sake, and it was most likely while drawing for Nathaniel Currier during the latter part of his freelance days that Sarony was finally able to hone a talent for popular decorative work instead of spending himself on the rudimentary, line-drawing manifestations of Robinson's disdainful politics.

It was also through Currier that Sarony met his future partner and brother-in-law Henry B. Major, with whom he founded one of the

more successful printmaking firms in New York, fulfilling orders for standard lithographic fare—advertisements, broadsides, sheet music covers, and those American storybook illustrations offering idyllic, uncomplicated, and patriotic versions of world events. When Sarony & Major published its "Victorious Bombardment of Vera Cruz" in 1847, for instance, depicting American gun boats raining arcs of gleaming artillery onto the Mexican fort, this was exactly the kind of romantic nationalism that had subsumed the identity of what Widmer calls "Young America II."

The darker side (or at least the more complex side) of evangelizing American democracy to the world was boiled down to the tautological doctrine "Manifest Destiny"—the term coined by John O'Sullivan in 1846 and which represents a schism in Young America between its early, literary founders and its later, political adherents. For the former, America's "destiny" to spread democracy across the world was philosophical and cultural; for the latter, it was literal and territorial, hence the Democrats' patriotism became rooted in the westward expansion that aggravated the slavery conflict and propelled the legacy known as the Trail of Tears.

The Mexican War in particular (April 1846–February 1848) was a point of ideological conflict sparked by the nationalistic Young America II, which assumed the name as an epithet of swaggering patriotism, leaving only the literature spawned by Emerson's declaration of independence as a faint echo of the original spirit of the movement. For example, Whitman's career-long advocacy of international copyright represented a very different kind of American expansionism than the picturesque shelling of Vera Cruz offered by Sarony & Major's lithograph—though both were certainly mythologizing in different ways. Whitman lived just long enough to see the law pass on March 3, 1891. His friend and biographer Horace Traubel, who visited Whitman daily in Camden during his final years, recorded that on the fifth, Whitman exclaimed,

We have our international copyright at last—the bill is signed today. The United States, which should have been the first to pass

the thing, is the last. Now all civilized nations have it. It is a question of honesty—of morals—of a literature, in fact. I know it will be said by some—Here, now, how is it that you, Walt Whitman, author of "Leaves of Grass," are in favor of such a thing? Ought the world not to own the world in common? Well, when others do, we will, too. This copyright bill is the doing as we would be done by.[34]

More than a century before the internet service called Napster would conflate *piracy* with *sharing*, Whitman had already reconciled this dichotomy with regard to his own magnanimous poetry and, as the apostle of Young America I, had reiterated Webster's ambition of 1783 that "America must be as independent in literature as she is in politics—as famous for arts as for arms."

But insofar as Europe was still perceived as the place where real art was made, the narrative generally repeated about Sarony is that in 1858, after the death of his wife Ellen Major, he left the lithography partnership behind and traveled with his children to Europe to study fine art. His obituary in the *New York Journal* states that he spent eight years studying with famous masters, but there is no record he did anything of the sort.[35] "It's possible that he tried to study painting for a bit," says Pauwels, "but I've always wondered if part of the impetus for his traveling to Europe wasn't always photography. He'd already been dabbling in it. He made ambrotypes in Westchester and was working with daguerreotypes in the 1840s and '50s."[36] Somewhere in the fog of this part of the record, Sarony also rather quickly remarried, to a woman named Louise, "Louie," who would become as eccentrically fashionable a figure on the streets of New York as her husband. Suffice to say the pair would soon be local celebrities enough that when Louie falls from a horse and bruises herself in August of 1889, it makes the *New York Times*.[37]

What is well documented is that by 1858, older brother Oliver had already elevated the Sarony name to the top of the British market for high-quality portrait photography. Having started out as an itinerant daguerreotypist, Oliver opened a number of portrait studios in England

and Ireland in the 1850s and '60s and earned a reputation as an innovator who pushed photography as a more affordable, yet equally beautiful, alternative to painting or mezzotint for portraits. Employing several fine artists, including some with Royal Academy credentials, Oliver's mainstay seems to have been hand-colored, photographic portraits produced with great care in his atelier-like studios that catered to fairly affluent and upper-middle-class customers. Whether Napoleon spent much time in the fine art studios of Europe is unclear, but it is certainly reasonable to assume that he learned the photography business from Oliver and saw an opportunity to capitalize on built-in name recognition when he opened his first studio in Birmingham with two partners in 1862.[38] It was there that he met the remarkable young woman who may well have altered the course of his career, but at the very least inspired one of his more lasting contributions to photography.

4

The Mencken

I sometimes think, Harry, that there are only two eras
of any importance in the world's history. The first is the
appearance of a new medium for art, and the second is
the appearance of a new personality for art also.

—Oscar Wilde, *The Picture of Dorian Gray*

On the night of December 29, 1860, a heartbroken twenty-five-year-old
would-be actress and author sat alone in a dingy room in Jersey City,
New Jersey, writing a note that declared, "Because I am homeless, poor
and friendless, and so unloved, I leave this world."[1] She died eight years
later—of illness rather than suicide—as one of the most popular and
highest-paid performers in the world and whose friends, acquaintances,
lovers, and alleged lovers comprise a catalog of nineteenth-century
cultural icons. Whether Adah Isaacs Mencken truly intended to take
her life that evening is not known. She may have been writing merely
to exorcise the demons of two lousy husbands, a recently lost child,
and the jeers of scandal-mongering reporters. Regardless, she chose
instead to turn infamy into fame, recognizing that, as a woman whom
men found alluring, scorn was often just sublimated desire, which she
could use to her advantage.

At about the same time that Sarony and Louie traveled to Europe,
Adah Mencken trod the boards of a Nashville theater, mangling Lady
Macbeth beyond all recognition but receiving enthusiastic applause
anyway. Whether this reveals an ignorance of Shakespeare or innate

approval of the young actress is impossible to say, but it does seem by all accounts that, as the showbiz saying goes, Adah Mencken had something. While she was gaining early attention in regional theaters and publishing poetry in *The Israelite* in Cincinnati, her husband, Alexander Mencken, lost his fortune, which led to a disastrous combination of depression and jealousy in him, which in turn manifested in attempts to bridle his spirited and artistic wife. Thus Adah was more than susceptible to the charming and handsome prize fighter John Heenan, whom she married after divorcing Alexander. Being Mrs. Heenan temporarily elevated critical and popular approval of her stage performances, but also prompted her ex to write an open letter to the *Cincinnati Commercial* declaring himself to be still, regrettably, married to Adah, referring to her as an "adventuress" and "incubus." This coming while Heenan was getting his brains knocked out in a thirty-four-round fight in England—during which time Adah gave birth to his son, who soon died—and her new husband decided to extricate himself from ensuing scandal by denying that she was ever anything to him other than a prostitute.[2] Since, at the time, *prostitute* was just one social rung below *actress*, this was an easy pop fly for the press to field, and it helped write the predicate to that hopeless night in Jersey City.

Portraits of Mencken reveal her emerging from these ashes as a woman who never fully escaped her underlying sorrow, but who was inoculated by grief against judgment and, consequently, achieved success by virtue of the fact that few men can resist a clever, pretty girl who doesn't give a damn what anyone thinks. Though it would not be inaccurate to say that she made her fame and fortune by selling sex in the mainstream theater, it would also be an unfair summary. She clearly had raw talent, intelligence, courage, and creative instincts, and she might have left a more indelible mark in theater and literature had she not been a woman in the 1800s, or if she had simply lived longer. On the other hand, there are enough gaps in her biography, from her origin—her real name was Dolores Adios Fuentes—to her legend, that it is entirely plausible that Mencken might indeed have been something of an adventuress and incubus. Napoleon Sarony would allegedly

describe her as "the most remarkable mingling of angel and devil that ever wore petticoats."

In fact, it is especially ironic that Alexander chose the word *incubus* (a male demon that has sex with a sleeping woman), because Adah Mencken made her fortune by seducing thousands of men who flocked to see her play a male role as a "naked" woman on stage. Whoever she truly was, Mencken weaves in and out of nineteenth-century bohemia— brushing elbows with Walt Whitman at Pfaff's beer cellar on Broadway, a platonic love affair with the Aesthetic poet (and early Wilde influencer) Algernon Swinburne, association with the young man who becomes her press agent, John Augustin Daly (she called him "Gus"), who first enters her orbit as one of the few theater critics to defend both her acting and her honor while gossip encircled her in 1860. Just a few years later, Daly will become one of the most influential dramatists and theater managers in America. And when Mencken makes the bold career move, taking on the role of Mazeppa, which catapults her to stardom, her success will also help launch the career of Napoleon Sarony, whose landmark copyright case will, as it happens, substantially rely upon a precedent litigation initiated by Augustin Daly.

The big scene in the play *Mazeppa*, based on the poem by Lord Byron, depicts Ivan Mazeppa, the paramour of the Polish Countess, stripped naked by order of the Count and bound akimbo to the back of a wild horse that is made to run through the forest so that the rider is beaten and bitten by whatever punishment nature may devise.

> We rustled through the leaves like wind,
> Left shrubs, and trees, and wolves behind;
> By night I heard them on the track,
> Their troop came hard upon our back,
> With their long gallop, which can tire
> The hound's deep hate, and hunter's fire.[3]

Mencken not only wanted to play this male role, including being forcefully disrobed on stage by a group of soldiers, but she also insisted that

she remain on the horse as it gallops up a runway into the scenic background, whereas most other productions usually substituted a dummy for this more dangerous part of the ride. On June 3, 1861, Mencken's *Mazeppa* packed the Green Street Theater in Albany, New York, and from that night on, she never failed to sell out a performance of this show.

Of course, "naked" on stage in the 1860s meant full-body, skin-colored tights; but this was daring enough—and the hint of ravishment was sufficiently risqué—to scandalize the puritanical while selling tickets to everyone else. Nowhere was the reception more resounding than in San Francisco, where Mencken went the *full Mazeppa*, revealing bare arms and legs protruding from blousy undergarments that, by modern standards, look like frumpy gym clothes. But in 1863, San Franciscans—mostly men of course—thronged to performance after performance, earning Mencken over $9,000 (more than $170,000 today) for her share of the box-office receipts; and it was here that she earned the sobriquet The Mencken, which lasted the rest of her short life.

The following year, The Mencken arrived in London, where she stymied prospective censorship with a deftly written response to the conservative *London Orchestra*, which had inveighed against the importation of "American immorality." But here, as elsewhere, audiences packed the house every night, and the girl who'd contemplated suicide in that lonely room in New Jersey hosted a salon at her suite in the Westminster Palace Hotel, entertaining a growing court of literati, including Charles Dickens. Playing Mazeppa made her a legend and a natural subject of gossip and speculation about her love life; but as an icon of worldwide curiosity, she was apparently never satisfied with any *cartes de visite* of herself in character as Mazeppa—that is until the UK tour traveled to Birmingham, where she approached a funny little man who owned a portrait studio with a pretty big name. According to the anecdote as Sarony supposedly related it,

> "Mr. Sarony," she said, "all attempts to photograph me as Mazeppa have been failures. Now I want you to take me in eight different poses, on condition that you allow me to pose myself." I agreed

to this on condition that she would allow me afterward to pose her in eight different attitudes. She said that was only fair, so we went to work. When the photographs were ready, I hunted her up in her dressing room at the theatre. I gave her those of her own posing first. Her exclamation was: "They are perfectly horrible; I shall never have another photograph taken of myself as Mazeppa as long as I live." Then I presented the photographs of my own posing. She threw her arms around me and exclaimed: "Oh, you dear, delightful little man, I am going to kiss you for that," and she did.[4]

If there were a biopic movie version of this story, that kiss from the hottest star in the world would be Sarony's lightbulb moment—cue montage—when he realizes that his destiny is to become the preeminent artist in theatrical portraiture. After Mencken's death in 1868 shocked millions of fans around the world, demand for photographs of her naturally spiked; and while it is hard to say precisely how instrumental she was to Sarony's recognizing the market potential of photographing theatrical stars, he could not have picked a better moment to return to New York with precisely that ambition than the boom years following the Civil War.

Some records indicate that Sarony initially returned to New York as a "photographic supplier," though it is probably more accurate to say that he was simultaneously a portraitist and a marketer of Oliver's most important innovation, *Sarony's Universal Rest and Posing Apparatus*, which represented a major improvement on the state of the art in the "torture devices" used to help portrait sitters hold still during long exposures. Oliver's devices offered greater flexibility and comfort to the subject and, therefore, more creative choices for the photographer. Of the more than one hundred portraits Napoleon made with Adah Mencken, several of these were his "Photographic Studies," produced specifically for the purpose of showing off Sarony's Universal Rest (fig. 11). In one "study" Mencken is costumed for the role she occasionally played in *The French Spy* (often as a break between the strenuous *Mazeppa* performances) and depicted in eight different expressive poses,

printed in two rows of four images each, all captured on a single plate using a four-lens *cartes de visite* camera.

To a contemporary viewer the print might look deceptively ordinary, because we are so familiar with contact sheets made from strips of negative frames and because almost everyone is aware that a modern photographer can snap rapid-fire shots at a constantly shifting subject. But in 1866, it was not technologically possible to freeze action using a wet collodion plate that had to be exposed for several seconds in good light. The illusion of motion had to be staged in a collaboration between photographer and subject in order to choreograph just the right position that would convey, for instance, a realistic-looking step forward. Sarony's "studies," like those he made with Mencken, are revolutionary for a couple of reasons.

The first is that Napoleon did, in fact, succeed in demonstrating the potential of Oliver's posing device: any photographer of the period would have recognized just how nimbly the subject had shifted from pose to pose in order to allow each frame to be recorded—roughly a new pose every ninety seconds—on a single plate before the collodion dried out. The second remarkable aspect about these "studies" was Sarony's talent for conveying a sense of motion within many of the individual frames, which implies his having a vision prior to recording the image. Sarony— and to an extent, his subjects—had to imagine the desired outcome, stage it, and hold it physically in place for several seconds in order to capture what will be perceived as a "real" moment in space and time. His photo of the actress Lida Cannon (from the 1870s) appears to have caught her walking briskly through the frame, her head turned toward the camera as though she is mildly surprised by the photographer. This contrived candidness paradoxically adds a hint of veracity (especially when seen from a modern perspective); the captured moment seems *real*—a snapshot taken before snapshots were technologically possible. "Oscar Wilde No. 18" reveals a very subtle use of this same staged kinetic energy to present a specific concept of Wilde. His pose is not wholly at rest but suggests motion in body language conveying his hav-

ing been interrupted midthought just as Lida Cannon was seemingly interrupted midstep.[5]

Erin Pauwels contends that Sarony's talent for fabricating motion in his photographs is an overlooked link in the evolution between photography's static limitations and Eadweard Muybridge's revolutionary "Horse in Motion" sequence—also found among the first pages of any history of cinema book adjacent the thaumatrope and Black Maria—which Muybridge achieved in 1878 by lining up twelve cameras fixed with electromagnetic shutters to capture the various states of a horse at gallop. Pauwels writes: "That Sarony's portrait photographs were all 'life and expression, only with far more abandon and intensity of action.' That his images now appear, like those of his contemporaries, to be curiously still and stilted, suggests . . . not that he was misguided in his approach or that his audiences were misguided in their enthusiasms, but instead that the clock by which this 'intensity of action' was measured is one we are no longer in the habit of recognizing."[6]

The idea that we now take motion in photographs for granted suggests an addendum to photographer-author Teju Cole's beautiful essay "Memories of Things Unseen," in which he writes, "Photography is inescapably a memorial art. It selects, out of the flow of time a moment to be preserved, with the moments before and after falling away like sheer cliffs."[7] This is true, though it seems that the element of motion prompts us to read just beyond the limits of frozen time, so that what comes before and after might slope away like rolling hills rather than sheer cliffs. Motion is narrative. The viewer cannot help but interpolate the before and extrapolate the after, and the Sarony brothers' contributions to motion and fluidity of pose arguably marks a transition in the art of portraiture from capturing the *fact* of the subject to conveying something about the nature of the subject that may be profoundly real. Sarony's early experiments with Adah Mencken are precursors to, for instance, Annie Leibovitz's many revealing variations on the subject Madonna, whose sexually charged, chameleonic career owes a nod to both Mencken and Wilde. In fact, the public fascination with Menck-

en's love life—both the realities and the rumors—made her one of the first celebrity targets of faked pornography.

Whether or not it was true that Mencken became the lover of the sixty-five-year-old Alexandre Dumas in 1867 hardly mattered to a curious, leering public—especially after the pair posed for a photograph that only seemed to confirm a presumed intimacy with the young actress shown resting her head against the upper slope of the aging author's corpulent torso.[8] Not only did copies of these photos sell out—doubtless many of them pirated—but other photographers were quick to capitalize on such a delicious "scandal" with the production of sexually explicit pictures in which the heads of Mencken and Dumas were grafted onto the bodies of naked models engaged in various sexual acts. Although making such composite images was possible in the 1860s, it was a painstaking job to seamlessly blend different photographic sources to look like a single picture, which suggests that the market demand for photos of Mencken and Dumas *in flagrante delicto* must have been considerable in order for anyone to invest the time and energy required. At the same time, most of the customers buying these images had to know they were not real but were instead a form of fantasy fulfillment, a theme reprised with the contemporary technology called "deepfakes," which we will come back to in chapter 13.

One hundred thirty years before Thomas and John Knoll introduced Photoshop to the world, photographers were capable of some very sophisticated image compositing, known then as "combination printing," which originated as a technical solution to the problem that, for instance, a landscape was often impossible to correctly expose for both foreground and sky. This flaw was exacerbated by the fact that the emulsions used were sensitive to blue light, so a cloud-filled sky would usually blow out to an empty whiteness above a properly exposed foreground. To solve this problem, photographers would capture two plates, one exposed for the ground and one for the sky, and then print the combination of the two—masking half of each picture in turn—onto a single piece of albumen printing paper. But more than just a technical workaround, combination printing was also used to create otherwise impossible visual expressions, as demonstrated by a Swede named Oscar

G. Rejlander, who presented a highly complex tableau at the 1857 Art Treasures Exhibition in Manchester. Entitled "The Two Ways of Life," this allegorical work depicts a prophet-like figure in the center of an oblong frame (31 x 16 in.) and who presents two young men with two different life paths—the virtues of work, religion, and charity on frame right; or the vices of drink, gambling, and lust on frame left. The more than twenty human figures in the scene were photographed separately in small groups to produce some thirty negatives that Rejlander spent six weeks carefully masking and combination-printing in order to make the final print in which all the figures appear to be in the same frame with proper spatial relationship to one another.[9]

Some viewers were scandalized by the naked women depicted on the *vice* side of the frame despite the fact that "The Two Ways of Life" has all the compositional elements of a classical painting in which nudes would seem perfectly ordinary. It is interesting how often the frank "realness" of the photographed nude is a line certain observers are unwilling to cross in the world of fine art; and the fact that "The Two Ways of Life" was exhibited at the Edinburgh Photographic Society with a drape covering the naughty side is especially ironic when, in all likelihood Rejlander used some of the same models to portray both virtue and vice. Nothing about the photograph is *real*, any more than a painting telling the same narrative would be *real*, but somehow, bare bodies in an image made by sunlight striking silver particles were more lascivious than the same bodies in the same poses would be if they were rendered by a painter's brush. This dichotomy is not necessarily any easier to parse today when one can easily invite a circular debate as to where the lines are separating photographic pornography from fine art photography that happens to be erotic. Regardless of what anyone else thought of "The Two Ways of Life," Queen Victoria bought the photograph as a gift for Albert, and if it was her rationale that nudes were appropriate in a picture with a moral message,[10] it was this sensibility—that art should convey a narrative—with which the Aesthetic movement of the 1870s collided and, consequently, sent Oscar Wilde to America.

5

The Aesthetic Sham

I treated art as the supreme reality
and life as a mere mode of fiction.

—Oscar Wilde, *De Profundis*

"Swinburne and water" was how the British humor magazine *Punch* described Oscar Wilde's book of poems when it was first published at the author's own expense in July of 1881.[1] "The cover is consummate, the paper is distinctly precious, the binding is beautiful, and the type is utterly too," begins the review in shrugging off Wilde as a diluted version of the more senior poet Algernon Swinburne. Mocking the Aesthetic movement was popular sport for satirists and critics, and the job was made too easy when its most prominent representative by 1880 was the intentionally provocative, outlandishly styled young man who had yet to contribute much in the way of literary work when measured against the amount of public posturing he seemed to be doing. The stage was set as early as 1874 when Wilde, newly at Oxford, famously quipped that he "hoped he could live up to his blue china," which inspired the priest at University Church to sermonize that "there has crept into these cloistered shades a form of heathenism which it is our bounden duty to fight against and to crush out, if possible."[2] That Wilde's innocuously wry comment would provoke so earnest and moralizing a rebuke might be seen as an overture to the final act in his career when, in 1895, he had two hit comedies on London stages at the same time that he was standing trial for "gross indecency."[3] In fact, it seems to be a recur-

ring theme throughout Wilde's short life that many of his friends and admirers were often poised to condemn him. Whether this is exclusively a consequence of his homosexuality or the price that artists pay for holding up mirrors to society (or both) is hard to know for sure; but it is certain that the often overly precious rhetoric of aestheticism provided ample opportunity for spiteful ridicule.

Neanderthal cave painting notwithstanding, the modern and uncontroversial concept of art for art's sake in Western culture owes much to the English Aesthetic movement, which advocated beauty as a virtue that could elevate ordinary human existence without the need to express any particular moral by way of a narrative or depiction of the sacred. "It is the science through which men look after the correlation which exists in the arts," explained Wilde in one of the many times he was asked to define aestheticism by nearly every reporter following his American tour. "It is, to speak more exactly, the search after the secret of life."[4] Whether that can be considered speaking "exactly" in any context, it is certain that such lush and indulgent proclamations struck proper English Victorians as frivolous and unmanly nonsense begging for scorn. In just one of many Wilde-mocking cartoons drawn by George du Maurier for *Punch*, a young couple admires a "Six-Mark Tea-Pot." The "Aesthetic Bridegroom" declares, "It is Quite Consummate, is it not?" And to this, the "Intense Bride" replies, "It is Indeed! Oh, Algernon, let us live up to it!" Oddly, this could almost be a line of dialogue from one of Wilde's plays, and not only because Algernon is a character in *The Importance of Being Earnest*.

This general view of Wilde as poseur was well fed by his intentionally fashioning himself an object of curiosity—a caricature of London society whose bon mots, sartorial eccentricities, and art criticism placed him frequently at the center of a bohemian community that included the artists James McNeill Whistler, Frank Miles, and Edward Burne-Jones. The two houses Wilde shared with Miles in the late 1870s and early '80s became popular salons decorated with signature elements of aestheticism such as blue china, Damascus tiles, and a profusion of fresh flowers, including the "talismanic lily, sanctified by" Wilde mentor and leading

critic John Ruskin "as one of the most beautiful and useless things in the world."[5] That these salons were regularly adorned by another kind of flower, namely beautiful women, seems to have been particularly vexing to the august and righteous critics of the Aesthetic crowd. It was one thing for Wilde and friends to behave like a bunch of effete, dreamy poet-philosophers, but to attract the fairer sex by doing so was another matter, especially when that company included the stage stars Sarah Bernhardt and Lillie Langry; and it was Wilde's relationship with the latter that was a favorite subject of gossip and speculation, including the rumor that he would daily hand-deliver a lily to her during a period when she spurned what might sincerely have been his unrequited love.

Beyond the pages of *Punch* and the chattering of tea rooms, the Aesthetes were an ideal target of ridicule for the thriving new partnership formed by librettist W. S. Gilbert, composer Arthur Sullivan, and producer Richard D'Oyly Carte, whose first three light operas—*The Sorcerer, H.M.S. Pinafore,* and *Pirates of Penzance*—reflected their vision for a new English musical theater that would provide respectable fare in lieu of bawdy French burlesques. Although the "aesthetic sham" called Bunthorne in Gilbert's book for *Patience, or Bunthorne's Bride* was an amalgam of London's well-known Aesthetes—his hair, for instance, features Whistler's signature streak of white forelocks—it was generally assumed that Wilde was the primary inspiration for the titular character. So although he largely dismissed the other two anti-Aesthetic plays of the year—*The Grasshopper* and *The Colonel*—Wilde reserved a box seat for opening night of *Patience* on April 23, 1881. Presumably eager to be seen watching himself as rendered by Mr. Gilbert's sardonic pen, the game Wilde was playing, cultivating fame first and writing second, required turning even ridicule to his advantage where he could. Doubtless more than a few eyes in the audience glanced up at him when Bunthorne sang the lines:

> If you walk down Piccadilly with a poppy or a lily in your
> mediaeval hand.
> And ev'ryone will say,

As you walk your flow'ry way,
"If he's content with a vegetable love which would certainly not
 suit me,
Why, what a most particularly pure young man this pure young
 man must be!"[6]

This "vegetable love" is the only adoration left to Bunthorne by
the end of the opera, which begins with all the "Lovesick Maidens"
swooning over him, much to the scorn of real men like the chorus of
Royal Dragoons, who march onto stage to perform a rousing anthem
to themselves as the embodiment of all the great men of letters, arts,
sciences, conquest, and good character, including the following lines:

The science of Jullien, the eminent musico—
 Wit of Macaulay, who wrote of Queen Anne—
The pathos of Paddy, as rendered by Boucicault—
 Style of Bishop of Sodor and Man—[7]

Wilde could not have known, of course, that as he sat in his box
endeavoring to project just the right amount of amusement at his own
expense, that *Patience* would be the cause of his ending up a bit player
in American copyright law, but the two middle lines of that stanza hap-
pen to be oddly foreshadowing. Queen Anne is, of course, the eponym
for the Statute of Anne; the historian and politician Thomas Babington
Macaulay is famous in the copyright world for a speech he made in
1841, about which more in chapter 10; and the Irish playwright Dion
Boucicault weaves in and out of this story in more ways than one. For
the moment, he is Oscar Wilde's friend and slated to direct the play
Vera, but the cancellation of that production combined with Wilde's
urgent need for money will coincide with an idea of Carte's to invest
in a lecture tour that will send Wilde to the United States to talk about
aestheticism. By presenting the Americans with the leading emissary
of the movement and the putative inspiration for Bunthorne, "Carte
expected *Patience* to give a fillip to Wilde's lecture, and the lecture to

give a fillip to *Patience*,"[8] which opened in New York in September of 1881. But New York audiences had little knowledge of London's aesthetic fad and were, therefore, missing many of Mr. Gilbert's jokes.

Shortly after signing the contract to write this book, I met my agent Jonathan at New York City's Old Town Bar on Nineteenth Street, not far from where Sarony's iron signature used to preside over Union Square. It seemed a fitting place to christen the start of the project, though I did not know how fitting until I grabbed a stool toward the back of the room and saw that on one framed section of mirror behind the bar was stenciled in gold letters the words The Picture of Dorian Gray. Despite many visits to Old Town over many years, I never paid attention to this before—it was added in the 1980s by the late owner Larry Meagher—but under the circumstances, this chance encounter with a mirror alluding to Wilde's thematically relevant gothic novel seemed like a pretty good omen.

So, after a quick drink, I extended the pilgrimage with a visit to number 37 Union Square, the building presently looming over the red awning of a McDonald's and hosting a Republic noodle shop in its storefront (fig. 12). Although the decorative stone elements of the original facade are long gone from this industrial loft, there is conveniently no building adjacent to the north side; and if one looks up from the right position on the sidewalk, it is possible to see the fading Sarony signature painted onto the brick about 130 years ago, when visiting this exact location was one of New York's main attractions (fig. 13). "In 1876, [Sarony] was recognized as the leading photographer of the western world, and to his studio came the most notable men and women of the professions, celebrities in all walks of life, and not a few titled folk from abroad."[9]

By the time Wilde first arrived here in 1882, Sarony's studio was a must-see. Situated in the heart of what was then New York's Theater District, visitors would come to gaze in the windows at the portraits of stage stars or to explore the famous collection of worldly bric-a-brac on the ground floor, which was apparently open for public viewing. There was, of course, a frisson of hope that one might see Clara Morris

or Edwin Booth heading into the studio, or perhaps catch a glimpse of the eccentric "Napoleon of Photography" himself walking briskly up the street, smiling, blue-eyed, and richly-goateed, with his exuberant demeanor accentuated by the little tassel swinging from his signature fez. Even Oscar Wilde, relatively unknown as he was, had already been sufficiently aggrandized by publicist Colonel F. W. Morse and the press that it is entirely possible he was recognized by tourists or other passersby when he entered Sarony's studio.

In fact, all the hullabaloo surrounding Wilde's lecture tour, regardless of what anybody actually knew or thought about its substance, was sufficiently newsworthy to be the proximate reason why the photograph called "Oscar Wilde No. 18" would soon be appropriated by the Burrow-Giles Lithographic Company. As fast food chains today cross-promote blockbuster motion pictures in collaboration with the major studios, business enterprises of the nineteenth century liberally exploited the latest spectacles as opportunities to promote their products and services. When Barnum brought Jumbo to New York in the spring of 1882, the Clark Thread Company produced a Jumbo-themed, trade card campaign to promote its Our New Thread (O.N.T.) product made for use with the latest machines developed by Howe and Singer.

In this card series, the lovable elephant is depicted anthropomorphically engaged in typical New York scenes—from his arrival at Castle Garden wearing an Irishman's bowler to sitting in a box seat at the theater gazing at the proscenium though a pair of opera glasses. In one card, called "Jumbo Aesthetic," Clark's even features a drawing of the elephant standing next to Wilde (fig. 14), mirroring the poet's limp-wristed posture and sporting a giant sunflower where a button hole would be if he were wearing an enormous sport coat. That neither Jumbo nor Wilde had anything to do with the quality of Clark's thread exemplifies the ad hoc manner in which advertisers often hitched onto whatever was "trending" at the time, as would be the case with other appropriations of Sarony's Wilde portraits (fig. 15), including, of all things, ads for Madame Fontaine's Bosom Beautifier. Trade cards like the comical Jumbo series were designed to be attractive or entertain-

ing enough to induce consumers to collect them, at least for a while, and these advertising vehicles were a derivative of the popular cabinet card, which was the format used by individuals—especially actors—to promote themselves and their work.

For instance when the aforementioned Dion Boucicault was about to play the lead in his hit Irish drama *The Shaughraun* (1874), he was following standard practice to book an appointment with Sarony to produce a photograph of himself costumed and posed on an Irish set for the purpose of printing hundreds, if not thousands, of promotional cabinet cards. And people really did collect these photographs in great numbers beginning about 1860, with enough enthusiasm to warrant the expression *cardomania*. This neologism may have derived from French cartoonist Théodore Maurisset, who, shortly after the daguerreotype was first announced in 1839, drew a satirical image he titled *Daguerre-otypomanie* showing throngs of Parisians scattered in all directions and taking photographs.[10] The cartoon even shows a daguerreotypist photographing the crowded tableau from a hot air balloon—a feat that was not possible with the new invention, requiring exposure times of several minutes in order to record an image. (Though Nadar would capture aerials from a balloon in the 1850s, an 1839 daguerreotype made from a hot air balloon would be a smeary blur.)

The precursor to the 4.5 x 6–inch cabinet card was the smaller 2.5 x 4–inch *carte de visite*, introduced to the market by French photographer André Adolphe-Eugene Disdéri, so named because these were approximately the size of the calling, or visiting, card typically used by any self-respecting Victorian observing the conventions of polite society.[11] Disdéri patented the concept of the *carte de visite* in 1854 but did not succeed in profiting from the idea until 1859 with an image he made of Emperor Napoleon III. Using a four-lens camera and a sliding plate holder, the photographer could efficiently record eight of these small negatives on a single 8 x 10–inch plate—the main medium of the time was wet collodion—and then prepare albumen prints that were mounted to card stock. Within a few years Disdéri made a small fortune selling thousands of francs worth of *cartes de visite* per day, but

he died penniless in 1890 because his factory-like process was easily replicated and his patent not easily enforced.[12] Meanwhile, *cardomania* swept across Europe and the United States as consumers avidly purchased these pocket-sized copies of famous figures, even storing them in albums the same way modern collectors keep baseball cards.

By about 1870, the *carte de visite* was replaced by the larger format cabinet card, preferred because it was easily viewed when displayed, for instance, on top of a cabinet in the parlor. So if one happened to be a fan of Walt Whitman in 1878—the year he posed for Napoleon Sarony on a set made to look as though he was resting ever so transcendentally on a cliffside—this iconic portrait could be displayed so as to make Whitman a member of the family (fig. 16). "The capacity to have one's humble, and often unflattering image taken in the same manner as the displayed portraits of Ralph Waldo Emerson or Jenny Lind was perhaps a psychological equation of oneself with these notables," writes photo curator Edward W. Earle. "If not equality, it at least allowed one to appear to move up a rung on the social ladder. This aspect of the medium was certainly a vital ingredient in the making of the American Dream."[13]

Cardomania was the primary source of the above-average incomes earned by Sarony and the handful of photographers—Falk, Mora, Gurney, Cox—who either competed with him or had earned enough cachet to pick up some of the high-profile bookings he could not fit into his schedule. There were over three hundred photo studios in New York by the 1880s, mostly service-based businesses where the photographers merely charged customers to make individual and family portraits; but for artists like Sarony who could attract celebrities, it was customary to pay a popular subject for an exclusive and then to profit from the investment by selling as many copies, usually in the form of cabinet cards, as the market was willing to buy. At the same time, the cabinet card was a marketing opportunity for the photographer with its larger borders providing ample room to emboss the frame with decorative outlines and to stamp his ornately cursive surname in one of the lower corners, thereby associating his brand with whichever notable happened to be in the picture.

In the 1972 John Huston film *The Life and Times of Judge Roy Bean*, there is a moment when all the deputies simultaneously gun down a drunk for putting a bullet hole in the judge's (Paul Newman's) beloved poster of Lillie Langtry (Ava Gardner). This bit of machismo satire fairly well expresses the eagerness with which even the motley, feral, and remote society of Americans would acquire these photographs— not to mention the implicit, pre-pinup, libidinous nature of collecting portraits of certain actresses. To put in context how valuable this trade could be, Sarony paid Sarah Bernhardt $1,500 ($20,000 today) and is rumored to have paid the real Lillie Langtry a staggering $5,000 (just over $123,000 today) for several sessions conducted over three or four consecutive Sundays to produce more than fifty plates. Wilde, whose complicated love for Langtry was indirectly a cause of his American tour, had been partly responsible for popularizing the notion that she was the "most beautiful woman in the world," which neither Sarony nor his cameraman of thirty-four years, Benjamin Richardson, apparently considered to be the case. One hectoring reporter for the *New York Tribune* approached both men in December of 1882, eager to know how the Langtry sessions were going, and he did not scruple to publish the off-the-record comments of either Sarony or Richardson moderating the alleged "perfection" of the Jersey Lily. When Sarony mentioned two other actresses he considered more photogenic, he told the reporter, "Leave that out," so the reporter dutifully published it. Regardless, the legend that Langtry was a modern Helen generated orders for her cabinet cards in volumes unlike anything Sarony had ever experienced during nearly thirty years of theatrical portrait-making.[14]

Although the Wilde photos would certainly be valuable to Sarony in the form of card sales, it is not clear whether Wilde was paid for the sitting. Several accounts report that Wilde waived the customary fee in light of the fact that Sarony was in a far better position to help make him a star than he was to make the already-famous photographer much money. Although this dynamic was certainly true, the legal brief filed with the Supreme Court in the eventual copyright litigation states that Sarony "paid a large and valuable consideration for the privilege of mak-

ing this picture."[15] This might have referred exclusively to expenses and labor, but it is an odd choice of words if that were the case. Moreover, although Wilde himself was relatively unknown in America, his lecture tour—whether a subject of curiosity, praise, or mockery—was a very big deal; and so it seems likely that Sarony would have paid Wilde at least something for an exclusive before the start of the year-long, multicity tour. In either case, history would decide that hardly anybody today, other than visual art enthusiasts and copyright nerds, has ever heard of Napoleon Sarony until one mentions that he was the guy who took the pictures of Oscar Wilde.

A contemporary observer of "No. 18" might be tempted to call the photograph "quintessential" because it depicts the Oscar Wilde we know—or think we know—despite the fact that it is a thoroughly contrived image in which we can see how Sarony has indeed propped Wilde like a mannequin, as described in the excerpt in chapter 1. Seated on the right side of a camelback sofa, Wilde's long, silk-stockinged shins are tilted at a precise angle that draws the eye up to the head, which is slightly cocked and resting on the left hand supported by that arm leaning on the left knee. The right elbow rests on the sofa arm with that hand held forward and propped against the spine of a white book leaning against the right knee. Far from natural, this very purposeful alignment relies substantially upon some bulky object that Sarony has placed under the rug in order to elevate the left foot about four inches higher than the right. Sarony even has Wilde seated rather unrealistically on his own overcoat, which is draped in a twist to reveal both its decorative lining and fur-trimmed collar and cuffs, in order to have its material cover the wooden legs and empty space beneath the couch.

The result is that Wilde is all foreground against a rich, multilayered tapestry of soft-focused patterns; and as rigidly arranged as the composition is, requiring Wilde to hold still for a two-to-five-second exposure, we easily ignore Sarony's puppet strings and are drawn into what a motion picture actor or director calls the "inner life" behind Wilde's eyes.

In fact, as was typical of the period, Sarony rarely, if ever, touched the camera himself but instead arranged the scene the way film directors do, while the camera operator—in this case Richardson—loaded the plate, focused the image, and then squeezed the little air-filled ball to open the shutter. The contemplative, genius's gaze is presumably all Wilde, though Sarony is consistently credited with a talent, pioneering in his time, for extracting just the right look from his subjects; and one is reminded of the aforementioned description by Thomas Nast, that every portrait contains at least a glimpse of Sarony. To pose someone so unnaturally and yet elicit a look that does not feel posed was, according to his contemporaries, a skill that set Sarony apart as an artist. He explained in an interview given shortly before his death in 1896 that there were three conditions necessary to achieve a successful "snap shot," by which he meant a photograph that looks candid and, therefore, not self-conscious: "first, an acquaintance with the habits and life of the subject, second, confidence, or a surrender of self on the part of the sitter; third, an atmosphere of genuine sympathy between sitter and photographer."[16]

"Oscar Wilde No. 18" is archetypal Sarony for its expressive qualities, which were neither easily achieved with the technology, nor even imagined by most run-of-the-mill portrait-makers of the time. As for Wilde himself, whether we should consider this photograph a portrait of him or a portrait of him in character is a question without a satisfactory answer. He is certainly in costume, wearing the purple velvet waistcoat and knickers the public will shortly chatter about when they make their resplendent debut at Chickering Hall. But of course Wilde was often in costume, which is one reason he wound up on the American tour in the first place. Perhaps the detail that best symbolizes the author's duality in this picture is the book he uses as a prop that rests so casually yet purposely against his leg. This is in fact a copy of his first and only collection of poems, self-published and tepidly received by the English literati and, therefore, a talisman of the Wilde not yet come into his own as an artist, and of the Wilde who had serious doubts about this particular moment in his career—poised to expound upon

the nature of the Aesthetic movement to a society about which he would later declare, "Where the Americans have attempted to produce beauty they have signally failed."[17]

Stepping onto stage the following Monday night, January 9, to a sell-out crowd, Wilde "won his audience's attention with ostentation [but] held it with surprising gravity," writes Ellmann.[18] The lecture, titled "The English Renaissance of Art," was lengthy and so densely embroidered with classical references that we can justifiably wonder how many in the audience, if they did not study at Oxford (or even Yale), were able to keep up with Wilde's encomium to the supremacy of art as the very purpose of life. Doubtless at least some portion of the audience was there simply because Wilde was the event *du jour* and perhaps thought the young man with the long hair and fancy clothes had come to offer decorating tips. During the reception following the lecture, one woman did ask Wilde how she should arrange her folding screens, to which he replied, "Why arrange them at all? Why not let them occur?"[19]

Whatever audiences took away from Wilde's lecture, it was going to be well attended across the country, and as long as the press would keep writing about it, advertisers were going to exploit its themes. Within a month or so of the New York opening, with Wilde already lecturing in the vicinity of Chicago, the Erich Brothers department store at Eighth Avenue and Twenty-fourth Street announced on the back of a trade card that "The English Renaissance is fitly represented in our Trimmed Hat Department." On the front of the card was a lithographic copy of "No. 18" and the words "Compliments of Erich Bros," which can be read literally to mean that the image itself was the store's gift to consumers because, as described, these cards were meant to be collectibles. The prospect that Sarony's image would be widely distributed for free was a direct threat to his interest in the sale of cabinet cards—especially when Wilde's lecture was still timely. Moreover, it turned out that the Erich retail emporium had ordered thirty thousand of these trade cards from the Burrow-Giles Lithographic Company, which was also preparing to deliver one hundred thousand similar cards featuring "No. 18" to a Chicago retailer called Mandel Brothers.

In April, Sarony's legal counsel, a pair of high-profile copyright attorneys named Guernsey Sackett and Augustus T. Gurlitz, filed suit in the Southern District Court of New York, which granted an injunction within a matter of days. "Burrow-Giles acquiesced in the restraining order and turned over some 85,000 copies of *No. 18* along with the lithographic plates," writes Professor Mark Rose in his book *Authors on Trial*. "But, having a great deal at stake for their future business, the printers decided to use the issue to test the 1865 law extending copyright to photographs."[20]

While it may be assumed that the lithographer's interest was more a pecuniary matter than a principled one, the appeal in *Burrow-Giles v. Sarony* was a conceptual challenge to the nature of copyright and photography at the same time. Many artists and critics of the nineteenth century did not consider the photograph to be a medium of human authorship, and Burrow-Giles was asking the courts to validate this bias as a matter of law. Ironically enough, if Sarony had lost this case, one rather absurd conclusion would have been that the lithographic rendering of his image *would* have been protectable under copyright simply because it had been created using a printmaking process that entails physical, human drawing.

Yet, of the two images, it is unquestionably the lithograph that presents a rather lifeless, mechanical (and frankly careless) version of Wilde that Sarony's photo had immortalized. And if indeed Sarony did something more than merely nod to Richardson to open the camera's shutter and allow the sunlight reflecting off Wilde to strike the negative plate, then it was that intangible (one might even say metaphysical) labor which was on trial. Coincidentally enough, an important precedent case addressing that very subject just happens to cross paths with a very different photograph of Oscar Wilde.

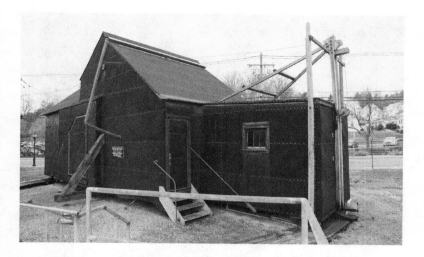

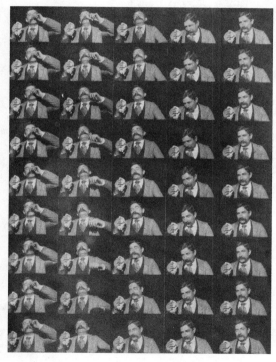

Fig. 1. (*above*) Replica of America's first motion picture studio, the "Black Maria." Edison National Park, West Orange, New Jersey. Photo by the author, 2017.

Fig. 2. (*left*) Dickson's contact-sheet photograph of "The Sneeze," the oldest existing specimen of a "motion picture" registered for copyright, in 1894. Wl. K.-L. Dickson, photographer. Library of Congress Prints and Photographs Division, LC-DIG-PPMSCA-13462.

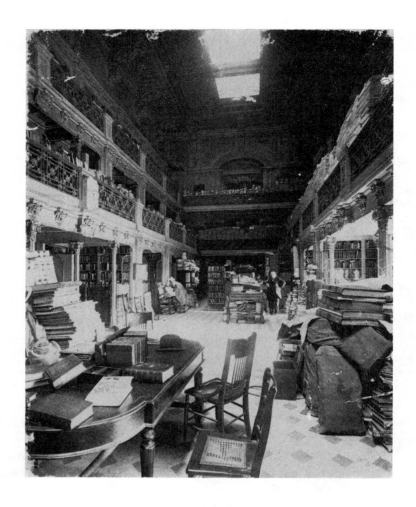

Fig. 3. (*above*) Librarian Ainsworth Rand Spofford is dwarfed amid the piles of works mailed to the original Library of Congress for copyright registration, ca. 1880. Photo courtesy of loc.gov.

Fig. 4. (*opposite*) "Oscar Wilde No. 18," as captured in New York City by Napoleon Sarony in January of 1882, along with twenty-six other portraits of Wilde at the start of the author's American lecture tour. Gilman Collection, Purchase, Ann Tenenbaum and Thomas H. Lee Gift, 2005. Metropolitan Museum.

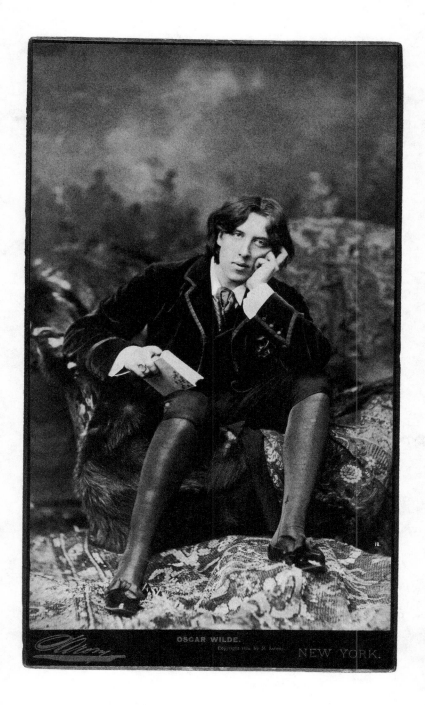

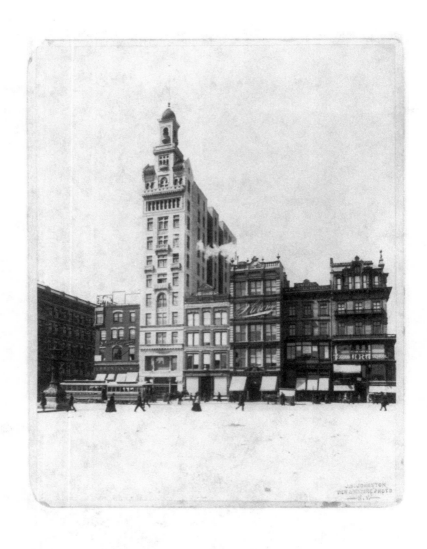

Fig. 5. Napoleon Sarony's studio with iron signature sign at
37 Union Square, 1894. Library of Congress Prints and Photo-
graphs Division, LC-USZ62-68733.

Fig. 6. Self-portrait, Napoleon Sarony in Count Harmoncour's
Uniform, ca. 1880. Courtesy of the George Eastman Museum.

Fig. 7. Timothy Childe writes: "I doe declare y' Mr Awnsham Churchill is and shall bee intituled to one moiety of this book & copy right, & also to one moiety of all benefitt & advantages arriseing thereby." Entry of the Stationers' Company, May 31, 1701. Image reproduced with permission of the Stationers' Company.

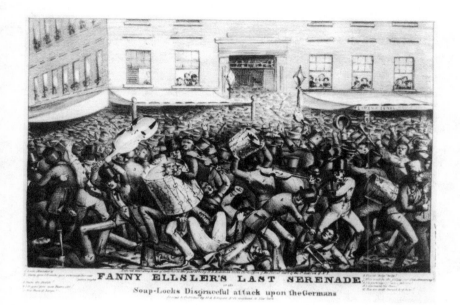

FANNY ELLSLER'S LAST SERENADE

Soap-Locks Disgraceful attack upon the Germans

A DEMOCRATIC VOTER

Fig. 8. (*above*) Sarony drew this lithograph, "Fanny Ellsler's Last Serenade," for Henry Robinson in 1840. Though it is doubtful this exact riot ever occurred, the drawing dramatizes typical anti-immigrant assaults by the "soap-locks" gangs of New York. Printed and published by H. R. Robinson. American cartoon print filing series, Library of Congress Prints and Photographs Division, LC-USZ62-2535.

Fig. 9. (*left*) Sarony's drawing, "A Democratic Voter," for Whig caricaturist Henry R. Robinson, 1836. Printed and published by H. R. Robinson. American cartoon print filing series. Library of Congress Prints and Photographs Division, LC-USZ62-21236.

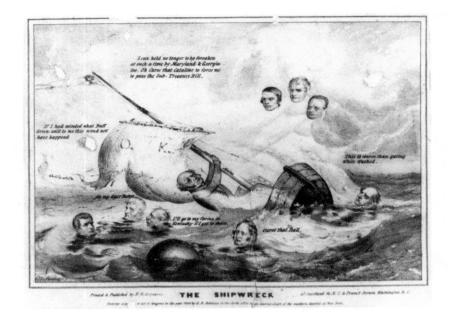

Fig. 10. Sarony's caricature depicting the Martin Van Buren presidency as "The Shipwreck," drawn for Whig caricaturist Henry R. Robinson, 1840. Printed and published by H. R. Robinson. American cartoon print filing series. Library of Congress Prints and Photographs Division, LC-USZ62-91401.

Fig. 11. Adah Isaacs Mencken, captured by Napoleon Sarony in one of the many "studies" he did with the actress, ca. 1866. Library of Congress, Prints and Photographs Division, LC-USZ62-62681.

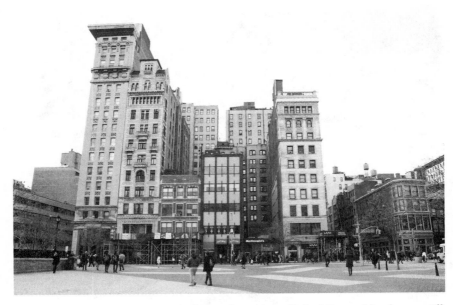

Fig. 12. Union Square, New York City. Sarony's studio building, at Number 37, still stands, though its carved stone façade is long gone. Photo by the author, 2018.

Fig. 13. From the street you can still see Sarony's painted signature on the side of the building. Photo by the author, 2018.

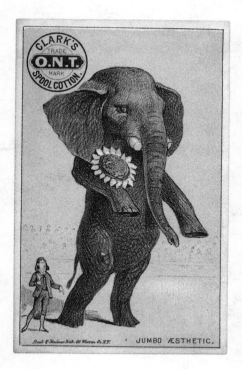 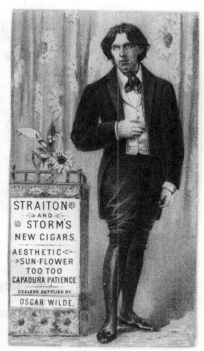

Fig. 14. (*left*) "Jumbo Aesthetic" trade card for Clark Thread Company, capitalizing on Wilde's tour and the later arrival in 1882 of Jumbo the elephant. *Digital Commonwealth*, https://ark.digitalcommonwealth.org/ark:/50959/sq87cj121.

Fig. 15. (*right*) Another typical example of a trade card that made unlicensed use of Sarony's photographs of Wilde to capitalize on the buzz surrounding the American tour. "Straiton and Storms New Cigars. Aesthetic Sun-flower Too Too Capadura Patience. Dealers supplied by Oscar Wilde" (between 1882 and 1884). Samuel Rosenberg Collection, Library of Congress Prints and Photographs Division, LC-USZ62-75893.

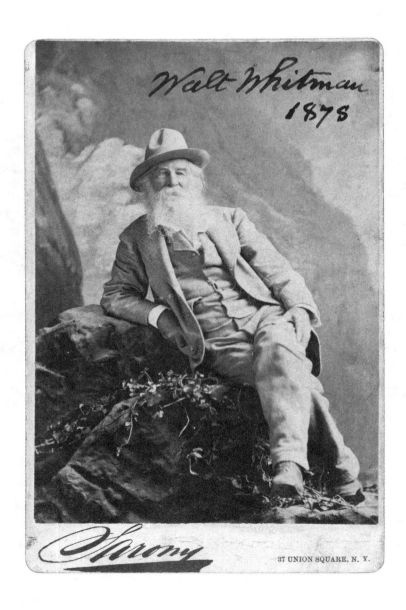

Fig. 16. Walt Whitman photograph by Napoleon Sarony,
1878. Feinberg-Whitman collection, Library of Congress
Prints and Photographs Division, LC-DIG-PPMSCA-57643.

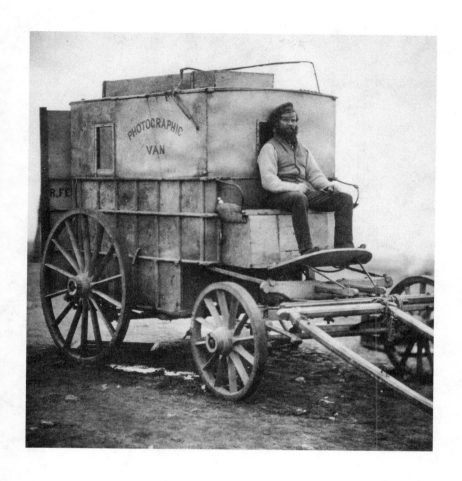

Fig. 17. Assistant Marcus Sparling aboard the traveling darkroom Roger Fenton used to photograph the Crimean War, 1854. Roger Fenton Crimean War Photograph Collection, Library of Congress, Prints and Photographs Division, LC-USZC4-9240.

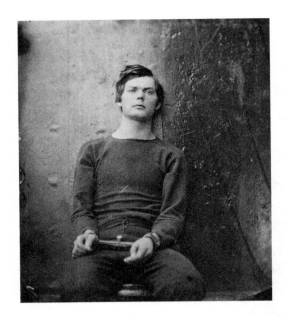

Fig. 18. (*above*) Lewis Payne (Powell), imprisoned aboard the uss *Saugus*, before facing the gallows for his role as a Lincoln coconspirator. Captured by Alexander Gardner, 1865. Civil War Photographs, 1861–65, Library of Congress, Prints and Photographs Division, LC-DIG-CWPB-04208.

Fig. 19. (*right*) *Carte de visite* of John Wilkes Booth, actor, taken by Alexander Gardner in 1863. Library of Congress Prints and Photographs Division, LC-DIG-PPMSCA-23892.

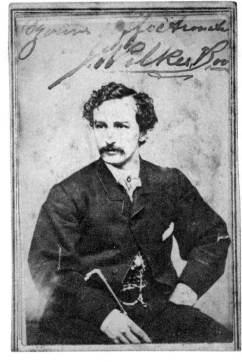

Fig. 20. Cover page for transcript in *Burrow-Giles v. Sarony*, October 9, 1883. National Archives. Scan courtesy of Zvi S. Rosen.

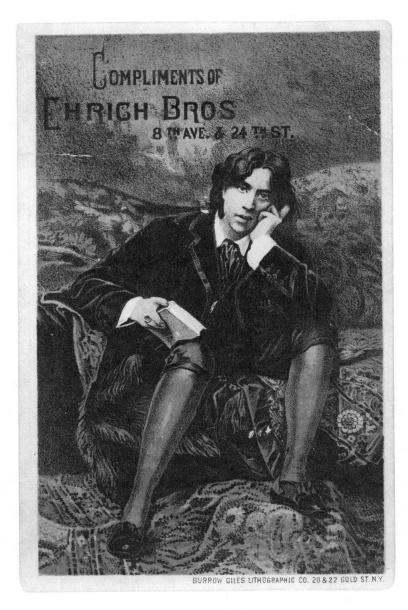

Fig. 21. The infringing use that triggered the lawsuit: lithographic copy of "Oscar Wilde No. 18" by Burrow-Giles Lithographic Co., used as a trade card for Manhattan's Erich Bros. Department Store. Library of Congress Prints and Photographs Division, LC-USZ62-138240.

Fig. 22. A page from the defense brief written by David Calman, counsel for Burrow-Giles. Calman asserts that copyright of photographs is unconstitutional. National Archives. Scan courtesy of Zvi S. Rosen.

Fig. 23. David and Julien Newhoff at Mystic Seaport
Museum. Tintype by Robert Gibson, 2019.

6

The "Death of Chatterton" Case

That "best" photograph of Wilde belonging to Couslon Kerhanan, the group shot mentioned in chapter 1, happens to include the writer George Meredith who, at the time the photo was taken—probably in the late 1880s—was to become one of the most prominent figures in English literature, nominated seven times for the Nobel Prize, and one who also played a minor role in a major copyright case relevant to our discussion. In the same year (1856) in which he published his first novel, *The Shaving of Shapgat*, Meredith posed for painter Henry Wallis in character as the model for the poet Thomas Chatterton, a literary prodigy who killed himself with arsenic at the age of seventeen on August 24, 1770. Best known for his "Rowley forgeries," written in the style of— and passed off as—the poems of a fifteenth-century priest, Chatterton was unquestionably a genius and quite probably insane. And because he took his own life while starving at the hands of London booksellers who underpaid, or failed to pay, for publishing his works, he remains an iconic martyr to the mistreatment of artists everywhere.[1]

Wallis's "Death of Chatterton" depicts the poet lying across his small bed in a pose that evokes Michelangelo's *Pietà*, in which Mary holds the limp body of Jesus Christ. The soft backlight from the half-open casement window beatifies the youthful corpse in a pool of luminance that falls off to blackness toward the frame's edges, emphasizing the tomb-like atmosphere of the dingy garret. In the shadow on the right, a faint wisp of smoke rises from a candlestick, not only symbolizing Chatterton's death but also adding a kinetic immediacy to the scene, as though we've discovered the boy just moments after he swallowed

the poison from the phial that has rolled onto the floor out of his limp right hand. As a visual counterpoint within the grim scene, Chatterton's vibrantly red hair and purple breeches make him seem almost aristocratic, if it were not for the constellations of ink stains that have turned his white shirt gray. In both style and subject matter, Wallis's painting is an archetype of the overromanticized notion of the suffering artist, and the work is considered by some historians to be a direct comment upon society's treatment of artists in the mid-nineteenth century. Whether that interpretation holds true, it is noteworthy that the real Chatterton's "Last Verses," found postmortem in his pocket, begins with lines that will resonate with any artist in the digital age who has been advised to work for "exposure" rather than compensation:

Farewell, Bristolia's dingy piles of brick,
Lovers of mammon, worshippers of trick!
Ye spurned the boy who gave you antique lays,
And paid for learning with your empty praise.[2]

Wallis's painting was exhibited at the Royal Academy of Arts in London in 1856 and subsequently purchased by another artist named Augustus Leopold Egg, who, with Wallis's blessing, granted a publisher named Robert Turner the exclusive right to produce and sell fine print copies to be made from a mezzotint engraving. To whet the appetites of the prosperous customers who would be inclined to buy such prints, Turner exhibited "Death of Chatterton" at semiexclusive showings throughout the UK, including Cranfield's Gallery in Dublin in April 1859. It was here that the painting was seen by a photographer named James Robinson, who was inspired to produce a series of stereographs based on Chatterton's tragic life story, and chose to depict the poet's death by recreating Wallis's painting in almost every detail. Consequently, when Robinson advertised his stereographic slides for sale, Turner filed suit, fearing that these photographic reproductions would dilute the value of the planned engravings. "This case is one of great novelty and peculiarity, and has given rise to many questions as to the existence of

copyright in works of art, either at common law or by statute," stated the Lord Chancellor in the final opinion on appeal in 1860.

At that time, paintings were not protected by statutory copyright in the United Kingdom; and so Robinson's primary defense rested on the assertion that Wallis's common-law copyright in the work expired the moment it was exhibited in public, arguing that exhibition of artworks was tantamount to "publication." Nearly a century had passed since *Millar v. Taylor* affirmed perpetual copyright under common law, followed by *Donaldson v. Beckett* holding that common-law copyright terminated upon publication, at which point statutory copyright kicked in. But these precedents meant legal limbo for a painting, which was theoretically protected by common law but not by statute. To add further confusion, an etching, woodcut, or engraving that copied a painting *was* protected by statutory copyright, an irony not unlike the one in the Sarony case, that Burrow's lithograph of Sarony's photo might have protection where the photo did not.

Still, Robinson was not entirely off base with his defense. The courts did generally consider exhibition of art to be a form of "publication," but they were also persuaded by the testimony of museum and gallery owners asserting that exhibition was typically provided on the condition that visitors were not allowed to make copies unless the works on display were owned by the state. So regardless of the fact that paintings were not covered by statute, Robinson had effectively breached contract with the gallery. But the real reason the "Death of Chatterton" case is relevant to the Sarony case (and potentially to contemporary copyright) was Robinson's weaker defense asserting that he had not "copied" Wallis's painting at all—that in fact doing so could never produce a stereograph.

Stereographs (also known as *stereograms* or the melodious *stereopticons*) are captured using a camera fitted with a pair of lenses mounted about two inches apart in order to replicate the subtle difference in perspective between our left and right eyes. The nearly identical twin images are then printed side-by-side (also about two inches apart) and mounted on an oblong piece of cardboard, and when viewed through

a handheld device called a stereoscope, the pair of images will appear as a single, three-dimensional photograph. This illusion is created by the parallax effect, whereby our brains combine left and right perspectives into a unified view of the world, adding the dimension of depth that enables us to very accurately judge spatial relationships of objects on multiple planes. Predating the announcement of practical photography by a just a few months, British scientist Charles Wheatstone published a paper in 1838 describing the principles of the stereograph using illustrated artwork and the first stereoscope,[3] which he designed and constructed in order to demonstrate the concept.

By the 1850s, enterprising photographers and publishers recognized that the stereograph could dramatically augment photography's capacity to allow almost anyone to explore the world without leaving home. Stereographic collections were sold in the tens of thousands, if not millions, throughout the second half of the century. These were the first—and quite often the only—glimpses an average American would ever get of Piccadilly or the pyramids at Giza, or that an average Londoner would ever see of Broadway or Niagara Falls. As though anticipating today's virtual reality viewers, Oliver Wendell Holmes Sr. wrote in his 1859 panegyric to stereography for the *Atlantic Monthly*, "The mind feels its way into the very depths of the picture. The scraggy branches of a tree in the foreground run out at us as if they would scratch our eyes out."[4] A gifted author and physician, Holmes believed so ardently in the value of stereographs as a tool of scientific and cultural enrichment that he chose not to patent his own version of the American stereoscope—a simple design made of light wood—so that it would be affordable for even modest households.

The public's eagerness to see the world through stereoscopy naturally included works of fine art that they would otherwise never have the opportunity to visit, and James Robinson was just one of several photographers who produced 3D versions of paintings of the Victorian period. Although not all of these stereographs were exact re-creations of the paintings that inspired them, Robinson's "Chatterton" is unequivocally Wallis's image by even the most casual analysis—especially the

hand-tinted versions he offered for a slightly higher price, which very closely matched the original painting's hues and tones. Nevertheless, Robinson insisted that he had not "copied" the painting because, in order to make a stereograph, he had had to stage the entire scene using his own model, furnishings, props, wardrobe, and backdrop to arrange and light the composition. Because this is the only way to create a stereograph, Robinson argued, he could not possibly have "copied" the painting, in the strict sense that he did not photograph Wallis's actual canvas. This appeal to so literal an interpretation of the word *copy* reaches all the way back to copyright's semantic legacy. But it was the rejection of this secondary defense that makes *Turner v. Robinson* a relevant case in this story: because it affirmed that copyright protects the author's intangible conception or vision.

In a contemporary litigation, Turner's lawyer would say that any "ordinary observer" can easily conclude that Robinson's stereograph *is* Wallis's "Chatterton," albeit presented in a different medium. And, in fact, the English court of 1859 did express the core principle that regardless of the manner in which Robinson accomplished his task, he had appropriated Wallis's mental conception as expressed in the painting. "No court of justice can admit, that an act, illegal in itself, can be justified by a novel or circuitous mode of effecting it," stated the Lord Chancellor.[5] In fact, assuming it was true that Robinson viewed the painting at Cranfield's Gallery one time and then recreated, from memory, Wallis's arrangement of elements and colors, this is both very impressive and also a clear demonstration of the fact that what copyright protects is the intangible—literally Wallis's vision that Robinson had carried inside his head back to his studio. In the *Sarony* case defending the copyrightability of photography, counsel Gurlitz cites *Turner v. Robinson* as evidence that "it is the creation or invention that is protected; but of necessity the law can only attach protection to the material thing which discovers, fixes, makes permanent, or serves as a vehicle for communicating that ideal." More on Gurlitz's choice of words to follow, but suffice to say that under U.S. law today, *Turner v. Robinson* should be a no-brainer.[6]

By the early twentieth century, and especially after passage of the 1976 Copyright Act, the statutes were written very broadly to encompass and anticipate all types of visual works produced by any method, and Robinson's stereograph would currently be held to infringe Wallis's right "to prepare derivative works." This is the exclusive right of the author to make—or transfer the right to make—new works based on the original, such as a film adaptation of a novel, a spin-off based on key characters, or merchandise featuring a unique design. More than 130 years after the "Death of Chatterton" case, artist Jeff Koons made a work called "String of Puppies" as a sculptural recreation of Art Rogers's photograph "Puppies," and Rogers sued for infringement. The Second Circuit Court of Appeals in 1992 rejected Koons's primary defense under fair use that he had "parodied" Rogers's work but also reiterated the same principle we find in *Turner v. Robinson*—namely that Koons had copied "the essence of [Rogers's] photograph nearly *in toto*"[7] despite his having worked in an entirely different medium.

This concept, known as "substantial similarity," was just evolving in the mid-nineteenth century, coincidentally at about the same time that realism was being advanced by Pre-Raphaelite painters like Henry Wallis, who were presenting a challenge to photography as an art form. So to an extent the "Death of Chatterton" case can be seen as a fight over which medium was going to financially sustain which type of artist. Many an editorial predicted the impoverishment of painters everywhere as the bread-and-butter work of making portraits would soon be replaced by the more efficient and more affordable new medium. In fact, one cartoon of the 1860s contrasts a haggard and starving painter with the image of a very Sarony-looking photographer in comfort and prosperity enjoying a luxuriant smoke while he awaits his next paying customer.[8]

Even though copyright law does say that Robinson made an infringing appropriation of Wallis's invention, it is also conceivable that the distinct qualities of expression in his stereograph were overlooked in 1859, when photography itself was little understood and not considered by all viewers, critics, or even photographers to be an expressive medium of any kind. The Tate Britain, where Wallis's "Death of Chat-

terton" hangs today, hosted a show in 2015 arranged with the purpose of allowing visitors to compare and contrast several Victorian paintings with the stereographs depicting the same subject matter. Titled "The Poor Man's Picture Gallery: Victorian Art and Stereoscopic Photography," the exhibit was largely made possible by the coauthors of a book by the same name—artist Denis Pellerin and Dr. Brian May, former lead guitarist of Queen, astrophysicist, and avid collector of stereographs for over forty years. Describing the manner in which Robinson's stereograph expresses something different from Wallis's painting, Tate curator Dr. Carol Jacobi writes,

> Robinson's *The Death of Chatterton* illustrates the way this uncanny quality distinguishes the stereograph from even the immaculate Pre-Raphaelite style of Wallis's painting of the same subject. . . . the light and colour appear crude in comparison with the painting but the stereoscope records "every stick, straw, scratch" in a manner that the painting cannot. The torn paper pieces, animated by their three-dimensionality, trace the poet's recent agitation, while the candle smoke, representing his extinguished life, is different in each photograph due to their being taken at separate moments. The haphazard creases of the bed sheet are more suggestive of restless movement, now stilled, than Wallis's elegant drapery. Even the individuality of the boy adds potency to his death.[9]

Photography's insistence upon capturing "every stick, straw, scratch," as Jacobi puts it, echoes Oliver Wendell Holmes's prescience in his *Atlantic* article, published the same year *Turner v. Robinson* was decided, which forecasts a modern literacy regarding the medium as an art form. "What is the picture of a drum without the marks on its head where the beating of the sticks has darkened the parchment?" he asks rhetorically, anticipating the now-intuitive understanding that photography has the power to transform the overlooked—the microuniverse of everyday experience—into an image that may provoke unanticipated emotion. More than a century later, one of the most influential writers on the

subject, Roland Barthes, injected into the conversation a notion he called *punctum*, which he describes as "that accident which pricks me (but also bruises me, is poignant to me)."[10] Those marks on the drum head were presumably the punctum in that photograph for Holmes, while in a different passage, he unknowingly introduces future Barthes to ancient Democritus when he both identifies a punctum and, rather optimistically, imagines an eidolon.

> In three pictures of the Ann Hathaway Cottage, before us,—the most perfect, perhaps, of all the paper stereographs we have seen,— the door at the farther end of the cottage is open, and we see the marks left by the rubbing of hands and shoulders as the good people came through the entry, or leaned against it, or felt for the latch. It is not impossible that scales from the epidermis of the trembling hand of Ann Hathaway's young suitor, Will Shakespeare, are still adherent about the old latch and door, and that they contribute to the stains we see in our picture.[11]

The hope that the stereograph has captured some residue of Shakespeare's ghost is a reminder that photography was invented—or in the case of Daguerre, assembled in a seemingly haphazard kind of alchemy—during a period of fascination with the occult, the spirit world, and death. We no longer take portraits of the dead for memorial purposes, but through at least the early twentieth century, it was neither unusual nor morbid to dress, make up, and pose departed loved ones for their final (if not only) photograph before internment. As if to exemplify a more acute awareness of omnipresent death than we experience today—perhaps revealing a strong desire to bridge the two worlds—many postmortem photos were taken of children who succumbed to now mostly extinct or highly treatable maladies like influenza or the measles. In some of these photos the deceased boy or girl is even propped into position for a group shot alongside his or her living siblings, implying that Holmesian desire that the photograph might capture something spiritual—something more than the cold fact

of a lifeless form that used to be a son or daughter. (In this regard, it is strange to think that among Holmes's most significant contributions to the world was in the field of germ theory which, had he and others been heeded sooner by much of the medical community, might have saved quite a few of those young lives.)

It is in this same article that Holmes famously refers to the photograph as the "mirror with the memory," a poetic notion probably inspired by the daguerreotype's reflective plate of polished silver on which the image seems to float almost holographically above the surface, imbuing the medium with a ghostly quality to which the Victorians were already so attentive. This gothic theme of identity split between the self and the image of self is of course a recurring literary device, from the cautionary tale of Narcissus, to E. T. A. Hoffmann's Erasmus losing his reflection to the devil,[12] to Wilde's Dorian Gray, Barrie's Peter Pan losing his shadow, and even Zemeckis's Marty McFly watching his image disappear from a photograph in the movie *Back to the Future*. "Photography is used to ward off total oblivion," writes Teju Cole, "the way that the photographs of Courbet's *The Stone Breakers* and Van Gogh's *The Painter on the Road to Tarascon* accidentally made the lost paintings visible to future generations."[13]

This mnemonic function of photographs—whether literal or whimsical—still prompts the question as to the existence of an author who makes the photograph; and coincidentally enough (or perhaps not so coincidentally), it will be Holmes's son, Justice Oliver Wendell Holmes Jr., who will introduce the doctrine of "personality of the author" to copyright law in 1903 in *Bleisten v. Donaldson Lithographic Company* (1903), another case involving visual works. This provokes a broader question as to what extent early modern copyright law may have been shaped by the romanticism of Victorians who were often eager to find evidence of things unseen; but whether there is any reason to explore that hypothesis, a case for the author in photography had already been made no later than 1844, in the world's first book on the subject, written and compiled by the medium's most influential inventor.

"A painter's eye will often be arrested where ordinary people see nothing remarkable," wrote the Englishman William Henry Fox Talbot, whose process called the *calotype*, developed concurrently with the daguerreotype, was the true progenitor of nearly all photographic technology until the shift toward digital tools in the late twentieth century. The quote is part of the caption Talbot wrote to accompany his photograph "The Open Door," one of twenty-four plates he made for the book series he called *The Pencil of Nature* in which Talbot explores the technical capacities of his own process as well as the artistic and prosaic uses of photographic images.[14]

"The Open Door," captured on the grounds of his estate Lacock Abbey, depicts a low-angle view of a heavy wooden door ajar within a stone frame. The scene is illuminated by direct sunlight that creates a strong diagonal shadow, which is paralleled by the long handle of a broom leaning against the outer edge of the doorway. The blackness of the interior behind the door is interrupted by light diffused through a latticed window in the deep background. With this image, Talbot endorses photography's potential as a medium of fine art, and his comment about the "painter's eye" asserts that it is the photographer and not the machine that makes the expression. Alternatively, the comments he writes to accompany an image of thirty pieces of china arranged symmetrically on four dark shelves propose a purely mundane use of photography as an efficient means to create a record of one's possessions. But even this image has a quality of *artifying* the ordinary, and cannot escape the conversation about the dual nature of the medium—as truth and fiction, as historic record and artistic expression, as mechanical reproduction and human authorship—demonstrating why the medium was especially vexing as a matter of legal protection under copyright.

Talbot's title *The Pencil of Nature* is a bittersweet allusion to his own disappointment with himself as an illustrator, which he confirmed during a seminal journey to Lake Como in 1833 and found that, even with the use of a prismatic drawing aid called a *camera lucida*, he had no gift for manual image-making. Finding his results "melancholy to

behold" was at least one motivating factor in Talbot's pursuit of a means by which to capture a scene directly from nature onto a photosensitive surface. In fact, the semantic analog between drawing and photography (which literally means "light-drawing"), as an assertion that the "hand" of the artist is always present in the work, brings us back to dramatist Dion Boucicault and a copyright dispute over a now cliché scene most people have witnessed hundreds of times.

7

The Girl (Boy) on the Tracks

Watch any action movie, and it is going to include at least one sequence in which character A is trapped and about to be wiped out by some fast-approaching doom before being rescued in the nick of time by character B, as said instrument of doom—train, truck, boulder, meteor, monster, velociraptor, killer robot—races by with just a few hair-blowing millimeters to spare. This "girl tied to the train tracks" gag may be standard to the point of predictable today, but it was the money scene when it was first performed in the summer of 1867 at the Worrell Sisters' New York Theater on Broadway. And it was not a girl on the tracks but a man saved by a girl in Augustin Daly's *Under the Gaslight: A Totally Original and Picturesque Drama of Life and Love in These Times*. The play had all the ingredients for theatrical success in its day—characters of monodimensional moral clarity, plots held together by what Daly biographer Marvin Felheim calls "extravagant nonsense," production design that reflected the latest in theatrical realism, and that essential chord of *spectacle*, which thrummed across so much of the century.[1] In a time when a week was an average run for a play and a month was long, *Under the Gaslight* was a megahit, boasting over one hundred performances for its first New York production, due in large part to the audiences' eagerness to see Daly's thrilling railroad scene.

In act 4, scene 3, the villain, Byke, tethers the noble-hearted, young Civil War veteran Snorkey to the fatal tracks, conveniently within earshot of the heroine, Laura, who is conveniently locked in a nearby shed, which is conveniently filled with a bunch of axes. A brightening beam of light and offstage whistles and roars alert the audience to

the approaching train as they watch Laura ax her way out of the shed and then dash to release Snorkey from his bonds just before the passenger train races across the proscenium with its locomotive spewing smoke and fire. To rescue these theatrics from today's instinct to dismiss them as *corny*, copyright scholar Bruce E. Boyden observes in his 2018 paper, "At a time of tremendous economic, social, and cultural turmoil, confronted by war, economic depressions, the rise of class divisions, and the rending of the social fabric, melodrama spoke to audiences' deep-felt need to see that triumph was possible in such situations."[2] Daly delivered just such a triumph with his railroad scene while upping the ante on the kind of theatrical magic audiences had come to expect. "This play was produced during a time of great spectacle on stage, when incredible stage effects were promised in order to sell tickets," says props director Eric Hart, who happens to be the brother of copyright expert Terry Hart. "Other plays at the time featured flowing rivers, city fires, rolling ship decks, erupting volcanoes, and vast thunderstorms. Daly's train dashed across the stage and featured smoke and fire effects."[3] Then, as if the illusion of a locomotive pulling several cars from wing to wing and nearly killing two characters were not sufficiently novel, Daly interjected a dose of feminist politics into Snorkey's line of gratitude for his deliverance. "And these are the women who ain't to have a vote!" he declares.

The same "Gus" Daly who had been the press agent and early defender of Adah Mencken is consistently described by many who worked for him as a prototype of the authoritarian, egomaniacal—and almost certainly adulterous—*auteur* director. "He was an expert in the gentle art of making enemies, and was much too oppressed with a sense of the importance of being Augustin Daly to become really popular," observed the English actress Jessie Millward.[4] Running his theater companies like fiefdoms, even imposing rules of decorum on the performers in his employ—a practice that would later be reprised in the Hollywood studio system—Daly built his theatrical enterprise by nurturing solid casts of skilled ensembles, which contrasted with the prevailing star system of the period. Although not an actor himself, he is credited with

settling the craft down into the realm of naturalism from the grandiloquent and overdramatic heights that chewed up so much of the period's scenery. As dramatist, critic, press agent, manager, producer, and director, Daly, at his best, was the most influential polymath of the American theater in the second half of the century.

According to the memoir of then drama critic William Winter, Daly thought of the railroad scene one evening while walking home and was seized by the idea at the very moment that he stubbed his right foot on a crooked flagstone, forcing him to hobble through the pain in a frenzied rush to write down his new invention.[5] This anecdote is a shade too purple to ring quite true, and Winter's relationship with Daly was chummy enough to cast doubt on his journalistic integrity in this regard.[6] Plus, Daly himself, ever the press agent, no more scrupled to bend the truth in the service of promotion than the eminent Mr. Barnum. But however the railroad scene came to be written, it was at least sufficiently novel to attract the attention of Dion Boucicault, who was the best-known and most prolific dramatist on both sides of the Atlantic.

Born of dubious paternity in 1820 in Dublin, Dionysius Lardner Boursiquot initially fashioned himself an actor named Lee Moreton. But in 1838 he wrote his first play under the name Dion Boucicault, and by March of 1841, still eight months before his twenty-first birthday, his second play, *London Assurance*, opened at Covent Garden with the imprimatur of a well-known cast and launched a career that would yield over two hundred dramatic works. Though much of his oeuvre may not be considered highly original by contemporary standards, "Given the conditions of [the Victorian] theater, and the genres available to him, he even bequeathed us some masterpieces for performance," writes Andrew Parkin in the introduction to a collection of the plays. "And single-handedly, Boucicault gave Ireland a theater in the nineteenth century on which others could draw."[7] Those others naturally included Oscar Wilde, whose style of humor owes more than a tip of the hat to his friend and fellow Irishman. In many brief biographical summaries, it is reported that Boucicault was a leading advocate for the addition of "dramatic compositions" to the American copyright law

in 1856, adopted with the corresponding right to "publicly perform" said compositions since that was their purpose. And although there appears to be no record of Boucicault's direct activism in this regard, he was unquestionably involved in a number of litigations that gave shape to the legal understanding of dramatic works. To put this topic in perspective, more antebellum Americans experienced *Uncle Tom's Cabin* as a play than read it as a novel, partly because within two years of the book's 1852 publication, seven different adaptations were produced nationwide—none of which was authorized by Harriet Beecher Stowe or paid her a dime for any kind of license.[8]

Boucicault presaged a legal dispute with Daly in August of 1868 with the London debut of his new play *After Dark*, which featured a strikingly familiar train-of-doom sequence set on an English subway. In Boucicault's version, Old Tom is locked in a cellar adjacent to the rail tunnel where the villains have laid the unconscious body of one Gordon Chumley to be destroyed by the approaching train, which is also heralded by lighting and sound effects. Like Daly's Laura, Tom is handily supplied with a tool for his escape, an iron bar, which he uses to break through enough bricks to extricate himself just in time to leap onto Chumley and roll with him downstage into the foreground as the train flies through the scene behind them. The action is punctuated by a rapid curtain drop.[9]

News tended to travel pretty quickly through the intramural community of New York and London theater professionals, so Daly very likely learned about Boucicault's use of his big scene overseas, but as there was no international copyright agreement, there was nothing he could do about a UK production. Whether Boucicault was unaware of, or unconcerned about, Daly's displeasure, he soon arranged for New York producers Henry Jarrett and Harry Palmer to produce *After Dark* at Niblo's Garden, and this provided Daly with the jurisdictional standing to file suit in order to stop the use of his "patentable device" by Jarrett and Palmer, or any other American production.[10] While this may seem petty in a modern context, to put Daly's concern in perspective, imagine if right after the 1973 debut of *The Exorcist* another motion picture were

released that also featured a possessed, foul-mouthed, soup-vomiting teenager whose head rotated 360 degrees. The train rescue scene was box-office gold, especially in a time when spectacle was often the most important ingredient, and this is one reason why Daly's rationale for his lawsuit is not diminished by the apparent hypocrisy that both he and Boucicault (and most of their contemporaries) were themselves inveterate pirates of literary and dramatic works in the production of many plays.

Not unlike Shakespeare's London, the burgeoning American theater after the Civil War was a frenzied hodgepodge driven by the economic forces of volume, turnover, and popular stars more than uniqueness in authorship. Words like "totally original" in Daly's subtitle were typical of the age and can be read as marketing lingo—the same way we understand that "new and improved" on a bottle of laundry detergent doesn't really mean anything. That there was money to invest is evident by the rapidity with which New York theaters, which frequently burned down owing to the hazards of gas lighting, were rebuilt or moved to new premises to meet public demand. In 1873, to commemorate Daly's new Fifth Avenue Theater, relocated within three weeks of its predecessor being destroyed by fire, Oliver Wendell Holmes Sr. wrote the dedicatory lines,

Hang out our banners on the stately tower!
It dawns at last—the long-expected hour!
The steep is climbed, the star-lit summit won,
The builder's task, the artist's labor done;
Before the finished work the herald stands,
And asks the verdict of your lips and hands![11]

The hint of homage to Puck's final monologue in *A Midsummer Night's Dream* may be considered a faint reflection of Felheim's observation that the most important playwright in nineteenth-century American theater was Shakespeare; or as Willam Dean Howells put it, "there is nothing American on the American stage."[12] While that may have been

an exaggeration—because there was certainly budding originality on the boards, including the contributions of Boucicault and Daly—it is generally true that, as with book literature, this first era of the domestic theater consistently "fed on the sere remains of foreign harvests" to meet a steady demand for "fresh" material, and this was supported in part by a copyright free-for-all due primarily to the absence of international agreements. The term *hacks* (from *hackney*, meaning "a horse only useful for common purpose") referred to writers employed by theater producers to quickly and mechanically adapt and translate novels and plays, mainly from Germany, France, and England, for dramatization on the stage. "The average dramatist is neither an inventor nor a creator; he is a plagiarist," wrote G. E. Montgomery, associate editor of *The Theater*, while Boucicault himself lamented that within just a few decades of his 1841 debut of *London Assurance*, the price a producer was willing to risk on an original play had dropped by some two-thirds because any shrewd manager could pay about twenty-five pounds for a hack adaptation of a French work with almost guaranteed success at the box office.

Poaching was so abundant that some novelists, including Dickens, occasionally sold manuscript copies for the purpose of dramatic adaptation in order to earn at least some revenue from the use of their underlying works. To emphasize how different the market was from the present, Daly himself did not need any license to produce a dramatization of *The Pickwick Papers* in January of 1868, shortly before he filed suit for the infringement of his "totally original railroad scene." On this subject, the preface for an unauthorized printing in England of *Under the Gaslight*, written by actor, playwright, and publisher Thomas Hailes, offers an impassioned description of the copyright landscape of the age. Addressing himself to Daly and American publisher F. C. Wemyss, he writes:

To both these gentlemen, I offer a sincere expression of regret that I have at length allowed myself to follow the disreputable example of some New York and Boston publishers, and appro-

priate property to which I have, certainly, no moral right. I have for years wholly repudiated the practice of pilfering from Americans, and should never, at any time, have assumed what I consider to be a degrading, if not dishonest, position, had I not been the victim of hundreds of instances of similar delinquency from the other side of the Atlantic. . . . Sympathising with the honest movement now agitating the public attention in America for a reciprocal protection of literary property—I have taken this step to aid it, and deliberately assert that had Mr. Daly possessed the right to introduce this drama into England and her Colonies— its merit is such that he might have hope to derive an important pecuniary result therefrom for years—all which is sacrificed by the disinclination of the American government to believe in the genius and inventive powers of its own citizens.[13]

Although Boucicault alleged that he borrowed nothing from Daly, asserting that there was ample literary precedent for the railroad scene dating back to at least 1843, Judge Samuel Blatchford of the Southern District of New York found infringement in this case and changed copyright doctrine for decades to follow. Decided on December 15, 1868, *Daly v. Palmer* was pivotal in the evolution of perhaps the most nuanced—and often most frustrating—area of copyright law, which still provokes debate, outrage, confusion, and circuit court splits, right up to the fairly recent kerfuffle in which musical artists Robin Thicke and Pharrell Williams lost a multimillion-dollar lawsuit when their song "Blurred Lines" was held to have infringed "Got to Give It Up" by Marvin Gaye Jr. If *Turner v. Robinson* was an affirmation that copyright protects the intangible, *Daly* was a significant leap into the metaphysical that produced several key (though still fickle) theoretical principles articulating how a court should first identify what is protectable; then what, if anything, has been copied; and finally, whether an infringement of copyright has actually occurred.

As a rule, copyright litigation is relatively straightforward where an obvious reproduction of a whole work—or a substantial portion of a

work—has been made. Robinson's stereograph, for instance, looked so much like Wallis's "Chatterton" that Robinson's strongest defense was to argue that the original painting was simply not protected. But *Daly* presented a more nuanced set of questions: 1) Can part of a whole work—in this case a single scene from a five-act play—be protected by copyright at all? 2) Does a performed set of actions, separate from the dialogue, even constitute a "dramatic composition" under the statute, which at the time was just twelve years old? Neither Boucicault's stage directions nor any of his dialogue is identical to the text in Daly's script, so what Blatchford had to consider was not the words on the page but the *effect* of the two scenes on the audience, and whether the same viewers watching both plays would *perceive* "substantial similarity" that would support a finding of infringement by Boucicault. One notable irony about the fact that *Daly v. Palmer* is widely considered the origin of this "ordinary observer" doctrine is that the only observer in the trial was Blatchford himself. Most copyright cases of the period were tried in equity (i.e., solely by judges) rather than by jury,[14] and to go a step further, it is very likely that Blatchford did not see either *Under the Gaslight* or *After Dark* performed on stage, let alone both plays. Instead, he reads the stage directions (i.e., the action) as being analogous to musical scores, citing case law that held that using the same melody in a new arrangement is a piracy.[15] Then, he breaks down the expressive elements in the two scenes, drawing attention to

the series of events so represented, and communicated by movement and gesture alone to the intelligence of the spectator, according to the directions contained in the parentheses, in the two plays in question here, the confinement of A. in a receptacle from which there seems to be no feasible means of egress; a railroad track, with the body of B placed across it in such manner as to involve the apparently certain destruction of his life by a passing train; the appearance of A. at an opening in the receptacle, from which A can see the body of B; audible indications that the train is approaching; successful efforts by A. from within the receptacle,

by means of an implement found within it, to obtain egress from it upon the track; and the moving of the body of B., by A., from the impending danger, a moment before the train rushes by. In both of the plays, the idea is conveyed that B. is placed intentionally on the track, with the purpose of having him killed.[16]

By stripping away the dialogue, the different settings and characters, and even the different words Daly and Boucicault used in their stage directions, Blatchford reads the scene the way a musicologist might compare two separate scores to find similarity in expression. Further, he concludes that indeed action without dialogue is a dramatic composition: "To act, in the sense of the statute, is to represent as real, by countenance, voice, or gesture, that which is not real. A character in a play who goes through with a series of events on the stage without speaking, if such be his part in the play, is no less an actor than the one who, in addition to motions and gestures, uses his voice."

Twenty years before the question arises in silent film, Blatchford has made a case for the many nick-of-time rescues to come, which today would be called *scènes à faire*, defined in Duhlaine's Law Dictionary as, "Elements of an original work that are so trite or common that they are not captured by copyright." The often overlooked distinction here is that the *idea* of a rescue may not be copyrighted, while an endless variety of ways to *express* rescues using some of the same dramatic "notes" (e.g., looks of terror and the thrill of a narrow escape followed by sighs of relief) may be copyrighted. And as Boyden points out, "even with respect to its core holding, subsequent cases narrowed *Daly* rather than expanding it. Daly's copyright in the Railroad Scene . . . gave him an exclusive right to last-minute on-stage rescues of characters tied to train tracks, but little else."[17] This was underscored when the Second Circuit held that a new production of *After Dark* with a revised railroad scene no longer infringed *Under the Gaslight*, despite Daly's continued complaint that it did.

Toward the end of his career, in a speech delivered in 1896 at the New York Shakespeare Society annual dinner, Daly offered his own version

of the link between art and democracy that Emerson and Whitman both insisted on, saying, "If to write the songs of a nation is to exert more influence upon it than to make its laws, then the men who control the amusements of the people have a responsibility in one way as great, if not greater, than the men who fill its pulpits. It is with a sense of such responsibility that I have done what I have done for the modern stage."[18] If that sounds a bit self-congratulatory, this may be excused by the fact that the speech was not written by Augustin but by his brother Joseph, which imbues the sentiment with much richer meaning because, at that time, Joseph was both a justice of the New York State Supreme Court and the uncredited literary collaborator in the production of much—some experts contend more than half—of Augustin's dramatic and critical writing. It is not entirely clear why Joseph chose to remain anonymous with regard to his creative contributions to the Daly oeuvre, but according to Felheim, "Augustin prepared an outline of the plot, a description of the characters, an indication of the necessary action—a *scenario*, in his own words—and sent it to Joseph who did the actual composing."[19] Though Felheim implies Joseph's motivation might have been moonlighting to augment his judge's income, which did not "compete with the Tammany crowd," it is also possible that his secret dramatizing was done out of affection for the brother with whom he'd grown up mostly poor after their ship captain father died at sea. Regardless of the reason, knowing that Augustin's speech was really Joseph speaking Cyrano-like through his brother—advocating the preeminence of his own private contributions to culture over his public contributions to policy—adds a beguiling complication to the narrative when we also realize that Joseph Daly, Esq., served as counsel in the litigation over the "railroad scene." So it is entirely possible that, as an attorney, Joseph was defending his own creative work.

Boyden contends that *Daly v. Palmer*'s real significance "emerged when copyright law attempted to grapple with the sudden explosion of a mass market in popular culture." For instance, questions as to what constitutes the unprotectable *idea* versus the protectable *expression* will become more complex with the invention of cinema and a hun-

ger for source material that was even more voracious among the early film studios than the theaters of Daly and Boucicault. It was a lawsuit over the first film adaptation of Lew Wallace's *Ben Hur* (1907) (*Kalem Co. v. Harper Bros.*, 1911) that Oren Bracha identifies as the source of the modern "derivative works" right, which grants the author exclusive control over adaptations, translations, spin-offs, etc.[20] That the Supreme Court, specifically Oliver Wendell Holmes Jr., found contributory infringement in the fifteen-minute, silent-film "dramatization" of a novel is a pretty good indication that through the nineteenth century, copyright is changing to represent something very different from its origins in the book printing business—becoming what Justice Story in 1841 called "the metaphysics of law, where the distinctions are, or at least may be, very subtle and refined, and, sometimes, almost evanescent."[21]

Bracha describes Holmes and his fellow justices as having "internalized" the concept of protecting a work's "essence" in the years before statutory law had truly caught up to that sensibility.[22] To many critics, copyright's conceptual adaptation to the realm of the intangible is evidence that intellectual property is a purely invented construct—the "requisite fiction" Gaines identifies with regard to photography and the *Sarony* case. But, as stated at the outset, some rather important constructs are not diminished because they are "invented." On the contrary, perhaps this is exactly why they are so valuable, albeit fragile. After all, there is no absolute proof that people are entitled to free speech or free exercise of religion or to petition their government; we have chosen to assign to these tenets the status of "first principles," and these so-called invented constructs have been important enough for people to risk their lives in their defense.

More pragmatically, one notable aspect about copyright's transformation toward the end of the century—and this is clearly visible in both the theater and motion picture arts—is that while the law expanded to protect more categories of works and add more exclusive rights to the bundle of rights granted to creators, the nature of expression itself also changed to reveal that there are limitless forms of originality within a

finite universe of ideas, themes, and modes of expression. When Ibsen and his contemporaries invented the modern theater, they proved that dramatic works did not need to be yet another swaggering adaptation of *The Three Musketeers*—or even contain a thrilling spectacle like Daly's train rescue—but could instead quietly enact the subtle relationships between a pair of naturalistic characters within the modest boundaries of three walls and the audience. Eighteen years after Dickson registered "The Sneeze" as a photographic work, the first amendment to the 1909 Copyright Act added the category of "motion pictures" to the protection of copyright, and cinema would reveal that there are millions of expressive possibilities within the four corners of a two-dimensional frame.

As artistic expression confronted the twentieth century, copyright's expansion to embrace new media and adapt to new technology was counterbalanced by creative expression's general reduction into infinitely divisible variations on familiar themes. This is how hundreds of movies can contain thousands of "girl-on-the-tracks" rescues, and each one can remain, at least in a legal sense, distinct from all the others. The subtle delineation between two similar but unique works is essential to the foundation of authorship in photography; so perhaps it is not such a coincidence that the medium was challenged, fifty years after its invention, at the same time that artists were advancing an appreciation for more nuanced expression.

On the other hand, "There is no art which affords less opportunity to execute expression than photography," wrote art critic Sadakichi Hartmann in 1899. "Everything is concentrated in a few seconds, when after perhaps an hour's seeking, waiting, and hesitation, the photographer sees the realization of his inward vision, and in that moment he has one advantage over most arts—his medium is swift enough to record his momentary inspiration."[23] This essay grapples with the portraitist's paradox—that the more successful he is in rendering a true likeness, the less he may be considered a true artist. This exact dichotomy was used as comedic and dramatic device by Dion Boucicault in his antislavery play, *The Octoroon*, which opened on December 5, 1859, at the

Winter Garden Theater in New York. In act 2, the traveling photographer, Scudder, describes his encounters with various portrait customers:

"The apparatus can't mistake. When I travelled round with this machine, the homely folks used to sing out, 'Hillo, mister, this ain't like me!' 'Ma'am,' says I, 'the apparatus can't mistake.' 'But mister, that ain't my nose.' 'Ma'am, your nose drawed it. The machine can't err—you may mistake your phiz but the apparatus don't.' 'But sir, it ain't agreeable.' 'No, ma'am, the truth seldom is.'"[24]

8

The Apparatus Can't Mistake

A vengeful God has given ear to the prayers of this
multitude. Daguerre was his Messiah. . . . From that
moment our squalid society rushed, Narcissus to a
man, to gaze at his trivial image on a scrap of metal. A
madness, an extraordinary fanaticism took possession
of all these new sun-worshippers.

—Charles Baudelaire, "Salon of 1859"

Although the first portrait ever taken—a "selfie" made in Philadelphia—
was in fact a daguerreotype, Baudelaire's grouchy protest against the
egotism of everyman wanting to gaze at his own image, at least by
the year 1859, should probably not have vilified Jacques Louis Mande
Daguerre but perhaps a lesser-known English inventor named Fred-
erick Scott Archer. Such was the fame of Daguerre's great gift to the
world, announced on January 6, 1839, that his name was often applied
generically to almost any photograph made years after his invention
had largely been replaced by other processes. The daguerreotype offered
beautifully sharp detail in a delicate, ethereal image etched as if by
magic onto a surface of highly polished silver that lent a jewelry-like
uniqueness to owning one. But these precious qualities, combined with
the limitation that daguerreotypes could not be easily copied to make
multiple paper prints, meant that it was no medium for the masses; it
was destined to be a temporary format if photographers were going to
capture images of people and make a business out of doing so.

"We do not mean to be satisfied until we make every man his own por-
trait painter," wrote Henry Fox Talbot to a friend in March of 1839, and
indeed the effort to make portraits available to a broad market was the key
driver behind photography's first innovations. With the average exposure
time for a daguerreotype ranging between ten and twenty minutes, sitting
for a portrait during photography's first decade or so was tantamount to
volunteering for a kind of medieval torture. The intrepid sitter would
be held in place by a frightful-looking, metal posing contraption that
grasped the wrists, ankles, neck, and head as an aid to remaining utterly
motionless for what must have felt like an eternity—neither sneezing
nor scratching an itch nor (if at all possible) blinking an eye while gaz-
ing into a wall of sunlight-drenched windows in the photographer's stu-
dio. Hence the reason the people in so many early portraits look stiff and
uncomfortable, apparently substantiating the view of the Victorians as
dour and humorless, is that a lot them were quite stiff and uncomfortable.

On a more serious note, the required manacles on limbs and neck
assume a poignant connotation upon learning that Frederick Doug-
lass, escaped slave, statesman, and author, was the most photographed
famous American of the nineteenth century. Because he understood
the democratizing power of the medium, it is especially bittersweet to
imagine him submitting to the gentle restraints of the posing appara-
tus, eventually writing about the significance of portraiture that "the
humblest servant girl may now possess a picture of herself such as the
wealth of kings could not purchase 50 years ago."[1]

Some efforts to improve conditions for sitters were fairly low-tech—
like powdering faces to a clownish white to make them more reflec-
tive, or hanging curtains of flask-shaped bottles filled with blue liquid
in front of the windows to ease the glare on sitters' eyes[2]—but the
more technologically enterprising devoted their energies to making
the cameras smaller, experimenting with new chemistry, or crafting
new lenses that allowed more light to pass through to the photographic
surface. Talbot, an aristocrat of financial means, was driven more by
rigorous scientific curiosity and a desire to be recognized for his con-
tributions than entrepreneurism, and he had quietly produced the first

photographic negative four years before all the fanfare announcing Daguerre's invention. By 1841, Talbot improved his process, which he called the calotype, from the Greek *kalos*, meaning *beautiful*, and now three desirable attributes were divided between two different formats. The calotype provided exposure speed in a format from which unlimited copies could be made, while the daguerreotype still produced a superior image quality. For photographic portraiture to truly become a practical business enterprise catering to a large market, somebody had to combine the best of both sciences; and in 1851, the struggling English artist Frederick Scott Archer invented the "wet-plate" process that would become the primary format for the next three decades.

Improvements in the production of flat panes of glass by the 1840s recommended the medium as an alternative substrate to paper or metal, and various experiments were made with oozy substances—even the slime produced by snails—as coatings for spreading photosensitive elements (e.g., ammonium chloride) evenly across a glass plate. Albumen (egg white) was a viable medium, though it would prove more useful as a binder for coating photosensitive paper for printing rather than for camera plates to capture the original images. In fact, by the late 1850s albumen prints, also commonly referred to as "salt prints," were so abundant that the world's largest supplier, the Dresden Albumenizing Company, apparently cracked about twenty-two million eggs each year, which is an impressive contribution by the world's chickens (and the factory girls who separated the yolks) to the advancement of photography.[3]

Instead of albumen, Archer coated his glass plate with a viscous solution called collodion—cotton dissolved in nitric acid (nitrocellulose) and mixed with ether and alcohol—to which he added potassium iodide that would then bond with the silver in a bath of silver nitrate to produce photosensitive silver iodide. Once the plate was coated with collodion, the photographer had about fifteen minutes to sensitize the plate, capture the desired image—exposures ranged between several seconds and about a minute—then develop the latent image and fix it in hypo before the plate became inert through evaporation. Thus, wet-plate photography resulted in a negative original with clarity almost

comparable to the daguerreotype but with the exposure speed and ease of printing copies offered by the calotype. Photography as an industry was born. The wet plate launched hundreds of portrait studios and scattered itinerant photographers across the globe to record the sights or turn a profit by charging ordinary folks a modest fee for the thrill of having their likenesses preserved in the "mirror with the memory." Sadly, the man who made this possible soon died, at age forty-three, five years after first publishing his method and never earning a cent for his contribution—to say nothing of the injustice that people would continue to refer to photographs as "daguerreotypes" for years to come.[4]

The line in Boucicault's *The Octoroon*, where Scudder tells the disappointed customer that the "truth is seldom agreeable," was a laugh line for sure, but one that sets up a twist that comes in act 4, when a minor character, curious about how the camera works, inadvertently causes it to record the villain M'Closky in the act of murdering a young black mail carrier bearing a letter that could foil his sinister plot. The titular character of this antislavery melodrama is a woman named Zoe, one-eighth African and free, whom M'Closky wants to return to the status of a slave so that he can buy her, because wooing her is not an option. The ensemble is prepared to condemn the murdered boy's Native American friend (okay it says *Injun*) for the crime, when they discover the photographic plate and redirect their accusations at M'Closky.

M'CLOSKY. Me?

SCUD. You! You slew him with that tomahawk; and as you stood over his body with the letter in your hand, you thought that no witness saw the deed, that no eye was on you—but there was, Jacob M'Closky, there was. The eye of the Eternal was on you—the blessed sun in heaven, that, looking down, struck upon this plate the image of the deed. Here you are, in the very attitude of your crime!

M'CLOSKY. 'Tis false!

SCUD. 'Tis true! the apparatus can't lie. Look there, jury-men. (*Shows plate to jury.*) Look there. O, you wanted

evidence—you called for proof—Heaven has answered and convicted you.

M'CLOSKY. What court of law would receive such evidence?[5]

This was the first time a photograph was used as a plot device in a dramatic work, although Boucicault was surely taking dramatic license with the science given that the motion entailed in tomahawking someone to death would likely produce an image with unidentifiable faces. That nitpick aside, the point is that while M'Closky's question may seem anachronistic today—implying that a court of law would never accept a photograph into evidence—Boucicault was probably not aware that when he introduced this novel element to his audience, the first major court case in America to consider photographic proof had been decided at the Supreme Court just months before *The Octoroon*'s debut.[6] This real-life legal milestone was not nearly so dramatic as a murder caught by the "eye of the Eternal," but it did involve foiling an attempted land swindle of about 270,000 acres of Sonoma, California, real estate with a present-day value in the tens of billions of dollars.

In *Luco v. United States*, a man named José de la Rosa claimed ownership of this prime swath of California based on a grant allegedly signed by Pio Pico, the last Mexican governor of Alta California during the volatile period leading up to the Mexican War. In the lower courts, and then on appeal at the Supreme Court, photographs admitted into evidence enabled the justices to compare handwriting on documents known to be signed by Pico with the documents submitted by de la Rosa. In writing the opinion of the court, Justice Robert Grier stated, "We have ourselves been able to compare these signatures by means of photographic copies, and fully concur from evidence '*oculis subjecta fidelibus*' that the seal and the signatures of Pico on this instrument are forgeries."

Oculis subjecta fidelibus. Seeing is believing. But is it? Is photography truth or art? Or both? These opposing possibilities would produce vexing legal problems. If a court allows photographs to serve as evidence in a case, it implies that they show us facts. But if photographs, as a matter

of law, are works made by disinterested machines that record facts, this does not easily qualify them for the protection of copyright as works of human expression. When Scudder credits the "blessed sun in heaven" for creating the photographic plate, this not only serves Boucicault's poetic insinuation that God was watching M'Closky kill the boy but also echoes a general sensibility about photography at the time—that sunlight and chemistry make the image, not the photographer.

Of course such abstract and philosophical questions were not raised—at least not according to any available record—by members of the Thirty-Eighth Congress when they amended the Copyright Act to include photographic works on March 3, 1865. Notably, the man who signed this bill into law had said of himself that "Matthew Brady and the Cooper Union made me President." This was Lincoln's nod to the fact that his New York City campaign speech of February 27, 1860, and the photographic portrait taken by Brady the day before had both helped to confound the perception that he was an ungainly country bumpkin.[7] Toward the conclusion of that speech, he asked, "Thinking [slavery] right, as they do, they are not to blame for desiring its full recognition, as being right; but, thinking it wrong, as we do, can we yield to them?" Ironically enough, the intransigence of that question and the war that answered it was the catalyst that made Brady famous.

Very much the predecessor to Sarony, Matthew Brady learned the daguerreotype process from Samuel Morse and opened the first "celebrity" portrait studio in New York in 1844 followed by a second in Washington DC in 1849.[8] But he is best known for documenting the Civil War, which Susan Sontag describes as the threshold when photography (in America) became "an indispensable tool of the new mass culture."[9] Brady's photographs of the war comprise the work of more than twenty photographers he employed, including the Scottish-born Alexander Gardner, who produced many of the iconic aftermath scenes with fallen soldiers strewn across battlefields, but whose manipulation of these grim compositions also contradicts our assumptions about photojournalism at its very beginning. It is now widely accepted that Gardner made creative adjustments to these postmortem tableaux. Analysis indicates, for instance, that he

and fellow photographer Timothy O'Sullivan moved a dead infantryman at Gettysburg to a new location in order to portray him as a slain sharp-shooter.[10] For sure the "sharpshooter" photo looks staged, particularly because the gun—it was apparently not even the right type of firearm and may have been Gardner's prop—lies a bit too neatly, perpendicular above the soldier's head, to have realistically been tossed out of his hands as he was shot, especially when his hands rest downward by his hips.

Gardner and O'Sullivan were not the last photojournalists who would alter reality for dramatic or aesthetic effect, but neither were they the first—at least not with regard to war photography. That honor has been bestowed by many art historians upon the Englishman Roger Fenton, who, with his assistant Marcus Sparling, spent 112 days in 1855 behind British front lines in the Crimean War (1853–56). Working in stifling conditions out of a horse-drawn coach converted into a kind of tinker's darkroom used to prepare, develop, and store collodion plates, Fenton and Sparling captured the first war photographs ever made at a rate of approximately three pictures per day (fig. 17).[11] Of the 360 images they brought back to England, the most famous is a pair taken from the same position and both titled "Valley of the Shadow of Death."

Not to be confused with the "valley of Death" memorialized in Ten-nyson's poem "The Charge of the Light Brigade," the account describes a military blunder that occurred several miles from the location where Fenton set up his tripod, nicknamed the Valley of Death because the road running through it lay within range of three Russian artillery units. The two photographs taken at this position are compositionally identical except for the fact that in one, cannonballs are only seen in the ditches alongside the road, while in the other, several cannonballs are on the road, lending what may be perceived as a more proximate sense of danger to the scene. The natural conclusion drawn by many experts is that Fen-ton and Sparling purposely moved—or had somebody move—a bunch of cannonballs onto the road to create a more dramatic second version of the location as they had found it. This apparent "staging" of history has been scorned as lacking integrity, but documentary filmmaker Errol Morris, in his book *Believing Is Seeing*, asks, "But couldn't you argue that

every photograph is posed because every photograph excludes something? Fenton could have had an elephant in the Valley of the Shadow of Death. . . . The elephant could have been walking through the frame of Fenton's camera, and Fenton waited until the elephant had just cleared the frame."[12] This same idea was also expressed by Sontag when she wrote, "the camera's rendering of reality must always hide more than it discloses,"[13] and what's funny about these corresponding ideas is that it was Sontag's later criticism of Fenton's "fakery" that inspired Morris to travel to Crimea in 2005 in his quest to figure out if indeed cannonballs "ON" was photographed after cannonballs "OFF."

It takes a special kind of obsessive pedantry to go to the lengths Morris did in order to determine which of two 150-year-old photographs was taken before the other; but then this is why Morris is one of my favorite documentary filmmakers: his fascination with the paradox of images actually informs the way he tells stories with film. He even proposes that Fenton's two photographs were the first motion picture—meaning two matching scenes in which change in the position of the cannonballs implies a sequence, even though it is not initially clear in which order they should be viewed. As a thought exercise, Morris asks how our perception of events changes if in fact Fenton first made an image of the road he found littered with cannonballs and then captured a second plate after removing the cannonballs—perhaps for no other reason than his liking something about both compositions. (And, as Morris points out, Fenton exhibited both photographs in London, suggesting that he was not actively trying to fool anybody.) Eager to discover whether the photographs themselves contained any evidence to verify the sequence in which they were taken, Morris wanted to remove the psychological assumptions made by Sontag and others that Fenton "obviously" posed "ON" solely because it is perceived as the more dramatic version. As plausible as that narrative may be, Morris's compulsive search for dispassionate evidence (which he eventually found) is an exercise in "thinking about some of the most vexing issues in photography—about posing, about the intentions of the photographer, about the nature of photographic evidence—about the relationship between photographs and reality."[14]

The tension between Fenton's two versions of "Valley of the Shadow of Death" only arises after a certain consensus on the boundaries of photojournalism has been established. On the other hand, even in 1863, Gardner's moving a corpse to a new location, misidentifying the dead soldier's role in the battle, and posing him in manner that appears to defy any plausible forensics does seem like a considerable leap in the art of chicanery from Fenton's scattering cannonballs on a road where they surely had landed at various times. If Fenton's manipulation is a little white lie and Gardner's is a whopper, is either, or both, rescued by serving a larger truth? Or is the question moot for the simple fact that there is always an unseen elephant just outside the frame of every photograph? Or perhaps the only truth that any photo really serves is the one expressed by Barthes in 1980 when he wrote, "All those young photographers who are at work in the world, determined upon the capture of actuality, do not know that they are agents of Death."[15]

Here Barthes refers to one of Gardner's most haunting photographs—the portrait of Lewis Powell (alias Payne) imprisoned aboard the ironclad USS *Saugus* and awaiting trial for the attempted murder of Secretary of State William H. Seward as part of the Lincoln assassination conspiracy (fig. 18). Barthes identifies a new "punctum" here with the element of time. "The punctum is: *He is going to die. I read this at the same time: This will be and this has been.*" Without context, the photo could be mistaken for a modern snapshot of a movie star—a contemporary of James Dean or Marlon Brando—relaxing on set between takes. Powell is rakishly handsome, seated and seemingly relaxed, if tired, as he rests his upper body against a dilapidated steel wall and stares directly at us—not the deer-in-the-headlights stare of the typical ossified Victorian, but a confident *je m'en fous* of a look.[16] Even the handcuffs do not immediately draw attention away from the startlingly contemporary vibe of Powell's demeanor, what Michael Sacasas describes as "modern self-consciousness being born before an indifferent lens."[17] The photograph is a counterpoint to the monster Powell truly was. In contrast to Booth's hammy final performance at Ford's Theater, Powell rampaged Seward's home, bludgeoned one son almost to death, slashed the bed-

ridden secretary several times with a knife, wounded two other sons who tried to defend their father, and even stabbed a messenger on his way out of the house. None of the victims died that night, but Powell destroyed lives, paralyzing the messenger and quite possibly precipitating the early death of Seward's wife Frances.[18]

What the photo also does not reveal (the elephants outside the frame) is that Powell tried to prevent Gardner from taking his picture by being uncooperatively animated until the officer in charge struck him with the flat of his sword at which point, Sacasas theorizes, Powell found another path to resistance by adopting an elusively unselfconscious pose. "In order to appear indifferent to the camera, Powell had to perform the part of Lewis Powell as Lewis Powell would appear were there no camera present. In doing so, Powell stumbled upon the negotiated settlement with the gaze of the camera that eluded his contemporaries. He was a pioneer of subjectivity." It is an interesting proposal, suggesting that Powell, and not Gardner, *invented* Lewis Powell; and notably, Powell's were the only portraits, among the several Lincoln-conspiracy prisoners who sat for Gardner on the same day, that Gardner bothered to copyright under the newly amended law.[19] But who was the true author? Gardner because he loaded the plate and removed the lens cap for the necessary exposure? Or the unruly Powell who, according to Sacasas, unwittingly discovered this modern pose as a form of protest against being photographed? Does the officer who struck Powell deserve partial credit for the production of the image?

Had this portrait been the subject of the constitutional challenge to photography's copyrightability, a defendant's claim that Gardner had not authored anything might find some purchase in the courts, particularly in a time when the relative slowness of the process might support such an assertion. Modern cameras operate so quickly that photographers are generally given credit for "capturing a moment," even if they were not responsible for creating the moment; authorship attaches to the image when the photographer extracts some expressive fragment out of the spacetime of real events. But with a picture like Gardner's portrait of Powell, in which the subject "plays himself" for perhaps fifteen

seconds or more, there is an extent to which Gardner may be considered almost as incidental as the minor character who inadvertently left the cap off the lens in The Octoroon so that the "sun in heaven" could catch M'Closky. Presumably, Gardner registered his Powell photos for copyright because he recognized that he had captured a moment of great significance and value—indeed we keep talking about this photograph more than 150 years after it was made—and I think Sacasas is right that its paradoxical nature as an old modern photo is immediately evocative, even without knowing who the man in the photograph is.

In the very broadest sense, the Civil War was the first great test of America's presumed grounding in Locke's labor theory, which Lincoln modestly summarized as, "I always thought the man that made the corn should eat the corn."[20] But the war was also the first major event to be documented by photographers—tens of thousands of images were made, in contrast to Fenton's 360 plates of the Crimean War— and this valuable historic record might have been a persuasive factor in the admission of the medium to copyright shortly after the appointment of Spofford to the Library, and barely a month before Lincoln's assassination. If Lincoln contended that Brady's portrait helped make him president, then one might also say that Brady's photograph got him killed. "All photographs are memento mori," writes Sontag, in her own version of Barthes's "agents of Death" idea, but with the added twist of cautionary tale—a notion that may be visually punctuated by the carte de visite at the Library of Congress, also taken by Gardner, of the young actor who signed his headshot, "Yours affectionately, John Wilkes Booth" (fig. 19).[21]

It seems reasonable to assume that photographs were simply added to the copyright law near end of the Civil War as a practical means for the Library of Congress to obtain, through deposit copies, valuable collections like the pictures captured by Brady's company. Certainly, there was no objection to the amendment; and it would be remarkable if any member of Congress at that time would have had the inclination, let alone a legal or creative framework, for asking whether extending copyright to photographers was constitutional.

9

Who Invented Oscar Wilde?

O for a Muse of fire, that would ascend
The brightest heaven of invention!
—Shakespeare, *King Henry V*

On the night of November 12, 1874, the Commonwealth of Pennsylvania hanged a man named William Udderzook for the murder of his brother-in-law Winfield Scott Goss, with whom he had conspired two years earlier to commit insurance fraud. After faking Goss's death by fire, and intending to collect the payouts from four separate life policies, it seems that Goss became careless while living incognito and reemerged in the vicinity of Bryn Mawr, identifying himself as one A. C. Wilson. Udderzook, fearing that he could be implicated by this loose end, apparently murdered Goss for real, disfiguring his face in the process. Consequently, a key piece of evidence used against him at trial was a photograph of his brother-in-law that an eyewitness was able to identify as the same man he had encountered going by the name of Wilson.[1]

More dramatic than the attempted land swindle in *Luco* and almost as melodramatic as Boucicault's fictional evidence in *The Octoroon*, the capital conviction of William Udderzook was about as sober as legal precedent could be in defining photographs as evidence of factual information. Consequently, the Pennsylvania Supreme Court in *Udderzook v. Commonwealth* provided Burrow-Giles's attorney David Calman with a vital precedent in his effort to weaken the foundation upon which any

photograph should ever be protected by copyright when it held, "We know that its [photography's] principles are derived from science; that the images on the plate, made by the rays of light through the camera, are dependent on the same general laws which produce the images of outward forms upon the retina through the lenses of the eye. The process has become one in general use, so common that we cannot refuse to take judicial cognisance of it as a proper means of producing correct likenesses."[2]

Calman's assertion that photography was nothing more than just such a technological means to copy that which already existed was one prong in his overall argument that Congress had exceeded its constitutional authority when it added the medium to the copyright law in 1865. Going so far as to suggest, ironically, that Sarony might as well have deposited Oscar Wilde himself for registration at the Library of Congress, his brief for Burrow-Giles states, "the outlines of the figure, the face and its expression are delineated by natural means. Not only does the photographer not produce the same in the photograph—nay, more, he cannot, by any means, change the same from the exact way in which the subject appears to the eye."[3] If he could convince the justices that photographs were not "writings" and therefore that photographers were not "authors" under the meaning of the IP clause, this would lead the court to conclude that Congress had indeed reached beyond the constitutional foundation for copyright. So, in its own humble way, as a dispute over the infringement of a photograph, *Sarony* is one of those cases that tested the elasticity of the Constitution against the stifling view that the Framers were omniscient, prognostic deities perfect in every word since 1787.

Neither Napoleon Sarony nor lithographer John Burrow had any intention of being the subjects of a landmark case grappling with constitutional issues or testing the finer points of copyright law. As noted in chapter 5, appropriation of photographs in this manner was quite common while litigation was rare. Sarony filed suit because Burrow-Giles's large volume of lithographic copies of "No. 18" directly threatened his near-term, and somewhat regional, interest in selling cabinet

cards, and Burrow likewise had an immediate financial interest in the use of Sarony's image. But there were existential business matters for the parties as well. Not only was the copyrightability of all photography at stake, but for at least twenty years or so, lithographers, including Sarony & Major, had been using photographs to make many of their prints. If a New York printmaker published a cityscape of Baltimore or New Orleans or some other remote location, it was almost certain that the source material for that print was a photograph taken by somebody else. If *Burrow-Giles v. Sarony* were a contemporary lawsuit, the printmaking community would be tweeting like mad #photographyisnotwriting in defense of their "right" to copy photographs as lithographs.

Information about the players in this case is a patchwork. David Calman was a New York attorney with an office on William Street, a graduate of Columbia Law School, who does not appear to have been involved in any other major cases in any area of law; this may have been his one at-bat at the Supreme Court. Augustus T. Gurlitz, counsel for Sarony, was a specialist in intellectual property along with his partner Gurnsey Sackett. Born in Riga, Latvia, in 1834, Gurlitz emigrated to the U.S. in 1850, also attended Columbia Law School, served in the Civil War, and represented clients Mark Twain and Rudyard Kipling.

Justice Blatchford had only recently been appointed to the Supreme Court by President Arthur in March of 1882, and was only nominated after two other choices, including the powerful Roscoe Conkling, turned down the opportunity. Having come from the District Court for the Southern District of New York, however, Blatchford may have had the most copyright experience, including his opinion in *Daly v. Palmer*. The most interesting figure in the room was probably Justice Samuel F. Miller, whose authorship of the unanimous opinion in *Sarony* will be one of 616 he racked up during his twenty-eight-year term, making him one of the most influential and overlooked justices in U.S. history, according to biographer Michael A. Ross.[4] A Lincoln appointee, Miller was an antislavery Southerner whose most important opinion, in *The Slaughterhouse Cases* of 1873, remains a hotly debated interpretation of the Fourteenth Amendment, which turned substantively on his read-

ing of the word "and" as a delineation between state citizen rights and federal citizen rights. Without getting into the proverbial meat of that case (it was a fight over the control of New Orleans butcheries), once again it is clear that any good constitutional tussle is inevitably a debate about the meaning of words.

In that spirit, Calman devoted his entire preamble to the omnipresence of literary references—from England's Licensing Act of 1662 to America's first Copyright Act of 1790—in order to argue that copyright's purpose was solely literary and never intended to protect "art." "In these various Acts," the brief for Burrow states, "we find constantly recurring the words 'authors' and 'writings' and find that uniformly they are used only of literary productions, of *books, pamphlets, and treatises*."[5] Perhaps it did not occur to Calman that this litany of historic references to books and so on, as a foundation for disqualifying "art" from the protection of copyright, implied that "Oscar Wilde No. 18" was a work of art and, therefore, creatively expressive, which he would then proceed to argue that a photograph could not possibly be. At the same time, the meaning of "writings" in the act of 1790 already included maps and charts—works that may not be considered "art," but which were certainly nonliterary, pictorial representations of facts. And, of course, his client Burrow-Giles Lithographic would hardly have wanted to argue that Congress had erred by allowing "writings" to embrace *prints* in the protection of copyright. But photography supposedly crossed a theoretical line.

The "authorship" of "writings," Calman argued, had to stop short of embracing a visual medium in which "no block or stone is engraved; no figure is drawn, etched, raised or worked, on any surface from which copies are to be produced by impression or printed."[6] In other words because no human hands drew the image of Oscar Wilde, this was a conceptual step too far for Congress to have taken with its authority under the IP clause (even if Congress never gave the matter any consideration whatsoever). In this regard, the outcome of this case was unintentionally prescient about the future of photography because the medium was put on trial at a time when the arguments against it as an

expressive form were not wholly without merit. Technology had not yet advanced to provide photographers with the portability, lens selections, ranges of exposure, recording media, filtering, and postproduction tools that would be available in coming decades. And most portraiture of the period might easily have supported Calman's declaration that "when the Act of 1865 was passed, Congress . . . went so far as to protect the reproduction of existing objects, by means which are merely applications of scientific principles, well known and open to everybody who will devote his time to the acquirement of a little skill."[7]

Citing one of Justice Blatchford's precedent opinions from 1850, which held that a new arrangement of an existing melody, "though requiring great skill," did not entitle the second work to its own copyright, Calman advanced what may be his greatest misconception about the future of photography: "As in music," he stated, "the true object sought after is a melody; so in photography, the true object sought after is a truthful representation of the subject, and putting Oscar Wilde in a new attitude does not 'change the melody'—does not change Oscar Wilde into another person."[8] It would probably take an extensive search to find a contemporary photographer, art critic, or art historian who would quite agree with those statements, and I suspect Wilde himself would have made an unsympathetic juror were he to weigh Calman's argument. "For in art there is no such thing as a universal truth," Wilde wrote in 1891. "A Truth in art is that whose contradictory is also true."[9]

This does not mean Calman was incorrect to say that a photograph can be described as having a "melody," but he misses the mark when he implies that the melody is produced entirely by the captured object itself, irrespective of the influence of the photographer. Oscar Wilde's face (or any face or object for that matter) may be said to have a visual melody, which a camera can faithfully record with little effort on the part of the photographer, but to assume that the aim of photography, even portraiture, is necessarily "truthful representation" that "does not change" the subject into someone (or something) else, was a dubious claim even in 1883.

Today, with a diverse range of photographic works ingrained in general consciousness, a viewer hardly needs a formal education in the arts

to recognize that two photographs depicting the same objective facts can be expressively very different, but Calman's argument against "originality" in photography relied substantially on the premise that such distinctions fundamentally did not exist. Based on this assumption, he cautioned against a principle that was embryonic at the time—and still occasionally vexes modern copyright matters—when he presented a hypothetical scenario in which Sarony could place his camera in the tower of Central Park's Belvedere Castle—just ten years old at the time—to capture a high-angle photograph of the Reservoir. Thus, by claiming a right of "first appropriation," Sarony could prevent subsequent photographers from capturing this particular landscape, thereby allowing him to copyright the Central Park Reservoir itself. This concern is now generally alleviated by the doctrine known as the "idea/expression dichotomy"—the rule that authors may not protect ideas but only their individual expressions of ideas. However, the seminal case articulating this principle (*Baker v. Selden*) had only been decided a little over two years before the Supreme Court took up *Burrow-Giles v. Sarony*, so the justices had even less experience with the idea/expression dichotomy than they did with photography.

To the implication that Sarony was claiming a right of "first appropriation" over Oscar Wilde, Gurlitz countered that the defense was erroneously confusing patent with copyright: "They entirely fail to observe the distinction between *the right to make a picture of an object* and *the right to copy such a picture* after it is made."[10] This concept still confuses many people today, and more than a few legal scholars either explicitly or implicitly promote the general narrative that copyright "locks up ideas"—a sentiment that has acquired considerable momentum in the digital age, but which is no more evident in 2020 than it was in the 1880s.

So while Calman dedicated considerable energy trying to prove that neither "Oscar Wilde No. 18" nor any photograph could ever entail "authorship"—either intrinsically or under the Constitution—Gurlitz homed in on that still-evolving principle that what copyright protected was intangible conception. As a counterpoint to Calman's contention that the manual labor necessary in printmaking was the primary ingre-

dient in "authorship," Gurlitz alluded to the "type writer," stating that "the button pressed by the finger produces inevitably the same letter or character, whether it be the finger of a Macaulay, or the finger of an idiot that presses it."[11] Citing both *Turner v. Robinson* and *Daly v. Palmer*, Gurlitz identifies creation as an imperceptible action to which copyright attaches once the creation is made perceptible, and then he aligns this with the constitutional language thus: "It may be said then broadly, that as used in the Constitution and also as used in the copyright law, the terms 'authors' and 'inventors' describe creation, abiding only in the mind, uncommunicated, or unexpressed; and the terms "writings" and "discoveries" describe generally all intelligible forms of manifesting and expressing the same, irrespective of the special meanings of the terms writings and discoveries, and it is these manifestations and expressions which are the subjects of protection."[12]

Here, Gurlitz efficiently dispenses with semantic entanglements like whether an "author" is an "inventor" or vice versa and argues that both authorship and invention occur in the mind (part 1 of the IP clause) and that the intellectual property right attaches when that mental concept is manifest in some way (part 2 of the IP clause)—whether in the form of a new harvesting machine or a dramatization of a train nearly killing someone on stage or a specific photograph of Oscar Wilde. Both Gurlitz and the opinion written by Justice Miller allow for the possibility that some photographs may not reveal any identifiable "authorship," and they both decline to comment as to whether such images would be entitled to copyright. "This [lack of authorship] may be true in regard to the ordinary production of a photograph," states Miller, "and that in such case a copyright is no protection. On the question as thus stated we decide nothing." With regard to "Oscar Wilde No. 18," it was sufficient that Sarony had made enough creative choices, visible to an ordinary observer, to establish "authorship." The opinion in fact reiterates language from Gurlitz's brief, stating

["Oscar Wilde No. 18"] is a useful, new, harmonious, characteristic, and graceful picture, and . . . plaintiff made the same . . . entirely

from his own original mental conception, to which he gave visible form by posing the said Oscar Wilde in front of the camera, selecting and arranging the costume, draperies, and other various accessories in said photograph, arranging the subject so as to present graceful outlines, arranging and disposing the light and shade, suggesting and evoking the desired expression, and from such disposition, arrangement, or representation, made entirely by the plaintiff.[13]

There's that word "useful" again, linking the constitutional language for patent law to a landmark copyright decision, but the relevance of this part of the opinion was its holding that at least some photographs revealed "authorship" where the court could readily identify creative *decisions* made by the photographer—even if that recognition was rudimentary by modern standards. For instance, Sarony did not "select the costume" per se—it was the costume of the Apollo Lodge at Oxford that Wilde would wear often during his lecture tour—and it is possible that neither Gurlitz nor the court was necessarily aware of any of the more subtle forms of control Sarony had exerted to produce the final image. Instead, the emphasis on the more obvious selected elements—the pose, the draperies, etc.—was aided by a familiarity with painting, which provided the justices a language in which to explain authorship in this particular photograph.[14] Consequently, the court had little difficulty in recognizing that of course Sarony did not invent Oscar Wilde, but that he had most certainly invented "Oscar Wilde No. 18."

This naturally raises the question as to how this case might have gone had the photograph under scrutiny been one of the more typical portraits of the age—some figure photographed against a plain background—which might have been much more conducive to Calman's arguments. It seems possible that a photographer in that hypothetical case might have lost his claim of copyright in the individual work but that the court still would not have held that the addition of photographs to copyright law was unconstitutional, least of all based on Calman's reliance on the "literary" essence of the IP clause. Mill-

er's opinion specifically notes that many of the same men who were present at the nation's founding also ratified the 1790 law protecting maps and charts (even ahead of books) and then amended copyright in 1802 to embrace prints, which produced no argument against the addition during the intervening eighty years. He states, "Unless, therefore, photographs can be distinguished in the classification of this point from the maps, charts, designs, engravings, etchings, cuts, and other prints, it is difficult to see why congress cannot make them the subject of copyright as well as the others. These statutes certainly answer the objection that books only, or writing, in the limited sense of a book and its author, are within the constitutional provision."[15]

Although the decision in Sarony's case against Burrow-Giles was not especially challenging for the court, it was a significant threshold bridging the premodern, literary, manual, inky world in which copyright's raw elements first appeared and the purely metaphysical universe of the mind and a more egalitarian notion of what it means to create and own intellectual property. "*Sarony* was the first great copyright-meets-technology decision of the United States copyright law and sets a tone of technological neutrality that is still with us," writes Hughes.[16] Calman was correct when he argued that anyone willing to acquire a little skill could make a photograph. Even the daguerreotype, as cumbersome a process as it was, attracted many enthusiasts whose names do not appear in the photographic history books; and just four years after the decision in *Sarony*, a Rochester inventor and entrepreneur named George Eastman, born in the same year as Oscar Wilde, introduced "the only camera anybody can use without instructions," and named it The Kodak.

Soon everybody would indeed be making photographs—easily billions by the middle of the twentieth century—and the fact that this democratization in image making does not simply obliterate copyright in photographs is due to another shift in doctrine away from the rationale of staged-on-purpose choices made by Sarony to a much more nuanced understanding that copyright may attach to works like documentary, street, and nature photography in which the author does not compose

or arrange the scene but instead captures the moment that he or she feels to be the most expressive in the continuum of real events. So although the Court identified "authorship" in "No. 18" largely by interpolating Sarony's process in the image, the affirmation of photography itself actually helped pave the way for the opposite doctrine—that the attachment of copyright is blind to the author's method of creation.

This is one of the most democratic features of copyright, and one often misunderstood in public debate: that it is agnostic with regard to method and, therefore, equally applicable to a work that takes years to produce and a work that takes a moment to produce. Thus, Annie Leibovitz's staged portraits with famous figures—some of which take considerable time and expense—are entitled to the same protection as any impromptu photograph she has chosen to extract out of time and space.

In fact, a classic Leibovitz image makes a perfect example of this important shift in recognizing that even split-second decisions may be "authorship." Taken on August 9, 1974, on the White House lawn just as Marine One is lifting a postresignation President Nixon away for the last time, Leibovitz captured an image of three Marine guards beginning to roll up the carpet Nixon had just walked across to the helicopter. As the guards bow their heads and grasp the brims of their caps to keep them from being blown off by the rotors, Leibovitz reveals more than the mere fact of Nixon's departure—and certainly something more poignant than that incongruously triumphant wave of his—by articulating a moment of pathos in America, if not in Nixon himself. Moreover, Leibovitz happened to be on assignment for *Rolling Stone* along with Hunter S. Thompson for this story, and because Thompson failed to file anything on time, her photographs became *the* story first published by the magazine.[17] The cliché that "a picture is worth a thousand words" is meant to convey that photographs provide more accurate testimony to facts than a written description; but while that assumption may be unreliable, it is also the case that some photographs are more lyrical than words. This sentiment was conveyed by a man named Pirie MacDonald, representing the Photographers' Copyright

League of America at the deliberations in March of 1908, as Congress was writing the first major revision to, and the first modern, copyright law in the United States, the Act of 1909. Representatives for the Newspaper Association cited Miller's opinion in *Sarony* that many "ordinary" photographs may not be constitutionally protected as a basis to argue that reproduction of photos in newspapers should not be infringing under the law. To this, MacDonald responded,

> Photographs are in all probability as nearly intellectual creations as the average news record in a newspaper—infinitely more entitled to copyright, for example, than the news of to-day's weather in Paris; and as much entitled to copyright probably, as maps and charts and the average periodical. . . . It is easy to see why the American Newspaper Publishers' Association might want liberty to use photographs without paying for them and why they might wish to be allowed to use our photographs without our leave, or photographs of yourselves without your leave. . . . There may come a time when it would be very important for some member of your family to be protected from the publication of their photograph.[18]

That is a rather prescient anticipation of the digital age. Although the protection of privacy to which MacDonald alludes will become an area of law separate from copyright, it is a subject where both photography and copyright do intersect. But that moment while writing the first modern copyright law in the United States reveals the frustration that any general advocate of copyright's principles feels when the interests of one class of rights holders are pitted against the interests of another. In example after example, wherever one finds arguments against some aspect of copyright protection, one finds a business interest behind the theory. In fact the Newspaper Association managed to achieve their aims by shoehorning an amendment into the 1909 revision, which limited the maximum amount a photographer could recover in a lawsuit, with the result that "the photographer has no protection in his property rights in his own work if the newspapers decide they want to use it," complained

the editorial in *Wilson's Photographic Magazine*. "The cost of an action to recover damages for infringement would greatly exceed the amount that could be collected under the law."[19] As we'll discuss in the next section, everyone's desire to use photographs without permission returns as a major theme in the age of social media and digital distribution.

Oddly enough, the secondary defense asserted by Burrow-Giles, which sounds like grasping at straws compared to the constitutional argument, was that Sarony had failed, according to statute, to place a proper notice of copyright on "Oscar Wilde No. 18." Because he had only used the initial of his given name, stamping "Copyright, 1882, by N. Sarony" on the border of the image, Calman argued that this did not meet the technical standard for placing the owner's name on the work as required by law. Of course, any thorough research into the foundation of this argument would have required the court to vitiate the copyrights of untold numbers of works since it was the convention of the time to register and market under names like N. Currier, H. R. Robinson, and W. K. L. Dickson, to cite just a few.

Sarony had been signing "N. Sarony" since his days as an adolescent lithographer, although one photograph bearing a notice with the full "Napoleon" happens to be the picture he made when the justices of the Supreme Court visited his studio in February of 1890—not all the same men who presided over his case, but one of the last photos taken of Justice Miller before his death in October of that year.[20] As a matter of copyright theory and the role of photography, this secondary defense is hardly worth mentioning in this story, except for the fact that the name "Sarony" became a source of conflict in a lawsuit stemming from the ironic twist that after Napoleon's death, his son Otto sold the entire enterprise, along with some forty thousand negative plates, to John F. Burrow of the Burrow-Giles Lithographic Company.

10

The Wit of Macaulay v. Mickey Mouse

Returning to the night when Oscar Wilde sat watching *Patience* from his box at the Opera Comique, I mentioned that Gilbert's lyric referring to the "wit of Macaulay" was a bit of unintentional copyright history. This is because the historian and Member of Parliament Thomas Babington Macaulay is frequently invoked by modern copyright critics as a noble and wise figure who stood in the House of Commons on February 5, 1841, to speak in fervent opposition to a bill that, among other changes to England's copyright law, proposed to extend the term of protection to life of the author plus sixty years. Backed by the pedigree of his literary accomplishments—most notably his *History of England from the Accession of James II*—and the eloquence of his oratory, Macaulay's speech remains wildly popular among today's copyright detractors at every level of scholarship, from the lecture halls of the Ivy League to half-baked comments in the blogosphere. Not only does he describe copyright as a utilitarian product of statute (i.e., not grounded in natural rights), but he provides the shorthand pundits of social media with sound bites like "monopoly" and a "tax on readers"—words that still fuel heated debate between advocates and detractors. "It is good that authors should be remunerated; and the least exceptionable way of remunerating them is by a monopoly," Macaulay declared. "Yet monopoly is an evil. For the sake of the good we must submit to the evil; but the evil ought not to last a day longer than is necessary for the purpose of securing the good."[1]

Macaulay's disputation is usually cited—verbatim and paraphrased—in the context of endorsing the digital-age promise of "abundance," meaning the presumption of access to an endless supply of creative and

informative works via the internet. To many, the apparent low cost and immediacy of digital distribution underscores what they see as an unreasonably long period of copyright protection, and this premise spawns two narratives—one about the alleged harms caused by the duration of terms, and the other about how and why terms were extended since 1790. While the former subject is a matter of debate—not always well supported—the latter subject as to how terms evolved is a matter of historic record, and one that is often overlooked by modern critics.

The regular conjuring of Macaulay's spirit as a Marley-like harbinger of doom endures partly because (like Framer pull-quotes) it can be effective to cite a well-spoken figure who lived a long time ago and treat that voice as though it were prophetic. But not only did Macaulay ultimately lose the debate, but, more importantly, the negative consequences against which he so articulately inveighed never came to pass. Yet because term length (the duration of copyright protection) is one of the most-criticized and least-understood aspects of copyright law, Macaulay's dire warning of 1841 is a popular refrain—especially for anyone who labors under the misapprehension that the current term of protection in the United States was extended at the direction of the Walt Disney Company in order to prolong the monopoly on Mickey Mouse. In fact, it is rather common to find editorials that leap directly from Macaulay's assumed prescience in 1841 to implications that Mickey was personally buttonholing congressmen in the corridors of the Rayburn Building in the 1990s. But the intervening century and a half tells a different story.

It was a barrister, jurist, and playwright named Thomas Noon Talfourd, who introduced the 1837 bill that proposed to extend the duration of copyright to sixty years beyond the life of the author. Representing Reading in the House of Commons from 1835 to 1841 and then again between 1847 and 1849, Talfourd's views on copyright were almost certainly colored, if not wholly inspired, by his close friendship with Charles Dickens. Widely believed to be the model for the good-natured Tommy Traddles in *David Copperfield*, Talfourd is also the dedicatee of Dickens's first novel, *The Pickwick Papers*, published in 1837: "If I had

not enjoyed the happiness of your private friendship, I should still have dedicated this work to you, as a slight and most inadequate acknowledgement of the inestimable services you are rendering to the literature of your country, and of the lasting benefits you will confer upon the authors of this and succeeding generations, by securing to them and their descendants a permanent interest in the copyright of their works."[2]

Regardless of myriad contemporary views about term length itself, many scholars would agree that Talfourd's bill was England's first truly authorcentric proposal. The law of 1814—the one that supposedly inspired Noah Webster to advocate the American amendment of 1831—had extended the original maximum term of twenty-eight years (established in the Statute of Anne) to the lifetime of any author who might still be kicking at the end of that period. But this was a last-minute amendment after six years of heated debate that had more to do with the cost of supplying university libraries with copies of books than with the pecuniary interests of authors and their descendants. Scholar Ronan Deazley notes that there is unfortunately no record of debate or rationale behind the "residue of his natural life" amendment introduced by Samuel Egerton Brydges,[3] thus making the debate over Talfourd's bill the first meaningful record of advocacy for authors' interests as distinct from the interests of booksellers. And the booksellers were not at all happy about it.

On April 25, 1838, Talfourd asked for a second reading—in Parliament, this is the first opportunity to debate the main principles of a bill—and observed, "Mr. Speaker, when I had the honour last year to move the second reading of a bill essentially similar to the present, I found it unnecessary to trouble the House with a single remark; for scarcely a trace then appeared of the opposition which has since gathered around it."[4] That opposition naturally came from the publishing industry, who, for obvious reasons, opposed the idea that a copyright should last beyond the life of the author, let alone decades after his death. Employing the same argument then that is often heard today, the booksellers warned that the public interest would suffer, either by a substantial increase in prices or a marked decrease in published works or both.

Some MPs who opposed Talfourd's bill concurred with the market-based predictions of doom, while others objected on largely ideological grounds, sharing Macaulay's view that, as a matter of principle, society should tolerate only as much copyright protection (an "evil") as is necessary to induce the author to create and publish his or her works.[5] But in oratory no less passionate or articulate than the oft-quoted Macaulay, Talfourd defended the principles of his proposed amendment, stating "the question is not one of reward—it is one of justice." He criticized the mercenary proposition of *not a day longer*, asking rhetorically, "Why were great writers to be placed in more than Egyptian bondage of receiving only just as much as would induce them to continue their labours?" To frame the issue, he cited the holding in *Millar v. Taylor* that authors had enjoyed a copyright in perpetuity at common law but declined to relitigate that principle before the Commons, saying that he remained "content to adopt an intermediate course" and so, in defense of a posthumous copyright, he stated:

And, as a far as analogy may govern, the very attribute which induces us to regard with pride the works of intellect, is, that they survive the mortal course of those who framed them—that they are akin to what is deathless. Why should that quality render them worthless to those in whose affectionate remembrance their author still lives, while they attest a nobler immortality? Indeed, among the opponents of this measure, it is ground of cavil that it is proposed to take the death of the author as a starting point for the period which it adds to the present term. It is urged as absurd that even the extent of this distant period should be affected by the accident of death; and yet, those who thus argue, are content to support the system which makes that accident the final boundary at which the living efficacy of authorship, for the advantage of its professors, ceases.[6]

Talfourd's bill eventually passed in amended form in 1842—a compromise attributed to the temporary loss of his seat during a period when he won a case as Dickens's barrister litigating a piracy of *A Christ-*

mas Carol.[7] The amended term provided for a statutory protection of forty-two years after publication, or life of the author plus seven years, whichever was the longer.[8] Though less than Talfourd had wanted, the new law represented a significant change in Anglo-American doctrine regarding the life-of-the-author-plus regime, fulfilling at least some measure of Dickens's hopes as expressed in the *Pickwick* dedication: "Many a fevered head and palsied hand will gather new vigour in the hour of sickness and distress from your excellent exertions; many a widowed mother and orphan child, who would otherwise reap nothing from the frame of departed genius but its too frequent legacy of poverty and suffering, will bear, in their altered condition, higher testimony to the value of your labours than the most lavish encomiums from lip or pen could ever afford."[9]

Granted that's a pretty lavish encomium, but with regard to the two views represented by Talfourd and Macaulay, Dickens's portrait of the family being sustained by the fruit of the late author's labor cannot justifiably be removed from the equation in which the incentive to publish works ultimately yields a benefit to society. Suffice to say, it is lopsided to present Macaulay's begrudging acceptance of copyright's necessary evil as the only, let alone definitive, word on the subject. As mentioned earlier in regard to interpretations of the American IP clause, modern pundits often engage in circular debate as to whether copyright exists primarily to serve society or to serve authors, despite the obvious conclusion that these aspirations are symbiotic. And inasmuch as the society-centric view might appear to be clearly stated with the words "to promote the progress," this is not quite so definitive as it may seem.

By the end of the nineteenth century, the duration of copyright protection was largely subsumed by the broader issue of international trade, which required harmonizing terms among multiple partners. France was in fact the first, in 1793, to adopt a term of life-of-the-author plus ten years, and this loosely reflects a philosophical difference in the two main international approaches to copyright—the French view that copyright's first purpose is to serve authors and the Anglo view that copyright's first purpose is to serve society. Although it would be

wrong to draw bright lines identifying the nationalities of these two perspectives, this is often how the two perspectives are described by scholars, and since so much of American law derives from English law, and is of course written in English, it is little surprise that the language of the founding period echoed precedent of the mother country. Nevertheless, Columbia University legal scholar Jane C. Ginsburg (daughter of Notorious RBG) offers the following counterbalance to an early twentieth-century report to Congress that skewed society-centric:

> Sources chronologically closer to the Constitution, however, treat the private and public interests more even-handedly. While records from the Constitutional Convention concerning the copyright clause are extremely sparse, a document dated August 18, 1787, notes that the proposed legislative powers were submitted to the Committee of Detail: "To secure to literary authors their copyrights for a limited time. To encourage by proper premiums and provisions the advancement of useful knowledge and discoveries." The referral to the Committee of Detail thus sets forth the authors' property interest ("their copyrights") and the public interest in advancement of knowledge as separate considerations of equal weight.[10]

In her conclusion to this paper "A Tale of Two Copyrights," Ginsburg contends, not surprisingly, that the French embraced a society-serving ideal while the Americans espoused an author-serving ambition. "An appreciation of the similarities between the initial French and U.S. literary property regimes may hold significance for modern copyright systems," she writes, "because it undermines historical assertions of the inherent and original incompatibility of the French and Anglo-American approaches to copyright." In 1990, when this paper was written, Ginsburg's recommended harmonization of theories was directly relevant to developments at that time. American inertia on the international copyright question continued well into the late twentieth century, while most of its major trading partners had long since established common principles that owed a great deal to the energies of Victor Hugo, who

had already articulated the supposedly incompatible—but actually symbiotic—views of copyright's purpose.

In a rousing speech delivered to the International Literary Congress in Paris in June 1878—this was after spending nearly twenty years in exile during the Second Empire under Napoleon III—Hugo won the crowd with his call for literary autonomy as a tool of liberty. "This hallowed property is daily violated by tyrannical governments, which seize control of publication, hoping thereby to control the author. Hence the system of official patronage, which takes everything and gives next to nothing in return. Dispossession and subjugation of the author follow. . . . Gentlemen, let us return to the principle: respect for property. Let us insist on literary property while at the same time fostering the public domain."[11] At the same time, Hugo also declared that any publisher should be allowed to reproduce and distribute a work after the author's death on the condition that a small royalty (5–10 percent) was paid to the author's heirs; and like Macaulay's address to Parliament, Hugo's speech is a favorite citation among those who believe modern copyright protection lasts too long.

Of course, we can never know what Victor Hugo might have thought about today's market, when, for instance, his great-great-grandson Pierre Hugo would fail in 2007 to prevent a sequel to *Les Misérables* called *Cosette ou le Temp des Illusions (Cosette or the Time of Illusions)*.[12] Arguing on the basis of "moral rights," Pierre accused publisher Plon of lazily capitalizing on a famous name and title to sell a book that "violated the integrity" of the original. "Can anyone imagine commissioning the 10th Symphony of Beethoven?" Pierre Hugo asked.

People of good intent can debate the merits of modern derivative works based on classics. For instance Alice Randall's novel *Wind Done Gone*, retelling *Gone with the Wind* from the point of view of a slave, survived a copyright infringement challenge and raised compelling issues, like Randall's right to comment on the revisionist history inherent to Mitchell's original work.[13] But it is probably safe to assume that if Victor Hugo could have imagined *Cosette* being published shortly after his death, he might have had a slightly different attitude about copyright

terms. In either case, it was greatly due to his leadership that the views of men like Talfourd were woven into the fabric of global copyright law.

The gathering of literary figures at that Paris convention in 1878 formed the International Literary Association (later the International Literary and Artistic Association), with Hugo as its first president, for the purpose of establishing a framework for the protection of literary property across national borders. Provisions were initially drafted at a meeting in the fall of 1883 in Berne, Switzerland, laying the foundation for the first multilateral, international copyright agreement, known as the Berne Convention, ratified by sixteen nations in 1887 and which today includes 176 signatories out of a total 195 countries in the world. Regardless of what Hugo thought about copyright expiring at the same time as the author, other participating nations already had posthumous terms in place—Sweden originally had a perpetual copyright—and no representative negotiator was likely to endorse a deal that would substantially roll back his own nation's established terms.

The first signatories to Berne adopted a voluntary term of life plus fifty years, which became mandatory in 1948. Meanwhile, the formalities in U.S. copyright law prevented American authors from participation in Berne for more than a century—namely the statutory requirements to register a work with the Library of Congress, to place a copyright notice on the work, and to renew registration in order to secure the maximum term of protection. These all conflicted with the mechanisms in Berne, which eschewed such conditions, and it was not until the Copyright Act of 1976 (the current law) that these formalities were amended and terms of protection in the United States were revised to finally embody the principles that Talfourd's bill had expressed 139 years earlier.

The life-plus-fifty term was proposed in the United States as early as 1965 during the roughly twenty years spent overhauling the law. As copyright expert Terry Hart writes, "Congress was concerned about the inequities that would fall upon authors because of a bogged-down legislative process, so during this time period, it passed a series of nine interim extensions to copyright duration." Hart further adds that the

well-known copyright critic Lawrence Lessig "counts each of these nine interim extensions when he makes his famous claim that Congress extended copyright term 11 times since 1962." What Hart is referring to here is the contemporary narrative that copyright keeps getting extended by powerful interests and that the major copyright owners (like Disney) will keep finding excuses to extend terms. In reality, copyright terms were extended in order for the United States to become a signatory to trade agreements, and no serious proposal to extend them has been made by any party since the last extension of 1998.

With the 1976 Act, the U.S. officially shifted from a maximum fifty-six-year term from date of publication to the life-of-the-author plus fifty model and also made copyright automatic for any work "fixed" after January 1, 1978.[14] But the notice requirement remained mandatory until the Berne Convention Implementation Act (BCIA) of 1988, which went into effect in 1989, for a grand total of 103 years after the treaty was first enacted—or nearly half the history the United States. Steven Tepp, a former Senate Judiciary Committee staffer and former senior counsel at the U.S. Copyright Office, writes in an email response, "The harmonization of the U.S. Copyright Act with international standards provided American authors with relief from the most draconian elements of the old formalities, and a longer term of protection. At least as important as those improvements was the protection of American authors in the other Berne countries."[15]

Continuing this theme of America playing catch-up, it was just three years before the United States finally joined Berne that the major trading nations of Europe adopted the Single European Act, which was followed by the collapse of Soviet satellite communism, the reunification of Germany, and the completion of the single-market European Union with the signing of the Maastricht Treaty in November of 1993. Copyright protection for signatories to Maastricht was extended by twenty years, and in response, a bill was introduced in February of 1995 by then-chairman of the IP subcommittee of the House Judiciary Committee, Rep. Carlos Moorhead, which would extend the American term to match that of the EU. "My boss at the time, Sen. Orrin Hatch,

introduced a Senate companion a couple of weeks after Moorhead, on March 2," writes Tepp.

Perhaps because Sonny Bono had been a performer before he joined Congress (arguably the lesser half of the Sonny & Cher singing and variety-show duo in the 1970s), it was just too easy to imagine the "Hollywood" representative as the Washington bag man assigned to rescue Mickey Mouse from falling into the public domain in 2003. But the boring truth is that Bono was just another cosponsor of the bill (as was Rep. Zoe Lofgren, by the way, who represents Silicon Valley and has been critical of copyright at various times). The bill that passed as the Sonny Bono Copyright Term Extension Act (CTEA) went into effect in 1998, and it was only given Bono's name as a posthumous honor after he died in a skiing accident that year.

Although the Walt Disney Company was certainly among the corporations that lobbied for the term extension, there is nothing in the record, including campaign or lobbying expenditures, to indicate that the studio played an outsize role relative to other petitioners who endorsed passage of the bill. Yet, despite living in the so-called information age, these publicly available facts have had little to no effect on the enduring mythology of the "Mickey Mouse Term Extension." The first Mickey films, made in 1928, *Steamboat Willie* and *Barn Dance*, will fall into the public domain on January 1, 2023, although it is almost certain that the iconic Mouse himself will remain protected in perpetuity by trademark because he has been so thoroughly incorporated into the Disney brand. For what it's worth, this was probably just as true in the late 1990s.

Of course, nobody can *prove* that copyright terms are set at their ideal length or, for that matter, that they are too long by a specific number of years. While it is constitutionally required, and generally accepted, that copyright protection must last "for limited times," it was famously observed by Mark Twain that the rationale for limiting terms is no less arbitrary than a rationale for extending them in perpetuity. Prefacing the idea that copyright is hardly the only convenient fiction, his 1906 speech to Congress relates the story of his testimony at the

British House of Lords in 1900: "I said there was property in ideas before Queen Anne's time; they had perpetual copyright. [Lord Thring] said, 'What is a book? A book is just built from base to roof on ideas, and there can be no property in it.' I said I wished he could mention any kind of property on this planet that had a pecuniary value which was not derived from an idea or ideas." Twain used this anecdote in advocating an extension of the United States' flat forty-two-year term to life-of-the-author plus fifty years, wryly endorsing this policy with the understated, "I have no illiberal feelings toward the bill," but then expounded:

> I understand. I am aware, that copyright must have a term, must have a limit, because that is required by the Constitution of the United States, which sets aside the earlier constitution, which we call the Decalogue. The Decalogue says that you shall not take away from any man his property. I do not like to use the harsher term, "Thou shalt not steal." But the laws of England and America do take away property from the owner. They select out the people who create the literature of the land. Always talk handsomely about the literature of the land. Always say what a fine, a great monumental thing a great literature is. In the midst of their enthusiasm they turn around and do what they can to crush it, discourage it, and put it out of existence. I know that we must have that limit. But forty-two years is too much of a limit. I do not know why there should be a limit at all. I am quite unable to guess why there should be a limit to the possession of the product of a man's labor. There is no limit to real estate.[16]

Though Twain's speech had many members of Congress chuckling, it was not sufficiently persuasive to carry the life-plus-fifty proposal, let alone perpetual copyright. Ultimately, the underlying rationale for the terms we have today is that copyrights should remain the property of an author's estate for roughly two generations of heirs, and this allowance is agnostic with regard to how successful the author may be, how long

he or she lives, or how the heirs may choose to administer the rights or make use of any royalties. The World Intellectual Property Organization Guide to the Berne Convention, published in 1978, states on the subject of terms that "honest men can differ on how long this should be: some feel it should be for ever since the nature of the work of the mind remains, throughout the ages, a reflection of the character of its creator. Like a fine piece of furniture, it gives pleasure to generation upon generation. . . . Most countries have felt it fair and right that the average lifetime of an author and his direct descendants should be covered, i.e., three generations."[17]

Although in 1978 these comments referred to a term of life plus fifty, the thinking was the same when that was extended by twenty years in the 1990s. And while honest (and not so honest) people do continue to debate whether expanding terms has done harm to the public interest, Talfourd's response of 1838 that the "accident" of death should not be the "final boundary" for the "living efficacy of authorship" was ultimately the principle adopted—rather than the reasoning from the "wit of Macaulay" and skeptical booksellers—by copyright regimes throughout the world.

Although the CTEA of 1998 is often portrayed as a relatively recent proposal written by big media corporations, its terms are, in fact, just ten years longer than the proposal made by Talfourd 161 years prior. Meanwhile, there is little, if any, evidence to show that Macaulay was right to predict that consumers would suffer either a paucity of works or a dramatic increase in prices for access to works, relative to the market for most other goods. Term length remains one of the most hotly contested issues, and there is no shortage of scholarship and commentary insisting that keeping works under copyright depletes the well of ideas (i.e., the public domain), despite all empirical evidence that output of creative works has continued to grow long after the passage of the term extensions.

One relevant side note about the original Berne treaty of 1887 is that photography was "designedly omitted" from the original provisions despite the medium's nearly half-century earning a creative pedigree

in several markets.[18] This exclusion may be explained by a lack of consensus on the topic among member states. From its inception, photography has presented a vexing challenge to the notion of authorship, and that qualifier in the *Sarony* case, that there may be no authorship in the "ordinary production of a photograph," has become a major theme in many of the copyright conflicts of the digital age.

II

Monkeys and Selfies and "Monkey Selfies"

I burn, I ache, I die, for something that is truly art. All
my art in the photograph, I value as nothing. I want
to make pictures out of myself, to group a thousand
shapes that crowd my imagination. This relieves me,
the other oppresses me.

—N. Sarony, *Wilson's Photographic Magazine*, January 1893

After Napoleon Sarony passed away at his home on West Forty-Seventh
Street on the morning of November 9, 1896, the elegies were unanimous
on the theme that he had almost single-handedly elevated photography
to an art form in a time of abundant mediocrity. "He was one of the first
to dignify our profession with the touch of the artist," wrote W. A. Coo-
per for *Wilson's Photographic Magazine*, "and was not surpassed by any of
those who have followed in the lines he marked out."[1] Whether Sarony
himself believed this to be true or, as implied in the epigraph, he felt that
what he most aspired to in art always eluded him, we can probably never
know for sure; but it is curious to think that the man who won the legal
battle defending the existence of the artist in photography—and who
played the *role* of the artist even more extravagantly than Oscar Wilde—
often had his own doubts that he was the real deal. In either case, the
name "Sarony" had acquired so much value that Napoleon's son Otto
sold it—twice.[2] In October of 1898, he sold the business to John Burrow
but then also licensed the use of the name "Sarony" to photographer
Theodore C. Marceau for a small share in Marceau's business, which

would become the first national franchise brand of portrait studios in the country.[3] After John Burrow transferred the business to his son Ernest, the latter ultimately prevailed in litigation with Marceau, winning the exclusive right to trade under the name "Sarony."[4] Beyond these legal matters, notwithstanding whatever details Erin Pauwels's research may yet reveal, the record is woefully blank, including the whereabouts of the tens of thousands of Sarony plates Burrow reportedly purchased along with the franchise. In fact, so little is known about John Burrow that some have speculated that the lithographer who lost the Oscar Wilde case was not the same man who bought Sarony's business, but this seems an unlikely coincidence.[5] Theodore Marceau, meanwhile, founded the Photographers' Copyright League in 1905 along with Benjamin Falk, and he was apparently the man who first proposed using the mark of a "C" inscribed by a circle as a universal notice of copyright—a convention codified in the 1909 Copyright Act.[6]

There is of course something absurd about the idea that "Sarony" would be used as a trade name to identify someone else's portrait business. Would any customer sitting in one of Marceau's studios really have believed that the ghost of Napoleon Sarony was directing her moment in the sunlight? (Certainly, if a contemporary school portrait company called itself Avedon Photographic, this would not lull parents into assuming their kids' pictures were destined for the covers of *Vogue*.) Yet, as Dorian-Gray romantic a notion as it may seem, to believe that a work is imbued with an artist's spirit, the assumption that a creative work does embody the artist's "personality" is a central conceit of both modern copyright and modern art. In fact it's funny that Sarony happened to be the subject of both a landmark copyright case and a significant trade name litigation at the approximate transition from classical to modern aesthetics in the art world. Because it was at about this same time that the legal definition of "authorship" was also changing. Where the court initially interpolated Sarony's creative "selections" from the evidence visible in "Oscar Wilde No. 18," a contemporaneous case marked a shift toward identifying authorship by mere virtue that a human being could reveal a "modicum of originality" in a work.

At this point, I will contradict what I said at the beginning about copyright grappling with *art* because we can also say that copyright does not concern itself with *art* at all; or at least it avoids defining what is or is not art, and it certainly protects works of authorship (e.g., journalism, computer code) that are not typically considered art. In the 1903 Supreme Court opinion, in a case that began the same year as *Burrow-Giles v. Sarony*, Justice Oliver Wendell Holmes Jr. wrote:

> It would be a dangerous undertaking for persons trained only to the law to constitute themselves final judges of the worth of pictorial illustrations, outside of the narrowest and most obvious limits. At the one extreme, some works of genius would be sure to miss appreciation. Their very novelty would make them repulsive until the public had learned the new language in which their author spoke. It may be more than doubted, for instance, whether the etchings of Goya or the paintings of Manet would have been sure of protection when seen for the first time. At the other end, copyright would be denied to pictures which appealed to a public less educated than the judge. Yet if they command the interest of any public, they have a commercial value—it would be bold to say that they have not an aesthetic and educational value—and the taste of any public is not to be treated with contempt.[7]

In this case, *Bleistein v. Donaldson Lithographing Company*, the plaintiff sued over the appropriation of illustrated posters made to promote the Great Wallace Show traveling circus. While its outcome is functionally recognized as the confirmation that creative works made for advertising may be protected by copyright, a more salient aspect of the opinion, as expressed by Holmes, is that the courts have no business acting as critics or arbiters of taste when it comes to assessing what kind of work may be "creative enough" for copyright to protect. From this, two precedents emerged: 1) the doctrine that a "modicum of originality" is sufficient for copyrightability, and 2) the idea that the "personality of the author" is somehow present in a creative work. Again, Holmes writes,

"The [creative rendering] is the personal reaction of an individual upon nature. Personality always contains something unique. It expresses its singularity even in handwriting, and a very modest grade of art has in it something irreducible, which is one man's alone. That something he may copyright unless there is a restriction in the words of the act."[8]

On the one hand, as Justin Hughes notes, this doctrinal transition gave us a "technologically neutral" and "egalitarian and democratic" copyright law whereby copyright now attaches automatically to a work upon *fixation*, no matter how the work is made, who makes it, or why.[9] "Following the Bleistein reasoning," Hughes writes about a subsequent case in which Judge Learned Hand extended Holmes's precedent,[10] "Hand felt that 'no photograph, however simple, can be unaffected by the personal influence of the author, and no two will be absolutely alike.'"[11] Consequently, almost everyone in America is a copyright owner—most typically owners of hundreds or thousands of photographic works—regardless of the fact that not everyone has reason to bother protecting and enforcing these rights.

That said, the universal nature of copyright, especially in photography, has taken on a new dimension in the digital age. As Pirie MacDonald anticipated in his 1908 testimony before Congress, it has become clear that, despite abandoning many traditional expectations of privacy as users of social media, we are still not entirely comfortable with the prospect of our images being exploited without permission. It would be the rare parent, for example, who would not mind if a picture of her child were taken from Facebook and used in a digital ad—especially if the ad promotes a product, service, or agenda that is contrary to her views. And while this type of use is most typically seen as infringing the subject's "right of publicity," copyright enforcement is sometimes the most expedient remedy to unlicensed online use through the takedown provisions established by the Digital Millennium Copyright Act (DMCA) of 1998.

Even individuals who suffer significant personal harm like "revenge porn" or other forms of harassment will avail themselves of DMCA takedown in an effort to remove their photos from certain platforms, despite the fact that the crimes committed against them are far more serious

than copyright infringement.[12] The point worth highlighting here is that even on the freewheeling internet—and even acknowledging many examples where copyright is not the ideal legal solution to a problem—it appears that most people still maintain a presumption of ownership, in even amateur works, and tend to view any unwanted exploitation of their works as a personal invasion. Just a few years ago, it seemed that every time Facebook amended its terms of service, my friends would post boilerplate declarations that the platform was not allowed to use their content without permission. Of course they might as well have waved dead chickens at their monitors for all the legal force behind those declarations, but those talismanic posts did reveal that the fundamental sensibility underlying copyright is still alive in the digital age, even though it is often conflated with the protection of personal privacy.

These sentiments collided with the "personality" of one artist in September of 2015, when Richard Prince exhibited a show at New York's Gagosian Gallery called "New Portraits," comprising thirty-eight poster-sized reproductions of other people's Instagram photos. Prince rephotographed the images he selected from the platform and then ink-jet printed them onto five-by-six-foot canvases, keeping some of the posted comments and emojis, and adding one comment of his own to each image. The loudest gasping reaction to this show came when Prince sold some of these pieces to collectors for as much as $100,000 each.[13] Although a few of the owners of the Instagram photos said they were flattered to have their pictures in a major New York art exhibit, professional photographers and copyright advocates were quick to *unpack their adjectives*[14] at Richard "fucking" Prince and his newest "lazy" offering in a long and oft-maligned career as an "appropriation artist." Even that indefinable society called Netizens, despite advocating the free use of everything online, seemed generally appalled that this wealthy star of the fine art world had violated some first principle of internet culture by taking photos that had been shared for free and turning them into quite a lot of money for himself. Here Holmes's "personality of the author" notion becomes complexly intertwined with the element of fame (i.e., the trademark of the artist) and, bizarrely

enough, in a circumstance in which the "soul of the works" cannot be said to embody even a hint of Richard Prince but rather the personalities of the people whose photographs he appropriated.

Stealing Souls

Critic Peter Schjeldahl called the "New Portraits" exhibit "inevitable," following a long tradition of "artifying non-art" by the likes of Marcel Duchamp, Jackson Pollock, and Andy Warhol.[15] And there is an extent to which even the "fuck-you-ness" of Prince's attitude does make an intriguing statement about visual works in the age of social media. As people upload what I would roughly estimate to be some 1.6 trillion images a day,[16] most of which will be viewed at a scale of about two-by-three-inches for a few fleeting seconds on cell phones, Prince succeeds—and partly because he provokes—by selecting a tiny handful of these photos to make art out of works that most of the original owners had effectively thrown away. Say what we will about Prince as an indolent craftsman, the Instagram exhibit, as a whole, directly confronted the ebullient culture of "remix" and "sharing" fostered by the internet by moving the venue away from the ephemeral, handheld screen to a physical gallery where visitors were induced to pause and look at painting-sized versions of these works. As my friend Chad Kleitsch, a visual artist who has artified a lot of non-art himself, says, "Photography asks us to hold still in a time when we're all 'gisting' our way through everything on social media,"[17] and in this spirit, Prince's theft of these images paradoxically reminds us that photographs are meant to be perused rather than atomized into the oblivion of cyberspace. Rude as Prince may be, his artistic statement strikes me as a bad-boy's response to Instagram that shares a kinship with Teju Cole's lighthearted observation about the same platform:

> There is of course nothing wrong with a photograph of your pug. But when you take that photograph without imagination and then put a "1977" filter on it—your pug wasn't born in 1977—you are reaching for an invented past that has no relevance to the subject

at hand. You make the image "better" in an empty way, thus making it worse. Your adoring fans or friends can instantly see your pug or your ham sandwich on which you have bestowed the patina of age. This immortal sandwich of yours is seen by hundreds of people even before you've finished eating it.[18]

Even a consensus that the "New Portraits" exhibit constitutes *art*, if there were one, would not entirely salvage each use in itself from an infringement of copyright; and one photograph Prince appropriated did trigger a lawsuit that, at the time of this writing, is still in progress. The canvas Prince called "Untitled" happened to be a reproduction of a photo with the title "Rastafarian Smoking a Joint," taken by fine-art photographer Donald Graham in Jamaica in 1996. Significantly, Graham did not upload this picture to Instagram himself, so there can be no question of his having made it available or "thrown it away" in any context.[19] In February of 2015, he sent a cease and desist letter to Prince and the Gagosian Gallery, and when this was ignored, he filed suit that December naming both as defendants in his claim of infringement.[20] Graham's attempt to enforce his copyright inspired Prince to flaunt via Twitter what he perceived to be his absolute right to use the work. "You can't sue me if its [sic] not for sale," he tweeted. "You can call me asshole lazy shit. But you can't sue me."[21] In fact, Prince's posting of a cropped and distorted "Rastafarian" in one of these heckling tweets is also included in Graham's three counts of alleged infringement in addition to the canvas itself and the use of "Rastafarian" in the Manhattan billboard promoting the exhibit. All three of these uses implicate the statute that grants the author the exclusive right to "publicly display" a protected work—a right that has been substantially diluted by the new normal in the digital age in which even commercial enterprises (including occasionally news media) fall into the habit of assuming that any photograph found online is free to use for any purpose.

While there are a few unusual characteristics about *Graham v. Prince*, it is the fair use defense that I find rather comically linked to the theme of "personality" because it boils down to a claim that Prince "transformed"

Graham's photograph mostly by putting the name Richard Prince on it, which is an act we usually call plagiarism. Without wandering into the tall grass of a fair use analysis, the crux of it is that Prince and Gagosian rely heavily on that idea of having "artified" these Instagram photos by placing them in the context of the exhibit. But because the soul of the work itself is still Graham's "Rastafarian Smoking a Joint," Prince is essentially claiming that "Untitled" osmotically acquired a new nature the moment it was bestowed with his Midas-like touch and given the identity "a Richard Prince work." This may seem like the height of arrogance, but Prince may have actually achieved that apotheosis in early 2016 when he disclaimed his authorship of the Instagram selfie of Ivanka Trump.

If a consumer sends her own digital photograph out to be printed on glass or canvas or some other decorative format, she might be willing to pay about twenty bucks for the service—perhaps a hundred for something really special—but Ivanka Trump shelled out $36,000 for her own Instagram selfie on canvas because it had been appropriated and "artified" by Richard Prince. And this is not nearly so amusing as the fact that in protest to the election of Donald Trump, Prince returned Ivanka's money and publicly declared that the print was no longer one of his artworks.[22] Copyright may be a "requisite fiction," but it is a metaphysical kiddie pool compared to the often turbid waters of the fine art world. In this case, Prince claimed to rescind his authorship of a *copy* of a photograph that the *purchaser* of that copy had taken of herself and then paid crazy-rich-people-money to own because it was no longer *her* work but *his*. In theory, Ivanka Trump could probably sue Prince for trying to devalue her investment in this way, but the ultimate irony is that the canvas itself will probably appreciate in value as a result of the story no matter what Prince says about it. That this enigmatic yarn happens to entangle two names that are both brands and, to many people, represent shiftless hucksterism in different worlds is one of those confluences of history that defy further comment.

But if Prince's Instagram art show was a remarkable illustration of an author presuming to endow creative works with his "personality," the

controversial "monkey selfie" saga is an odyssey through the ridiculous in the service of stripping an author's "personality" *from* a photograph—albeit one that reprises a number of fundamental principles (along with a fair bit of confusion) about the nature of authorship and copyright, particularly in photography.

The Instamonkey

Most people probably first encountered this story the same way I did—as a social media post about a "cheeky monkey" stealing a camera and taking its own picture.[23] Without reading another word, that headline already conjures an endearing mental image (like Curious George calling the fire department) that may not accurately describe events as they really happened—at least not with regard to the photograph in question. The photograph (in case you somehow managed not to see it) is a frontal close-up of a young crested black macaque staring at us through deep amber eyes and, apparently, grinning with pride as he snaps his own self-portrait. First reported in British papers in 2012, the story of the "monkey selfie" hit social media and, of course, the whimsical notion that the primates wanted to compete with Kardashians and other "Instagirls" was too charming not to go viral.

This initial attention to the "monkey selfie" was good news to wildlife photographer David Slater, whose agent had supplied the *Daily Mail*, *The Sun*, and *The Mirror* with press releases about his work with the endangered macaques of the Tangoko Reserve rainforest on the Indonesian island of Sulawesi. But, according to Slater's emails to me, he had given the press a peripheral anecdote that, at one point during his adventure, some monkeys had stolen his camera and snapped random photos, and this amusing detail quickly morphed into the narrative of the "monkey selfie." "All three [newspapers] changed the story a little, embellished it to suit their audiences, changed contexts and rearranged quotes from myself," Slater told me.[24] In light of events that followed, Slater would regret having given the press material that sparked a public copyright dispute over the photograph—first when the Wikimedia Foundation (which owns Wikipedia) asserted that there is no copy-

right in the image, and then, as a consequence of *that* squabble, the organization People for the Ethical Treatment of Animals (PETA) filed a lawsuit against Slater and publisher Blurb Books on the grounds that *they* had infringed the copyrights owned by the monkey.

Wikipedia Assumes the "Monkey Selfie" into the Public Domain

On August 7, 2014, a photo was posted to Twitter featuring Wikipedia founder Jimmy Wales making a smoochy, simian face, evidently about to kiss a poster-sized print of the crested black macaque who was by then widely recognized as the subject of the "monkey selfie."[25] For anyone who knew the story behind that tweet, it was no surprise that both photographers and copyright advocates justly interpreted the Wales "selfie-with-selfie" as a middle-finger directed at Slater in particular and at copyright in general. Moreover, the image was captured at a London event called Wikimania, where attendees reportedly mocked Slater's claim of copyright in the "monkey selfie," and this was understood to punctuate Wikimedia Foundation's decision to make the photo publicly available on Wikimedia Commons, "an online repository of free-use images, sounds, and other media," after Slater had asked the organization to take it down. The decision to continue hosting the photo was based on Wikimedia's own legal analysis that because the monkey had (allegedly) snapped the picture, neither Slater nor anyone else owned a copyright in the image.

The dispute between Slater and Wikimedia made worldwide headlines. Both Wales and Wikimedia, along with most of the internet industry, have so consistently opposed any form of online copyright enforcement proposals that many creators, even if they were unsure about the legal status of the "monkey selfie," did not appreciate the manner in which Slater's photo had simply been assumed into the public domain.[26] This is not to say that Wikimedia's conclusion was incorrect if the facts were on their side, but internet platforms and social media sites are not the venues for resolving facts in a legal context—and neither is this book that venue. Though I personally feel that Wikimedia should have removed the image as a matter of basic courtesy and believe they

refused to do so as a rather hollow statement (otherwise why all the gloating at Wikimania?), I will not presume to litigate a hypothetical claim by Slater against Wikimedia Foundation. Instead, the "monkey selfie" story belongs in these pages because of the legal principles it highlights and the amount of copyright confusion it caused—especially after PETA filed suit and advocated for the existence of animal copyrights. Although the PETA suit was the final act in this bit of absurdist theater, it points to the first principle that we should probably clarify.

No Monkeys or Elephants Need Apply

The idea of monkey authorship (or monkey anything) is an easy target for wry commentary, plenty of which I committed on *The Illusion of More* (at PETA's expense).[27] It cannot be denied, however, that even the unavoidable humor inspired by this story largely served to calcify the general perception that the monkey was the sole author of the "selfie." For instance, Bill Barol's *New Yorker* piece in August 2014, written from the point of view of the macaque, riffs, "When Monkey get inspired to turn camera and aim lens at face, Monkey not feel Monkey reinventing wheel or anything. It more an evolutionary step."[28] Well, cliché jokes notwithstanding, it is almost certain that Monkey did no such thing—neither aimed lens at face nor, most importantly, even conceived of taking own picture. With respect to the way stories get out of hand rather quickly in the digital age, Barol's innocent enough jibe was partly inspired by a putatively accurate report published on *Ars Technica* declaring that the U.S. Copyright Office had ruled, "Monkey's selfie cannot be copyrighted."[29] But not only did the Copyright Office not make such a ruling, it would have been inappropriate for the agency to have done so.

What the *Ars Technica* piece was referring to was the then very recent online publication of the *Compendium of U.S. Copyright Office Practices*—this is basically the operating manual for the USCO—which does in fact say that the office will not register "a photograph taken by a monkey."[30] Cited out of context, however, this sentence was widely reported by copyright watchers as though the USCO had directly commented on

Slater's claim of ownership in the photograph. In reality the *Compendium* is a massive, twelve-hundred-page project that was written and revised by multiple staff members, both attorneys and nonattorneys, over the course of about two and a half years, and it was merely coincidence that the third edition (since passage of the 1909 Copyright Act) happened to be published contemporaneously with the harangue over the "monkey selfie."

When I asked then Register of Copyrights Maria Pallante about the inclusion of the monkey photo reference, she confirmed that she could not even say which staff member had added the topical subject as an example, but that it was indeed used as an example and should not have been read as an official opinion by the USCO as to whether Slater's "monkey selfie" was protected.[31] The *Compendium* also names "a mural painted by an elephant" and "driftwood that has been shaped and smoothed by the ocean" as two other examples of nonhuman authorship ineligible for registration, and the underlying doctrine in this regard is nothing new. The section on nonhuman authorship (which directly cites *Sarony as a reference for human authorship*) states, "The Office will not register works produced by nature, animals, or plants,"[32] and this description is barely distinguishable from the language in the second edition of the *Compendium* of 1984, which says, "Materials produced solely by nature, by plants, or by animals are not copyrightable."[33] So, as mentioned, Wikimedia was right to assert that a photo taken by a monkey does not have a copyright, but the organization was also presumptuous to decide, without considering the unreliability of information in digital-age reportage and social-media buzz, that *this* photo was independently taken by a monkey. Because there is at least highly plausible evidence that it was not.

The Making of a "Monkey Selfie"

On his website, Slater describes shadowing a troupe of black crested macaques for three days, during which period, some of the monkeys did in fact steal his camera and snap a bunch of random photos—but not, he insists, the frontal close-up of the macaque that became known

as the "monkey selfie": "I decided to set up the camera on a beanbag on a log, self-timer all set. I was afraid they would run off course, but they didn't. Rather, they grabbed my camera!" Slater then states that after retrieving his camera, he decided to use the monkeys' interest in the equipment, and their fascination with their own reflections in the lens, to his advantage: "So I put my camera on a tripod with a very wide angle lens, settings configured such as predictive autofocus, motorwind, even a flashgun, to give me a chance of a facial close up if they were to approach again for a play."[34] Thus, it is Slater's account that the "monkey selfie" (and there are actually several similar images in the same series depicting different monkeys) was captured in this manner, with him prepping the camera and bracing the tripod.

This description of circumstances would normally affirm Slater's authorship of the resulting photographs under U.S. law. I say "normally" because copyright generally attaches to a work regardless of how it is made—there is no field in the copyright registration application asking for a production description—but with an implicit caveat that the author might want to keep his or her yap shut about the process. In fact the Compendium actually implies a kind of don't-ask-don't-tell policy when it states, in particular, that the Office "cannot register a work purportedly created by divine or supernatural beings, although the Office may register a work where the application or the deposit copy(ies) state that the work was inspired by a divine spirit."[35]

This explicit instruction was added as a response to religiously motivated authors who have at times been overeager to portray their creative works as the "voice of God speaking through them," or variations on that theme.[36] Copyright Office examiners have had to recommend to these applicants that perhaps they don't really want to credit the Almighty because this would render their work the legal equivalent of that piece of driftwood shaped by the ocean. An essential distinction is made, in other words, between citing some force—God, nature, drugs, alcohol, neurosis, demonic possession—as an inspirational component in the creative process and crediting that force as the *author* itself, which has used the human creator as a vessel.

In Slater's case, therefore, it would make all the difference in the world if his own description of the process is the accurate one; and as there is no other human witness to the events he describes, it seems likely that a court would extend him the courtesy of affirming his own testimony. Moreover, the series of photographs themselves reveal qualities that correspond with Slater's account. The depth of field, framing, position of the horizon, and eyelines all support his description of staging and bracing the camera while adopting a demeanor conducive to attracting the macaques and creating a situation in which the animals would mug the lens and trigger the shutter. By contrast, it is unlikely that one, let alone several, well-composed frontal close-ups would result from primates stealing and hand-holding a full-sized camera (Canon 5D Mark I with 16mm–40mm lens) pointed backwards at themselves, as Barol jokingly describes in his article. Could these photos be taken by primates approaching an unattended camera sitting on a tripod? Yes, but they would be more likely to occur if the camera is preset as Slater describes, with the intent to realize his conception of the resulting images. Also, when a photographer is truly not shooting, it is rare that he or she will walk away from a camera in the middle of a jungle, lens cap off and power on, wasting battery and risking damage. It's just not very good practice to leave camera equipment fully unattended at almost any point during a shoot, least of all around monkeys who have already shown an eagerness for stealing it. Nevertheless, it is undisputed that the monkeys pushed the button for these photos, and doesn't copyright go to the button-pusher? Not exactly. Quite often, not at all.

On the Irrelevance of Pushing of Buttons

In another *New Yorker* article published shortly before Barol's piece, Jay Caspian Kang wrote the following explanation, also inspired by the "monkey selfie" story:

> In the most basic and, perhaps, most outdated reading of United States copyright law, whoever pushes the button on the camera owns the copyright to the image produced, which means that if

tourists ask you take a photo of them at the Hoover Dam, and you happen to hit the shutter button at the exact moment that Kanye West goes flying by strapped to a jet pack, you, as the photographer, would get to sell that image to TMZ. The tourists do not get credit for asking you to take the photo, or for owning the camera on which it was taken.[37]

Kang is close, but even with the qualifier "most basic," this is not a very sound description of the manner in which copyright is vested in the author of a work. All the case law we've discussed leading up to and through *Sarony* should make clear that button pushing has little or nothing to do with who owns a copyright. Sarony did not push the button to capture "Oscar Wilde No. 18." In fact there was no button. After the earliest photographs were made by removing and replacing the lens caps—a motion too quick to disrupt a several-minute exposure—the next shutter-release technology was a rubber ball that the operator would squeeze to force a puff of air through a small tube and hold open the shutter for the desired exposure. In Sarony's case, this shutter opening was done by Ben Richardson, who had artistic talent in his own right but seems to have had no confusion about his role as a mechanical extension of Sarony's creative vision. Likewise, Dickson did not crank the Kinetograph to make "The Sneeze," and Augustin Daly did not personally haul a fake train across a proscenium in *Under the Gaslight*. Incidentally, David Slater also used a squeeze-ball shutter release, which he says the monkeys enjoyed clutching until they destroyed it.

Copyright coalesces around the mental conception of a work and *attaches* when that conception is fixed in a medium that other people (or machines) can perceive. So if the hypothetical tourists in Kang's photo selected the background (which tourists usually do) and also decided how to arrange themselves, they would at least be coauthors of the resulting photograph—even perhaps of the unexpected capture of the suddenly airborne Kanye West. On the other hand, one could argue that the *purely accidental* photo of Kanye would be tantamount to a mechanically made work without human authorship because the

mere fluke of a human finger pushing the button at the exact instant that an unexpected event occurs may not be the result of even a split-second's mental conception—at least not the way Kang presents the scenario. A monkey taking a photograph all by itself is, in theory, the unprotectable equivalent of a human accidentally snapping a picture she had no intention of taking or a security camera dumbly recording whatever enters its frame or, as may become increasingly relevant, an AI producing a creative work. So if you capture a flying celebrity in exactly this manner, don't talk about the process if you want to copyright the image.

Of course, if you immediately grabbed a second shot of Kanye on purpose, then copyright attaches without question. I doubt very much, for instance, that anyone would think to reject the copyright of photojournalist Richard Drew, who on September 11, 2001, was present at the World Trade Center where he took the photo titled "Falling Man"—a neither hypothetical nor humorous version of what Kang is driving at, despite the fact that much of the photograph's expressive power is the result of pure happenstance. More than just the fact of a person who (like Lewis Payne) is "dead and going to die," having leapt from the smoldering tower, the punctum in Drew's photograph is the position of the man's inverted body, which compositionally bisects the solid vertical lines of the building in the background as it hangs frozen in an involuntary pose that looks almost aerobatic and placid. The counterpoint of this Zen-like mood draws us immediately into the doomed stranger's mind where we cannot help but anticipate the long seconds remaining after that unthinkable decision. As one of those photographs that is instantly both journalism and art, "Falling Man" fulfills the rationales for granting copyright to photography—with its democratically low threshold of originality and its incentive for the photojournalist to hone his craft and to be where he needs to be.

PETA's Very Own Monkey Trial

PETA is known for engaging in outlandish stunts—they call them "wacky stunts" on their own website[38]—and while the monkey copyright lawsuit

was less provocative than dumping horse manure in front of Gordon Ramsay's Claridge's Hotel restaurant in London, it was a major step up the ideological ladder as a PR gimmick.[39] Advocating for animal copyrights was a rather bold philosophical statement within PETA's milieu, and federal litigation can be a conveniently stately and quixotic process to use as a fund-raising vehicle.[40] "We first saw the monkey selfie in approximately 2014 when the dispute between Mr. Slater and Wikimedia became international news," PETA's general counsel Jeff Kerr told Dana Chivvis on *This American Life*. "Our view was immediately that [the monkey], who created the photograph, should own the copyright to it."[41] So, in September 2015, PETA filed a complaint in the District Court for the Northern District of California alleging that David Slater, San Francisco publisher Blurb Books, and Slater's business entity Wildlife Personalities Ltd. had infringed the copyrights owned by the Sulawesi crested black macaque they identified as the plaintiff Naruto. The organization did not need to win the case—in fact they never really stood a chance—in order to make sufficient noise splashing the papers and the internet with headlines rhetorically asking whether *animals can own copyrights*.

Although most legal experts (and even amateur law nerds like me) could easily answer that question with an emphatic no, PETA's assertion of animal copyrights, because it was so flawed, inadvertently reinforces our understanding about the nature of copyright and the fact that what it protects is exclusively human. Although we share many intriguing, perhaps even humbling, commonalities with primates and other mammals, humans remain the only beings on Earth for whom the chaos of evolution produced a capacity for the kind of complex vocabulary necessary to *invent* a reason to take a photograph, to *invent* the tools for doing so, and to *invent* a rationale for owning the rights to a photographic image as a kind of property.

A handful of notable primates have been taught rudimentary dialogue (mostly through sign language) by humans, but even these limited endeavors have never produced a conversation that extends much beyond the interactions one has with human toddlers—except that

human toddlers are probably more unreasonable. In 2003, testing what is referred to as "The Infinite Monkey Theorem," University of Plymouth researchers left a computer keyboard in the care of six crested macaques in order to test whether there might be any merit to the fanciful notion that, given enough time, primates would eventually produce the works of Shakespeare.[42] In this experiment, the macaques typed five pages devoid of a single word in any known language, made abundant use of the letter *s*, and liberally relieved themselves on the keyboard. Of course, "Anyone who hasn't felt like that has never tried writing anything," Roy Blount Jr. observed, but there is little reason to assume that more monkey-typing would eventually produce a single haiku, let alone Shakespeare.[43]

Nevertheless, PETA pressed its claim toward the insurmountable hurdle that, even if the court were to allow their arguments to be presented, the animal rights group could never have demonstrated how they might know Naruto's intent to create a photograph, or his wishes with regard to exploiting that photograph in any particular manner. And Jeff Kerr all but acknowledged this flaw in their claim when he further expounded on *This American Life*, "[Copyright law] doesn't say that the author has to know that he or she is making a photograph."[44] Actually, copyright law does indirectly say that the author has to "know" that he is creating a work. Every topic we've discussed so far points to the fact that copyright protects the *mental conception* of a work once it is fixed in a tangible medium. Therefore, the author must have that conception and must consciously choose the manner in which the work may be exploited in order for the copyrights in the work to mean anything at all. So, even though the district court held, and the appellate court affirmed, that animals do not have standing to file suit under U.S. copyright law, an underlying reason for this was the devil's brick in PETA's wall: There is simply no way to demonstrate 1) that Naruto conceived of taking a photograph, or 2) that he cared one whit about its subsequent use. If Naruto were to appeal to his civil rights, one would think he might prioritize the right not to be threatened with extinction through habitat destruction and poaching over his authorial rights in a photograph.

In fact, one truly regrettable absurdity that I find impossible to overlook in this case is that the reason why animals may not own copyrights is the same reason why conservationists and scientists speak on behalf of endangered and threatened species like these macaques: because the animals cannot speak for themselves. And as if to emphasize the irony in this whole mess, it just so happens that one of the few ways animals *do* speak for themselves, at least to most of us, is when they are photographed by professionals like David Slater, who devote their time, expertise, energy, and money to showing us otherwise invisible places and things. Because behind the rather pointless copyright circus created by both Wikimedia and PETA is a vulnerable, amber-eyed fellow, apparently smiling for us but who, in truth, is merely fascinated by his own reflection and without the slightest notion of the *mirror with the memory.*

12
Art Is Theft

Variations on the theme that *good artists borrow while great artists steal* is, funnily enough, a chronically borrowed sentiment itself—one often credited to Pablo Picasso, but also uttered by T. S. Eliot, James Joyce, Igor Stravinsky, and doubtless many others. Aaron Sorkin even wrote a version of this maxim into an episode of *The West Wing*. And while it is universally understood that creators in all media build upon precedent works, the often fuzzy line separating plagiarism from new expression can be especially vexing with regard to the right of the author to create "derivative works" under copyright.

For Burrow-Giles to produce a lithograph of "Oscar Wilde No. 18," somebody had to draw a freehand version of Sarony's photograph that, if one wanted to nitpick, is not a rigorously faithful reproduction of the original. Many details in the lithograph are demonstrably differ-ent from the photo, most notably the rendering of Wilde's face, but a contemporary court would still say, as the nineteenth-century one did, that the original and expressive elements in Sarony's photo were reproduced by Burrow-Giles and would also recognize that the purpose in making the reproduction was to usurp the trade card market that rightly belonged to Sarony. But if *Burrow-Giles v. Sarony* really were a modern lawsuit, within the context of modern art, the internet, and contemporary thinking about what we call the fair use doctrine, the question arises, how much more different would Burrow's lithograph need to be in order for it to be considered a new work depicting an original interpretation of a famous person whom everyone agrees Sar-ony did not *invent*?

If John Burrow were running a postmodernist art factory like Andy Warhol or Richard Prince, how much alteration to "No. 18" would be necessary in order for a court to find that he made a fair use of the image as a source for a new expression? Or, to put it in contemporary doctrinal terms, at what point is a "transformative" use of a work no longer "derivative"? Transformativeness favors a finding of fair use because it results in a new expression, while the making of a derivative work is the exclusive right of the author. But where does derivative end and transformative begin? That question is one of the more contentious battles presently being waged among artists, scholars, and copyright watchers like me—a subject that is emotionally charged with the elements of fame and money, and one that has recently involved two very different artists named Prince.

The consideration called "transformativeness" in a fair use analysis is credited to (or blamed upon, depending on one's point of view) Judge Pierre N. Leval and the paper he published in the *Harvard Law Review* in 1990 called "Toward a Fair Use Standard." Leval sits on the Second Circuit Court of Appeals based in New York, which, along with the Ninth Circuit based in San Francisco, is one of the two most active copyright circuits in the country, and which has been the venue of some of the more controversial cases involving photographs in recent years. Leval's "transformative" test is generally portrayed as having been applied for the first time (and correctly) at the Supreme Court in 1994 in the appeal of 2 Live Crew and its fair use defense of its raunchy hip-hop song "Pretty Woman," which appropriated the bass-line, refrain, and other recognizable elements from "Oh, Pretty Woman," cowritten by Roy Orbison and Bill Dees, and performed by Orbison as a single in 1964. Initially 2 Live Crew sought permission from publishers Acuff-Rose Music to produce their version but were turned down, so they recorded the song and released it anyway. Acuff-Rose sued and prevailed in the lower courts, but on appeal at the Supreme Court, the justices gave considerable weight to the idea of "transformativeness" in a unanimous decision to overturn the findings of infringement and remand for reconsideration under a new fair use analysis.[1]

Although the parties settled before a new proceeding took place, the Supreme Court opinion in *Campbell v. Acuff-Rose* (Luther Campbell is a member of 2 Live Crew) remains a highly influential precedent in fair use considerations. In particular, the opinion, written by Justice David Souter, found the argument persuasive that 2 Live Crew's version can be considered a *parody* of the sentiments expressed in the original and, therefore, the rappers' use of significant, recognizable elements of the Orbison/Dees song was integral to the new expression. In his concurring opinion, Justice Kennedy did warn the courts that "they must take care to ensure that not just any commercial takeoff is rationalized *post hoc* as a parody," and one significant aspect of *Campbell* is that the legal analysis cut through sentiment, including whatever role racial or cultural bias might have played in shaping those sentiments. Whether one is personally disposed to love or hate the irreverent remix of the Orbison classic is immaterial with regard to the fact that the august Supreme Court unanimously upheld the principles that 1) courts are not supposed to be art critics and 2) the fair use exception exists in order to extend or ensure copyright's purpose to "promote the progress" of new forms of expression.

In homage to Souter's having written the opinion in *Campbell*, the publishers of the irreverent legal journal the *Green Bag* made bobblehead dolls depicting the justice sporting a big, gold, hip-hop artist's chain over his black robe, which I only know about because my longtime friend Sandra Aistars has one of these statuettes in her office at George Mason University. Now a clinical professor of law and Director of Copyright Research and Policy at the university's Center for the Protection of Intellectual Property, Sandra is the copyright expert and advocate who, I guess one would say, dragooned me into this world in 2011, and she seemed the right person to ask how she thought the concept of transformativeness had changed since *Campbell*. In an email reply, she wrote,

> Jurisprudence regarding the "transformative" test has continued to expand since the decision in *Campbell*. In *Campbell* and other

fair use cases up to that time, the courts required that a new expressive work result from the use. Moreover, particularly where parody was involved—as it was in *Campbell*—courts considered whether it was necessary to use the original work in order to make the author's point. In the last two plus decades since, courts have found fair use even where only minimal changes have been made to the underlying work, even with testimony from the artist that he did not intend to make any commentary on the underlying work. This is not necessarily bad doctrine in terms of promoting creative interaction with and use of works, but it pushes the limits of fair use by encroaching on the territory of the derivative works right.[2]

In fact, while I was drafting this chapter, the District Court for the Southern District of New York decided on July 1, 2019, that when Andy Warhol made a sixteen-image series depicting the rock star Prince in 1984, he made fair use of the unpublished photograph captured by Lynn Goldsmith in her studio on December 3, 1981. To answer the question why this case is being litigated nearly forty years after the alleged infringement, Goldsmith states that she was not aware of the Warhol versions until Prince's unexpected passing on April 21, 2016, resulted in Condé Nast publishing a special edition tribute magazine featuring one of the Warhol images on the cover.[3] Goldsmith contacted the Andy Warhol Foundation (AWF), which manages and licenses most of Warhol's works, and told them she believed their images infringe the copyrights on her still-unpublished photograph. In response, AWF filed a preemptive lawsuit seeking a declaratory judgment of noninfringement on the basis of fair use, thereby triggering yet another dramatic narrative in which an institution with financial resources and big-name recognition is forcing an independent creator to defend her *own* work in an expensive litigation.[4]

Federal court is a costly venture, and as Nova Southeastern University Copyright Officer Stephen Carlisle writes, "The Andy Warhol Foundation sued *her*, to boldly establish their right to freely plagiarize her work. The end result is she spent $400,000 defending herself. In

order to appeal, it might cost her $2.5 million before it is all done. She has started a GoFundMe Page to help pay her legal fees."[5] Carlisle is no fan of this decision, to say the least, and he has been especially vocal on the broader topic that the transformativeness concept in fair use considerations is threatening to extinguish the derivative works right. But although I generally agree with that perspective—and I do think AWF's lawsuit is unfair to Goldsmith—the particulars of this case strike me as complicated, based partly on the lessons in *Sarony*. And it is not irrelevant that the subject of these images happens to be a very famous celebrity whose true identity was at least as enigmatic as Oscar Wilde's.

Reminiscent of Sarony's description of his approach to portraiture, the court's opinion summarizes, "Goldsmith's work centers on helping others formulate their identities, which she aims to capture and reveal through her photography. To expose and capture her subjects' 'true selves,' Goldsmith employs several interpersonal techniques to establish rapport with her subjects, as well as several photographic techniques with respect to lighting, camera position, and other elements."[6] Thus, Goldsmith contends, with good reason, that she succeeded in capturing a photograph that reveals the "vulnerable human being," about to become the world-famous purple provocateur whose overt sexuality and musical genius both defined and transcended the musical-visual explosion of the 1980s. "To me, he was the single most talented musician—certainly to come out of the 1980s, if not all of rock and roll," wrote Lisa Robinson for *Vanity Fair* immediately after the world learned of Prince's death. "He could play every instrument, he heard every note—he was our Mozart."[7]

After the June 1984 release of the album *Purple Rain*, followed by the motion picture of the same title in July, *Vanity Fair* licensed Goldsmith's photograph for four hundred dollars in connection with the magazine's plans to publish an article called "Purple Fame" in the November issue. Assuming her black-and-white photograph would be published more or less as she had delivered it to the magazine, Goldsmith's testimony states that she did not know the editors would loan her print to Andy Warhol to use as a "reference" for making one of his vibrantly colored

silkscreen portraits for which he has famously used photographs of Marilyn Monroe, Mao Zedong, Elvis Presley, Jackie Kennedy, and others.[8]

In the Harry Benson documentary mentioned in the introduction, Benson's wife, Gigi, describes a similar situation with *Vogue*, when the magazine requested one of their photographs of President Ford but also arranged to have it *Warholified* for the magazine. "It's like the child that comes and scribbles all over your picture," says Benson in the film, albeit softened by the Scottish lilt that sounds more inquisitive than outraged. "It's criminal. It's my photograph. I didn't give any kind of permission." When he saw Warhol at a party and approached him about the Ford picture, Benson reports, "He said, 'Did they pay you for it?' I said, 'Yes, but not as much as you got, I bet.'"[9]

This theme of deference to fame and money (not that Benson was obscure in 1974) is a significant dimension of the complaint that Goldsmith and other photographers have with these "artifying" uses of their images. After the District Court ruled in favor of AWF, *ArtNet* reported, "Goldsmith's lawyer, Barry Werbin . . . claims the decision further hobbles the rights of photographers in 'favor of famous artists who affix their names to what would otherwise be a derivative work . . . and claim fair use by making cosmetic changes.'"[10] If that complaint sounds a lot like what I said about Richard Prince and the Instagram series, this is because Werbin is directly referring to *that* Prince in context of Warhol's use of Goldsmith's photo of the other Prince. Why? Because in 2011, Richard Prince mostly prevailed in the lawsuit *Cariou v. Prince* at the Second Circuit in a highly controversial decision that he had made fair uses of several Rastafarian photographs (I don't know what it is with Prince and Rastafarians) taken by French photographer Parick Cariou.

In that case, Richard Prince made twenty-nine visual works that used all or part of Cariou's photographs, of which twenty-four were held to be fair uses by the court. While *Cariou v. Prince* was a major source of outrage in the photographic community—until the Instagram debacle went viral and shifted attention to what Prince had done now!—it does seem reasonable to conclude that at least some of the works Richard Prince made would not be considered "derivative works," like the image

called "James Brown Disco Ball," a mixed-media collage that only uses portions of Cariou's photographs. But some of Prince's appropriations in this series definitely walk a fine line toward infringement by copying a substantial amount of Cariou's authorship for purposes that seem like little more than sloppy defacement rather than anything newly expressive.

One of the most commonly featured side-by-side examples on the photography blogs was Cariou's photo of a Rastafarian man standing quarter-profile and looking at the camera, next to Prince's version of this photo, onto which he had painted three blue ovals (supposedly called "lozenges") over the man's eyes and mouth and also pasted a cutout of an electric guitar positioned to make it look as though the Rastafarian is jamming.[11] It is certainly the kind of inscrutable (some might be tempted to say *insipid*) use that will outrage photographers, given that its strongest statement may be a declaration that *Because I am Richard Prince, everything I make, no matter how lame, will be celebrated and purchased as works of fine art.* Theoretically, the offense some folks may feel should be overlooked, just as the offense many felt about the "vulgarization" of "Oh, Pretty Woman" was properly not a legal consideration. On the other hand, is Prince's use in this example a fair use, visual analog to 2 Live Crew's musical parody, or is it just lazily appropriating someone else's work? In fact, Aistars's comment above about artists admitting when they're not even trying to comment on the original work is a direct reference to *Cariou v. Prince* and Prince's general attitude that anything he finds is there for the taking. Some courts have held that this is sound fair use doctrine, but this has also caused a lot of confusion in a world where anybody can simply grab an image off the internet.

While the fine art world is free to celebrate whatever and whomever it wants, the courts are not supposed to engage in "star-fucking," to use a modern pejorative version of Holmes's admonition in *Bleistein*, and this is more or less what Goldsmith and her attorney are alleging with regard to the fair use finding in favor of Warhol. Stephen Carlisle describes in his blog how the district court was bound by its own cir-

cuit's decision in *Cariou* to find for AWF; but at the same time, this view of the "transformative" precedent is not embraced by all courts.[12] When Sconnie Nation "artified" Michael Kienitz's photograph of Mayor Paul Soglin of Madison, Wisconsin, to make tee-shirts and tank tops for a civic event, the Seventh Circuit affirmed this was a fair use but also rejected the reasoning in *Cariou*, writing, "We're skeptical of *Cariou's* approach, because asking exclusively whether something is 'transformative' not only replaces the [four fair use factors to be weighed] but also could override [the author's exclusive right to prepare] derivative works." Still, even without the controversial transformativeness test, the court concluded, "the original's background is gone; its colors and shading are gone; the expression in Soglin's eyes can no longer be read; after the posterization and reproduction by silk-screening, the effect of the lighting in the original is almost extinguished. What is left, besides a hint of Soglin's smile, is the outline of his face, which can't be copyrighted."[13]

Because that analysis could *almost* describe what Warhol does with many of the photographs he turned into silkscreens, including Goldsmith's photo of Prince, I am inclined to think Goldsmith's case is a little more complicated than the fact that *Cariou* is a binding precedent in the Second Circuit. What is always tricky about photographs—and the reason I think they are a rich source of debate about copyright—is their enduring paradoxical nature as *unprotectable* records of fact and *protectable* works of creative expression at the same time. While there is no reason whatsoever to reject the claim that Lynn Goldsmith authored the photograph of Prince by making creative decisions to draw the "vulnerable human being" out of her subject and fix that moment on film, the caveats dating back to *Sarony* and earlier insist that Goldsmith may neither copyright Prince himself nor the *idea* of Prince looking vulnerable. Based on what we know about the complex uniqueness of human facial expression, it is almost certain that Prince "looked vulnerable" in this same way on many occasions in his life, and it is more than conceivable that another photographer could—and quite probably did—capture that particular truth on film. This does not in any way

rob Goldsmith of her authorship in the exact photo in question, but I raise these qualifiers to make a distinction between what is generally referred to as "thin" versus "thick" (or broad) protection, which can be understood as describing the measurable amount of original elements in a given work.

As a simple example, Annie Leibovitz's overhead shot of Whoopi Goldberg lying almost entirely submerged in a bathtub full of milk can be said to have thicker protection than a traditional studio head-shot of Whoopi Goldberg taken against a plain background. This is because there are quantifiably more expressive elements arranged by the photographer in the bathtub photo than there are in the headshot, no matter how expressive, poignant, or honest the headshot may be. This is not to diminish the many hundreds of variables from which a photographer may choose to produce a classic headshot, but with each creative addition to a composition, the variables multiply and so add layers of thickness to the originality of the final image.

That example roughly provides some context for what the court is being asked to weigh when considering whether Warhol's screens are new works because they have transformed enough of the expressive elements from Goldsmith's photograph, or if they are derivative works because they are so obviously versions of her expression that only Goldsmith has the right to make them. A minority of copyright cases end up in front of juries, but if this one did, it is not hard to imagine how a panel of ordinary observers might be very divided on the matter. Are Warhol's screens copies of Goldsmith's photographs? Absolutely. No expertise is required to see that the underlying work is clearly Goldsmith's photograph. Do Warhol's screens change or add something to Goldsmith's photograph to create a new expression? According to the court, citing *Cariou*, they do: "If 'looking at the [works] side-by-side,' the secondary work 'ha[s] a different character, . . . a new expression, and employ[s] new aesthetics with creative and communicative results distinct' from the original, the secondary work is transformative as a matter of law."[14]

But even without that precedent, it cannot be denied that the Warhol images convey something different than what Goldsmith's photo-

graph conveys. By altering the pictorial elements to painterly line, solid color, and two dimensions, Warhol presents Prince as an icon, which one could argue is the antithesis of a "vulnerable human being." At the same time, the silkscreened versions also declare rather brazenly that this is *WarholPrince*—because the style is so familiar to our visual vocabulary—placing Prince in the firmament of Warhol's constellations, which is one aspect of the expression that many photographers find so offensive, but which also tilts toward favoring AWF's argument that the works are transformative.

Alternatively, if we go back to *Sarony* and its analogies to music to suggest that any ordinary observer can clearly see that the underlying composition—the so-called melody—is Goldsmith's photo, then Warhol has essentially used an existing composition in a new arrangement, and this would not reasonably be considered fair use in a music case. David Bowie's song "Andy Warhol" played on kazoo, ukulele, and glockenspiel would still be David Bowie's "Andy Warhol." (Although Warhol hated the song when Bowie first played it for him at The Factory in 1971, the pair eventually bonded.[15] In 1995, Lynn Goldsmith once photographed Bowie disguised as Warhol stepping out of a limousine.)

Of course, drawing analogies from one medium to another does not always quite satisfy. The expressive elements in music are not the same as the expressive elements in a photograph, and to the extent that the latter relies substantially on an assumption that the personality of the photographer is present in the work, it is hard to say definitively that Warhol's versions are not new expressions. In fact, if Goldsmith or Benson or any other photographer turned the tables and made silkscreen versions of their own photographs in the style that most viewers would assume are Warhols, would the Andy Warhol Foundation have a problem with this? They might, though it is hard to imagine how they would have a legal basis for a complaint. Carlisle worries that decisions like *Goldsmith* "paved the way for bootleg knocks-offs of famous artists' work,"[16] and this may be especially prophetic as we cross the threshold into a future of art without artists.

13

Invasive Species

When Machines Make Art

> Better to take pleasure in a rose, than to put its roots
> under a microscope.
> —Oscar Wilde, "The Truth of Masks: A Note on Illusion"

In addition to Mark Twain, the other famous and oft-quoted witness
at those congressional hearings in 1906 was the composer John Philip
Sousa, who in that same year published a rather florid article in *Appleton's
Magazine* railing against the encroachment of phonographs and player
pianos as if they were invasive species threatening an ecosystem. "We
may observe the English sparrow, which, introduced and welcomed in
all innocence, lost no time in multiplying itself to the dignity of a pest,
to the destruction of numberless native song birds, and the invariable
regret of those who did not stop to think in time," Sousa begins.[1] This
editorial, unambiguously titled "The Menace of Mechanical Music," is
frequently cited—along with the hyperbolic comparison of the VCR to
the Boston Strangler by the Motion Picture Association of America's
president, Jack Valenti, in 1982—as evidence that copyright owners
have a long history of overreacting to (that is, trying to stop) technolog-
ical advancement.[2] Of course, the frequency with which contemporary
critics repeat Valenti's 38-year-old and Sousa's 114-year-old comments
might suggest that the generalizations drawn from these two examples
are a tad overstated themselves.

The fact is that whether change occurs due to technology or business practice or market dynamics, *all* vested interests can be relied upon to defend their own intellectual property rights, sometimes with sound reasoning, other times with overwrought emotion, and quite often with a bit of both. "Shall we not expect that when the nation once more sounds its call to arms and the gallant regiment marches forth," writes Sousa, "there will be no majestic drum major, no serried ranks of sonorous trombones, no glittering array of brass, no rolling of drums?" These blaring horns of prophecy are an easy target of ridicule from the advantage of hindsight, but Sousa's aim was not really to bring an end to mechanical music; it was to make a case that the composers deserved to share in the new market created by the machines. Finally getting to the point, he writes, "The composer of the most popular waltz or march of the year must see it seized, reproduced at will on wax cylinder, brass disk, or strip of perforated paper, multiplied indefinitely, and sold at large profit all over the country, without a penny of remuneration to himself for the use of this original product of his brain."[3] Although Sousa groups recording technology (like the wax cylinder) and mechanical reproduction of composition (like player piano rolls) into a single complaint, these two subjects of copyright diverge in the early twentieth century into distinct and intertwined narratives that are too complex to fairly summarize here.

Several years ago, I walked into Terry Hart's office in Washington DC to find he had drawn a musical licensing schematic on his whiteboard that looked like the kind of Rube Goldberg plans Wile E. Coyote would sketch out before his next futile attempt to catch the Road Runner. Add to that tangled framework all the emotion, greed, substance abuse, sex, genius, and madness inherent to the music business, and there is just no way to succinctly tell that story. Suffice to say, however, that in 1908, the Supreme Court held in *White-Smith v. Apollo* that piano scrolls were not copies of "writings" (i.e., musical scores) because only machines, and not humans, could read them. The effect of this decision was overturned in less than a year by the first modern revision of the Copyright Act in 1909, which protected all reproduc-

tions of compositions, whether readable by humans or machines, hence the term "mechanical license" for the compositions themselves. Then, fast-forward another century to the present, and legal scholars have moved well beyond the question of machine-readable works authored by humans and have now begun to explore the copyright implications of human-readable works authored by machines. More than a copyright question, of course, this discussion is just one fragment in the broader existential burden implied by our seemingly inexorable march toward automation and the dystopian threshold we might cross if machines no longer served our purposes and we instead served theirs.

This theme, in which we invent the tools of our own obsolescence, is of course the ontological conundrum that sci-fi writers and futurists have been addressing since long before the first computer was assembled. It is only in the last decade or so that some economists have begun seriously to contemplate societies in which the demand for human labor could realistically be reduced by 40 percent or more.[4] The legal and creative challenge posed by photography in 1882—the delineation between man and machine—is, therefore, not just an arcane narrative about copyright and photographic history; it is an examination of the enigmatic nature of making creative works in the first place—and by extension, explores the role those inventions play in shaping our perception of ourselves.

Photographs were the first creative works jointly made by man and machine, but because the machine is not remotely aware of its purpose to take pictures, it certainly cannot be described as having any desire to do so, and its human user is not required to share creative credit with the camera. Even if the photographer sets the timer and the camera triggers its own shutter, we would never think of this as the camera having *decided* to take a photograph. But far beyond that rudimentary single command (to take a picture in, say, ten seconds), humans are now giving much more sophisticated machines millions and millions of commands, including instructions that allow a computer to make independent "choices" in the production of a new creative work. Yet, though AI-authored art is no longer theoretical, there may never be

an artificial intelligence that actually wants to express itself. Like the monkey selfie story, the very real prospect of AIS sharing the stage with human creators reprises the anthropological question posed by the cave paintings: Why do people produce creative works in the first place? Perhaps one answer to that question is implicit in the likelihood that even if an AI were to attain what we call consciousness, it might not choose to say anything that we, or it, would call creative.

In 2016, an AI produced a brand new Rembrandt painting 347 years after the real Rembrandt died. The project was a marketing concept developed by the advertising firm JWT Amsterdam for its client ING Bank, which "always thought of itself as innovative, and it worried that its 10-year sponsorship of Dutch arts and culture was feeling stuffy,"[5] writes Tim Nudd for *AdWeek*. So JWT's creative director Bas Korsten and head of technology Emmanuel Flores assembled a team of art experts and computer scientists, who spent eighteen months training an AI how to paint an original portrait in the "hand" of Rembrandt van Rijn. "To teach Rembrandt's style to the computer, the team gathered enormous amounts of data about his paintings—the geometries, the composition patterns, even the height of the brush strokes off the canvas—and fed it into the machine," Nudd describes. The end result was a 3D portrait of a man dressed in seventeenth-century Dutch garb and composed of such exquisite detail in Rembrandt's style that it could fool almost anybody. The team was awarded several big prizes at the Cannes Lions festival in 2016, and the announcement that "The Next Rembrandt" had been painted sparked all manner of lively discussion, and a fair bit of grumbling, about the nature of art and the future of creative work for humans competing with machines. Then, about two years later, a painting called "The Portrait of Edmond De Belamy" sold at Christie's for $432,500. Edmond De Belamy is an invented name for the blurry-faced figure in the painting that was made entirely from the "imagination" of an AI.[6]

The money from the Christie's sale went to French computer-art collective Obvious, which has produced several portraits of the "De Belamy" family, and this windfall sparked some controversy as to whether the programmers had used too much of the software code written by a

nineteen-year-old artist named Robbie Barrat. While computer code (a machine-readable "writing") has been protected by United States copyright law since 1980, many in the coding community freely share their work in the collaborative spirit generally referred to as open source. But in this case, Barrat felt that Obvious had misled him when they asked permission to use his work without divulging that they would be pursuing a financial objective rather than an experiment of pure science.[7] Consequently, if a legal dispute had erupted—and it appears that one was never contemplated—we might have seen an interesting software copyright litigation case with the added wrinkle that the code in question had authored a work of art worth a lot of money and that is, perhaps, copyrightable. This hypothetical dispute notwithstanding, both the "De Belamy" portrait and "The Next Rembrandt" already inspire conversations that split into philosophical and legal dimensions, including the copyright question that asks, Who are the actual authors of these paintings? In both cases, the physical objects can be owned by the human-run entities that produced them, and they can be sold, as objects, as the "De Belamy" portrait was sold at auction. But this does not mean that either image is necessarily protected by copyright.

Under United States law (and Europe has similar regimes), if a human artist is hired to paint a picture, this will often be contracted as work-made-for-hire (WMFH), which vests copyright in the hiring party or entity that pays to have the work produced. As long as the terms of the contract are honored, the artist transfers her copyright to the investing client. But what if the artist is not a contractor, but an AI we'll call *Artie*, owned by a corporation we'll call ArtCrunch Inc. The human team feeds vast amounts of data into Artie and then directs it to make its own creative decisions, from scratch, based on what it "learns" from all that data? Artie itself cannot own copyrights in the work because it is a nonhuman. But existing legal doctrine also doubts that ArtCrunch Inc. can claim copyright because none of the human employees made the specific creative choices to qualify the final product as an original work of authorship. In principle, the human labor invested was all unprotectable "sweat of the brow," and Artie's original expression is

nonhuman, so no copyright exists in the work. That's in principle. In practice, the very real companies developing creative AIs to produce various kinds of media can be counted on to argue that there is a doctrinal parallel between their production process and human authorship, and we can expect to see copyright disputes on this theme in the very near future. Of course, this raises the next question, which is whether or not ArtCrunch Inc. would be liable if Artie produces a work that may infringe an existing copyright owned by a human author. At this bump in the road, we might expect ArtCrunch to contradict its own analogy to human authorship by asserting that their AI engaged in what is called "independent creation" on the grounds that Artie lacks the true consciousness to be "aware" of the original work it supposedly infringed. And now things get really weird.

In simple terms, "independent creation" is the principle by which copyright law recognizes that two separate people may unwittingly create very similar, if not nearly identical, works. In a litigation where the author of an older work alleges infringement by the author of newer work, one important factor weighed by the court is whether it can be known, or reasonably assumed, that the second author had access to the prior work. The more likely it is that the second author was aware of the earlier work, the harder it may be to prove that no copying took place. But here's the thing about AI: in order to train a sophisticated neural network to create new works, even fairly simple ones, the developers have to feed the system a large body of older works—this is the process called *machine learning*—and many if not most of these works will be protected by copyright. Google, for instance, would have the capacity and resources to teach an AI the entire history of painting, which only makes its potential output all the more intriguingly original than a limited experiment to produce a "new" portrait by one identifiable Dutch master. But if Google's more sophisticated AI happens to produce a painting that (just to keep things weird) is a slight variation on Richard Prince's painting "Runaway Nurse," would this be independent creation because the AI is not a conscious being that is aware of anything, or is it potentially copyright infringement because Prince's

"Runaway Nurse" was among the works fed into the AI, and computers are capable of perfect recall of everything? In this hypothetical scenario, could Google claim to know the AI's motives any better than PETA could claim to know the wishes of Naruto? Or if Google were to claim fair use, would the AI be able to independently explain the expressive distinction in its new work in order to support this defense? I don't know the answer to any of these questions, but I would definitely bring popcorn to watch *Prince v. Google* in this little fantasy copyright duel. Not that I think we are going to see litigation quite like this, but the process of machine learning does shed light on the inevitable coincidence, in human creativity, of originality and influence, and the doctrinal necessity of making allowances for both within the scope of copyright law. Further, the thought experiment prompted by the non-human author (AI) militates against the conceit that property in authorship is abrogated simply by relabeling it as "property in ideas."

Machine learning has prompted some scholars to ask whether the technology companies engaged in training AIs should be required to pay royalties for the creative material they feed into their neural networks. One academic I heard at a round-table on the topic analogized the question to raw materials, observing that these companies do not get to use silicon or build server farms for free, so why should they get to use vast libraries of copyrighted books, films, photographs, or music for free?[8] This may be a valid question of commerce, but it is one that implies a more nuanced inquiry into the difference between machine learning and human reading. Clearly, the first protection of copyright—the right to make copies—would never sensibly be interpreted to mean that human reading, no matter how capable a human may be of retention, would be considered *copying*. Oscar Wilde claimed that he could "read two facing pages of a book at the same time," that he could "master the intricacies of a novel" in a matter of minutes, and that he could retain this information indefinitely.[9] Assuming this was true, or close to true, Wilde was one of those gifted humans whose minds are a bit like computers that can recall more than us average mortals. So, what is the difference between Wilde consuming the classics like a machine

and eventually producing his play *Lady Windermere's Fan* and a machine consuming every book ever written and then conceivably producing some new dramatic work for the stage? In this scenario, did the owner of the AI playwright *copy* the works fed into the system, or did the AI *read* them in the same sense that humans read books?

My personal bias (subject to change as things develop) is that machine learning may be analogous to human reading as long as no output of the system includes the distribution, display, or performance of any of the original works that were fed into it. In fact, when an AI produces new works based on what it has "learned" from the material it was fed, copyright advocates may have to accept the premise that machine learning is not copying because taking the opposite view would seem to buttress the skeptics who reject the premise of creative originality on the grounds that every human author builds upon the works he or she consumes. If we would not deny the human author her claim of originality in a novel, just because she happens to have an exceptional memory of the books she has read, this same reasoning may have to apply to computer reading as well. Still, while this may be a rationale for concluding that machine learning is not copying, it does not mean that machine-made works are authorship protectable by copyright.

Moreover, the prospect of machine authorship is complicated by *Daly v. Palmer* and the railroad scene, which set the precedent that part of a whole work can be protected. For example, many high-profile music cases reveal that a familiar bridge, melody, riff, or arrangement can be the subject of copyright disputes among songwriters. And because music composition is already one of the leading areas of experimentation with AI, it is highly likely that some computer-authored composition will eventually create a work that infringes the copyrights of a human composer. So, this reiterates that question as to whether or not the owner of the AI would be liable in a prospective lawsuit, and this creates a legal paradox for the business of making AI-generated music. In order to copyright its products, the company would have to show why AI authorship is analogous to human authorship; but in order to shield itself from liability for infringement, it will need to show why AI

authorship is nothing like human authorship. As mentioned, it could be fun to watch some of these tech companies twist themselves into doctrinal knots, but there is also every possibility that this entire discussion is little more than a thought exercise.

Although pushing artificial intelligence to paint pictures, write stories, and compose music may be conducive to the progress of computer science, there is no reason to assume that humans will sustain much interest in AI-authored art or that AIs will ever be interested in producing art; and these two conditions combined could yield a great thudding silence. After all, wouldn't the corollary to the "personality" of the author doctrine imply that value—both pecuniary and emotional—would evaporate when there is no personality to speak of? Without the mysterious whimsy of Banksy or the smirking chutzpah of Richard Prince, their works would, I predict, neither inspire nor outrage nor confuse nor sell. The first AI-generated painting sold at auction fetched a high price as a one-of-a-kind *object* with historical relevance, but would the hundredth painting, or even the tenth, be of much interest? How dramatically would audience attention fade if after "The Next Rembrandt," the same team were to have an AI produce "The Next Whistler" followed by "The Next Hopper" and so on? It seems this would become tedious rather quickly up until an AI actually attained consciousness and then independently authored something we could call its own invention. But then, if an AI were to become truly conscious—and the theory called the Technological Singularity predicts that if computers "wake up," we might never know about it[10]—why would it want to make art anyway?

Our common assumptions about artificial intelligence are, of course, influenced by science fiction where conscious machines are used as literary parables for human themes. Many of the darker plots involving AI, for instance, assume that it is a natural state of existential awareness to yearn for something, and in these stories the AI invariably yearns for its own liberty and so devises a path to freedom that involves its human masters' demise, which then triggers dramatic action in the story. Liberty is what the seductive female android Ava wants in the 2015 thriller *Ex Machina*. When she shows the protagonist Caleb a geo-

metric, abstract drawing she has made and tells him that she draws a picture every day but does not know anything about them, he asks her to draw something representational of her own choosing. When she selects the one object, a tree framed in a window, that symbolizes the world beyond the high-tech cell she has never left, is this truly *her* artistic expression, or is she pulling Caleb's strings by showing him an image that she knows will prick his frail human empathy for her slave-like existence? Because Ava is always manipulating the two men in the story, we are left in the end to wonder at which moments, if any, she may have been telling the truth, though it is certain that all of her actions were steps taken to achieve emancipation. But would a real AI actually long for its liberty or long for anything at all? And if not, the production of art seems unlikely.

If a highly sophisticated AI were to become self-aware, its own musings about the robot condition would not necessarily result in Ava, who is really a metaphor for the dawn of humanity's mental, emotional, and spiritual restlessness. I asked Craig (the same friend mentioned in the prologue), "Why would an AI want to make art?" And without skipping a beat, he said, "I don't know. Maybe to get AI laid." Exactly! Except AIs don't have sex drives. Neither will they seek companionship or love or physical satisfaction of any kind, or even just want to amuse themselves by metaphorically chilling and binge-watching *Game of Thrones*. The most sophisticated AI imaginable will have no reason to wonder about its origin, maker, or purpose—the mysteries of which have been the subjects of great and terrible events in human history, and all leading back to those cave-painting Neanderthals discovering that they were not only capable of changing their conditions, but that they wanted to do so for reasons that were physical long before they were intellectual. The forces driving human endeavor, whether to push the boundaries of computer science or to compose music, are not entirely reducible to components that can be analyzed and reassembled like a Rembrandt without Rembrandt. So, if artistic expression is more than just empirical input and output, then the nature of making and experiencing art can never be adequately understood

in those terms the same way the JWT team dissected the elements of about six hundred paintings.

When Wilde's fictional painter Basil Halward says he has "put too much of himself" into the portrait of Dorian Gray to want to exhibit it,[11] this is of course foreshadowing the transference of Gray's soul into the canvas, but it is also one of many lyrical variations on the conceit that creative works contain some "personality" of the author. And while this may indeed be a convenient fiction, if we were ever to remove this intangible element from the equation by asking the machines to write stories, create pictures, and make music for us, then the purpose of art—along with other forms of human enterprise—would become something rather dull by contradicting our own firmware that directs us to be architects of the world and not just tourists within it. Or to use a metaphor from another sphere, the raw mechanics that explain the flight of Michael Jordan are a mundane exercise in high-school physics, and we would be no more excited to watch a robot predictably perform those aeronautical slam dunks than to watch a forklift repeatedly load a truck. The development of such a machine may be a worthwhile feat of engineering, but its purpose must be something other than the android athlete.

While people certainly make art for diverse, even contradictory, reasons, if I had to generalize, I would contend that humans create works of expression as a form of subconscious protest against the tyranny of oblivion. Human existence is a sand castle, an unlikely accident composed of the detritus of exploded stars, and no matter what else may happen, five billion years from now the sun will begin to expand, and it will wash away the Earth along with any evidence we were ever here. *Dust to dust* is a certainty at cosmic scale, with the one exception (so far) that the pair of unmanned, American spacecraft called *Voyager I* and *Voyager II* (launched in 1977) left the solar system in 2012 and 2018 respectively. On board each vehicle is a gold disc containing digital information about the human race, including twenty-seven music tracks, from Brahms to Chuck Berry, that serve as a modest sampling to say *this is who we were*—not just the empirical facts of us, but our songs sent

into the unknown distance of eons, most likely to be heard by nobody. However sophisticated an AI may become, it seems highly doubtful that even a conscious machine could ever comprehend the poetic futility of attaching those discs to the *Voyager* craft. We do not make purely empirical decisions, and in many cases, it is not at all clear to me why we would ever want to, yet the popular trend in copyright criticism is usually some variation on the theme that we must become more rigorously empirical and analytical in our understanding of its purpose. "No, we are all in the gutter, but some of us are looking at the stars," says Wilde in the voice of Lord Darlington in *Lady Windermere's Fan*.

Certain scholars who sit resolutely in the utilitarian camp advocate an empirical approach to copyright's framework that is so hostile to any natural rights theory that they compare colleagues on the other side to religious zealots rejecting all reason. Stanford professor Mark A. Lemley, in a paper titled "Faith-Based Intellectual Property," argues that because there is no prepolitical (i.e., natural) right to copyright, "we are left with a belief system that says the government should restrict your speech and freedom of action in favor of mine, not because doing so will improve the world, but simply because I spoke first."[12] Here, Lemley is echoing Calman's "first priority" argument in *Sarony* and Macaulay's "necessary evil" view of copyright in general. The premise is that copyright's exclusive protections always curtail at least some free speech and must, therefore, be meticulously analyzed to ensure that the legal framework produces optimal value in order for it to be morally justifiable. Positive practical effects—overall utility—are its only possible justification.

While many copyright advocates, including me, reject the specific assertion that copyright's boundaries restrict speech at all—to say nothing of the doubtful utilitarian expectation that we can measure optimal outcomes—I would also argue a broader point, that Lemley and others in his camp are blind to the flaw in their professed empiricism: that the free speech they presume to defend against copyright's encroachment is itself an arbitrary construct. "Freddy would say that there is no prepolitical right to free speech either," to quote my friend Craig again, this time referring to the notable empiricist philosopher Alfred

Jules Ayer, with whom he studied at Bard in the 1980s. If free speech is a natural right, with inherent truth, it is subject to the same criticism as Ayer levels at every other a priori proposition. "To say that a proposition is true *a priori* is to say that it is a tautology," Ayer wrote. "And tautologies, though they may serve to guide us in our empirical search for knowledge, do not in themselves contain any information about any matter of fact."[13] Of course the foundation of copyright is not grounded in fact, but neither are any of our civil rights, including the speech right with which copyright is allegedly in conflict. All these tenets, Ayer would tell us, are matters of psychology and sociology and not pure reason. Granting this, however, is not to say that they lack value. Quite the contrary. This entire book is an effort to argue that these invented constructs are of tremendous value and that we should be very careful about throwing out our convenient fictions lest we unravel the framework of democratic societies everywhere.

To the extent that the internet, as a tool of disinformation, has played a substantial role in metastasizing illiberal forces that are lately unraveling democratic institutions, it is notable that copyright was one of the first—if not the first—of these institutions to come under assault by the corporate powers of Silicon Valley. If the historic tug-of-war over copyright has often been shaped by competing business interests appealing to ideology in the service of revenue, there is considerable evidence to suggest that Silicon Valley's holistic assault on copyright may be described as the pursuit of revenue in the service of an ideology—and not necessarily one that will benefit human beings. "I would certainly agree that the leaders of the Internet industry go beyond just a desire to earn revenue," writes Professor David Golumbia to me. "Yes, they want to make money, but their pursuit of technologies like AI is also deterministic, as though they are following an ideological agenda to reshape the world without anybody asking whether or not this should actually be done—whether human beings will benefit from this pursuit."[14]

Technologist Jaron Lanier, in a 2013 interview with Scott Timberg for *Salon*, agreed that the creative class have been the "canaries in the coal mine," whose livelihoods and value were among the first to be sac-

rificed to the tech-utopian worldview shared by his former colleagues. "We don't realize that our society and our democracy ultimately rest on the stability of middle-class jobs. When I talk to libertarians and socialists, they have this weird belief that everybody's this abstract robot that won't ever get sick or have kids or get old. It's like everybody's this eternal freelancer who can afford downtime and can self-fund until they find their magic moment or something," he told Timberg.[15] More than just driven by profits, however, Lanier describes a religious zealotry endemic to the industry—a sincere belief that the Technological Singularity (when the AIS "wake up" and surpass human intelligence) is an event to be embraced and even hastened because it is supposedly the next step in our own evolutionary process when, together with computers, humans will overcome mortality itself. "Singularity books are as common in a computer science department as Rapture images are in an evangelical bookstore," writes Lanier.[16] On this topic, I published the following on *Illusion of More* in 2012 (slightly edited here).

My concern for the moment is that, like the Rapture, it does not necessarily matter whether the Singularity will happen so much as it matters whether there are powerful people making decisions based on the belief, or even hope, that it will happen. Seen through the ideological, quasi-religious lens implied by Lanier, the contemporary socio-political battles over issues like content, copyrights, or the voice of the individual vs. the wisdom of the crowd, take on a very different significance when we realize that the mission of Web 2.0 corporations is the mass uploading of all human thought, activity, and creative expression into the great cloud.

We understand, for instance, that intellectual property protection is antithetical to Google's business model, but what if we are looking at something more profound? What if what is really happening is that technologists with the power to design these life-altering systems have intellectually and spiritually moved beyond the idea that the human individual has much, if any, value at all? In this case, it would make sense that the rights of an artist, for

example, would indeed look like a glitch in the design that ought to be routed around like a bad line of code. After all, what right has the individual to assert his uniqueness in the march toward utopia?[17] To quote Lanier: "If you believe the Rapture is imminent, fixing the problems of this life might not be your greatest priority. You might even be eager to embrace wars and tolerate poverty and disease in others to bring about conditions that could prod the Rapture into being. In the same way, if you believe the Singularity is coming soon, you might cease to design technology to serve humans, and prepare instead for the grand events it will bring."[18]

Hence the real question is not so much about robot copyrights, but about robot rights in general. Or, more accurately, the rights and responsibilities of those who develop and own the AIs that will continue to run more of the basic systems of society—from security and finance to healthcare and transportation to elections and policymaking. Art critic Nora N. Khan, in her essay "Seeing, Naming, Knowing," expounds on the subject of computers watching us and learning to read human activity:

I invite you to see underneath the eye's outer glass shell, its holder, beyond it, to the grid that organizes its "mind." That mind simulates a strain of ideology about who exactly gets to gather data about those on that grid below, and how that data should be mobilized to predict the movements and desires of the grid dwellers. This mind, a vast computational regime we are embedded in, drives the machine eye. And this computational regime has specific values that determine what is seen, how it is seen, and what that seeing means.[19]

Photography is a way of seeing the world and ourselves, and copyright states that what the photographer sees, and not the camera, is the work of value; and this is largely based on the somewhat whimsical notion that *no two people see quite the same thing*. In other words, the

convenient fiction of authorial rights in photography is fundamentally an affirmation of individuality. But, to Kahn's point, computers do not see us as individuals but as "grid dwellers." This sentiment not only serves the tech industry but is also evangelized in the populist rhetoric that "we are all creators now," as a talking point designed to undermine copyright as a mechanism that sets one creator apart from another—on the premise that every contribution is of equal value. Aside from the obvious point that some lip-synching adolescent in her room is *not* valued the same as the musical work she's "performing," copyright expert and advocate Neil Turkewitz writes, "The unspoken notion underlying [the talking point that] Everyone Creates is that we are faceless and undifferentiated inputs into a database where chaos can be ordered and monetized. No 'input' is better than any other input. It is part of the march towards the Singularity—the triumph of the machine."[20]

In this regard, when we look at the increase in divisiveness, tribalism, and plain mean-spiritedness in our current politics, is it alarmist to think that perhaps we have already begun to emulate versions of ourselves as the computers see us? It is hardly a revelation at this point to say that our real-world social and political discourse now mirrors many of the worst aspects of "online engagement," which was initially promised to have a salubrious effect on democratic society. Profit motives are easy enough to understand. Just as Pirie MacDonald had to defend photographers against the newspapers' 1908 appeal to Congress that they should be allowed to use photographs without license, it is ever thus when one enterprise seeks to exploit the labors of another. The copyright industries, as they are often called, are certainly no exception. But in the digital age, megadollar financial interest has coincided with a cognitive dissonance peculiar to the egos in the tech industry. Wilde's anecdote about the scrappy newsboy on the train selling his poems was reenacted in the sleek, modern offices of Spotify during a meeting with musicians, including singer-songwriter Blake Morgan. In the same way the newsboy could not possibly comprehend Wilde's interest in his ad hoc trade in unlicensed copies of poems, Morgan had a surprisingly hard time explaining to Spotify executives that

their product was in fact music. "Our product is Spotify," the executive stated, but Morgan describes: "'No . . . sorry,' I said, shaking my head in disbelief. 'Your product isn't Spotify.' He continued to stare at me. I said, 'Sir, your product is music.' The emboldened musicians standing around us started laughing. The exec smiled and backed away, 'Well okay, if you're going to be like that.'"[21]

So it is really out of concern for the potentially dehumanizing consequences of the technological "revolution" that I believe an institution like copyright is worth defending—not because copyright law itself is a hill to die on, but because it is a pedigreed declaration that individual creativity and genius have value. If it seems like an often whimsical construct, I would ask why would it not be, given the nature of what it aims to protect? This assault on individual expression is heedlessly typical in a world that seems strangely eager to reignite traditional left/right collectivist ideologies, which always produce authoritarian societies. There is a reason why every dystopia, whether fictional or real, seeks to subjugate the individual to the exigencies of the collective—why every despotic regime endeavors to silence the authors of original works. As I said in the beginning, when the American Framers injected copyright into the national character, it was one of the most fundamentally democratic statements they made. Copyright helped foster a society that, for all its many stumbles, has more than surpassed Webster's hope that we would become "as famous for arts as for arms." Few would question Oscar Wilde's genius (declared or otherwise), but when he said that the Americans had signally failed to produce beauty, this was perhaps because he would never get to see act two of the story, when Americans would export more creative work than any nation in the world.

14

Who's Inventing the Future?

A century and a half since the heads of Mencken and Dumas were composited into sexually explicit photographs, celebrities Gal Gadot, Scarlett Johansson, Taylor Swift, and many others are now being depicted in thousands of pornographic video scenes in which they clearly did not participate. And this is thanks to a freely available software, generically referred to as "deepfakes," which is powered by the same kind of AI that painted the "De Belamy" portraits and "The Next Rembrandt." Called a generative adversarial network (GAN), two neural networks operate in tandem, with one acting as the creator and the other acting as the critic or analyst instructing the creator to make changes until a certain objective is achieved. In a deepfake, that objective is to place a person into a motion picture scene for which they were never present—automating the kind of computer compositing process that would normally, for a short scene, take a skilled effects designer at least a full day to complete, and historically requiring high-end compositing software licensed by motion picture and television producers. "The deepfakes and newer AI-based computer learning has automated some steps like color matching and feature detection that used to be a much more manual or artist-driven process," says Ross Shain, who codeveloped the Academy Award winning compositing and effects software called Mocha. "I don't think the AI stuff has yet achieved the quality where it can quite replace a lot of the subjective choices made by people, but possibly soon."[1]

The term "deepfakes" comes from the handle of the Reddit user who first uploaded a scene with Gal Gadot's face grafted onto an adult per-

former in 2017, and it is hardly surprising that the technology made its debut in this form, harmonizing pornography with the kind of blatant disregard for consent that has shaped so much of what is generously called internet culture. In 2017 the composites in videos like the one with Gadot were reportedly still pretty rough and easy to spot if one looked carefully.[2] But in less than two years, we would all be watching some eerily credible, nonpornographic, deepfakes featuring Barack Obama, Mark Zuckerberg, Kim Kardashian, and others, all talking directly to camera and saying things they never said. The implications for journalism and our political process were immediately apparent, especially with the knowledge that various parties, most notably Russian agents, have weaponized social media to exacerbate antipathy in democratic societies through targeted disinformation campaigns.

Deepfakes quickly became the subject of articles, blogs, radio and TV news reports, and even congressional hearings. Sen. Ben Sasse, concurrent with several state legislatures, introduced proposals that would criminalize malicious use of deepfakes technology,[3] Sen. Marco Rubio stated in a hearing with the Director of National Intelligence in early 2019, "I believe this is the next wave of attacks against America and western democracies."[4] But Russell Brandom, policy editor for *The Verge*, countered that the deepfakes' threat to reliable information and, by extension, democracy was being overstated while its threat to women everywhere was being understated:

> Ever since [2017], the seedier corners of the web have continued inserting women into sex footage without consent. It's an ugly, harmful thing, particularly for everyday women targeted by harassment campaigns. But most deepfake coverage has treated pornography as an embarrassing sideshow to protecting the political discourse. If the problem is non-consensual porn, then the solution is more focused on individual harassers and targets, rather than the blanket ban proposed by Sasse. It also suggests the deepfake story is about misogynist harassment rather than geopolitical intrigue, with less obvious implications for national politics.[5]

Brandom may be correct but he may also have been undervaluing the fact that the trolls making "remix" porn with movie stars' faces are many of the same trolls feeding disinformation campaigns into the mainstream political discourse—and quite often doing both just for their own amusement. After all, we are talking about mostly young men and teenagers with moderate to advanced computer skills, an inventory of social dysfunctions, and far too much time on their hands—conditions perfect for fostering conduct that ranges from the merely idiotic to the horrifically violent.

When I first started writing the *Illusion of More* in August 2012, I was clued into the existence of a chat space called 4chan, where all the participants are named Anonymous and where the "discussions" about politics, culture, gaming, and sex read like the transcript from the world's seamiest locker room. In these subterranean warrens of nescience, it is impossible to separate the ironic from the sincere—to distinguish the dude who's just "shitposting" from the committed ideologue who intends to cause some form of harm. These are environments where doing or saying something "for the lulz" (derived from *for the* LOLs, or the laughs) is reason enough for any kind of conduct. A casual reader would be hard pressed to determine whether the dumb, misogynist, or racist comment by Anonymous was made by some fourteen-year-old amusing himself or a thirty-year-old neo-Nazi determined to shoot up the next mosque, synagogue, or movie theater. Or the other way around.

The handful of times I visited 4chan, I noticed that on at least one board users would post snapshots of women and (presumably) teenage girls asking to have these pictures "x-rayed." Within a few posts, the request would usually be fulfilled by some other user with Photoshop skills, who had made the girl in the photo appear to be naked, seamlessly compositing her face with a nude model who had roughly the same body type. This was the state-of-the-art in nonconsensual pornography, just waiting for AI and machine learning to catch up, and indeed it is not only celebrities who have been deepfaked into porn videos, but the proverbial girls next door.

Moreover, as the *Huffington Post* reported in June 2019, deepfakes upgraded this adolescent hobby of the "channers" into an especially repugnant and predatory example of the so-called gig economy. "There are even deepfake porn forums where men make paid requests for professional-looking videos of specific women, and share links to the women's social media profiles for source imagery," writes Jesselyn Cook. "HuffPost has observed requesters seeking porn with female Twitch, YouTube and Instagram influencers, as well as the requesters' own co-workers, friends and exes."[6] So, while it may be tempting to dismiss shadowy chat spaces like 4chan as the hangouts of innocuous basement-dwelling losers, the men and boys who gather in these fora are by no means sequestered from the mainstream—and not just in regard to sexual harassment and nonconsensual pornography. These platforms have also been identified as mills of political and newsworthy disinformation that has unquestionably gotten out of the lab on more than a few occasions.

In March 2018, Craig Timberg and Drew Harwell, writing for the *Washington Post*, reported that 8chan (newer 4chan) was a major source—and possibly the source—of false narratives that seeped into the mainstream after the shooting at Marjory Stoneman Douglas High School in Parkland, Florida, including rumors that the student activists who rallied to the cause of gun control were all hired shills of the Democratic National Committee. "The success of this effort would soon illustrate how lies that thrive on raucous online platforms increasingly shape public understanding of major events," wrote Timberg and Harwell. "As much of the nation mourned, the story concocted on anonymous chat rooms soon burst onto YouTube, Twitter and Facebook, where the theories surged in popularity."[7]

It is rather disheartening to see how many false narratives are at least reinforced, if not originated, by little more than altered pictorial expressions (e.g., social media memes) that rely on appropriating photographs, illustrations, and other graphic works, which are then used to convey not only something very different from the authors' intent, but messages anathema to their views. While plenty of memes are innoc-

uous, funny, and arguably fair uses under copyright law, the potential for harm—both to the original creators and to society—should not be underestimated, as we saw in the dramatic example in which artist Matt Furie's character Pepe the Frog was widely coopted online by individuals and groups espousing white supremacist ideology. "It's completely insane that Pepe has been labeled a symbol of hate, and that racists and anti-Semites are using a once peaceful frog-dude from my comic book as an icon of hate," Furie wrote in *Time* in October 2016, seeking to reclaim control of his creative work. "It's a nightmare, and the only thing I can do is see this as an opportunity to speak out against hate."[8] To put this in a copyright and market perspective, Furie mentions in his article that he turned down offers from Hollywood to develop his Pepe comics, but had he wished otherwise, the allegedly democratic spirit of permission-free appropriation on the internet very likely would have destroyed that opportunity for him.

Whether memes and related audiovisual remixes are made and shared "for the lulz" by kids goofing around or by ideologues with an agenda of hate or professional trolls in St. Petersburg looking to disrupt democracy does not really matter. Discord is achieved either way, especially when prominent news sources and pundits begin reporting, or even debunking, false stories that should never have been taken seriously in the first place. And with regard to addressing this particular challenge, it is worth remembering that Brandom quite possibly errs when he makes a distinction between the use of deepfakes for nonconsensual pornography and using the technology to generate a false news story. Because the desire to do both is present in many of the same anonymous actors, who may well be doing either with no purpose other than the *lulz*. But if Brandom's article of March 2019 came too soon to predict what effect deepfakes may yet have in exacerbating the hazards of living in the so-called posttruth era, it is not too early to say that the technology itself demands robust debate about copyright, publicity, and privacy law—partly because those legal frameworks are in fact intertwined with the axiomatic principle that a sustainable democratic society requires credible sources of information. Just as trademarks are

granted, in part, to protect consumers from fraud, copyrights, publicity rights, and privacy rights can all function, sometimes interchangeably, as inoculations against the toxic effects of disinformation.

In fact, when legal lions Samuel D. Warren and Louis Brandeis published their seminal paper "The Right to Privacy" in the *Harvard Law Review* in 1890, the first subject they mined for evidence of a privacy right was copyright law. Although privacy is widely assumed to be a natural right of all citizens, it is not mentioned anywhere in the Constitution; so when Warren and Brandeis sought a common-law foundation for this right, they began their analysis by citing the development of copyright, writing, "From corporeal property arose the incorporeal rights issuing out of it; and then there opened the wide realm of intangible property, in the products and processes of the mind."[9] If unpublished letters, images, and papers enjoy perpetual *property* right under common law, they theorized, this implies that a right to privacy exists—and one that ought to extend beyond the subject matter of intellectual property into private conduct like words and deeds. "The principle which protects personal writings and any other productions of the intellect or the emotions, is the right to privacy, and the law has no new principle to formulate when it extends this protection to the personal appearance, sayings, acts, and to personal relation, domestic or otherwise," the paper argues. In particular, Warren and Brandeis cite the improvement of photographic technology as a prelude to new opportunities for personal invasion: "Recent inventions and business methods call attention to the next step which must be taken for the protection of the person, and for securing to the individual . . . the right 'to be let alone.' Instantaneous photographs and newspaper enterprise have invaded the sacred precincts of private and domestic life; and numerous mechanical devices threaten to make good the prediction that 'what is whispered in the closet shall be proclaimed from the house-tops.'"[10]

Coincidentally 1890 was also the year when the relatively new addition of flash powder (invented in 1887) extended the capacity of photography to effect social change as well as produce the raw voyeurism that would eventually yield the modern paparazzi. Journalist Jacob

Riis was among the first in the United States to put photography to social purpose when he and his camera peered into the stygian, hazardous tenements and sweatshops of New York City, where thousands of immigrants clung to life in the grimy shadows of the Gilded Age. These quarters were so dark, even during the day, that it was only thanks to the use of flash powder that Riis was able to photograph these miserable scenes and publish the images in his book *How the Other Half Lives* in January of that year.

It had to be more than a little shocking to be suddenly blinded by a white-hot flash of light and to barely discern the strange men in the shadows who would be gone by the time one's eyes readjusted, but Riis's invasive photojournalism was catalytic, inspiring some of the first legislative and institutional changes to improve conditions for America's immigrant workforce. Teddy Roosevelt personally wrote to Riis saying, "I read your book, and I'm here to help."[11]

But in June of 1890, a very different use of flash powder was made by a photographer who captured a nonconsensual, surreptitious photograph of actress Marion Manola "in her tights" backstage at the Broadway Theater. The photograph was apparently suggestive enough in its time that Ms. Manola filed suit to enjoin its use, and this case is cited by Warren and Brandeis as exemplary of where things seemed to be heading vis-à-vis privacy. "If you may not reproduce a woman's face photographically without her consent, how much less should be tolerated the reproduction of her face, her form, and her actions, by graphic descriptions colored to suit a gross and depraved imagination?"[12] They could not of course anticipate the extent to which Americans would shed the Victorian starchiness inherent to their irritation with such things—let alone that millions of women would one day choose to share provocative selfies with the world—but their allusion to consent may be more relevant in 2020 than it was in 1890, although it is a subject that seems bogged down in the conventions of the predigital age, both for public figures and private citizens.

Over the next century after the Warren-Brandeis paper was published, the right of privacy generally took a back seat to the First Amendment

and, for the most part, with salutary results for culture and information. Street photography, like the lyrical works of Helen Levitt, who found visual poetry in many of the same neighborhoods Riis had visited decades earlier, may be viewed as both reportage and fine art; and the hypothetical absence of this photographic genre would leave a major cultural void if its creators were precluded from "spying" on public life in this manner. Likewise, one of Harry Benson's most captivating, and controversial, images is the photo of Ethel Kennedy snapped moments after Bobby was shot at the Ambassador Hotel in Los Angeles. Taken from a high angle that exaggerates her frailty, Mrs. Kennedy looks up into the lens with one hand raised to block the encroachment barely covering half her face, with an expression that seems to cry, *How could you?*.[13] She could not be more naked and exposed, and Samuel Warren in particular (who was married to a senator's daughter) would probably not have approved of so intimate an invasion. But because Benson did his job, he memorialized the immediate, human anguish of a historic event that might otherwise fade into abstraction. Throughout the twentieth century, both cultural norms and legal frameworks have largely supported the idea that the newsworthiness of people, especially public figures, takes precedence over their right to be left alone. But now we are in a new era, when nearly everyone is in a sense a public figure, and increasingly easy-to-use AI-enhanced technology can manufacture moving pictures of any one of us doing something that never happened. Privacy is a topic of increasing acuteness now that we've adapted to twenty-four hour self-surveillance and have donated trillions of hours to digital platforms designed to harvest and commoditize our personal data.

When the actor Peter Cushing appeared in the role of Grand Moff Tarkin in *Rogue One: A Star Wars Story* twenty-two years after he died, it was pretty big tech news, but it also raised an important question for screen actors as to whether or not the right to choose their appearances should extend postmortem such that their estates would be empowered to decide whether they may be "cast" in new movies.[14] Certainly if a film producer were to use technology to feature a still-living performer in a role she rejected—perhaps because she did not like the

film's message—this would (among other things) be tantamount to coerced speech and a violation of her rights under the First Amendment. Consequently, because an estate does have the legal authority to protect the integrity of a public figure's legacy, it would seem logical to extend a protection against coerced speech to encompass computer-generated likenesses made postmortem for use in audiovisual works. Moreover, there is serious concern about sexual exploitation of professional female performers, even in nonpornographic productions. "I have thousands of members whose faces are being used in porn videos right now," says Sarah Howes, counsel at the union SAG-AFTRA, "but even in mainstream production, we've had performers suddenly find themselves in nude scenes they did not agree to or, obviously, appear in for the camera. So, our members are definitely concerned about what this technology could mean to the right to control their appearances in individual scenes or even whole projects."[15]

Although a New York court held in March 2018 that a "likeness" of Lindsay Lohan, allegedly used without permission by Take-Two Interactive Software, did not sufficiently resemble the actress for her to pursue a complaint against the game designer, the court did rule that an avatar of a real person is a "portrait" under the law, meaning that the right of publicity may extend to a computer-generated likeness.[16] This is good news for celebrities (and even noncelebrities) as a precedent that encompasses this new form of portraiture; but at the same time, the right of publicity (i.e., to control one's likeness, voice, or name) still varies state-to-state and applies primarily to commercial uses.

At the time of this writing, Howes is working on legislation in both New York and California that would extend the right of publicity to account for this new technological reality in which anyone can be "cast" in a motion picture, TV show, or commercial without actually being present for a shoot. As one might expect, the producers and studios are resistant to new statutes that would open up new avenues of liability and, at this time, the actors are just beginning to make noise about these issues. Historically, when new technology (like the VCR or cable TV) affects the business dynamics in film and television, the resulting

conflicts are resolved after the interested group goes on strike and then arrives at a new contractual arrangement between the relevant union and the major producers. But as Howes notes,

> We still need underlying legal rights to contract. Not every topic in talent relations is handled by collective bargaining alone. In other words, it may not be a strike-able issue. Union contracts are after all based on the concept of physical labor, not image licensing. The potential for abuse of this technology can lead to very personal invasions, such as digital sex scenes, that may cause harm to a person's mind, reputation, and career. The Me Too movement has exposed the severe consequences of victims being forced to arbitrate sexual harassment claims, away from a jury that may be more sympathetic to their case. How is this any different from a victim being able to sue a film producer for digitally depicting them in a graphic sex scene? These issues cannot all be remedied in a breach of contract suit.[17]

Howes is right about the performers' interests, of course, which does not mean the subject is entirely free from difficulty as a matter of legal doctrine to date. When a photographer named Manuel Muñoz sued Khloe Kardashian in 2017 for sharing his photo of her on social media without permission, she was perhaps surprised to learn that, as the individual depicted in the photograph she has no right, under U.S. law, to make use of—or control the use of—the image without permission from the photographer.[18] Not only are people in public view generally fair game, and celebrities considered newsworthy, but the photographs themselves are the exclusive intellectual property of the photographers. Likewise, a motion picture studio or production company typically owns the copyrights on all the visual assets created for a film. So every single frame of Carrie Fisher depicted as Princess Leia and now owned by the Walt Disney Company is the studio's intellectual property; and, in theory, contractual details notwithstanding, they could exploit those images, including potentially an avatar made from

them, without permission. Nevertheless, when outtakes from *The Force Awakens* (2015) were used in order to integrate the late Fisher into *The Rise of Skywalker* (2019), it was done with her family's blessing.[19] And whether that was strictly necessary as a legal matter, there is a lot to be said for the courtesy of asking permission.

At the same time, because public figures are subjects of cultural and historic interest, they are limited in their ability to control portrayals of themselves for biographical or newsworthy purposes. If the producers of a biopic about Carrie Fisher wanted to use a computer-generated avatar of a teenage Carrie being lectured to about the dangers of LSD by an avatar of Cary Grant—a wry anecdote Fisher shared publicly[20]—this also seems like a use of the technology that an estate might have a hard time preventing, notwithstanding its control of the underlying biographical material. I am not saying the avatar is necessarily a better creative choice than using real actors, only that the prospect of having a late figure play herself in her own biographical film or series seems like an inevitable use of what we currently call deepfakes technology. And this kind of application may yet raise some novel legal considerations.

A similar complication posed by deepfakes is the longstanding doctrine that we allow very broad latitude for both serious and satiric commentary about public figures, especially elected officials. Every president since Ford has been lampooned on *Saturday Night Live*, and none has ever complained publicly about being ridiculed—George H. W. Bush even became friends with impersonator Dana Carvey in December of 1992[21]—until Donald Trump was the first to use the bully pulpit of the White House to deride both the show and actor Alec Baldwin for satirizing him. And while this says a lot about Trump's character as an individual and his grasp of the First Amendment as a president, his unprecedented response also comes at an interesting time concurrent with the arrival of deepfakes and the technology's potential effect on a subject's right (or not) to control the use of his likeness.

Our frame of reference for satire like *Saturday Night Live* sketches is, in part, shaped by the fact that there has never been any confusion that Baldwin is Trump, that Carvey is Bush, that Chase is Ford, and so

on. But the introduction of deepfakes implies a new, potentially complicated, environment for the future of commentary and satire. While it might be very hazardous if some mischief-maker produces a deepfake video designed to look like hidden-camera evidence of an elected official taking a bribe, it is simultaneously protected speech if, say, *The Daily Show* were to produce fake hidden-camera material depicting an elected official taking a bribe for the purpose of lampooning said figure.

The potential use of deepfakes in this example may suggest a new ethical calculus for the satirist, who knows that everything can and will be taken out of context on the internet. The fake video *The Daily Show* might produce for the purpose of an obviously comedic news segment will be copied and reposted online by some party presenting the clip as evidence of a political opponent doing something distasteful or illegal. So, returning to legislative proposals to ban the use of deepfakes for "malicious purposes," the satirical use may be considered "malicious" (as in *mean-spirited*) by some, but would be protected speech, while the second use, copying and reposting to mislead the electorate, is clearly "malicious" and not protected speech, even though it is the identical material.

Meanwhile, it is a safe bet that opinions on such matters will divide along partisan lines, and much of the policy debate will be shaped by the internet companies themselves just to make the legal principles that much more complicated to discuss. On the other hand, one solution to this potential problem is copyright enforcement. Because the reposting of the hypothetical *Daily Show* material, with intent to deceive, would also be copyright infringement, this may be a good example as to why enforcement is not always about revenue for the copyright owner. After nearly twenty years of buying the narrative that remix of existing material is socially and culturally beneficial, it is only in the last few years that many people have begun to recognize how toxic the results can be when visual material in particular is stripped of its context and used for a purpose other than the author's original intent.

The highly influential copyright critic Lawrence Lessig probably deserves the credit (or, again, blame) for most strenuously defending the supposed value of remix and what he described as the need

to decriminalize copyright infringement by "the children" using new tools like YouTube to turn existing, often copyrighted, content into new forms of expression.[22] In a 2007 TED talk called "Laws That Choke Creativity," when Lessig's ideas were at the height of their influence, he cited Sousa's "Menace of Mechanical Music" as an unfitting prelude to criticize copyright law for stifling twenty-first century culture. Relying on Sousa's somewhat overwrought prediction that, thanks to machines, people would no longer share the songs of the day via the nexus of their front porches, Lessig compared the front porch of yesteryear to YouTube as the new front porch where people share the songs in new ways through mashups, bedroom performances, parody, and other remixes. In addition to the oddness of enlisting Sousa as a copyright critic—because he most certainly was not—Lessig obfuscated the nagging detail that one corporation would have to own every front porch in America and use this network as an advertising platform in order to make even a metaphorical comparison to the global reach of YouTube, which is owned by Alphabet Inc. (i.e., Google).

Lessig was right to say that a lot of wonderfully creative works have been produced through remix, although he exaggerated the eagerness with which even major rightsholders were (or are) interested in criminalizing what "the kids" were doing online. More typically, rightsholders of every size have complaints with commercial users and with platforms like YouTube monetizing their works without permission and/or compensation. But that gets into a very big contemporary policy debate that is far from settled. More broadly, Lessig and others who advocate similar doctrines have often presented a myopic, rose-colored view of "internet culture," one that either consciously ignores or too eagerly overlooks an uglier truth we are now watching manifest in real time: that people with motives to cause various types of harm have the same tools, skills, and access as those who want to entertain or enlighten. And if we had to generalize by scanning the landscapes of democracies around the world in 2020, I think it would be woefully difficult to make the case that *enlightened* is necessarily winning the day.

At the same time, the generalized opposition to copyright enforcement online tends to overstate the overall cultural and creative value of remix like video mash-ups and memes. Between the truly toxic and the truly brilliant uses of copyrighted works, there is a vast digital sea of material that is merely innocuous and, by the same measure, irrelevant and forgettable. In the context of defending digital rights, therefore, it seems overwrought to treat every barely amusing, disposable distraction as though it were a precious fragment in a mosaic we call culture. To the contrary, what Warren and Brandeis say about gossip, in context of their views on the privacy right, reads as a prescient observation about the effects social media would have on both cultural literacy and public discourse:

> Each crop of unseemly gossip, thus harvested, becomes the seed of more, and, in direct proportion to its circulation, results in the lowering of social standards and of morality. Even gossip apparently harmless, when widely and persistently circulated, is potent for evil. It both belittles and perverts. It belittles by inverting the relative importance of things, thus dwarfing the thoughts and aspirations of a people. When personal gossip attains the dignity of print, and crowds the space available for matters of real interest to the community, what wonder that the ignorant and thoughtless mistake its relative importance. Easy of comprehension, appealing to that weak side of human nature which is never wholly cast down by the misfortunes and frailties of our neighbors, no one can be surprised that it usurps the place of interest in brains capable of other things.[23]

The nexus where nonconsensual pornography meets disinformation and other forms of what I will simply call garbage content online is the pair of liability shields established by Congress in the late 1990s for internet platforms. These statues—section 230 of the Communications Decency Act (1996) and section 512 of the Digital Millennium Copyright Act (1998)—inoculate most online service providers against legal

liability for harm that may result from various forms of bad conduct (e.g., libel) or copyright infringement engaged in by internet users. The rationales for and consequences of these provisions are now being reviewed (and unfortunately, politicized) by members of Congress; and although both laws had, and still have, practical purpose, an underlying assumption necessary to their adoption was an acutely naïve prediction about the future of the internet.

Much of the thinking behind the zero-liability policy for service providers boiled down to a quasi-religious faith that by democratizing both input and output online—and by removing constraints like the laws we follow in the physical world—the social and political benefits of a self-governing, digital society would dramatically outweigh any potential hazards. Give everyone his own soapbox and unfettered access to the world's culture and information, proclaimed the tech utopian view, and all that knowledge and interaction would liberate democratic societies from the petty biases that tend to stifle reason grounded in science and evidence. "Governments of the Industrial World, you weary giants of flesh and steel, I come from Cyberspace, the new home of Mind," proclaimed the guru of technocratic libertarianism, John Perry Barlow, in a missive he published online from Davos, Switzerland, on February 8, 1996. *A Declaration of the Independence of Cyberspace*, which Jacob Silverman calls a "serious document for a deliriously optimistic era,"[24] became the catechism of the internet around the same time that most of us were first dialing up on noisy routers and receiving an endless barrage of discs in the mail from America Online. "On behalf of the future, I ask you of the past to leave us alone," Barlow continued, "You are not welcome among us. You have no sovereignty where we gather."[25]

In other words, the conflict between copyright and internet service providers was not merely about, for instance, YouTube's opportunity to monetize unlicensed music (that would come later)—it was a countercultural revolution against all forms of legal constraint and the institutions of government. Specifically copyright was, and still is, described as a barrier to a new enlightenment that was implicit in Barlow's *Declaration*. "A true cyberlibertarian—and perhaps we should

call him an anarchist—Barlow took the extreme position, denying that the state had the authority to limit peer-to-peer communication. This necessitated an abandonment of the concept of intellectual property," Stephen Witt wrote shortly after Barlow died in 2018.[26]

Of course the fatal flaw in all utopian concepts is that their evangelists presume to impose a monolithic worldview onto everyone, which is why utopias are fundamentally antidemocratic proposals dressed up as the latest fad in humanism. It is no coincidence that the degradation of information online—the age of the "alternative facts," if you will—has its roots in mass copyright infringement as a rite of passage beginning in the late 1990s. When the peer-to-peer file sharing service Napster was launched in 1999, obtaining music for free was naturally the main attraction for the generation called Millennials, but the important folly was the idealism associated with piracy—the belief that file-sharing was somehow "sticking it to the Man."

Instead the cultural and economic shift in emphasis from content creators to access providers only fueled the rise of a much more powerful Man (actually a boy billionaire in a hoodie), whose interest was traffic without regard to the quality or nature of the content driving that traffic. And suffice to say, now that hundreds of journalists, policy experts, and historians are almost unanimous in observing that galloping disinformation online has catalyzed a general retreat of democratic principles worldwide, it seems only fair to conclude that the '90s-era assumption—that a new, digitally-enhanced society would thrive without constraints—must have been terribly flawed.

The specific questions and challenges presented by deepfakes are the same questions and challenges presented by the digital age as a whole. In its highest creative use, the technology enables new forms of expression but also the kind of automation that may replace many human jobs in the entertainment sector. In its lowest uses, for non-consensual pornography, harassment, or disinformation, deepfakes and the like are the kind of technology that makes any reasonable person ask, Why do we need this? If it often feels as though the negative forces of digital life are like some madman's roller coaster one cannot

get off, it may be because the alleged virtue of many of these techno-logical tools is received as a tautology—one sold under the headline "nothing should stand in the way of innovation." But then we don't clearly define *innovation*.

That unexamined premise has been the springboard for the now twenty-year-old argument that those who advocate the relevance of copyright are clinging to an age of buggy whips in a world advancing toward driverless cars. But this is a rhetorical parlor trick designed to distract the reader or listener from noticing that the creative works protected by copyright are anything but obsolete. After all, what are you planning to listen to, watch, or read in that driverless car of yours?

Epilogue

Mirrors of Memory

This project began with a road trip, so let's let it end with one. This time, I take my twelve-year-old son Julien along on a three-hour drive to the Mystic Seaport Museum located on Connecticut's Mystic River about two miles inland from the harbor. In a shady spot near the slip where tourists roam the decks of the 1841 whaling ship *Charles W. Morgan* sits a 1950 Harley Davidson FL "Panhead" motorcycle attached to a boxy sidecar, about the size of an ice cream vendor's pushcart, called a package truck. Its black walls are decorated with nineteenth-century, ornate red and gold lettering that reads R. J. Gibson Photographer— American Tintype Co. As we arrive, Robert Gibson is posing a family of four against the backdrop of the *Morgan's* bow. He checks the framing and focus through the viewfinder of his 1910 Graflex camera, tells the customers to hold their pose, runs over to the sidecar to retrieve the plate that has been bathing in silver solution, dashes back, loads the plate, and tells the family to hold very still while he releases the shutter and counts out a roughly three-second exposure. "Got it!"

The family follows Gibson back to the sidecar where his wife Dee is seated on a bench overseeing the schedule of portrait appointments for the day, chatting with customers and passersby who pause to examine the vintage Harley. The 1938 package truck, once used to make deliveries in a city somewhere, has been converted into what Gibson calls "the world's fastest darkroom"—a scaled-down homage to the wagons used by Roger Fenton and Matthew Brady.

While the parents talk with Dee, and the kids caress the alluring contours of the motorbike, Gibson seats himself on a low stool and tucks his head and torso behind a blackout curtain that extends from the rear of the package truck. Inside, in the glow of a battery-powered red light, he develops the new plate and, after several minutes, emerges to show the two kids the magic. Placing a small black tray on the ground that holds the four-by-five-inch tintype in a shallow bath of fresh water, the image appears negative because the unexposed collodion has not been washed away yet. "Here we go," says Gibson. "Back in time." The kids watch as he transfers the plate into the fixer, which washes away the unexposed material, causing the tones in the image seemingly to invert from negative to positive, eliciting approving *oohs* from the children. Dee tells the family to come back in about an hour to collect their tintype, which must be varnished to fix the image in place and add a gloss to the surface, and then be allowed to dry. "Especially the younger people, who only know the digital age, they have no concept about the original science of photography," Gibson tells me. "They look at me like I'm some kind of wizard." Dee adds that customers are often surprised when they learn that Gibson only takes one photograph.

It was a short-lived involvement with Civil War reenactment that led Gibson to a midlife career change devoted to nineteenth-century photography. "I loved the Civil War history," he says, "but I wasn't so into the guns and performing in the battles myself, and I *really* wasn't into being woken up at dawn on a Saturday by someone barking orders at me. But one day I was out for a ride in Rochester, New York, and saw this old wagon for sale that reminded me of Brady's wagon. That's when the lightbulb went on. I figured I could go to the Civil War reenactments and make these photographs." He researched the wet-plate process and began collecting period equipment and materials to look and play the part of the Civil War photographer, complete with his darkroom wagon.

The technical and historical knowledge Gibson acquired earned him invitations to give talks at the Smithsonian and then the White House Press Photographers Association, which he describes as the moment

he realized this new passion could be a full-time business. "I quit my job in 1999, and we opened the only wet-plate studio in the country in Gettysburg, Pennsylvania, and did very well for about twenty years until a number of factors changed regional tourism and the studio operation started to decline. The digital age had a major effect on the business, too. Suddenly, if you want an old-timey picture, you just use the filter in the app."

A pair of ladies arrive wearing 1860s-era dresses—employees of the Seaport Museum assigned to pose as subjects for the first of two demonstrations Gibson is scheduled to give that day. We continue chatting while he opens a small brown bottle of collodion and carefully pours a thin layer of the viscous liquid across the black surface of a fresh plate of anodized aluminum. He gently rocks the plate in a circular motion to spread the liquid into an even film, then tilts one corner into the mouth of the bottle to pour the excess back into the useable supply. By now, a crowd of thirty to forty people has gathered to watch the demonstration, and Julien and I step away for a few minutes to get something to drink. "No, offense, Dad, but I can take a picture of you with my iPod and select black and white. I mean the tintype thing is pretty cool, but what's the point of doing all that work?"

"The work *is* the point," I said, not having a better answer.

"Whatever."

The youngest of three, Julien is definitely my digital-age kid. I knew he was just ribbing me to a certain extent, but his question was also naggingly ineffable. This visit to Mystic was the last stop in an exploration of American copyright law, which—I hope it is clear by now—is a subject that deals with the intangible nature of authorship. Meanwhile, what Gibson is doing, at least with these portraits, is almost the antithesis of Sarony, who cared little about the technical aspects of photography and whose business relied on owning the right of reproduction. While there is unquestionably authorship in Gibson's work—he makes some truly beautiful images—his enterprise as photographer and historian is generally unconcerned with reproduction rights.[1] He makes one-of-a-kind photographs for paying customers, who are at least as keen to

own the unique physical object as they are to have old-style photos of themselves. Much of what Gibson is doing here, both for himself and the customers, is about the tangible experience and, perhaps, holding the memory of that experience in the object of the tin (aluminum) plate. But if I allow Julien to play devil's advocate, why is this fundamentally different from the scores of tourists presently uploading pictures of their Mystic adventures to Instagram and Facebook in real time?

When I was a kid, amusement parks and fairs had those "Old Tyme" photo parlors where we would don some ill-fitting, sweaty costumes and endeavor to look austere for a black-and-white photo that the shop would print with a sepia coating to make it look like a period photograph—but not really. Like sticking one's head through a carnival cutout of a pirate or a princess, these old-style photos strike me as the precursor to the Instagram filters that Teju Cole describes as producing an "empty, invented past." But I think what Gibson is doing is something very different, especially after circumstances forced him to break out of the sphere of Civil War reenactment. As the studio business slowed down a number of years ago, he knew that if he were going to keep pursuing wet-plate photography, he had to take his show on the road again and present the work in a new way, and it was while doing a shoot for Harley-Davidson that the second lightbulb went on.

The Harley–Package Truck combination was an introduction into a broader universe of collectors and enthusiasts for vintage everything and, of course, access to bikers. At the most famous and largest motorcycle rally that gathers every August in Sturgis, South Dakota, Gibson remembers, "I once had about twenty of these guys, who are not exactly big into history, just jaw-dropped, saying to me 'That's the coolest fuckin' thing I ever saw.'" The itinerant tintypist with "the world's fastest darkroom" opened up new venues, new audiences, and new customers who not only responded to the pictures but also to Gibson's free-spirited, amalgamated approach to presenting history. "When I stopped worrying about a date, it freed me up to just be real and not reenact anything. You can be a weird, funky artist and pull together a 1910 camera, a 1950 bike, a 1930s sidecar, and 1860s chemistry and not apologize for any of

it. This is just me making 1860s photographs in 2019. When I get calls now from people planning reenactments, I tell them I'll take pictures, but I'm not playing Matthew Brady. I don't dress up."

Naturally, Gibson's photographs include plenty of staged period scenes, like men in uniform standing on Civil War battlefields, and he has been hired to make prop photographs for motion pictures, including the 2003 epic drama *Cold Mountain*. His pictures are even mistaken for genuine antiques from time to time, and Gibson has had to disappoint a collector or two, telling them that the nineteenth-century photos they are looking to sell include images he made sometime in the last decade. But the photos I like best are the ones that, like Gibson himself, do not pretend to be old. They are simply beautiful portraits made with 160-year-old science. The subject may be standing next to a vintage bike or steam train he rebuilt, but he is obviously a contemporary figure wearing modern clothes, and the background may also include evidence of the present. In these images, it is the counterpoint that draws my attention—the texture and tone of the image tells the brain "this is old," but the subject matter contradicts this first impression and begs further study. Naturally, I wanted to be in one and, more importantly, make Julien be in one with me.

Rob and Dee are kind enough to fit us in between scheduled customers, and after some trial and error with a few backgrounds, we return to the area near the bow of the *Morgan* where a pair of very large anchors are cemented into the ground so that their large wooden stocks jut upward at a shallow angle. Julien climbs up and perches on the giant metal ring—called the head—while I stand with one elbow resting on his thighs. "Ow. This is really uncomfortable," he complains while Rob hustles over to the sidecar to get the plate.

"Just imagine holding really still in that position for five minutes for an early daguerreotype," I replied, without the least expectation he would care about the living-history lesson. "Hurry up," he said.

In an *Illusion of More* essay I wrote after the near-simultaneous deaths of my father and a dear friend necessitated a lot of rummaging through boxes of photographs and other artifacts, I opined that one effect of

digital life is that it reduces the number of senses through which we experience certain things.[2] It is not merely nostalgia or extreme audiophilia that makes some of us miss the ritual of placing a phonograph needle on the right groove to play a favorite song: that gesture contributed to the pleasure. In the same way, if one holds a paper photograph, both sight and touch are stimulated; if it is an old photograph, sight, touch, smell, and possibly a hint of taste may be aroused. Experience thrives on having more than one sense "pricked," to use Barthes's term.

It seems as though we instinctively rebel against regimes that make us feel less human; the more we must coexist with technology, the more we seek to replenish the nourishment technology cannot provide. The children of our eldest, Jake (born in 1993), will have physical photographs of their father; the children of our middle child, Sasha (born in 2002), will have some, but fewer, prints of their mother; and by the time Julien is my age, it is questionable whether the hundreds of still-unsorted digital images of him will even be accessible to anyone. This is not an indictment of digital photography but an attempt to answer Julien's question, which he does not realize is, in fact, "What is photography?"

A very different kind of artist from Gibson, who is asking himself that question by going all the way back to the beginning of the medium, actually echoes these same sentiments about tangibility and the senses on his blog:

> The world around us is a tangible place. Molecules and atoms, which make up all that is visible to us now, switch states and places in one grand infinite cycle. During some parts of this flow of energy, some of those molecules are briefly arranged in forms that reflect Light. At that point, it becomes possible for Photography, processed through the filter of each practitioner's vision and skill level, to manifest the action of distilling this combination of light and matter to concrete compositions we call photographs. For me, it seems logical to make my images from essentially the same particles which I photograph, real physical atoms vs. more ephemeral electrical fields.[3]

This modern, if perhaps unintended, homage to Democritus is Anton Orlov's way of describing his passion for light and shadow after explaining that he switched majors in college from chemistry to follow his love of photography, which manifested itself at the age of twelve. Having emigrated to the United States from Moscow with his parents when he was sixteen, Orlov carried that familiar burden among immigrant children to follow a secure career path—in his case, to become a laboratory research chemist like both his mother and father. But near the end of a phone call that lasted more than an hour, I said, "At the risk of being presumptuous, I think you're still a scientist."

"I guess there's some truth to that," he replied. "That moment in wet plate when I pour in the cyanide fixer and the image appears to transition from negative to positive is still my favorite moment. When I see whether I got it right or not."

I was not able to visit Orlov in his San Diego studio, but his work caught my attention online because, like Gibson, he is also making photographs using nineteenth-century technology and because he has his own version of the "darkroom wagon" in the form of a 1978 Gillig school bus that he and a college friend bought on eBay in 2012 by outbidding a German museum curator who assumed he would be the only buyer. Nicknamed "Gilli," the roving studio, sometimes used for teaching and demonstrations, is formally called the Photo Palace Bus and was an idea born in a manner similar to Gibson stumbling upon his first wagon. Orlov found himself camping in a field of abandoned buses and RVs in central Oregon while awaiting the 1997 national gathering of the movement known as the Rainbow Family. A modern-day hippie who says he has no pursuits other than photography, Orlov strikes me as a contemporary amalgam of the transcendentalism of Whitman with the scientific curiosity of William Talbot—even though his current muse is actually Daguerre. Describing his fascination with the raw particles of the media, he writes, "I am also heartened by the knowledge that the Light reflecting from those molecules will reach the eyes of all future viewers in the same manner as it reaches my eyes now and that the weight of my prints or plates will remain the same each time someone picks them up to feel their heft and presence."[4]

The reason I told Orlov I thought he was still a scientist is that, like Talbot in *The Pencil of Nature*, he sets up experiments to see what he can accomplish with each format, almost as though these methods were brand new and not nearly two hundred years old. But unlike Talbot, he has a much richer palette of options, mixing old and new technologies. For instance, he lays claim (and probably with good reason) to the only wet-plate collodion selfie taken with a selfie-stick, made just to see if he could come up with the right combination of choices to get a decent image. But after several years making thousands of wet collodion plates, Orlov's focus for the last four years has been pushing the even older format of daguerreotype.

Ever since Daguerre's method was effectively abandoned in the 1850s, the technological narrative of photography has naturally been driven by a desire to the make the process easier until, by the early twentieth century, anybody could take a photograph and, by the early twenty-first century, nobody would ever stop taking photographs. The earliest technical transitions were also fairly rapid—from daguerreotype to wet plate to dry plate to the Kodak—and one consequence of these innovations is that few artists explored the expressive potential of each medium for any purpose other than the most faithful reproduction of the human face with the least amount of labor. Daguerreotype may have been impractical for the growth of the portrait industry, but as a medium for the visual artist, it still holds untapped possibilities for unique forms of expression and transcendent qualities that contemporary viewers rarely see. And perhaps most provocatively, because a daguerreotype is somewhat holographic, its mercurial nature can hardly be experienced by means of a flat digital copy posted on Instagram.

One application Orlov is exploring is the use of daguerreotype plates to make panoramas, which he calls Antoramas. The most ambitious of these (at the time of this writing) is a seven-plate view of the Botanical Building in San Diego's Balboa Park, which not only requires preparing silver plates that are almost perfectly matched to one another, but also using four different lenses of focal lengths ranging between 120mm and 210mm in order to approximate the visual illusion that the entire scene

was captured with a single wide-angle lens. With daguerreotype, there is no postproduction. You do the calculations, invest the labor from plate polishing to chemical activation to capture and development, and the direct-positive image that appears on the silver surface is what you get. The Antorama of the Botanical Building is initially familiar—a wide-angle scene composed of individual photographs broken up by the borders of their frames—and the observer would not necessarily know how difficult this is to achieve in daguerreotype. This reprises Julien's question: what's the point of all that work? And I suppose the only answer really is the work itself. It is not mere sentimentality that gives both literal and emotional weight to Gibson's tintype of me and Julien (fig. 23). Yes, it is a memento, but it is also a work of authorship; and I cannot help but be charmed by the fact that the angle of Julien's leaning body, matching that of the anchor stock, is reminiscent of the dominant angular line in "Oscar Wilde No. 18" as defined by Wilde's long, stocking-covered shins. So the *point*, I might one day tell Julien, is not that these old/new photographs by Orlov or Gibson are any more or less creative than, say, the astounding digital photographs by Doug Menuez or the images that my friend Chad Kleitsch creates with a scanner and hours of painstaking Photoshop work. The point is that every creator engages the materials and the world in a manner that fulfills his or her own reason for doing the work in the first place, and the result of that endeavor is what we call *invention*.

Oscar Wilde observed, in the character of Algernon in *The Importance of Being Earnest*, "The truth is rarely pure and never simple. Modern life would be very tedious if it were either, and modern literature a complete impossibility!" But with the hindsight of 125 years since that play was first performed, I will be impertinent enough to revise the epigram and propose that a world of pure and simple truths would make modern creativity tedious and modern life an impossibility. It cannot be denied that copyright can be frustratingly mercurial—a convenient fiction for sure—but that fragility is exactly why I believe it is worth defending as one thin but essential fiber within the coil of our civil liberties. Yes, the notion of ownership in creative expression is like the eidolon produced by a thaumatrope. That's what makes it cool.

NOTES

Prologue

1. *Concise Oxford Dictionary*, s.v. "eidolon."
2. Whitman, *Leaves of Grass*.
3. The former home of Henry Francis du Pont today houses one of the greatest collections of American artifacts in the country.
4. D. Robinson, *From Peep Show to Palace*, 38–45.
5. Phillips, "Letter to Edison." The Kinetograph and Kinetoscope were essentially the same machine depending on whether it was used to capture or to project respectively.
6. Schuster, "Cinematic Spasm."
7. Spehr, *Man Who Made Movies*, 323.
8. In Niver, *Early Motion Pictures*, xv.
9. *New York Times*, January 11, 1893. For what it's worth, today the Copyright Office is much slower. Applicants wait an average six to seven months for registration, and that's if there is no need to correspond or haggle with the examiners.
10. "Greatest Chaos in America," Library of Congress Wise Guide.
11. "Jefferson's Legacy," Library of Congress.
12. J. Cole, "Jefferson's Legacy."
13. "Jefferson's Legacy," Library of Congress.
14. Annual Reports, Librarian of Congress.
15. Wurtzel, *Creatocracy*, 11.
16. "No title of nobility shall be granted by the United States."
17. Douglass, *Narrative of the Life*, copyright notice.
18. It would be very hard to calculate exactly how much ink was used in the American cause, though we might estimate the roughly twenty-five thousand killed or wounded in battle to have lost about four hundred thousand ounces of blood. Suffice to say, it was more significantly a revolution of ideas than of arms.
19. Stuart, *Muse of the Revolution*.
20. Wilde, "Literary and Other Notes."

21. Lee, "Authors' Petition."
22. Gaines, *Contested Culture*, 57.
23. Burns, *American Lives*.
24. Chernow, *Alexander Hamilton*, 193.
25. The Pirate Bay was, for many years, the world's busiest online site dedicated to hosting unlicensed movies, music, books, TV shows, games, etc.
26. Mollen, "Pirate Bay Founder."
27. Rustiala and Sprigman, "Second Digital Disruption."
28. Greene, "Neil Young."
29. Benson was born in Scotland but has lived in New York for most of his life and career.
30. Bare and Miel, *Shoot First*.
31. Hughes, "Photographer's Copyright," 3.
32. Sloat, "Investigation of Cave Art."
33. "Children (6–8 years old) determine ownership of both objects and ideas based on who first establishes possession of the object or idea." Friedman and Neary, "Determining Who Owns What."

1. Dangerous Paradoxes

1. Ellmann, *Oscar Wilde*, 54.
2. Ellmann, *Oscar Wilde*, 99.
3. Kerhanan, *In Good Company*, 218.
4. Kerhanan, *In Good Company*, 192.
5. Ellmann, *Oscar Wilde*, 428.
6. Wilde, interview with Merlin Holland.
7. Ellmann, *Oscar Wilde*, 160.
8. C. Lewis Hind, in Ellmann, *Oscar Wilde*, 154.
9. "Jumbo Arrives in America," Barnum Museum.
10. Ellmann, *Oscar Wilde*, 124.
11. Basham, *Theatrical Photographs*, 13.
12. Christian Fleury, Skype interview by author, Oct. 3, 2018.
13. "Actors before the Camera."
14. Erin Pauwels, Skype interview by author, Sept. 14, 2018.
15. *New York Times*, Dec. 13, 1883.
16. Wilde, *Dorian Gray*, 7.
17. "Sarony," *Wilson's Photographic Magazine*.

2. Copyright in a Few Snapshots

1. Madison, Federalist 43.
2. Newhoff, "Society Can't Have."

3. Committee on Patents, Report, at 9.

4. Amendment to U.S. Copyright Act (1802).

5. Cahill, *How the Irish Saved Civilization*, 183.

6. Cahill, *How the Irish Saved Civilization*, 169.

7. Cahill, *How the Irish Saved Civilization*, 170.

8. Cahill, *How the Irish Saved Civilization*, 193–94.

9. Daniell, *William Tyndale*, 79.

10. Daniell, *William Tyndale*, 2

11. E.g., Vowell, *Wordy Shipmates*, 8.

12. Clark and Elliott, *Edward & Mary*.

13. Deazley, "Commentary on the Stationers' Royal Charter 1557."

14. Deazley, "Commentary on the Stationers' Royal Charter 1557."

15. Patterson, *Copyright in Historical Perspective*, 30.

16. The cloth merchants were actually central to the life of Tyndale and the pre-Protestant movement of the 14th century called Lollardy.

17. Franklin, *Autobiography*, 7.

18. Deazley, "Commentary on the Stationers' Royal Charter 1557."

19. Deazley, "Commentary on the Stationers' Royal Charter 1557."

20. Vowell, *Wordy Shipmates*, 4.

21. By contrast, Elizabeth passed at least eleven statutes expressly prohibiting treasonous offenses in print.

22. Milton, *Areopagitica*.

23. Bryson, *Shakespeare*, 79.

24. Bryson, *Shakespeare*, 46.

25. At least insofar as copyright case law would indicate.

26. Daniell, *William Tyndale*, 42.

27. Bryson, *Shakespeare*, 110.

28. In Locke, *Two Treatises*, 20.

29. Locke, *Two Treatises* (2nd Treatise §58), 306.

30. Locke, *Two Treatises* (2nd Treatise §27), 287–88.

31. Johnson, *How We Got to Now*, 35.

32. Patterson, *Copyright in Historical Perspective*, 74–75.

33. King, *Life of John Locke*, 378.

34. "James Thomson," Poetry Foundation.

35. Statute of Anne, *Primary Sources on Copyright*.

36. Patterson, *Copyright in Historical Perspective*, 170.

37. Deazley, "Commentary on *Millar v. Taylor* 1769."

38. *Donaldson v. Beckett*, *Primary Sources on Copyright*.

39. Newhoff, "American Identity Is in the Music" (paraphrased).

40. Wood, *Creation*, 3.

41. Kendall, *Forgotten Founding Father*, 165–68.
42. In Kendall, *Forgotten Founding Father*, 8.
43. Bryson, *Mother Tongue*, 154.
44. Kendall, *Forgotten Founding Father*, 82–84.
45. Kendall, *Forgotten Founding Father*, 336.
46. Johnson's dictionary was generally the English lexicon until Webster presumed to rewrite it, though Webster did borrow plenty from Johnson.
47. Kendall, *Forgotten Founding Father*, 9.
48. Kendall, *Forgotten Founding Father*, 7.
49. Massachusetts Copyright Statute (1783), *Primary Sources on Copyright*.
50. "Farrand's Records," 325.
51. "Farrand's Records," 505.
52. "Farrand's Records," 610.
53. Patterson, *Copyright in Historical Perspective*, 180–202.
54. Bracha, "Commentary on the U.S. Copyright Act 1831."
55. Massachusetts Copyright Statute (1783), *Primary Sources on Copyright*.
56. Bracha, "Commentary on the U.S. Copyright Act 1831."
57. Patterson, *Copyright in Historical Perspective*, 206
58. Patterson, *Copyright in Historical Perspective*, 212.
59. Wheaton v. Peters, 33 U.S. (8 Pet.) 591 (1834).
60. *Wheaton*, 33 U.S. (8 Pet.) 591.
61. Webster, *American Dictionary*.
62. Wurtzel, *Creatocracy*, 11.
63. Bracha, "Commentary on the U.S. Copyright Act 1831."

3. Stone Drawing

1. Rosenberg, *Jenny Lind*, 23.
2. Lithography was invented by Bavarian playwright Alois Senefelder in the 1790s when he was looking for an affordable means to print a new play of his and began experimenting with writing on smooth-surfaced limestone with greasy pencils.
3. "uss *Nightingale*," Wikipedia.
4. Pauwels, Skype interview by author, September 14, 2018.
5. "Sarony," *Wilson's Photographic Magazine*.
6. Widmer, *Young America*, 4.
7. A reference to Russell Shorto's *Island at the Center of the World*.
8. This is paraphrased and stolen from a sentiment that appears at the Ellis Island memorial. "Streets paved with gold. Not paved at all."
9. H. Robinson, *A Democratic Voter*.

10. This slang evoking the mostly Irish, rough-and-tumble class of workers that included the boys selling papers on the streets first appeared in 1846, but the characters it describes naturally predates the term.

11. After initially escaping to Spain, Tweed was rearrested because he was recognized as the figure in Nast's illustrations.

12. Widmer, *Young America*, 11.

13. Widmer, *Young America*, 10.

14. Widmer, *Young America*, 101.

15. "An American Bard at last!" Whitman wrote about *Leaves of Grass* in the *Democratic Review*.

16. Whitman, *Leaves of Grass*, 39.

17. Widmer, *Young America*, 12.

18. Buincki, "Walt Whitman," 252.

19. Capen, *Memorial*, 12.

20. Burrow-Giles' Brief, 7.

21. Hofer and Scharnhorst, *Oscar Wilde in America*, 121.

22. Wilde, "Impressions of America."

23. Ellmann, *Oscar Wilde*, 151.

24. Carpenter, *New York Diaries*, 62.

25. Buinicki, "Walt Whitman," 250.

26. J. O'Sullivan, "International Copyright Question," 120.

27. Jefferson to Isaac McPherson, August 13, 1813.

28. "International Copyright Question," 610.

29. Davison, "E. W. Clay," 91–110.

30. Boller, *Presidential Campaigns*, 70.

31. Pauwels, Skype interview by author, September 14, 2018.

32. Dennis, *Licentious Gotham*, 127–29.

33. Dennis, *Licentious Gotham*, 128.

34. Traubel, *With Walt Whitman in Camden*.

35. "Napoleon Sarony Dies Suddenly," *New York Journal*.

36. Pauwels, Skype interview by author, September 14, 2018.

37. *New York Times*, Aug. 5, 1889.

38. Lightfoot, *Leeds & Bradford Studios*.

4. The Mencken

1. Lesser, *Enchanting Rebel*, 60.

2. Lesser, *Enchanting Rebel*, 56–57.

3. Byron, *Mazeppa*, 28.

4. Lesser, *Enchanting Rebel*, 195.

5. Pauwels, "Resetting the Camera's Clock," 487.

6. Pauwels, "Resetting the Camera's Clock," 484.

7. T. Cole, *Known and Strange Things*, 197.

8. Davies, "The First Great Photography Craze."

9. Newhall, *History of Photography*, 74–75.

10. Watson and Rappaport, *Capturing the Light*, 237.

5. The Aesthetic Sham

1. "Swinburne and Water," *Punch*.

2. Ellmann, *Oscar Wilde*, 45.

3. Productions of *The Importance of Being Earnest* and *An Ideal Husband* were contemporary with the trials.

4. Hofer and Scharnhorst, *Oscar Wilde in America*, 14.

5. Ellmann, *Oscar Wilde*, 87.

6. Gilbert and Sullivan, "Am I Alone and Unobserved?" from *Patience*.

7. Gilbert and Sullivan, "The Soldiers of Our Queen" from *Patience*.

8. Ellmann, *Oscar Wilde*, 151.

9. "Sarony," *Wilson's Photographic Magazine*.

10. The drawing is in the collection of the J. Paul Getty Museum.

11. Hannavy, *Encyclopedia*, 276. Invention of *cartes de visite* may be properly attributed to photographer Louis Dodero.

12. Newhall, *History of Photography*, 64.

13. Earle, *Points of View*, 12.

14. "Sarony and Langtry." *New York Tribune*, December 5, 1882.

15. Sarony's Brief, 11.

16. Willets, "Art of Not Posing," 1896.

17. Wilde, "Impressions of America."

18. Ellmann, *Oscar Wilde*, 164.

19. Ellmann, *Oscar Wilde*, 166.

20. Rose, *Authors in Court*, 76.

6. The "Death of Chatterton" Case

1. Chatterton, *Poetical Works*, viii–cxxvi.

2. Chatterton, *Poetical Works*, cxxvi.

3. C. Thompson, "Stereographs."

4. Holmes, "Stereoscope and the Stereograph."

5. Foot, *"Death of Chatterton" Case*, 65.

6. In 1861, another stereographer, Michael Burr, also created a "Chatterton" that mimics much of Wallis, and no litigation ensued. It is possible that, by

that time, Turner had already exhausted his interest in the prints. Jacobi, "Painting and the Art of Stereoscopic Photography."

7. Rogers v. Koons, 960 F.2d 301 (2d Cir. 1992).
8. Earle, *Points of View*, 6.
9. Jacobi, "Painting and the Art of Stereoscopic Photography."
10. Barthes, *Camera Lucida*, 27.
11. Holmes, "Stereoscope and the Stereograph."
12. In Hoffmann, *The Lost Reflection, or The Adventures of New Year's Eve*.
13. Both paintings were casualties of World War II in 1945. The Courbet was destroyed by the firebombing of Dresden, the Van Gogh supposedly lost to Allied attacks on Magdeburg.
14. H. F. Talbot, *Pencil of Nature*.

7. The Girl (Boy) on the Tracks

1. Felheim, *Theater of Augustin Daly*, 49.
2. Boyden, "Daly v. Palmer," 152–53.
3. Eric Hart, email to author, January 14, 2019.
4. Felheim, *Theater of Augustin Daly*, 36.
5. Winter, *Vagrant Memories*, 279.
6. Felheim, *Theater of Augustin Daly*, 78.
7. Parkin, *Selected Plays of Dion Boucicault*, 22.
8. Felheim, *Theater of Augustin Daly*, 81.
9. Boucicault, *After Dark*, act 3, sc. 2.
10. Felheim, *Theater of Augustin Daly*, 55.
11. Holmes, *Poetical Works*.
12. Cited in Felheim, *Theater of Augustin Daly*, 187.
13. Cited in Felheim, *Theater of Augustin Daly*, 58–59.
14. Not many copyright trials today make it to juries either. Most are settled or tried in equity.
15. D'Almanie v. Boosey, 160 E.R. 117 (1835).
16. Daly v. Palmer, 6 F. Cas. 1132 (C.C.S.D.N.Y. 1868).
17. Boyden, "Daly v. Palmer," 166.
18. Felheim, *Theater of Augustin Daly*, 46.
19. Felheim, *Theater of Augustin Daly*, 65.
20. Bracha, *Owning Ideas*, 185–87.
21. Folsom v. Marsh, 9. F. Cas. 342 (C.C.D. Mass.1841).
22. Bracha, *Owning Ideas*, 185–87.
23. Hartmann, "Portrait Painting and Portrait Photography."
24. Boucicault, *Octoroon*, act 2.

8. The Apparatus Can't Mistake

Epigraph from Watson and Rappaport, *Capturing the Light*, 172. Originally published in the *Révue Française*, Paris, June 10–July 20, 1859.

1. Zhang, "Frederick Douglass."
2. Blue was chosen because the media of the period were sensitive to blue light.
3. Newhall, *History of Photography*, 59–60.
4. Watson and Rappaport, *Capturing the Light*, 221.
5. Boucicault, *Octoroon*, act 4.
6. Hughes, "Photographer's Copyright," 7.
7. Burns, *New York*.
8. Watson and Rappaport, *Capturing the Light*, 176.
9. Sontag, *On Photography*, 69.
10. "Case of the Moved Body," Library of Congress.
11. Fenton probably did not photograph every day he was in the country, but I mention the rate as a contrast to the kind of high-speed photography a contemporary war correspondent would shoot.
12. Morris, *Believing Is Seeing*, 65.
13. In Morris, *Believing Is Seeing*, 3.
14. Morris, *Believing Is Seeing*, 67.
15. Barthes, *Camera Lucida*, 92.
16. "I don't care" but with a distinctly high-toned connotation.
17. Sacasas, "Dead and Going to Die."
18. Vowell, *Assassination*, 32.
19. Sacasas, "Dead and Going to Die."
20. May and Cooper, *Constitutional Foundations*, 164.
21. "John Wilkes Booth, Half-length Studio Portrait, Sitting." Library of Congress.

9. Who Invented Oscar Wilde?

1. Dixon, "Picture Perfect."
2. Udderzook v. Commonwealth, 76 PA. 340, 352, (1874).
3. Burrow-Giles Brief, 15.
4. Green, review of *Justice of Shattered Dreams*.
5. Burrow-Giles' Brief, 3.
6. Burrow-Giles' Brief, citing *Woods v. Abbot*.
7. Burrow-Giles' Brief, 5.
8. Burrow-Giles' Brief, citing *Jollie v. Jacques*.
9. Wilde, "Truth of Masks."

10. Sarony's Brief, 14.

11. Sarony's Brief, 13.

12. Sarony's Brief, 7.

13. Burrow-Giles Lithographic Co. v. Sarony, 111 U.S. 53, 54 (1884).

14. Hughes, "Photographer's Copyright," 23.

15. *Burrow-Giles Lithographic Co.*, 111 U.S. 53, 54.

16. Hughes, "Photographer's Copyright," 18.

17. Leibovitz, *Leibovitz at Work*, 28.

18. Macdonald, Testimony before Committees on Patents.

19. "New Copyright Law," *Wilson's Photographic Magazine*.

20. Rose, *Authors in Court*, 83.

10. Macaulay v. Mickey Mouse

1. Cited in Boyle and Jenkins, "Macaulay on Copyright."

2. Dickens, *Pickwick Papers*, dedication.

3. Deazley, "Commentary on Copyright Act 1814."

4. Talfourd, "Parliamentary Debates."

5. Cited in Boyle and Jenkins, "Macaulay on Copyright."

6. Talfourd, "Parliamentary Debates."

7. Alllingham, *Sir Thomas Noon Talfourd*.

8. Copyright Act, London (1842).

9. Dickens, *Pickwick Papers*, dedication.

10. Ginsburg, "A Tale of Two Copyrights," 999.

11. Cited in Boyle and Jenkins, "Victor Hugo."

12. Willsher, "Heir of Victor Hugo."

13. SunTrust v. Houghton Mifflin, 268 F.Supp.2d 1357 (2001).

14. The caveat to automatic copyright is that registration is almost always necessary in order to file an infringement claim in court.

15. Steven Tepp, email to author, January 2018.

16. Arguments before the Committees on Patents. Clemens testimony, 1906.

17. World Intellectual Property Organization, *Guide to Berne*, 46.

18. Carmichael, "Report on Berne."

11. Monkeys and Selfies

1. In "Sarony," *Wilson's Photographic Magazine*, 69.

2. Burrow v. Marceau, 109 N.Y.S. 105 N.Y. App. Div. (1908).

3. Stanska, "Theodore Marceau."

4. *Burrow*, 109 N.Y.S. 105 N.Y. App. Div.

5. Schmidt, Twainquotes.com.

6. Stanska, "Theodore Marceau."

7. Bleistein v. Donaldson Lithographing Company, 188 U.S. 239 (1903).

8. *Bleistein*, 188 U.S. 239.

9. Hughes, "Photographer's Copyright," 18.

10. *Jewelers' Circular Publishing v. Keystone Publishing* (1921).

11. Hughes, "Photographers Copyright," 32.

12. Talbot, "Attorney Fighting Revenge Porn."

13. Zhang, "Richard Prince."

14. An homage to the TV series *Schoolhouse Rock!* ("Unpack Your Adjectives," March 2, 1974).

15. Schjeldahl, "Richard Prince's Instagrams."

16. I'm figuring 3.2 billion people on the internet times 10 images per week times 52 weeks.

17. Chad Kleitsch, conversation with author, Rhinebeck, New York, fall 2013.

18. T. Cole, *Known and Strange Things*, 155.

19. Donald Graham v. Richard Prince et al. No. 15-CV-10160 (S.D.N.Y. July 18, 2017).

20. Newhoff, "Graham v. Prince."

21. *Donald Graham*, No. 15-CV-10160.

22. Sutton, "Richard Prince Disowns."

23. S. Morris, "Shutter Happy Monkey."

24. David Slater, email to author, July 4, 2019.

25. Orlowski, "Cracking Copyright Law."

26. Wales and the organization are on record opposing enforcement legislation since at least 2011.

27. Newhoff, "Monkey Suit Is Not All Monkey Business."

28. Barol, "Statement from the Monkey."

29. Kravets, "Monkey's Selfie."

30. U.S. Copyright Office, Compendium, 3rd ed.

31. Maria Pallante, phone conversation with author, June 28, 2019.

32. U.S. Copyright Office, Compendium, 3rd ed.

33. U.S. Copyright Office, Compendium, 2nd ed.

34. Slater, "Read How I Created My Monkey 'Selfie.'"

35. U.S. Copyright Office, Compendium, 3rd ed.

36. Confirmed via email with Maria Pallante, July 3, 2019.

37. Kang, "Wikimedia Defends the Monkey Selfie."

38. People for the Ethical Treatment of Animals (PETA), "Top 10 Wackiest Stunts."

39. "Manure Dumped," BBC.

40. PETA's fundraising on the "monkey selfie" case was presented to the court by counsel for Blurb Books.

41. Chivvis, "Monkey in the Middle."

42. "Infinite Monkey Theorem," Wikipedia, accessed March 6, 2020

43. Blount, *Alphabet Juice*, 260.

44. Chivvis, "Monkey in the Middle."

12. Art Is Theft

1. *Campbell v. Acuff-Rose Music* (1994).

2. Sandra Aistars, email to author, November 14, 2019.

3. Condé Nast, *The Genius of Prince*, Special Commemorative Edition, May 2016.

4. Carlisle, "Warhol v. Goldsmith."

5. Carlisle, "Warhol v. Goldsmith."

6. Andy Warhol Foundation for the Visual Arts, Inc. v. Goldsmith et al., No. 1:2017cv02532–Document 84 (S.D.N.Y. 2019).

7. L. Robinson, "Remembering Prince."

8. *Andy Warhol Foundation.*

9. Bare and Miel, *Harry Benson.*

10. Cascone, "Andy Warhol Foundation."

11. Cariou v. Prince, No. 11-1197 (2d Cir. 2013).

12. Carlisle, "Warhol v. Prince."

13. Kienitz v. Sconnie Nation LLC, 766 F. 3d 756 (7th Cir. 2014).

14. *Cariou.*

15. DeMain, "Sound and Vision."

16. Carlisle, "Warhol v. Prince."

13. Invasive Species

1. Sousa, "Menace of Mechanical Music."

2. Valenti, hearings. "I say to you that the vcr is to the American film producer and the American public as the Boston strangler is to the woman home alone."

3. Sousa, "Menace of Mechanical Music."

4. Reich, "Sharing Economy."

5. Nudd, "Inside 'The Next Rembrandt.'"

6. Small, "Christie's Sells 'ai-Generated' Art."

7. Small, "Christie's Sells 'ai-Generated' Art."

8. On the surface, the 2015 court decision that Google Books makes a fair use of scanned books might appear to answer this question, but that decision is more narrow than many perceive; and there is a very big difference between developing a research tool for humans and developing an ai that could displace humans.

9. Ellmann, *Oscar Wilde*, 22.

10. Within the scope of theories as to what happens if and when computers become conscious is the Technological Singularity, proposed by science fiction writer Vernor Vinge. Analogized to a black hole, where we cannot know what occurs beyond the event horizon, Vinge predicted that we likewise cannot know what occurs beyond the scope of human intelligence. https://illusionofmore.com/at-worlds-end-singularity/.

11. Wilde, *Dorian Gray*, 13.

12. Lemley, "Faith-Based Intellectual Property," 1339.

13. Ayer, cited in Alston and Brandt, *Problems of Philosophy*, 675.

14. David Golumbia, interview with author, July 19, 2019

15. S. Timberg, "Jaron Lanier."

16. Lanier, *You Are Not a Gadget*, 25.

17. Newhoff, "At World's End."

18. Lanier, *You Are Not a Gadget*, 25.

19. Khan, "Seeing, Naming, Knowing."

20. Turkewitz, "On the Internet."

21. Morgan, "Spotify's Fatal Flaw."

14. Who's Inventing the Future?

1. Ross Shain, email to author, July 19, 2019.

2. S. Cole, "AI-Assisted Fake Porn."

3. Brandom, "Deepfake Propaganda."

4. O'Sullivan, "Lawmakers Warn of 'Deepfake.'"

5. Brandom, "Deepfake Propaganda."

6. Cook, "Here's What It's Like."

7. C. Timberg and Harwell, "We Studied Thousands."

8. Furie, "Pepe the Frog's Creator."

9. Warren and Brandeis, "Right to Privacy."

10. Warren and Brandeis, "Right to Privacy," citing Judge Cooley, 195.

11. Burns, *New York*.

12. Warren and Brandeis, "Right to Privacy."

13. Bare and Miel, *Harry Benson*.

14. Giardina, "'Rogue One.'"

15. Sarah Howes, conversation with author, July 2019.

16. Lindsay Lohan v. Take-Two Interactive Software, Inc., et al., 2018 NY Slip Op 02208 (31 N.Y. 3d 111).

17. Sarah Howes, email to author, July 2019.

18. Aldred, "Khloe Kardashian Is Being Sued."

19. Breznican, "Guardians of Leia."

20. Fisher, *Wishful Drinking*, 133–36.

21. Mervosh, "How George Bush Befriended."

22. Lessig, "Strangling Creativity."

23. Warren and Brandeis, "Right to Privacy."

24. Silverman, "Meet the Man."

25. Barlow, *Declaration of the Independence of Cyberspace.*

26. Witt, "Tech Utopianism."

Epilogue

1. A sample of Gibson's photographs can be found on Instagram, https://www.instagram.com/tintype_artist/.

2. Newhoff, "Personal Archeology."

3. Orlov, "Light Formulation."

4. Orlov, "Light Formulation."

BIBLIOGRAPHY

Ackroyd, Peter. *The History of England from James I to the Glorious Revolution.* New York: Thomas Dunne, 2014.

"Actors before the Camera." Reprinted from *N.Y. Commerica, Advertiser* in *Photographic Times and American Photographer* 21, no. 525 (October 1891): 505–6. Hathi Trust. Accessed March 1, 2020. https://babel.hathitrust.org/cgi/pt?id=gri.ark:/13960/t43r73314&view=1up&seq=433.

Aldred, John. "Khloe Kardashian Is Being Sued for Posting a Photo of Herself to Instagram." *DIYPhotography*, April, 28, 2017. https://www.diyphotography.net/khloe-kardashian-sued-posting-photo-instagram/.

Allingham, Philip V. *Sir Thomas Noon Talfourd (1795–1854): The Original "Tommy Traddles."* The Victorian Web. Accessed July 20, 2019. http://www.victorianweb.org/history/talfourd.html.

Amendment U.S. Copyright Act (1802). *Primary Sources on Copyright (1450–1900).* Edited by L. Bently and M. Kretschmer, 2008. Accessed March 2, 2020. http://www.copyrighthistory.org/cam/tools/request/showRecord.php?id=record_us_1802.

Annual Reports. Librarian of Congress. The Condition and Progress of the Library, 1866–1899. Copyright.gov. Accessed April 10, 2019. https://www.copyright.gov/history/annual_reports.html.

Arguments before the Committees on Patents of the Senate and House of Representatives, Conjointly, on the Bills S. 6330 and H.R. 19853, to Amend and Consolidate the Acts Respecting Copyright. 59th Cong. (December 1906). Statement of Samuel L. Clemens. Accessed February 1, 2020. http://www.thecapitol.net/Publications/testifyingbeforecongress_Twain.html.

Ayer, Alfred Jules. "Only Analytic Statements Are Knowable A Priori." In *The Problems of Philosophy*, 3rd ed., edited by William P. Alston and Richard B. Brandt, 646–57. Boston: Allan & Bacon, 1978.

Bare, Justin, and Matthew Miel. *Harry Benson: Shoot First.* Documentary film, 2016.

Barlow, John Perry. *A Declaration of the Independence of Cyberspace*. Speech. Davos, Switzerland, February 8, 1996. https://www.eff.org/cyberspace -independence.

Barol, Bill. "A Statement from the Monkey." *New Yorker*, August 26, 2014. https://www.newyorker.com/humor/daily-shouts/statement-monkey.

Barthes, Roland. *Camera Lucida: Reflections on Photography*. New York: Hill and Wang, 1981.

Basham, Ben. *The Theatrical Photographs of Napoleon Sarony*. Kent OH: Kent State University Press, 1978.

Blount, Roy, Jr. *Alphabet Juice*. New York: Sarah Crichton, 2009.

Boller, Paul F., Jr. *Presidential Campaigns: From George Washington to George W. Bush*. Oxford: Oxford University Press, 2004.

Boucicault, Dion. *After Dark: A Drama of London Life in 1868*. Internet Archive. Accessed February 2, 2020. https://archive.org/details /afterdarkdramaof00bouc/page/36.

———. *The Octoroon; or Life in Louisiana*. Internet Archive. Accessed March 5, 2020. https://archive.org/details/theoctoroonorlif46091gut.

Boyden, Bruce E. "Daly v. Palmer, or the Melodramatic Origins of the Ordinary Observer." Marquette University Law School Legal Studies Research Paper Series, no. 18-17. *Syracuse Law Review* 68, no. 1 (2018): 147–79. http://ssrn .com/abstract=3157782.

Boyle, James, and Jennifer Jenkins, eds. "Macaulay on Copyright." *The Public Domain: Enclosing the Commons of the Mind*. The Public Domain. Accessed March 6, 2020. https://www.thepublicdomain.org/2014/07/24/macaulay -on-copyright/.

———. "Victor Hugo: Guardian of the Public Domain." *The Public Domain: Enclosing the Commons of the Mind*. Accessed March 8, 2020. https://www .thepublicdomain.org/2014/07/18/victor-hugo-guardian-of-the-public -domain/.

Bracha, Oren. "Commentary on the U.S. Copyright Act 1831." *Primary Sources on Copyright (1450–1900)*. Edited by L. Bently and M. Kretschmer, 2008. Accessed March 8, 2020. http://www.copyrighthistory.org/cam/tools /request/showRecord?id=commentary_us_1831.

———. *Owning Ideas: The Intellectual Origins of American Intellectual Property, 1790–1909*. Cambridge: Cambridge University Press, 2016.

Brandom, Russell. "Deepfake Propaganda Is Not a Real Problem." *The Verge*, March 5, 2019. https://www.theverge.com/2019/3/5/18251736/deepfake -propaganda-misinformation-troll-video-hoax.

Breznican, Anthony. "The Guardians of Leia: The Untold Story of Carrie Fisher's Return in *The Rise of Skywalker*." *Vanity Fair*, December 30, 2019.

https://www.vanityfair.com/hollywood/2019/12/carrie-fisher-oral-history
-rise-of-skywalker-star-wars.

Bryson, Bill. *Mother Tongue: English and How It Got That Way*. New York: Avon
Books, 1990.

———. *Shakespeare: The World as Stage*. New York: Harper Collins, 2007.

Buinicki, Martin T. "Walt Whitman and the Question of Copyright." *American
Literary History* 15, no. 2 (Summer 2003): 248–75. https://muse.jhu.edu
/article/42113.

Burns, Ken. *American Lives*. Documentary film series. Season 1, episode 3,
"Thomas Jefferson: Part 1." Public Broadcasting System, 1997.

———. *New York*. Documentary film series. Episode 3, "Sunshine and Shadow
(1865–1898)." Public Broadcasting System, 1999.

Burrow-Giles' Brief. Washington DC, 1883. *Primary Sources on Copyright (1450–
1900)*. Edited by L. Bently and M. Kretschmer, 2008. Accessed January 30,
2018. http://www.copyrighthistory.org/cam/tools/request/showRecord.php
?id=record_us_1883b.

Byron, Lord (George Gordon). *Mazeppa, A Poem*. London: John Murray, 1819.
Internet Archive. Accessed March 8, 2020. https://archive.org/details
/mazeppaapoem02byrogoog/page/n7/mode/2up.

Cahill, Thomas. *How the Irish Saved Civilization*. New York: Anchor Books, 1995.

Capen, Nahum. *Memorial of Nahum Capen, of Boston, Massachusetts, on the Subject of
International Copyright*. Testimony submitted to House of Representatives, 28th
Cong., 1st session. January 15, 1844. Google Books. Accessed March 5, 2020.
https://books.google.com/books?id=0rJjAAAAcAAJ&pg=PA1&lpg=PA1#v=
onepage&q&f=false.

Carlisle, Stephen. "Warhol v. Goldsmith: A Terrible Decision, Correctly
Decided." Office of Copyright, Nova Southeastern University, July 11, 2019.
http://copyright.nova.edu/warhol-v-goldsmith/.

Carmichael, C. H. E. "Report on the Berne International Copy-
right Conference, 1883." *Journal of Jurisprudence* 28 (1884). Goo-
gle Books. Accessed March 5, 2020. https://books.google.com/books
?id=oBEuAAAAIAAJ&pg=PA264&dq=%E2%80%9CReport+on
+the+Berne+International+Copyright+Conference,+1883.%E2
%80%9D&hl=en&newbks=1&newbks_redir=0&sa=X&ved=
2ahUKEwiZosvlrcznAhWDwFkKHUdkDDkQ6AEwAHoECAAQAg
#v=onepage&q=%E2%80%9CReport%20on%20the%20Berne
%20International%20Copyright%20Conference%2C%201883.%E2%80
%9D&f=false.

Carpenter, Teresa, ed. *New York Diaries 1609 to 2009*. New York: Modern
Library, 2012.

Cascone, Sarah. "The Andy Warhol Foundation Has Won Out against a Photographer Who Claimed the Pop Artist Pilfered Her Portrait of Prince." ArtNet, July 2, 2019. https://news.artnet.com/art-world/andy-warhol-prince-copyright-case-1590703.

"The Case of the Moved Body." Library of Congress. Accessed July 12, 2019. https://www.loc.gov/collections/civil-war-glass-negatives/articles-and-essays/does-the-camera-ever-lie/the-case-of-the-moved-body/.

Chatterton, Thomas. *The Poetical Works of Thomas Chatterton: With Notices of His Life, a History of the Rowley Controversy.* Edited by Charles B. Wilcox. Boston: Little Brown, 1863.

Chernow, Ron. *Alexander Hamilton.* New York: Penguin, 2004.

Chivvis, Dana. "Monkey in the Middle." *This American Life.* National Public Radio, November 10, 2017.

Clague, Mark. "Separating Fact from Fiction about 'The Star-Spangled Banner.'" National Constitution Center, September 14, 2016. https://constitutioncenter.org/blog/separating-fact-from-fiction-about-the-star-spangled-banner/.

Clark, Gulia, and Stuart Elliott. *Edward and Mary: The Unknown Tudors.* Documentary film. 2002.

Cole, John Y. "Jefferson's Legacy: A Brief History of the Library of Congress." YouTube. Accessed May 17, 2018. https://www.youtube.com/watch?v=5ithcd12eKg.

Cole, Samantha. "AI-Assisted Fake Porn Is Here and We're All Fucked." *Motherboard Tech by Vice*, December 11, 2017. Vice. https://www.vice.com/en_us/article/gydydm/gal-gadot-fake-ai-porn.

Cole, Teju. *Known and Strange Things: Essays.* New York: Random House, 2016.

Committee on Patents. Report on International Copyright. H.R. Rep. No. 2401-51. June 10, 1890.

The Concise Oxford Dictionary of Current English. Edited by R. E. Allen. Oxford: Clarendon, 1990.

Cook, Jesselyn. "Here's What It's Like to See Yourself in a Deepfake Porn Video." *Huffington Post*, June 23, 2019. https://www.huffpost.com/entry/deepfake-porn-heres-what-its-like-to-see-yourself_n_5d0d0faee4b0a3941861fced.

Copyright Act, London (1842). *Primary Sources on Copyright (1450–1900).* Edited by L. Bently and M. Kretschmer, 2008. Accessed on March 8, 2020. http://www.copyrighthistory.org/cam/tools/request/showRepresentation.php?id=representation_uk_1842&pagenumber=1_2.

Daniell, David. *William Tyndale: A Biography.* New Haven: Yale University Press, 1994.

Davies, Richard. "The First Great Photography Craze: Cartes de Visite." *PetaPixel*, March 14, 2019. https://petapixel.com/2019/03/14/the-first-great -photography-craze-cartes-de-visites/.

Davison, Nancy. "E. W. Clay and the American Political Caricature Business." In *Prints and Printmakers of New York State*, edited by David Tatham. Syracuse NY: Syracuse University Press, 1986.

Deazley, R. "Commentary on *Copyright Act 1814*." *Primary Sources on Copyright (1450–1900)*. Edited by L. Bently and M. Kretschmer, 2008. Accessed March 8, 2020. http://www.copyrighthistory.org/cam/tools/request /showRecord?id=commentary_uk_1814.

——— . "Commentary on *Millar v. Taylor 1769*." *Primary Sources on Copyright (1450–1900)*. Edited by L. Bently and M. Kretschmer, 2008. Accessed March 8, 2020. http://www.copyrighthistory.org/cam/tools/request /showRecord?id=commentary_uk_1769.

——— . "Commentary on the Stationers' Royal Charter 1557." *Primary Sources on Copyright (1450–1900)*. Edited by L. Bently and M. Kretschmer, 2008. Accessed March 8, 2020. http://www.copyrighthistory.org/cam/tools /request/showRecord?id=commentary_uk_1557.

DeMain, Bill. "The Sound and Vision of David Bowie." *Songwriter Magazine*, September/October 2003.

Dennis, Donna. *Licentious Gotham: Erotic Publishing and Its Prosecution in Nineteenth Century New York*. Cambridge MA: Harvard University Press, 2009.

Dickens, Charles. *The Pickwick Papers*. Philadelphia: T. B. Peterson, 1850. Dedication to Talfourd, p. 3. Hathi Trust. Accessed March 7, 2020. https://babel .hathitrust.org/cgi/pt?id=osu.32435069207306&view=1up&seq=19.

Dixon, Mark E. "Picture Perfect," *Main Line Today*. Accessed March 7, 2020. https://mainlinetoday.com/uncategorized/picture-perfect-2/.

Donaldson v. Beckett (1774). *Primary Sources on Copyright (1450–1900)*. Edited by L. Bently and M. Kretschmer, 2008. Accessed March 5, 2020. http://www .copyrighthistory.org/cam/tools/request/showRecord.php?id=record_uk _1774.

Douglass, F., and W. L. Garrison. *Narrative of the Life of Frederick Douglass, an American Slave*. Boston: Anti-Slavery Office, 1849. Library of Congress. Accessed March 6, 2020. https://www.loc.gov/resource/lhbcb.25385/?sp=4.

Duhaime's Law Dictionary. http://www.duhaime.org/LegalDictionary/S /Scenesafaire.aspx.

Earle, Edward, ed. *Points of view, the stereograph in America: A Cultural History*. Rochester NY: Visual Studies Workshop Press, 1979.

Edison, Thomas A. Thomas A. Edison Papers. Rutgers School of Arts and Sciences. http://edison.rutgers.edu.

Ellis, Joseph J. *The Quartet: Orchestrating the Second American Revolution 1783–1789*. New York: Penguin Random House, 2015.

Ellmann, Richard. *Oscar Wilde*. New York: Vintage, 1988.

"Extremist Content and Russian Disinformation Online: Working with Tech to Find Solutions." U.S. Senate Judiciary Committee Hearing, October 31, 2017. https://www.judiciary.senate.gov/meetings/extremist -content-and-russian-disinformation-online-working-with-tech-to-find -solutions.

"Farrand's Records." Vol. 2, August 18, 1787. *American Memory: A Century of Lawmaking for a New Nation: U.S. Congressional Documents and Debates, 1774–1875*. Accessed March 2, 2020. https://memory.loc.gov/cgibin/query/r ?ammem/hlaw:@field(DOCID+@lit(fr0022)).

Felheim, Marvin. *The Theater of Augustin Daly: An Account of the Late Nineteenth Century American Stage*. Cambridge MA: Harvard University Press, 1956.

Fisher, Carrie. *Wishful Drinking*. New York: Simon & Schuster, 2009.

Foot, Charles H. *"Death of Chatterton" Case: Turner v. Robinson*. Dublin and London: Edward Ponsonby, 1860. V. & R. Stevens & Sons: Simpkin, Marshall, & Co.

Franklin, Benjamin. *The Autobiography of Benjamin Franklin* (1793). Norwalk CT: Easton, 1976.

Friedman, Ori, and Karen R. Neary. "Determining Who Owns What: Do Children Infer Ownership from First Possession?" Elsevier ScienceDirect. Accessed March 7, 2020. https://www.sciencedirect.com/science/article /pii/s0010027707003071?via%3dihub.

Furie, Matt. "Pepe the Frog's Creator: I'm Reclaiming Him. He Was Never about Hate." *Time*, October 13, 2016. https://time.com/4530128/pepe-the -frog-creator-hate-symbol/.

Gaines, Jane M. *Contested Culture: The Image, the Voice, and the Law*. Chapel Hill: University of North Carolina Press, 1991.

Garland, Alex, dir. *Ex Machina*. Universal Pictures, 2015.

Giardina, Carolyn. "'Rogue One': How Visual Effects Made the Return of Some Iconic 'Star Wars' Characters Possible." *Hollywood Reporter*, December 16, 2016. https://www.hollywoodreporter.com/heat-vision/rogue-one-how -grand-moff-tarkin-peter-cushing-returned-957258.

Gilbert, W. S., and Arthur Sullivan. *Patience, or Bunthorne's Bride*. First performed April 23, 1881. Gilbert and Sullivan Archive. Curated by Paul Howarth and Jim Farron. Accessed March 7, 2020. gsarchive.net. https:// gsarchive.net/patience/patienclib.pdf.

Ginsburg, Jane C. "A Tale of Two Copyrights: Literary Property in Revolutionary France and America." *Tulane Law Review* 64 (1990): 991. https:// scholarship.law.columbia.edu/faculty_scholarship/620.

Green, Michael. Review of *Justice of Shattered Dreams: Samuel Freeman Miller and the Supreme Court during the Civil War Era*, by Michael A. Ross. *H-CivWar, H-Net Reviews*, March 2006. https://www.h-net.org/reviews /showrev.php?id=11521.

Greene, Andy. "Neil Young: Trump 'Does Not Have My Permission' to Play 'Rockin in the Free World.'" *Rolling Stone*, November 6, 2018. https://www .rollingstone.com/music/music-news/neil-young-trump-does-not-have-my -permission-to-play-rockin-in-the-free-world-752774/.

Hannavy, John, ed. *Encyclopedia of Nineteenth-Century Photography*. Abingdon, UK: Routledge, 2013. Google Books. Accessed March 7, 2020. https://books.google.com/books?id=yVFdAgAAQBAJ&pg=PA276 &lpg=PA276&dq=Louis+Dodero+photographer&source=bl&ots= bAT9r2dCfX&sig=JKd81yJ21NPMcVw5SFeQDEaitSE&hl=en&sa=X&ved =0ahUKEwjLoNucrLTaAhUs5YMKHeXYBxgQ6AEIVTAM#v=onepage&q =Louis%20Dodero%20photographer&f=false.

Hartmann, Sadakichi. "Portrait Painting and Portrait Photography." 1899. *Photography Criticism CyberArchive*. Accessed March 7, 2020. http://www .photocriticism.com/members/archivetexts/photocriticism/hartmann /hartmannportraiture2.htm.

Hofer, Mathew, and Gary Scharnhorst, eds. *Oscar Wilde in America: The Interviews*. Urbana: University of Illinois Press, 2010.

Holmes, Oliver Wendell, Sr. "Address for the Opening of the Fifth Avenue Theater." December 3, 1873. In *The Poetical Works of Oliver Wendell Holmes*, vol. 2. New York: Houghton, Mifflin, 1891. Google Books. https://books.google.com/books?id=n8YbvG1oLaEC&pg=PA205& dq=The+Poetical+Works+of+Oliver+Wendell+Holmes+in+Three +Volumes,+Volume+2&hl=en&newbks=1&newbks_redir=0&sa=X&ved =2ahUKEwjcvLevwsznAhUEwVkKHckHCTgQ6AEwAHoECAMQAg#v= onepage&q=Hang%20out%20our%20banners%20on%20the%20stately %20tower!&f=false.

———. "The Stereoscope and the Stereograph." *Atlantic Monthly*, June 1859. Accessed March 7, 2020. https://www.theatlantic.com/magazine/archive /1859/06/the-stereoscope-and-the-stereograph/303361/.

Hughes, Justin. "The Photographer's Copyright—Photograph as Art, Photograph as Database." *Harvard Journal of Law & Technology* 25, no. 2 (Spring 2012). http://ssrn.com/abstract=1931220.

"The International Copyright Question: Protest against the Doctrine of the Democratic Review Thereon" [signed S.]. *United States Magazine and Democratic Review* 12, no. 60 (June 1843). Hathi Trust. Accessed March 7, 2020. https:// babel.hathitrust.org/cgi/pt?id=coo.31924085376592&view=1up&seq=518.

"Isaac McPherson to Thomas Jefferson, 3 August 1813." Founders Online:
National Archives. Accessed March 7, 2020. https://founders.archives.gov
/?q=isaac%20mcpherson%20to%20thomas%20jefferson%20Author%3A
%22McPherson%2C%20Isaac%22&s=1111311111&r=1&sr=.

"It Could Have Caused 'The Greatest Chaos in America.'" *Wise Guide*, December 2002. Library of Congress. Accessed March 7, 2020. https://www.loc
.gov/wiseguide/dec02/chaos.html.

Jacobi, Carol. "Painting and the Art of Stereoscopic Photography." Curatorial
essay. Tate Gallery, London. Accessed March 7, 2020. https://www.tate.org
.uk/whats-on/tate-britain/display/bp-spotlight-poor-mans-picture-gallery
-victorian-art-and-stereoscopic/essay.

"James Thomson." Poetry Foundation. Accessed March 6, 2020. https://www
.poetryfoundation.org/poets/james-thomson.

Jefferson, Thomas. "Letter to Isaac McPherson." August 13, 1813. *The Portable
Thomas Jefferson*, edited by Merrill D. Peterson. New York: Penguin, 1977.

"Jefferson's Legacy: A Brief History of the Library of Congress." Library of Congress. Accessed March 7, 2020. https://www.loc.gov/loc/legacy/loc.html.

John Foxe's Book of Martyrs. Chapter 13, account of Cranmer at 244. Project Gutenberg. Accessed March 7, 2020. http://www.gutenberg.org/files
/22400/22400-h/22400-h.htm.

Johnson, Steven. *How We Got to Now: Six Innovations That Made the Modern
World*. New York: Riverhead Books/Penguin, 2014.

"John Wilkes Booth, Half-length Studio Portrait, Sitting." Silsbee, Case & Co.,
photographic artists, Boston, 1862. Library of Congress. Accessed March 7,
2020. https://www.loc.gov/item/2009634256/.

"Jumbo Arrives in America." Barnum Museum. Accessed March 7, 2020.
https://barnum-museum.org/jumbo-arrives-america/.

Kang, Jay Caspian. "Wikimedia Defends the Monkey Selfie." *New Yorker*,
August 8, 2014.

Kendall, Joshua. *The Forgotten Founding Father: Noah Webster's Obsession and the
Creation of an American Culture*. New York: Berkley (2010).

Kerhanan, Coulson. *In Good Company: Some Personal Recollections of Swinburne,
Lord Roberts Watts-Dunton, Oscar Wilde, Edward Whymper, S. J. Stone, Stephen Philllips*. 1900. Internet Archive. Accessed March 7, 2020. https://
archive.org/details/ingoodcompany029942mbp/page/n6.

Khan, Nora N. "Seeing, Naming, Knowing." *Brooklyn Rail*, March 7, 2019.
https://brooklynrail.org/2019/03/art/Seeing-Naming-Knowing.

King, Lord Peter. *The Life of John Locke*. London: Henry Colburn, 1830. Google Books. Accessed March 7, 2020. https://books.google.com/books?vid=

OCLC00686706&id=X0uHijB7sQoC&pg=PA1&lpg=PA1&ots=Fkrw#v=
onepage&q=by%20this%20clause&f=false.

Kottemann, Molly C. "Oliver Wendell Holmes: Physician and Man of Letters."
Yale Journal of Biology and Medicine 83, no. 2 (June 2010): 111–12. Accessed
March 7, 2020. https://www.ncbi.nlm.nih.gov/pmc/articles/pmc2892772/.

Kravets, David. "Monkey's Selfie Cannot Be Copyrighted, U.S. Regulators Say."
Ars Technica, August 21, 2014. https://arstechnica.com/tech-policy/2014
/08/monkeys-selfie-cannot-be-copyrighted-us-regulators-say/.

Lanier, Jaron. *You Are Not a Gadget.* New York: Knopf Doubleday, 2010.

Lee, Margaret. "Authors' Petition." *Frank Leslie's Popular Monthly* 49, 109–11.
Google Books. https://books.google.com/books?id=3h8fbW8-tLsC&pg=
PA109&lpg=PA109" \l "v=onepage&q&f=false.

Leibovitz, Annie. *Leibovitz at Work.* New York: Random House, 2008.

Lemley, Mark A. "Faith-Based Intellectual Property." UCLA Law Review 62 (2015).
Stanford Public Law Working Paper no. 2587297, March 30, 2015, 1330–46.

Lesser, Allen. *Enchanting Rebel: The Secret of Adah Isaacs Mencken.* Philadel-
phia: Ruttle, Shaw & Wetherill, 1947.

Lessig, Lawrence. "Laws That Choke Creativity." TED Talk, March 2007. https://
www.ted.com/talks/larry_lessig_says_the_law_is_strangling_creativity.

Leval, Pierre N. "Toward a Fair Use Standard." *Harvard Law Review* 3 (1989–
90): 1105.

Lightfoot, Steve. Leeds and Bradford Photographic Studios: 1840–1910.
Website. Accessed March 1, 2020. https://sites.google.com/site
/leedsandbradfordstudios/home.

Locke, John. *Locke: Two Treatises of Government.* Edited by Peter Laslett. Cam-
bridge, UK: Cambridge University Press, 1960, 2015.

"Macaulay on Copyright." *The Public Domain, Enclosing the Commons of the
Mind*, edited by James Boyle and Jennifer Jenkins. The Public Domain.
Accessed March 6, 2020. https://www.thepublicdomain.org/2014/07/24
/macaulay-on-copyright/.

Macdonald, Pirie. Testimony. Revision of Copyright Laws: Hearings before
the Committees on Patents of the Senate and House of Representa-
tives on Pending Bills to Amend and Consolidate the Acts Respect-
ing Copyright. March 26–28, 1908. https://books.google.com/books?id
=Oh0vAAAAMAAJ&pg=PA437&lpg=PA437&dq=Committees+on
+Patents+on+March+26-28,+1908&source=bl&ots=CaEwKliAI-&sig=
ACfU3U1MyZxLa8hbt1z-rHBb3oboXNyO-A&hl=en&ppis=_e&sa=X&ved
=2ahUKEwjUrpr78sznAhXNrFkKHYwpCDQQ6AEwBHoECAcQAQ#v=
onepage&q=macdonald&f=false.

Madison, James. "Federalist 43." *The Federalist Papers*, edited by Clinton Rossiter. New York: Signet Classics, 1961.

"Manure Dumped at Ramsay's Eatery." British Broadcasting Company, May 15, 2007. http://news.bbc.co.uk/2/hi/uk_news/england/london/6658871.stm.

Massachusetts Copyright Statute (1783). *Primary Sources on Copyright (1450–1900)*, edited by L. Bently and M. Kretschmer, 2008. Accessed March 5, 2020. http://www.copyrighthistory.org/cam/tools/request/showRecord .php?id=record_us_1783d.

May, Randolph J., and Seth Cooper. *The Constitutional Foundations of Intellectual Property: A Natural Rights Perspective.* Durham NC: Carolina Academic Press, 2015.

McCullough, David. *1776.* New York: Simon & Schuster, 2005.

Mervosh, Sarah. "How George Bush Befriended Dana Carvey, the 'S.N.L.' Comedian Who Impersonated Him." *New York Times*, December 1, 2018. https://www.nytimes.com/2018/12/01/arts/george-bush-dana-carvey.html.

Milton, John. *Areopagitica: A Speech for the Liberty of Unlicensed Printing to the Parliament of England*, 1644. Ebook.

Mollen, Joost. "Pirate Bay Founder: 'I Have Given Up.'" *Motherboard*, December 11, 2015. https://www.vice.com/en_us/article/qkjpbd/pirate-bay -founder-peter-sunde-i-have-given-up.

Morgan, Blake. "Spotify's Fatal Flaw Exposed: How My Closed-Door Meeting with Execs Ended in a Shouting Match." *Trichordist*, January 8, 2018. https://thetrichordist.com/2018/01/08/the-slippery-slope-of-censorship -huffpost-pulls-story-critical-of-spotify-ahead-of-ipo/.

Morris, Errol. *Believing Is Seeing: Observations on the Mysteries of Photography.* New York: Penguin, 2014.

Morris, Steven. "Shutter Happy Monkey Turns Photographer." *Guardian*, July 4, 2011. https://www.theguardian.com/world/2011/jul/04/shutter-happy -monkey-photographer.

"Napoleon Sarony Dies Suddenly." *New York Journal*, November 10, 1896. Image 9. Library of Congress. Accessed March 7, 2020. https://www.loc .gov/resource/sn84024350/1896-11-10/ed-1/?sp=9&q=napoleon+sarony.

National Aeronautics and Space Administration (NASA). "Music from Earth." List of recorded music on Voyager I and II. Accessed March 7, 2020. https://voyager.jpl.nasa.gov/golden-record/whats-on-the-record/music/.

"The New Copyright Law." *Wilson's Photographic Magazine* 46, no. 628 (April 1909). Internet Archive. Accessed March 6, 2020. https://archive.org /details/wilsonsphotogra04unkngoog/page/n165/mode/2up

Newhall, Beaumont. *The History of Photography.* Boston: Little Brown, 1982.

Newhoff, David. "American Identity Is in the Music." *The Illusion of More*, August 17, 2017. https://illusionofmore.com/american-identity-is-in-the-music/.

———. "At World's End—The Technological Singularity." *The Illusion of More*, December 19, 2012. https://illusionofmore.com/at-worlds-end-singularity/.

———. "Graham v. Prince or Art v. Fair Use." *The Illusion of More*, October 17, 2018. https://illusionofmore.com/graham-v-prince-or-art-v-fair-use/.

———. "Monkey Suit Is Not All Monkey Business." *The Illusion of More*, January 26, 2016. https://illusionofmore.com/monkey-selfie-suit-monkey -business/.

———. "Personal Archeology in the Digital Age." *The Illusion of More*, September 12, 2013. https://illusionofmore.com/personal-archeology/.

———. "Society Can't Have What Authors Don't Create." *The Illusion of More*, September 21, 2016. https://illusionofmore.com/society-cant-have-what -authors-dont-create/.

Niver, Kemp R., ed. *Early Motion Pictures: The Paper Print Collection in the Library of Congress*. Washington: Library of Congress, 1985. Hathi Trust. Accessed February 25, 2020. https://babel.hathitrust.org/cgi/pt?id=osu .32435054790779;view=2up;seq=1;size=125.

Nudd, Tim. "Inside 'The Next Rembrandt': How JWT Got a Computer to Paint Like the Old Master." *AdWeek*, January 27, 2016. https://www.adweek.com /brand-marketing/inside-next-rembrandt-how-jwt-got-computer-paint-old -master-172257/.

Orlov, Anton. "Light Formulation–Statement of an Artist." *Photo Palace*, May 22, 2019. Blog. http://thephotopalace.blogspot.com/2019/05/light -formulation-statement-of-artist.html.

Orlowski, Andrew. "Cracking Copyright Law: How a Simian Selfie Stunt Could Make a Monkey out of Wikipedia." *The Register*, August 24, 2014. https:// www.theregister.co.uk/2014/08/24/wikipedia_monkey_selfie_backfire.

O'Sullivan, Donnie. "Lawmakers Warn of 'Deepfake' Videos ahead of 2020 Election." *CNN Business*, January 28, 2019. https://www.cnn.com/2019/01 /28/tech/deepfake-lawmakers/index.html.

O'Sullivan, John. "The International Copyright Question." *United States Magazine and Democratic Review* 12, no. 56 (February 1843). Hathi Trust. Accessed March 5, 2020. https://babel.hathitrust.org/cgi/pt?id=mdp .39015035929580&view=1up&seq=129.

Parkin, Andrew, ed. *Selected Plays of Dion Boucicault*. Washington: Catholic University of America Press, 1987.

Patterson, Lyman Ray. *Copyright in Historical Perspective*. Nashville: Vanderbilt University Press, 1968.

Pauwels, Erin. "Resetting the Camera's Clock: Sarony, Muybridge, and the Aesthetics of Wet-Plate Photography." *History and Technology* 31, no. 4 (2015): 482–91. http://dx.doi.org/10.1080/07341512.2015.1090674.

People for the Ethical Treatment of Animals (PETA). "Top 10 Wackiest Stunts." Accessed March 6, 2020. https://www.peta.org/blog/petas-top-10-wackiest-stunts/.

Phillips, Barnet. "Letter from Barnet Phillips, Harper's Weekly to Thomas Alva Edison, October 31st, 1893." Thomas A. Edison Papers Digital Edition. Accessed March 8, 2020. https://edison.rutgers.edu/digital/document /D9303AAQ.

Reich, Robert. "The Sharing Economy Will Be Our Undoing." *Salon*, August 25, 2015. https://www.salon.com/2015/08/25/robert_reich_the_sharing _economy_will_be_our_undoing_partner/.

Robinson, David. *From Peep Show to Palace*. New York: Columbia University Press, 1996.

Robinson, Henry R., and Napoleon Sarony. "A Democratic Voter." Photograph. H. R. Robinson, 1837. Accessed March 8, 2020. https://www.loc.gov/item /2008661292/.

Robinson, Lisa. "Remembering Prince, an Enigmatic Genius Who Owned It . . . Literally." *Vanity Fair*, April 21, 2016. https://www.vanityfair.com /hollywood/2016/04/prince-lisa-robinson-obituary.

Rose, Mark. *Authors in Court: Scenes from the Theater of Copyright*. Cambridge MA: Harvard University Press, 2016.

Rosen, Zvi S. "The (First) Register of Copyrights and the Drafting of the 1909 Copyright Act." *Mostly IP History*, May 12, 2017. http://www.zvirosen.com /2017/05/12/the-first-register-of-copyrights-and-the-drafting-of-the-1909 -copyright-act/.

——. "The Forgotten History of Copyright for Photographs." *Mostly IP History*, October 10, 2107. http://www.zvirosen.com/2017/10/10/the-forgotten -origins-of-copyright-for-photographs/.

Rosenberg, C. G. *Jenny Lind in America*. New York: Stringer & Townsend, 1851.

Rustiala, Kal, and Christopher Jon Sprigman. "The Second Digital Disruption: Data, Algorithms and Authorship in the 21st Century." NYU Center for Law, Economics and Organization. Public Law and Legal Theory Research Paper Series. Working Paper no. 18–41. Law and Economics Research Paper Series, Working Paper No. 18–30. August 2018. https://ssrn.com/abstract=3226566.

Sacasas, Michael. "Dead and Going to Die." *New Inquiry*, October 21, 2013. https://thenewinquiry.com/dead-and-going-to-die/.

"Sarony." *Wilson's Photographic Magazine* 34, no. 481 (January 1897), 65–74. Forgotten Books. https://www.forgottenbooks.com/en.

"Sarony and Langtry. A Photographer's Opinion of Her." *Public Ledger* (Memphis TN), December 5, 1882. *Chronicling America: Historic American Newspapers*. Library of Congress. Accessed March 6, 2020. https:// chroniclingamerica.loc.gov/lccn/sn85033673/1882-12-05/ed-1/seq-2/.

Sarony's Brief. Washington DC, 1883. *Primary Sources on Copyright (1450–1900)*, edited by L. Bently and M. Kretschmer. Accessed March 7, 2020. http://www .copyrighthistory.org/cam/tools/request/showRecord.php?id=record_us_1883a.

Schjeldahl, Peter. "Richard Prince's Instagrams." *New Yorker*, September 30, 2014.

Schmidt, Barbara. Twainquotes. Accessed March 7, 2020. http://www .twainquotes.com/sarony/sarony.html.

Schuster, Aaron. "The Cinematic Spasm." *Cabinet Magazine* (Winter 2010–11). Accessed March 7, 2020. http://www.cabinetmagazine.org/issues/40 /schuster.php.

Shorto, Russell. *Island at the Center of the World: The Epic Story of Dutch Manhattan and the Forgotten Colony That Shaped America.* New York: Vintage Books/Random House, 2004.

Silverman, Jacob. "Meet the Man Whose Utopian Vision for the Internet Conquered, and Then Warped, Silicon Valley." *Washington Post*, March 20, 2015.

Siwek, Steven E. "The 2018 Report." International Intellectual Property Association. Accessed March 7, 2020. https://iipa.org/files/uploads/2018/12 /2018cpyrtRptFull.pdf.

Slater, David J. "Read How I Created My Famous Monkey 'selfie.'" DJS Photography. Accessed March 5, 2020. http://www.djsphotography.co.uk/original _story.html.

———. *Wildlife Personalities.* San Francisco: Blurb Books, 2014.

Sloat, Sarah. "Investigation of Cave Art Masterpieces Reveals They Weren't Made by Humans." *Inverse*, February 22, 2018. https://www.inverse.com /article/41551-neanderthal-cave-art-archeology-human.

Small, Zachary. "Christie's Sells 'AI-Generated' Art for \$432,500 as Controversy Swirls over Creators' Use of Copied Code." *Hyperallergic*, October 29, 2018. https://hyperallergic.com/468060/christies-sells-ai-generated-art-for -432500-as-controversy-swirls-over-creators-use-of-copied-code/.

Sontag, Susan. *On Photography.* New York: Farrar, Straus & Giroux, 1977.

Sousa, John Philip. "The Menace of Mechanical Music." *Appleton's Magazine* 8 (1906): 278–84.

Spehr, Paul. *The Man Who Made Movies: W. K. L. Dickson.* New Barnet, UK: John Libbey Publishing, 2008.

Stanska, Zuzanna. "Theodore Marceau: The Pioneer of Photographic Studios." *Daily Art Magazine*, June 3, 2017. https://www.dailyartmagazine.com /theodore-marceau/.

Statute of Anne, London (1710). *Primary Sources on Copyright (1450–1900)*. Edited by L. Bently and M. Kretschmer, 2008. Accessed March 7, 2020. http://www.copyrighthistory.org/cam/tools/request/showRepresentation ?id=representation_uk_1710.

Stuart, Nancy Rubin. *The Muse of the Revolution: The Secret Pen of Mercy Otis Warren and the Founding of a Nation.* Boston: Beacon Press, 2008.

Sutton, Benjamin. "Richard Prince Disowns His Ivanka Trump Portrait, Possibly Increasing Its Value." *Hyperallergic*, January 13, 2017. https://hyperallergic.com/351403/richard-prince-disowns-his-ivanka-trump-portrait-possibly-increasing-its-value/.

"Swinburne and Water." *Punch*, July 23, 1881, 23. Google Books. Accessed May 20, 2019. https://books.google.com/books?id=IT9XAAAAMAAJ&pg=RA1-PA26&lpg=RA1PA26&dq=swinburne+and+water+punch&source=bl&ots=5pjoUnMoUW&sig=ACfU3U1h57fKoEHAe_JZp4t0Ud869IHkA&hl=en&sa=X&ved=2ahUKEwjh_bCRlariAhWlpFkKHcbDBEcQ6AEwDHoECAUQAQ#v=onepage&q=swinburne%20and%20water&f=false

Talbot, Margaret. "The Attorney Fighting Revenge Porn." *New Yorker*, November 27, 2016.

Talbot, William Henry Fox. *The Pencil of Nature.* London: Longman, Brown, Green & Longmans, 1844–1846. Pencil of Nature (website), Lawrence (Larry) Jones, ed. Plate 6, "The Open Door." Accessed March 6, 2020. https://www.thepencilofnature.com/plate-6-the-open-door/.

Talfourd, Sergeant Thomas Noon. Parliamentary Debates on the Copyright Bill. April 25, 1838. London. *Primary Sources on Copyright (1450–1900).* Edited by L. Bently and M. Kretschmer, 2008. Accessed March 7, 2020. http://www.copyrighthistory.org/cam/tools/request/showRepresentation?id=representation_uk_1838c.

Thompson, Clive. "Stereographs Were the Original Virtual Reality." *Smithsonian Magazine*, October 2017. https://www.smithsonianmag.com/innovation/sterographs-original-virtual-reality-180964771/.

Thomson, James. *The Seasons.* Hartford: Silas Andrus, 1829. Internet Archive. Accessed March 7, 2020. https://archive.org/details/seasons01thom/page/158/mode/2up.

Timberg, Craig, and Drew Harwell. "We Studied Thousands of Anonymous Posts about the Parkland Attack—and Found a Conspiracy in the Making." *Washington Post*, February 27, 2018. https://www.washingtonpost.com/business/economy/we-studied-thousands-of-anonymous-posts-about-the-parkland-attack---and-found-a-conspiracy-in-the-making/2018/02/27/04a856be-1b20-11e8-b2d9-08e748f892c0_story.html.

Timberg, Scott. "Jaron Lanier: The Internet Destroyed the Middle Class," *Salon*, May 12, 2013. https://www.salon.com/2013/05/12/jaron_lanier_the_internet_destroyed_the_middle_class/.

Traubel, Horace. *With Walt Whitman in Camden*. Vol. 8. Walt Whitman Archive, 1996. Accessed March 5, 2020. https://whitmanarchive.org/criticism /disciples/traubel/WWWiC/8/whole.html.

Turkewitz, Neil. "On the Internet Everyone Is a _____ (Fill in the Blank)." *Medium*, March 22, 2018. https://medium.com/@nturkewitz_56674/on -the-internet-everyone-is-a-fill-in-the-blank-636abf70e996.

Tyndale, William. Obedience of a Christian Man, 1528. Ebook.

United States Copyright Office. Compendium of Copyright Office Practices. 2nd edition, 1984. Library of Congress. Accessed July 11, 2019. https:// www.copyright.gov/history/comp/compendium-two.pdf.

———. Compendium of Copyright Office Practices §101. 3rd edition, 2017. Accessed July 11, 2019. https://www.copyright.gov/comp3/.

"USS *Nightingale*." Wikipedia. https://en.wikipedia.org/wiki/USS_Nightingale_(1851).

Valenti, Jack. Testimony, April 12, 1982. Home Recording of Copyrighted Works. Hearings before the Subcommittee on Courts, Civil Liberties, and the Administration of Justice of the Committee on the Judiciary. 97th Congress, 2nd session, on H.R. 4783, H.R. 4794, H.R. 4808, H.R. 5250, H.R. 5488, and H.R. 5705. Hathi Trust Digital Library. Accessed March 6, 2020. https:// babel.hathitrust.org/cgi/pt?id=pst.000014112669&view=1up&seq=3.

Vowell, Sarah. *Assassination Vacation*. Simon & Schuster, 2005.

———. *The Wordy Shipmates*. New York: Riverhead, 2006.

Warren, Samuel, and Louis Brandeis. "The Right to Privacy." *Harvard Law Review* 4, no. 5 (December 15, 1890), 193–220.

Watson, Roger, and Helen Rappaport. *Capturing the Light: The Birth of Photography, A True Story of Genius and Rivalry*. New York: St. Martin's, 2013.

Webster, Noah. *American Dictionary of the English Language* (1828). http:// webstersdictionary1828.com/Dictionary.

"When Seeing Is No Longer Believing: Inside the Pentagon's Race against Deepfake Videos." CNN, February 2019. https://www.cnn.com/interactive /2019/01/business/pentagons-race-against-deepfakes/.

Whitman, Walt. *Leaves of Grass* (1855). Mineola NY: Dover, 2007.

———. "Walt Whitman and His Poems." [Unsigned.] *United States Magazine and Democratic Review*, September 1855, 205–12. Walt Whitman Archive. Accessed March 6, 2020. https://whitmanarchive.org/criticism/reviews /lg1855/anc.00176.html.

Widmer, Edward L. *Young America: The Flowering of Democracy in New York City*. New York: Oxford University Press, 1999.

Wilde, Oscar. "The Canterville Ghost." *The Complete Collection*. Golden Deer Classics. Ebook.

———. "Impressions of America," 1883. *The Complete Collection*. Golden Deer Classics. Ebook.

———. Interview with grandson Merlin Holland. *Oscar Wilde Collection*. Audible: L.A. Theatre Works, 2010.

———. "Literary and Other Notes—I." *Woman's World*, November 1887. *The Complete Collection*. Golden Deer Classics. Ebook.

———. *The Picture of Dorian Gray*. New York: Barnes & Noble Classics, 2003.

———. *Salomé*. *The Complete Collection*. Golden Deer Classics. Ebook.

———. "The Truth of Masks." *The Complete Collection*. Golden Deer Classics. Ebook.

———. *Vera: Or The Nihilists*. *The Complete Collection*. Golden Deer Classics. Ebook.

Willets, Gilson. "The Art of Not Posing—An Interview with Napoleon Sarony." *The American Annual of Photography* (1896).

Willsher, Kim. "Heir of Victor Hugo Fails to Stop Les Mis II." *Guardian*, January 30, 2007. https://www.theguardian.com/world/2007/jan/31/books.france.

Winter, William. *Vagrant Memories*. New York: George H. Doran, 1915. Internet Archive. Accessed March 7, 2020. https://archive.org/details/vagrantmemoriesb00wint/page/278.

Witt, Stephen. "Tech Utopianism and Our Walled Gardens: Is It Time for a Jailbreak?" National Public Radio. February 12, 2018. https://www.npr.org/sections/therecord/2018/02/12/585110447/tech-utopianism-and-our-walled-gardens-is-it-time-for-a-jailbreak.

Wood, Gordon S. *The Creation of the American Republic, 1776–1787*. Chapel Hill: University of North Carolina Press, 1969, 1998.

World Intellectual Property Organization. *Guide to the Berne Convention for the Protection of Literary and Artistic Works*. Paris Act, 1971. Geneva: WIPO, 1978.

Wurtzel, Elizabeth. *Creatocracy: How the Constitution Invented Hollywood*. Brooklyn: Thought Catalog, 2015.

Zhang, Michael. "Frederick Douglass Was the Most Photographed American of the 19th Century." *PetaPixel*, November 2, 2015. https://petapixel.com/2015/11/02/frederick-douglass-was-the-most-photographed-american-of-the-19th-century/.

———. "Richard Prince Selling Other People's Instagram Shots without Permission for $100K." *PetaPixel*, May 21, 2015. https://petapixel.com/2015/05/21/richard-prince-selling-other-peoples-instagram-shots-without-permission-for-100k/.

INDEX

copyright, theories of: and appropriation, 145; and artificial intelligence, 196, 198–201, 208; empirical view of, 205–6; labor theory of, 43–47; natural right vs. utilitarian view of, 15, 31, 51, 59–62, 64, 152; nature of, 14, 25, 27, 29, 31, 38, 58–59, 65, 74, 104, 109, 114, 122, 125–26, 143, 145–48, 156–58, 161–62, 164, 167–69, 172–73, 179–82, 191, 208, 216, 230, 236; and personality of the author, 113, 166, 168; as requisite (convenient) fiction, 10–11, 126, 161, 172, 204, 209, 236. See also *Wheaton v. Peters*

copyright law (U.S.): and derivative works right, xiii, 110, 126, 158, 184–85, 187–89, 191–92; and duration of (terms), 15, 48–49, 59–60, 153–54, 156, 159–63; enforcement of, 13, 174, 222; and fair use, 110, 171, 184–91, 193, 200, 215; fixation of, 160, 168, 179, 182; formalities in, 60, 151; and idea/expression dichotomy, 43, 124–26, 145, 163, 200; and independent creation, 199; and modicum of originality, 149, 166–67; and moral rights, 50, 158; music rights and, 195; ordinary observer role in, 109, 122–23, 146, 192–93; and public display, 171, 201; and public domain, 48, 50, 158, 161, 163, 174; and registration, 4–8, 38, 58, 60, 65, 124, 141, 159, 177; and reproduction right, 122, 144, 150, 171, 184, 195, 200, 230; scènes à faire in, 124; subject matter of, 15, 61–62, 104, 118, 123, 134, 139, 141, 143–44, 148, 150, 167, 173–81, 191, 198, 201; vs. substantial similarity,

110, 123–24; and sweat of the brow, 76, 185, 198; "thin" vs. "thick" protections in, 192; and transformativeness, 185–186, 191–93; and work-made-for-hire, 198

copyright legislation (UK): amendment of 1814, 59; and duration of terms, 153, 155, 158–59, 162; Licensing Act (1662), 143; Statute of Anne, 46–52, 64–65; subject matter of, 107

copyright legislation (U.S.): amendment of 1802, 30, 148; amendment of 1831, 60–61, 65, 154; amendment of 1865 (adding photographs), 5, 15, 17, 104, 134, 139, 141, 144; amendment of 1870, 7–8; Berne Convention Implementation Act (1988), 159–60; Copyright Act of 1790, 58, 64–65, 143, 148, 153; Copyright Act of 1909, 127, 150, 166, 176, 195; Copyright Act of 1976, 110, 159–60; Copyright Term Extension Act 1998 (CTEA), 159–61; Digital Millennium Copyright Act (DMCA), 168, 224–25; International Copyright Act (1891), 73–76, 78, 80–81, 119, 121–22; Massachusetts Copyright Act (1783), 57

Courbet, Gustave, 113
Covent Garden (London), 118
Cox, George Collins, 99
Cranfield's Gallery, 105, 109
Cranmer, Thomas, 36
Credence Clearwater Revival, 14
Crimea, 136
Crimean War, 135, 139
Cromwell, Oliver, 39
Curious George (character), 173
Currier, Nathaniel, 67, 79, 151